Art in New Mexico, 1900–1945

FOR IKE—
A SPECIAL
ARTIST...
NEWELL &
ROSEMARY
CHRISTMAS 1990

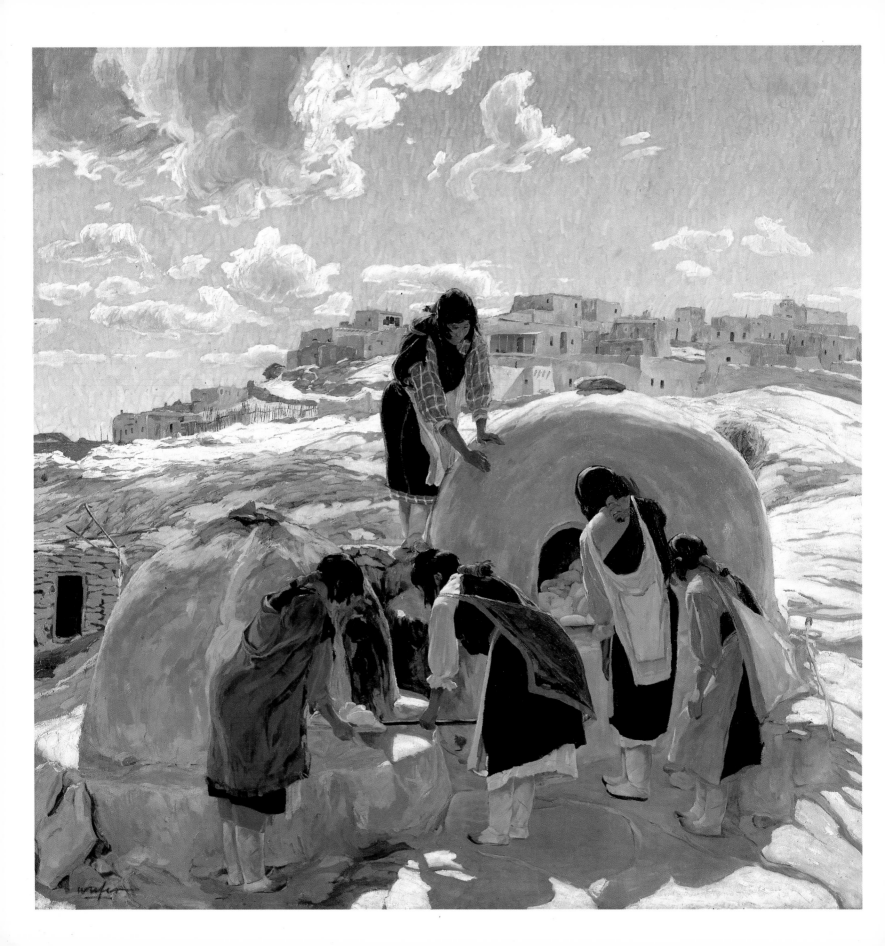

Charles C. Eldredge

Julie Schimmel

William H. Truettner

Art in New Mexico, 1900–1945
Paths to Taos and Santa Fe

National Museum of American Art Smithsonian Institution Washington, D.C.

Abbeville Press Publishers New York

Art in New Mexico, 1900–1945:
Paths to Taos and Santa Fe
has been made possible by the
Nelda C. and H. J. Lutcher Stark Foundation,
Orange, Texas.

Published for the exhibition
Art in New Mexico, 1900–1945:
Paths to Taos and Santa Fe

National Museum of American Art,
Smithsonian Institution, Washington, D.C.
7 March–15 June 1986

Cincinnati Art Museum, Cincinnati, Ohio
18 July–21 September 1986

The Museum of Fine Arts, Houston, Texas
31 October 1986–4 January 1987

The Denver Art Museum, Denver, Colorado
18 February–19 April 1987

Art director: James Wageman
Designer: Katy Homans
Editors
National Museum of American Art: Gaye Brown
Abbeville Press: Alan Axelrod
Production supervisor: Hope Koturo

Front cover:
Stuart Davis, *New Mexican Landscape*
(see p. 169).

Back cover:
Santo Niño Santero, *Saint Michael* (see p. 129);
Anonymous, Navajo, *Wedge-weave Blanket* (see p. 77);
Anonymous, Zia, *Water Jar* (see p. 74).

Frontispiece:
Walter Ufer, *The Bakers* (see p. 84).

Library of Congress Cataloging-in-Publication Data
Main entry under title:

Art in New Mexico, 1900–1945.

 Bibliography: p.
 Includes index.
1. Art, American—New Mexico—Themes, motives—
Exhibitions. 2. Hispanic American art—New Mexico—
Themes, motives—Exhibitions. 3. Indians of North
America—New Mexico—Art—Themes, motives—Exhibitions.
1. National Museum of American Art (U.S.)
N6530.N6A78 1986 709'.789'0740153 85-22876
ISBN 0-89659-598-6
ISBN 0-89659-599-4 (pbk.)

Hardcover and paperback editions
available in the United States
from Abbeville Press, Inc.,
505 Park Avenue, New York, New York 10022.

Contents

Preface

Since its heyday in the 1920s, the art of Taos and Santa Fe has never completely fallen from favor. An unflagging interest in the American West and the peculiar mystique of the Southwest helped to sustain a market for these images even when, in subsequent decades, American collectors were more interested in the succession of abstract styles that issued from New York and other urban centers. By the early 1960s, however, the pendulum had swung again, as historians and collectors cast a discerning eye toward earlier periods, seeking images that represented a more traditional American character.

Works by artists who had ventured west during the nineteenth century were in particular demand. Karl Bodmer's magnificent watercolors, documenting Prince Maximilian's journey up the Missouri in 1833–34, were sold in 1962 to InterNorth, Inc., of Omaha, already the owner of an extensive collection of works by Alfred Jacob Miller. In 1965 Paul Mellon gave to the National Gallery of Art in Washington more than three hundred fifty paintings by George Catlin, purchased several years earlier from the Museum of Natural History in New York. The next year a large cache of Miller watercolors surfaced at auction in New York, where they brought handsome prices. Sales of Remington paintings and sculpture, perhaps the benchmark of the western revival, were soaring by the early 1970s, spurred by interest in major collections recently opened to the public and publications that for the first time documented the artist's wide-ranging appeal.

Collectors in search of new fields soon discovered the art colonies of Taos and Santa

Fe, which gained prominence following Van Deren Coke's pioneering exhibition at the Amon Carter Museum in 1963. When Philip Anschutz purchased in 1973 Ernest Blumenschein's *Sangre de Cristo Mountains* (fig. 176), a painting consigned for many years to the basement of the Art Gallery of Ontario in Toronto, the stage was set for a collecting blitz that is still going strong. In fact, the pace of the market has left scholars behind, scrambling for biographical information, dates, and art-historical formulas to make sense of the bewildering range of artistic personalities who descended upon the colonies during the first decades of the twentieth century. In their rush to analyze divergent styles and attitudes, scholars may have temporarily lost sight of what originally bound these artists together and why they were attracted to New Mexico. Once again it is time to examine their deep commitment to the southwestern environment and to determine how it shaped certain images we now take for granted as representative of that era.

Selecting the works to illustrate the themes and perspectives we thought vital to a deeper understanding of the era was the most demanding part of the project. We are, therefore, especially indebted to those dealers who led us to the appropriate images: Stephen Good of Rosenstock Arts, Denver; Michael Frost of J. N. Bartfield Art Galleries, New York; and Gerald Peters of Santa Fe. Their thoughtful suggestions gave conclusive shape to our ideas. Forrest Fenn, Santa Fe; Frederick and James Hill of Berry-Hill Galleries, New York; Ira Spanierman, New York; and John Surovek, Palm Beach, were also generous with time and assistance.

Strong support at home came from Andrew Connors, exhibition coordinator and research assistant; museum editor Gaye Brown and her assistants Sara Faulkner and Carole Broadus; assistant registrar Melissa Kroning; and the library staff, in particular Cecilia Chin, Roberta Geier, and Karen Phillips. Their skills and cooperation gave professional finish to a project that grew more complex and demanding with each new insight we wished to provide.

From curatorial ranks, Elizabeth Cunningham of the Anschutz Collection and Sandra d'Emilio of the Museum of Fine Arts, Santa Fe, deserve special thanks. Their collections were thoroughly "raided" and their endurance tested for months after with additional requests. The following directors, curators, and administrators suffered less, but were particularly helpful: Fred Myers, Gilcrease Institute; Patrick Houlihan, Southwest Museum; Denny Young, Cincinnati Art Museum; Lewis Story, Richard Conn, David Curry, and Mary Ann Igna, Denver Art Museum; Karen Bremer, Museum of Fine Arts, Houston; Donna Pierce and Dessa Bokides, Museum of New Mexico, Santa Fe; Marceline McKee, Metropolitan Museum of Art; Candace Green, Barbara Stuckenrath, and James Rubenstein, National Museum of Natural History, Smithsonian Institution; Paula Fleming, National Anthropological Archives, Smithsonian Institution; Michael Hering and Shelby Tisdale, School of American Research, Santa Fe; Anne Hedlund, Millicent Rogers Museum, Taos; David Witt, Harwood Foundation, Taos; and Jonathan Batkin, Colorado Springs Fine Arts Center.

Scholarly assistance was generously provided by many Smithsonian colleagues, especially Richard Ahlborn and Lonn Taylor, National Museum of American History; William Merrill, National Museum

of Natural History; William Stapp, National Portrait Gallery; Elizabeth Broun and Lois Fink, National Museum of American Art. Others who gave us helpful advice are Father Thomas J. Steele, Regis Jesuit Community, Denver; Robert R. White, Albuquerque; Earl Stroh and Robert M. Utley, Santa Fe; Arthur L. Olivas, Photo Archives, Museum of New Mexico, Santa Fe; Christine Mather, formerly Museum of International Folk Art, Santa Fe; Susan Critchfield, Museum of Fine Arts, Santa Fe; Edna Robertson, formerly Museum of Fine Arts, Santa Fe; Mrs. Eugene Kingman and David Noble, School of American Research, Santa Fe; William T. Henning, Jr., Hunter Museum, Chattanooga; Dean A. Porter, Snite Museum of Art, Notre Dame, Indiana; Peter Hassrick, Buffalo Bill Historical Center, Cody, Wyoming; Michael Lawson, Bureau of Indian Affairs, Washington, D.C.; Patricia Trenton, Los Angeles; Jenny Parks Forwood and Ralph H. Phillips, San Diego; Virginia Couse Leavitt, Tucson; Mrs. David Winton, Lincolnshire, Illinois; Diane Tepfer, Washington, D.C.; and Elizabeth de Veer, Northfield, Massachusetts.

One collector who kept faith in Taos/Santa Fe artists long after their popularity waned was H. J. Lutcher Stark of Orange, Texas, who during the thirties, forties, and fifties built a superb collection of their work. His widow, Nelda C. Stark, has kept alive that faith, providing in 1975 an attractive home for the collection and, more recently, the funds necessary to launch this project. To Mrs. Stark, and to the memory of H. J. Lutcher Stark, this publication is gratefully dedicated.

The alphabetically arranged Bibliography (pp. 210–18) lists full citations for the short-form entries that are found in chapter footnotes.

1. *Georgia O'Keeffe*, Cliffs beyond Abiquiu—Dry Waterfall, *1943, oil on canvas, 30 x 16 in. Private collection*

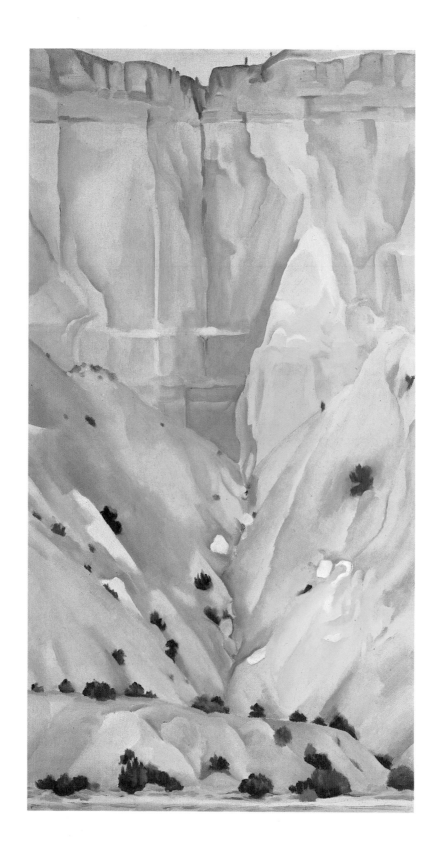

Charles C. Eldredge

Introduction

Beyond the Picturesque

The legend of the founding of New Mexico's premier art colony has developed over the decades on the basis of sketchy details. Bound from Denver for Mexico on an extended painting and camping expedition in the summer of 1898, Ernest Blumenschein and Bert Phillips suffered a broken carriage wheel in the rugged mountain country of northern New Mexico. Recalling tales of Taos told in Paris by their friend Joseph Sharp, the painters determined to seek a black-smith's help in that small village, twenty-plus miles away. Thus it was that on the fourth day of September, Blumenschein, wheel to the shoulder, found himself silent upon a peak in Taos, gazing with Columbian awe at a new world that far surpassed the "dim picture . . . made in imagination from Sharp's slight description. . . . The morning was sparkling and stimulating," he recalled.

The beautiful Sangre de Cristo range to my left was quite different in character from the Colorado mountains. Stretching away from the foot of the range was a vast plateau cut by the Rio Grande and by lesser gorges in which were located small villages of flat-roofed adobe houses built around a church and plaza, all fitting into the color scheme of the tawny surroundings. The sky was a clear, clean blue with sharp moving clouds. The color, the effective character of the landscape, the drama of the vast spaces, the superb beauty and serenity of the hills, stirred me deeply. I realized I was getting my own impressions from nature, seeing it for the first time with my own eyes, uninfluenced by the art of any man. Not-withstanding the painful handicap of the broken wheel I was carrying, New Mexico inspired me to a profound degree.

Blumenschein's conversion on the road to Taos was an important one, both for the artist

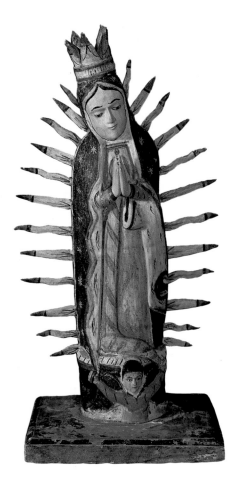

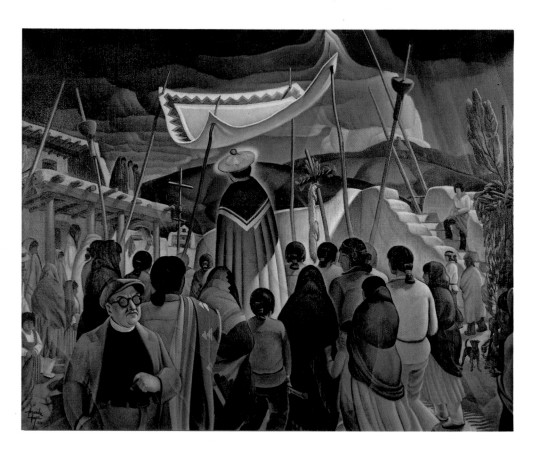

2. Santo Niño Santero, La
Virgen de Guadalupe, *ca.
1830, tempera and gesso on
wood, 16¾ x 8⅝ x 5½ in.
Fred Harvey Collection of the
International Folk Art
Foundation Collections at the
Museum of International Folk
Art, Museum of New Mexico,
Santa Fe*

*3. Alexandre Hogue,
Procession of the Saint—
Santo Domingo, 1928, oil on
canvas, 31 x 40 in. Nebraska
Art Association, Nelle
Cochrane Woods Collection,
Courtesy of Sheldon Memorial
Art Gallery, University of
Nebraska, Lincoln*

and for the settlement he saw. The traveler realized that his "destiny was being decided as [he] squirmed and cursed while urging the bronco through those many miles of sagebrush. . . . Mexico and other lands unknown could wait until the future."[1]

The stirring novelty of Blumenschein's discovery could scarcely have been less like the Long Island prospect "that flowered once for Dutch sailors' eyes—a fresh, green breast of the new world."[2] New Mexico's storied past and remarkable environs—its vast emptiness, colorful yet adobe drab; its diverse and ancient cultures, layered one upon another yet surviving side by side—

were without parallel elsewhere in America. The land's distinctive character, its separateness, was noted from the outset. One of the territory's earliest propagandists, Charles Lummis, declared New Mexico "the anomaly of the Republic" and "the Great American Mystery—the National Rip Van Winkle—the United States which is *not* the United States."[3]

The peculiar allure to which Blumenschein and Phillips succumbed drew many other artists to New Mexico as well, especially to Taos and subsequently Santa Fe. Some came for a lifetime, others for a single season; yet nearly all were touched by what

4. *J. Ward Lockwood,* Taos Plaza in Snow, *ca. 1933, oil on canvas, 30 x 40 in. Pennsylvania Academy of the Fine Arts, Philadelphia, Lambert Fund Purchase*

5. *Kenneth M. Adams,* Juan Duran, *ca. 1933–34, oil on canvas, 40⅛ x 30⅛ in. National Museum of American Art, Smithsonian Institution, Washington, D.C., Transfer from the U.S. Department of Labor*

D. H. Lawrence called the "spirit of place,"[4] and they sought to capture its picturesque drama with burin, brush, camera, or pen. Lawrence, Mary Austin, Walter Ufer, and John Marin were among those who tried to convey its limitless sweep. Others evoked its special character in vignettes, as did novelist Willa Cather in *Death Comes for the Archbishop,* or Georgia O'Keeffe with her skeletal, floral, and geological motifs excerpted from the desert environs (fig. 1).

Adding to its scenic possibilities were the rich traditions of New Mexico's Indian and Hispanic peoples. Their colorful dress and distinctive crafts (fig. 2), their unfamiliar mores and rituals (fig. 3), their adobe pueblos and rustic town plazas (fig. 4), and their simple dignity (fig. 5) all became the frequent subjects of artists in Taos and Santa Fe. These attractions, coupled with the stimulating climate and scenic setting, gave New Mexico's art centers an unrivaled status among other American summer colonies and contributed to their heyday in the early twentieth century.

In the several decades preceding the Second World War, Taos and Santa Fe were familiar to many Americans—even if they had never visited—through the extensive advertising efforts of corporations with

southwestern ties, most notably the Atchison, Topeka and Santa Fe Railway and the "Host of the Southwest," a chain of hotels and travel services owned by Fred Harvey. In many parts of the country, their posters, calendars, and display ads seemed ubiquitous, building on an appeal for tourism and emigration that dated back at least to the 1880s.[5] Much of that publicity featured the work of Taos and Santa Fe painters, particularly the first-generation colonists, thus bringing to wide public attention not only the region's attractions, but also its artists' achievements. Through the efforts of various associations, particularly the Taos Society of Artists (1915–27), exhibitions were also circulated outside the region; and the writings of tireless publicists like Edgar L. Hewett and Mabel Dodge Luhan helped inform readers remote from New Mexico of the artistic colonization of the Southwest.

After the First World War, the desert art colonies were visited by increasing numbers of modernists, whose innovative styles and techniques were not always compatible with the more conservative approaches of the pioneering generation. While few in this second migration were permanently attracted to the region—Georgia O'Keeffe being the primary exception—their unconventional solutions to its pictorial challenges were exhibited in New York and other major art centers, thus bringing additional note to the colonies. Like their predecessors, the modernists were drawn by the elemental experience of New Mexico. The landscape, in particular, offered subjects that inspired a sort of primal vision and stimulated, in various degrees, their newly acquired powers of abstraction.

The traffic between urban art centers and the desert colonies peaked sometime before the Second World War. After that upheaval, although some artists continued to discover Taos and Santa Fe, new stylistic trends inevitably led attention and travel elsewhere. The "triumph of American painting" was ultimately an urban victory, obtained at a distance from the isolated colonies that had fostered the creative impulse for much of the preceding half-century. While some Santa Feans reckon that theirs is still America's third art center—after New York and Los Angeles—its creative ferment no longer equals that which drew so many painters in the earlier part of the century. Charming Taos seems still, as it did to an earlier visitor, a place "where civilization fell asleep a thousand years ago—and has slept since."[6]

Ironically, the early painters who made the greatest commitment to New Mexico did so at the risk of their reputations within the broader canon of American art. There are exceptions, of course—again, O'Keeffe—yet, for the attention they have subsequently received in overviews of our nation's visual history, the "average" art settler in Taos or Santa Fe might as well have colonized Tibet or Mars.

This neglect of regional achievement, while not unique to New Mexico, does seem more acute in its case than with other art centers. The reasons for this are many; but it seems in part, to set Gertrude Stein's phrase on its head, that there was *too much* there there—that the vivid depictions of New Mexico appeared as scenes of an alien land when they were transplanted to cosmopolitan centers of urbanity and modernity. Until recently, the Taos and Santa Fe painters were generally considered an artistic breed apart —when they were considered at all. Their

lofty ambitions and considerable achieve-
ments, however, deserve better than
relegation to a provincial corner of the
national canvas. Not simply illustrators of
the picturesque or calendar artists, they
reflected artistic aspirations and cultural
influences felt throughout American society
in the early twentieth century.

Curiously, as the pace in the New Mexican
centers slackened, scholarly interest in
their histories increased, beginning with
Van Deren Coke's important book, *Taos and
Santa Fe, The Artist's Environment*, in 1963.
All subsequent studies, including this one,
are indebted to the foundation provided by
Professor Coke's research. Most of the more
recent publications, however, are more
concerned with biography and chronology,
and rare has been the effort to define the
underlying currents and overriding concerns
that led to the colonies' founding and
development. The present study seeks to
augment the conventional historical
approach with considerations of the broader
context into which the flourishing of Taos
and Santa Fe properly fit.

In New Mexico, as elsewhere, style and
content were inextricably bound, and the
former cannot be explained without a careful
examination of the latter. This publication
therefore separately considers the landscape
and Indian and Hispanic motifs, including
crafts and rituals as well as portraits and
figure studies. Chapters on antecedent
traditions of Indian depictions, both ethno-
graphic and sentimental, and the academic

roots of Taos School painting are intended
to provide a greater context for the New
Mexican pioneers than has heretofore been
attempted. It is hoped that this approach
will situate the New Mexican experience
within the broader history of American art
and clarify the unique character of the
colonies, where an amalgam of similar beliefs
and diverse talents produced a remarkably
strong and enduring contribution, more than
just a regional phenomenon.

Notes

1. Blumenschein, as quoted in Bickerstaff, *Pioneer Artists of Taos*, pp. 30–31.

2. F. Scott Fitzgerald, *The Great Gatsby* (1925; New York: Scribner's, 1953), p. 182.

3. Lummis, *The Land of Poco Tiempo*, p. 1.

4. "Every continent has its own great spirit of place. Every people is polarized in some particular locality, which is home, the homeland. Different places on the face of the earth have different vital effluence, different vibration, different chemical exhalation, different polarity with different stars: call it what you like. But the spirit of place is a great reality" (D. H. Lawrence, "The Spirit of Place," in *Studies in Classic American Literature* [1923; New York: Viking, 1964], pp. 5–6).

5. In 1885 one booster already had claimed, "The antiquity of Santa Fe has a worldwide reputation, which attracts to the city individuals, families, parties, and train loads of excursionists, composed of people in every walk of life, from every portion of both Europe and America. Many victims of consumption and asthma become residents, find relief, and live to a ripe old age" (Ritch, *Illustrated New Mexico*, p. 148).

6. Gibson, *The Santa Fe and Taos Colonies*, p. 12.

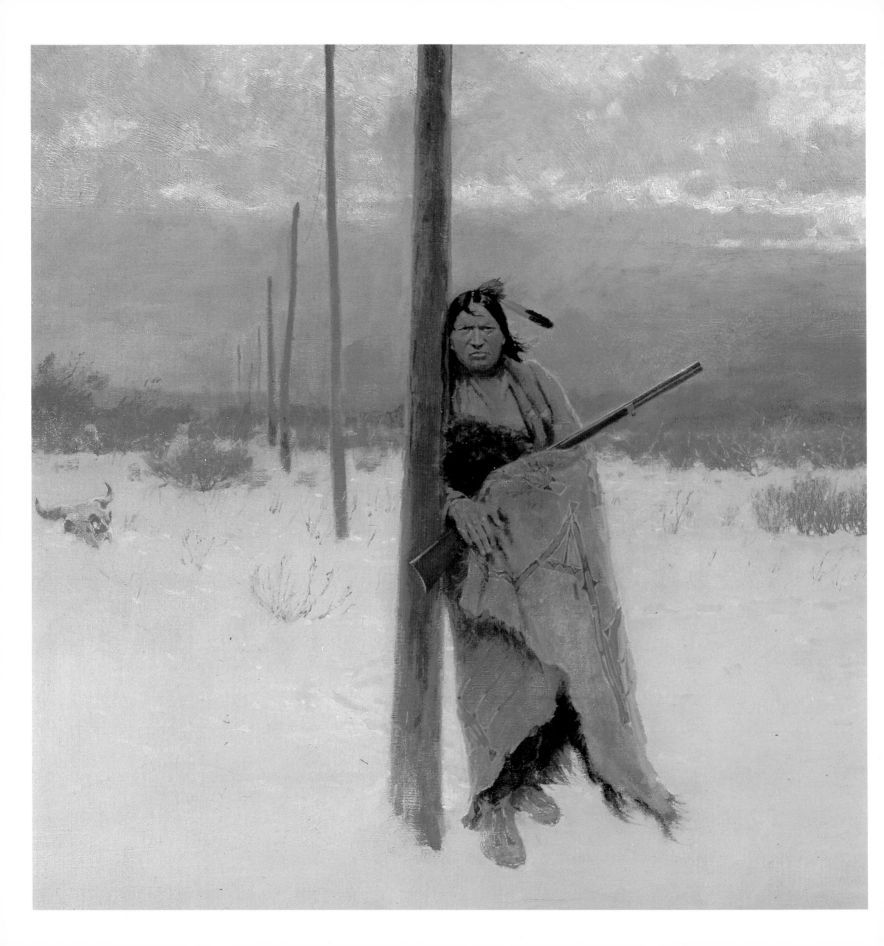

William H. Truettner

Science and Sentiment

Indian Images at the Turn of the Century

Henry F. Farny, The Song of the Talking Wire *(detail, see p. 36)*

Had the wealth of Cibola, the legendary cities of gold sought by the Spanish explorer Francisco Coronado among the mountains of northern New Mexico, proved to be a reality, the course of southwestern art and archaeology might have taken a very different direction. The cities would have been ruthlessly plundered, and little of what remained—sacred objects, architecture, even the local population—would have been left unscathed. Coronado's ambition was to return to Spain with treasures equal to those confiscated from Central and South America by his zealous predecessors, Cortés and Pizarro. Instead, at sites that archaeologists now believe constituted ancient Cibola, Coronado found streets paved with mud—not gold—and roughly tiered pueblo structures that rose to a height of four or five stories. When light struck these adobe walls at just the right angle, they did indeed gleam like precious metal, thus creating the myth that had led Coronado on his long and futile search.

The disappointed conquistador skirmished with the tribe that inhabited Hawikuh, one of the fabled cities, but left the pueblo intact, ensuring, for a time, the preservation of one of the most important sites of ancient culture in the Southwest. Four centuries later, the descendants of this tribe live in nearby Zuni, another of the pueblo villages associated with Cibola. Remarkably little has changed in Zuni during that time span, while outside the reservation almost nothing remains the same.

The enduring quality of pueblo life first prompted its rediscovery in the 1880s; it has remained the focus ever since of the most active and advanced anthropological research

on the North American continent.[1] How did this unique situation occur? In the wake of the Spanish conquest, what spared Pueblo tribes the tribulations of their Plains neighbors to the north, who by the 1880s had been forced to give up most of their traditional customs and life-style? Clearly a very different order prevailed in New Mexico, one that was based more or less on passive acceptance of the indigenous Indian culture and that eventually led to pictorial representations (fig. 6) directly opposed to the more heroic, often confrontational images of Plains Indians (fig. 7) formed in popular literature and the fine arts during the last decades of the nineteenth century.

The history of Spanish occupation of the Southwest during the centuries that followed Coronado's expedition tells much of the story. Further exploration, which dispelled once and for all the myth of New World riches, and the bloody Pueblo Revolt of 1680 convinced the governors at Santa Fe that tight control over Indian life in the region served no useful purpose. Local tribes were, for the most part, sedentary and occupied land that was only suitable for a meager agricultural existence. Antagonizing the Pueblo Indians only made it more difficult for the small garrison at Santa Fe to defend the farmers and ranchers who were slowly settling the area.

What changes occurred during the next century were mostly brought about by the Church, which managed to apply a veneer of Catholicism over many of the pueblos without disturbing the underlying culture of the Indians. Mexican independence, gained from Spain in 1821, had even less effect on the pueblos than the missionary activities of the previous century. The revolution brought a diminished government to New

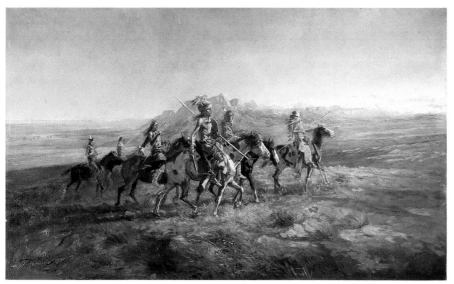

6. *Adam Clark Vroman*, Hopi Towns, Men of Sichimovi, *1901, modern print from original negative, 7⅗₁₆ x 9½ in. Adam Clark Vroman Collection, Seaver Center, Natural History Museum of Los Angeles County*

7. *Charles M. Russell*, Sun River War Party, *1903, oil on canvas, 18 x 30 in. The Rockwell Museum, Corning, New York*

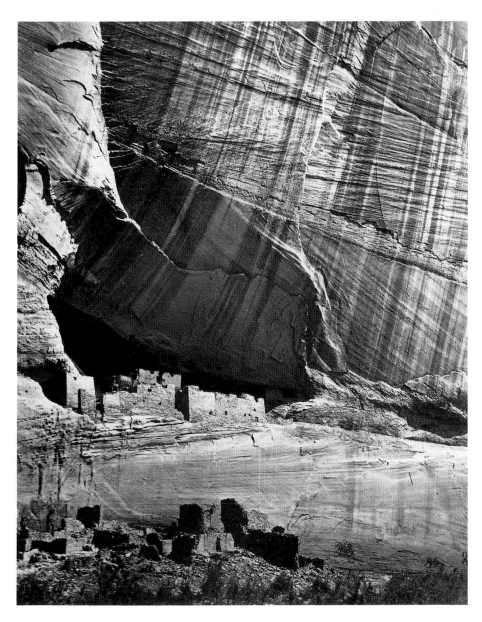

8. Timothy H. O'Sullivan
(ca. 1840–1882), Ancient
Ruins in Canyon de Chelly,
N.M., In a Niche Fifty Feet
above Present Canyon Bed,
1873. Still Pictures Branch,
The National Archives,
Washington, D.C.

Mexico, as well as a secular administration that left remote outposts of the Church without sufficient resources to carry out their mission. Not until the conclusion of the Mexican War (1846–48), and the appointment of Bishop Lamy (the subject of Willa Cather's celebrated novel) to a newly formed diocese that included the present state of New Mexico and much of Arizona, was Church administration strengthened. In Lamy, however, the Indians found a sympathetic friend who did much to preserve and sustain Pueblo life.

By the end of the bishop's reign (1888), the mantle of protection had shifted from Church officials to anthropologists, who were just beginning to draw connections between modern Pueblo groups and the incredible archaeological remains that had come to light in the Southwest following the Mexican War. Chaco Canyon in the northwestern corner of New Mexico, the most sophisticated urban complex in pre-Columbian North America, and the ancient cliff houses in Canyon de Chelly (fig. 8), the Navajo stronghold in northern Arizona, were discovered on a single military/scientific expedition in 1849.[2] Further military reconnaissance in the Southwest, often associated with the selection of a transcontinental rail route, led to the discovery and publication of additional archaeological sites during the next two decades.

The pace of activity increased when the major geological surveys took to the field in the late 1860s. After cataloguing the wonders of Yellowstone in 1871 and 1872, William Henry Holmes and William H. Jackson, the scientist and photographer whose long and productive careers began in those same years, were detailed to explore the hidden canyons off the Mancos River in southwestern

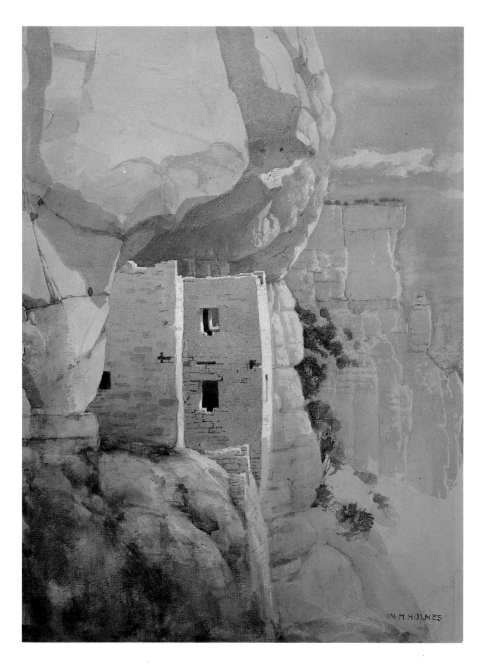

9. *William Henry Holmes,*
Cliff House in 1875, 1875,
watercolor on paper, 9⅞ x
13½ in. Peabody Museum of
Archaeology and Ethnology,
Harvard University,
Cambridge, Massachusetts

Colorado, rumored to contain a fascinating complex of cliff dwellings. Almost by chance, they discovered the first house tucked into the side of a cliff 700 feet above their camp. Up they climbed over successive ledges of sandstone until they reached the narrow plateau on which it stood, "a marvel and a puzzle . . . perched away in a crevice like a swallow's or a bat's nest," Jackson recalled (fig. 9).[3] Further investigation along the Mancos revealed numerous similar ruins, much of what now constitutes Mesa Verde National Park. Each new discovery was carefully surveyed and photographed for eventual publication,[4] but Jackson went a step further: from site elevations and photographs, he prepared scale models of major ruins and presented them at the 1876 Philadelphia Centennial, where they made a lasting impression on the public.

Professional scientists, aware now that the Southwest contained the richest possible evidence of ancient life in America, persuaded the Archaeological Institute of America, founded in Boston in 1879, to sponsor a study of Pueblo life by the indefatigable Swiss anthropologist Adolph Bandelier. Traveling thousands of miles on foot over the next ten years, Bandelier investigated ancient sites in New Mexico and Arizona, attempting to link the past with what he observed of modern Indian life at Cochiti, a Rio Grande pueblo. In the process, he produced a remarkably accurate historical and archaeological survey of the region, as well as a novel entitled *The Delight Makers* (1890), a lively account of ancient life in Frijoles Canyon (the major topographical feature of what is now Bandelier National Monument).

By 1880, it was generally agreed, the most alluring ethnographic fields in North America were to be found in New Mexico,

10. John K. Hillers, Zuni,
Looking Southeast, 1879,
albumen silver print, 9¹⁵/₁₆
x 13¹⁵/₁₆ in. National
Anthropological Archives,
Smithsonian Institution,
Washington, D.C.

Arizona, and southern Colorado. As one authority has noted: "An invigorating climate; sedentary populations of artisans in weaving, pottery, and silver; mysterious, bird-like cliff-dwellers of the remote past; possible links between the high civilizations of Central America and the North American aborigines: these were some of the appealing aspects that fed a popular romance with the Southwest."[5] Anthropology and archaeology were handmaidens in this quest, the one informing the other. Studies of contemporary Pueblo life were carried on to decipher remains of the past, and ancient practices and implements of the cliff dwellers were found to correspond closely to those still in use among the Pueblo tribes. Gradually, however, the relatively new science of anthropology began to take precedence, perhaps because it carried a more pressing responsibility. When Congress passed in 1879 the bill authorizing the U.S. Geological Survey, it also created the Bureau of American Ethnology (BAE), headed by the intrepid John Wesley Powell, who ten years earlier had navigated the entire length of the Grand Canyon. Powell's reconnaissance and the field work of others in the years that followed made anthropologists realize that although Pueblo tribes had changed little over time, commercial exploitation of the area would soon deeply affect their traditional way of life. The BAE mission, then, was twofold: to document Pueblo culture while it remained intact, and, through knowledge gained, to aid the tribes in their transition to more civilized pursuits. Much emphasis was subsequently placed on documentation and field work in official bureau publications; a program for preserving tribal customs, however, remained in contention well into the next century.[6]

The destination of the first expedition

Powell sent into the field was Zuni (fig. 10), the largest, most traditional, and most remote of all the New Mexican pueblos. In charge was veteran Smithsonian scientist James Stevenson, but accompanying the party was a young anthropologist named Frank Hamilton Cushing, whose subsequent exploits at Zuni led to a brilliant, if controversial, career. Cushing's visit to the pueblo was intended to last two months; instead he stayed four-and-a-half years, the last three as a full member of the Zuni tribe. Quickly mastering the language, he worked from the inside to gain access to every secret practice and belief of the Zuni, reconstructing bit by bit the origin, development, and structure of their society. In *Zuni Folk Tales*, one of the classic studies of the period, Cushing demonstrated conclusively the depth and richness of Pueblo culture. At the same time, he made it clear that the Southwest offered unlimited possibilities for anthropological as well as archaeological research.

Although the Pueblos enjoyed the most scientific attention during this period, major investigations were in progress among Indian tribes in other parts of the country. James Mooney, a midwestern journalist who joined the BAE in 1885, observed the ghost-dance ritual of the Plains tribes during the early 1890s, concluding that it was a means of reinvigorating their culture, not just a method of whipping warriors into a frenzy for one last confrontation with the cavalry. Alice C. Fletcher, working among the Omaha in the late nineteenth century, discovered the subtlety and beauty of Indian music; and Franz Boas, the dominant figure in American anthropology during these years, became convinced that potlatching among the Kwakiutl on the northwest coast was a cere-

mony as intriguing and complex as any he had ever witnessed.

Cushing, Mooney, Boas, and others carried their findings a step further, however. Not only did they place a high value on "inside" research and a sensitive reading of Indian life, they also discovered aspects of primitive society that they thought superior to their own. "I often ask myself," Boas wrote in 1882, "what advantages our 'good society' possesses over that of the 'savages.' The more I see of their customs, the more I realize that we have no right to look down on them. Where amongst our people would you find such true hospitality? . . . We have no right to blame them for their forms and superstitions which may seem ridiculous to us. We 'highly educated people' are much worse, relatively speaking."[7]

Boas's words penetrate to the very heart of changes going on behind the scenes in American anthropology during this period— changes that not only involved a new appraisal of Pueblo life, but a profound reappraisal of Indian life across the entire country. Politicians, bureaucrats, historians, scientists, and, not least, artists were deeply affected by anthropological discoveries made during the latter half of the nineteenth century. To put these changes into proper perspective, one must understand how one-sided and rigid the judgment against Indian life had been in previous anthropological studies, even as late as the 1880s. Anthropology during these years was in reality an attempt to enforce a preconceived index of material status that ranked white civilization at the top, and primitive tribes that enjoyed no visible amenities at the bottom, of some hypothetical ladder. Religion, art, mythology, the social and cultural life of a tribe, all were

largely ignored if they were not outwardly manifested in a physical setting that might impress a white (usually Anglo-Saxon) research party. At its most enlightened, this evolutionist theory allowed for so-called primitive peoples to progress up the ladder toward white civilization; at its worst, it assumed biological inferiority among "lower" races, typecasting the "savage" mentality as "improvident, credulous, incapable of abstraction . . . primarily a matter of reflexive or imitative response to environmental stimuli."[8] In other words, Indians had no real chance of developing a distinctive culture. This view was reinforced by anthropologists who refused to investigate the belief systems that would have disproved the theories, while accepting the objectionable practice of measuring the mental skills of primitive people by "simple performance tests" and comparative studies of cranial capacity.[9]

If the BAE under Powell was not the most progressive voice in American anthropology, it was one of the most concerned. Powell cared deeply about the Indians' future, fearing that they would either quickly perish or become miserably confused unless their cultural identity was preserved during the transition stages. "We must either deal with the Indian as he is," Powell wrote in 1878, "looking to the slow but irresistible influence of civilization . . . to effect a change, or we must reduce him to abject slavery. The attempt to transform a savage into a civilized man by a law, a policy, an administration, or a great conversion . . . in a few months or in a few years, is an impossibility clearly appreciated by scientific ethnologists who understand the institutions and social conditions of the Indians."[10] This gave a new slant to acculturation practices; Powell urged

that scientists be immediately involved in ameliorating the difficulties of transition to white society. By 1900, however, the approach had led to a far more sympathetic view than Powell or his more conservative colleagues had anticipated. Using language, religion, social customs, and artistic skill as indexes to tribal cultures—the very criteria shunned by previous anthropologists— Cushing, Mooney, Boas, and other kindred spirits perceived that Indian societies were indeed complex, incorporating customs and procedures that dealt as effectively with questions of faith, morality, and justice as any conceived of by white men. Moreover, Indian domestic accomplishments were considerable: they were artisans of a high order, their agricultural and irrigation systems were ingenious, and their daily activities were conducted with seemingly effortless efficiency.

Indians were different, it was acknowledged, but there was nothing gained by measuring their cultures against the white man's. And if evolution was not linear, then civilization was not absolute, but something relative. With this concept dawned a whole new era of anthropology, one based on assessing the individual merits of a culture rather than forcing data into an Anglo-Saxon mold. In turn, a more dignified status was granted many American tribes, especially those in the Southwest, which were under intense scientific scrutiny at the time.

No sooner had cultural relativism appeared on the scene, than a number of scientists and historians turned a more critical eye toward white civilization. Rampant industrial growth, gross inequality of income, and decaying cities disillusioned many who had once believed that America had sufficient resources to avoid or combat such problems.

Superior values were recognized in cultures that, as one historian noted, were "not obsessed with progress and self-serving Darwinian analogies."[11] The anticapitalistic aspects of the Indian culture, for example, were laudatory: tribal lands were shared, no one went hungry, everyone worked, or played, or worshiped on an equal basis. Anthropologists were most intrigued by the apparent "wholeness" of primitive life, the fact that religion, art, agriculture, and domestic affairs were not conducted separately but were part of one grand scheme. Indeed, they were mystified as to where one sphere of Indian life left off and another began, for no conflict or division could be ascertained. Those determined to resolve the mystery began living with Indians on equal terms, charting the complex fabric of a society once thought to be simple.

So deeply affected was Frank Hamilton Cushing by his stay in Zuni that he actually had visions in which his identity as a white man was questioned. "You are not what you seem to be," a voice spoke to him on one occasion. "You are the soul of an Indian of olden times . . . disguised as it were in the flesh of an American."[12] If Cushing's response to Indian culture was more extreme, it was nevertheless indicative of a trend that eventually filtered down from scientists in the field to the general public. For the first time in national history, there was a consuming interest in Indian life, a wish to identify with it, and a desire to atone for two centuries of neglect and misunderstanding.

News of archaeological discoveries in the Southwest and changing attitudes toward local tribes came forth slowly at first, in detailed government scientific publications, and then more quickly through popular journals, fairs, and expositions. By 1900, railroads and tourist associations were also promoting the region. Invariably their campaigns focused on the picturesque character of Pueblo life, its unique traditions, and the opportunity to study and collect the rare pots, baskets, blankets, and jewelry produced by southwestern tribes.

Once again Cushing, whose talent for publicity matched his anthropological expertise, was a pioneer in the field. In 1882, to convince his Smithsonian superiors that he was in fact engaged in useful activities, he wrote a fascinating account of his first two years at Zuni, which was subsequently published in *Century Magazine*. Every harrowing detail of his initiation into the tribe was included, as well as descriptions of domestic life calculated to reveal parallels to rural life elsewhere in America:

Strangely out of keeping with the known characteristics of the Indian race were the busy scenes about the smoky pueblo. All over the terraces were women, some busy in the alleys or at the corners below, husking great heaps of many-colored corn, buried to their bushy, black bare heads in the golden husks, while children romped in, out, over and under the flaky piles; others, bringing the grain up the ladders in blankets strapped over their foreheads, spread it out on the terraced roofs to dry. Many, in little groups, were cutting up peaches and placing them on squares of white cloth, or slicing pumpkins into long spiral ropes to be suspended to dry from the protruding rafters.[13]

Sylvester Baxter, a Boston journalist, followed with another popular article on Zuni, which included on-the-spot drawings

by a young illustrator named Willard Metcalf (fig. 11) and descriptions of "thoroughly Oriental" Zuni street scenes.[14] It was Charles Lummis, however, an ex-newspaperman and colleague of Bandelier, who first brilliantly portrayed the mystique of the Southwest. In *The Land of Poco Tiempo* (1893), Lummis blended his talents as an archaeologist, historian, and observant reporter to describe such landmarks as Acoma (fig. 12), the spectacular mesa west of the Rio Grande on which the descendants of tribes that once inhabited Chaco Canyon live. But Pueblo life was what most fascinated Lummis, and his discerning eye noted the subjects that would draw artists to the Southwest in the next decade. "The most unique pictures . . . are to be found among its . . . Pueblos," he wrote. "Their quaint terraced architecture is the most remarkable on the continent," and their "numerous sacred dances are by far the most picturesque sights in America, and the least viewed by Americans, who never found anything more striking abroad."[15]

The Philadelphia Centennial had already provided a showcase for William Henry Holmes and William H. Jackson to present models and photographs of cliff dwellings discovered in the canyons of Mesa Verde, and major expositions that followed during the 1880s offered similar opportunities for the display of Indian artifacts.[16] Much more ambitious, however, was the presentation of anthropological material at the Columbian Exposition in 1893. Billed as "the greatest ethnological display in the history of the world," it featured a large hall devoted to dioramas of tribal life and related displays of weapons and domestic utensils. Outside, arranged along the midway, were various encampments of primitive peoples, including

11. *Willard L. Metcalf,* Zuni Indians, *1883, gouache on paper, 9⁵⁄₁₆ x 13⁷⁄₈ in. The Hyde Collection, Glens Falls, New York*

12. *Ferenz Fedor,* View of Acoma, *ca. 1940. Museum of New Mexico, Santa Fe*

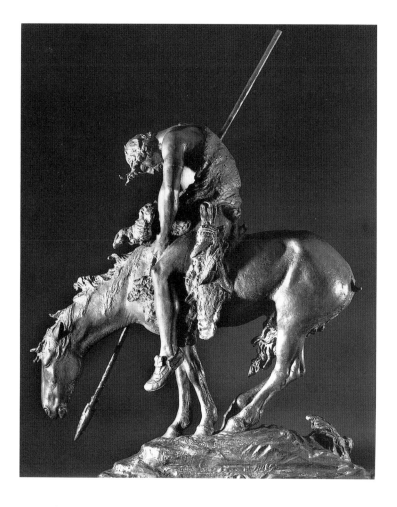

13. James Earle Fraser
(1876–1953), End of the
Trail, modeled ca. 1894,
bronze. The Rockwell
Museum, Corning, New York

an "authentic" Moqui village in which live cacti struggled to survive in Chicago's erratic climate. An abundance of Plains and southwestern material was installed in the Anthropology Building by Franz Boas, the curator in charge, in a way that established environment as an important factor in distinguishing cultures—a much more enlightened presentation than the showcases of primitive implements that had been the staple of most previous expositions. Despite criticism of midway "sideshows,"[17] over 27 million people had a chance to see a more legitimate portrayal of Indian life than had ever been presented.

Serious anthropological exhibits (arranged by James Mooney) were also included in the Trans-Mississippi Exposition held at Omaha in 1898. But nothing matched the displays and personnel gathered six years later at the Louisiana Purchase Exposition in St. Louis. Featured were heroic sculptures of American Indians and 1,100 representatives of aboriginal tribes, including numerous Plains and southwestern Indians. Expositions of this sort continued through the first decades of the twentieth century, each with an anthropological section that stressed current work in the field and displays that placed more and more emphasis on the artistic merits of Indian crafts. Cases of Pueblo pottery, blankets, jewelry, and clothing had been shown at Chicago, but by 1915, at the Panama–California Exposition in San Diego, an entire building was devoted to Indian arts, with the selections made by Edgar L. Hewett, director of the Museum of New Mexico in Santa Fe, William Henry Holmes, and other Smithsonian anthropologists. Chief publicist for the exposition was none other than Charles Lummis, who must have been delighted when the Santa Fe Railway contributed a full-scale model of a New Mexican pueblo, from which quantities of handsome Navajo blankets were sold.[18] For the corresponding Panama–Pacific Exposition in San Francisco (1915), James Earle Fraser enlarged to heroic size End of the Trail (fig. 13), his statue of a mounted Plains Indian, which, ironically, became famous as a symbol of a dying race.

The Santa Fe Railway, of course, was more deeply committed to promoting the image of a flourishing Indian culture than was the sculptor Fraser. Since the early 1880s, when its tracks first crossed New Mexico and Arizona (a spur connected the town of Santa

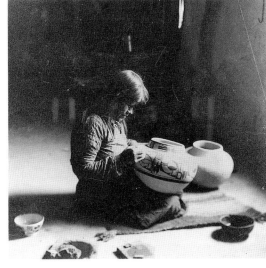

14. *G. W. Hance,* Interior of the Indian Room, Alvarado Hotel, Albuquerque, *ca. 1905. Museum of New Mexico, Santa Fe*

15. *Edward S. Curtis,* Nampeyo Decorating Pottery, *ca. 1900. National Anthropological Archives, Smithsonian Institution, Washington, D.C.*

Fe to the main line in 1880), it had been actively engaged in regional tourism. The pueblos of Isleta, Laguna, Acoma, Zuni, and Hopi—all either on the main line or a wagon ride of a day or two away—were the places most frequently publicized in those years, although tourists were occasionally induced to explore the "Homes of the Ancients" (Pajarito Park, Chaco Canyon, Mesa Verde) among the plateaus and canyons several days west of the Rio Grande. The railroad also underwrote activities that enhanced artistic interest in the Southwest. Thomas Moran was the first of many painters to whom it provided free passage to picturesque locations along its route; from other artists the railroad commissioned southwestern pictures for reproduction in popular magazines and for decoration of its train stations and affiliated Harvey restaurants and hotels.[19] Also

displayed in Harvey facilities were collections of pots, blankets, and baskets (fig. 14) by Pueblo artisans, whose work was in considerable demand by 1900. To encourage this market, the railroad promoted the work of certain Indians, like Nampeyo (fig. 15), the celebrated Hopi potter, who was taken to Chicago in 1898 to demonstrate her method of reproducing traditional Pueblo designs.[20] Authoritative texts were also deemed necessary to explain the cultural history of the region; George Dorsey, a leading anthropologist and curator of the Field Museum in Chicago, prepared the first comprehensive guide to Indian tribes in the Southwest, for distribution by the railway.[21]

Photographers arrived along with the tourists, the railroad again providing access to jumping-off places where transportation could be obtained to convey their heavy dry-

plate cameras to distant sites. Despite hardships of travel and limited access to certain subjects, their work constitutes a remarkable survey of the character and environment of the local tribes. John K. Hillers was one of the first on the scene, accompanying Cushing in 1879 on his mission to the Zuni pueblo, where he captured a virtually untouched primitive world (fig. 10). Lummis, whose many talents included photography, and Bandelier covered over a thousand miles on foot in 1888, the latter surveying ancient sites while Lummis photographed them. Adam Clark Vroman, a Pasadena photographer, and Frederick Webb Hodge, a BAE archaeologist, were another impressive team that, during the summer of 1899, visited every pueblo from Taos to Zuni, in addition to numerous ancient ruins.

Lummis and Vroman, along with the photographers George Wharton James, Frederick Monsen, and Carl Moon, were the most prominent members of the Pasadena Eight, a group dedicated to preserving California history and compiling a record of the Indian tribes of the Southwest. Their commercial work sold widely, both at local tourist stops and eastern photography galleries, as well as to such popular national publications as *Harper's* and *Leslie's Illustrated Weekly*, which reproduced many southwestern images at the turn of the century. Trade journals reached a more limited audience but carried photographs of higher quality and articles that revealed an attitude toward Pueblo tribes reminiscent of that espoused by Cushing, Bandelier, and other scientists who were first inspired by the area. "Only to be among these Indians," wrote Frederick Monsen, "to hear them talk, and to observe their treatment of one another and of the casual stranger that is within their gates,

is to have forced upon one the realization that here is the unspoiled remnant of a great race, a race of men who have, from time immemorial, lived quiet, sane, wholesome lives very close to nature."[22]

For the most part, the Pasadena Eight were dedicated to an objective and informed view of Pueblo life, and the profile of the Pueblo tribes captured by their lenses closely paralleled the perception of the anthropologists, who by the turn of the century seemed to have considerable influence over the publicity that conditioned public attitudes toward Indian life in the Southwest. Peaceful, agricultural, devoted to domestic arts, their lives an intricate blend of traditional values and spiritual concerns, Pueblo Indians became the premier example of America's ancient, unspoiled past. How long they could retain that image, however, was a question even then. Writing in 1902, George Wharton James noted the unhappy results of publicizing the Hopi Snake Dance:

It was decided that the photographers present— and they were legion—must be kept within a certain line, and that no one without a camera would be permitted in their preserves. This was an innovation. Hitherto every man had chosen his own field, and moved to and fro wherever he liked—in front of his neighbor or someone else; kicking down another fellow's tripod and sticking his elbow in the next fellow's lens. . . .

This placing of restrictions on photographers will undoubtedly continue as the dance becomes better known and attracts more people. Each year the number who flock there is greater, and it is imperative that some regulations be laid down or the poor Indians would be run over in the eager desire of the visitors to see them handle the deadly reptiles.[23]

Not every pueblo was invaded to the degree that the Hopi villages were, but by 1900 the Southwest and its picturesque tribes were no longer undiscovered. The popular image of the area began to work against itself to the extent that the first painters who arrived viewed the richness of the environment as a mixed blessing. An incomparable range of Indian subjects greeted them, but they wondered how long primitive life would sustain itself against the encroachment of civilization.

While Pueblo culture had maintained itself through a long, relatively dormant period in the Southwest and was just coming under increasing public scrutiny around 1900, a very different set of circumstances prevailed on the Great Plains. Indians who occupied the vast expanse of grassland between the Mississippi and the Rockies were essentially nomadic warriors, whose subsistence was based on buffalo meat and hides, and who were more skilled as hunters and fighters than farmers or artisans. With the introduction of the horse to Plains culture in the early eighteenth century, tribes began to hunt over wide areas, prospering in direct proportion to the land they could cover. By the early nineteenth century, their riding and hunting prowess guaranteed them an abundant supply of food and a degree of independence almost unknown among native tribes. The period during which they flourished was relatively short, however. Some historians have narrowed it to the century between 1780 and 1880, with the last twenty years spent in a deadly struggle with the United States Cavalry to maintain dominion over their lands.

Persistent as cavalry attacks were during that period, it was the advance of white settlers across the buffalo range that finally forced the Indians to surrender, to accept in place of their traditional hunting grounds the reservations and food supplies offered by the government. The parade of farmers, ranchers, miners, and even tourists into the Dakotas, Wyoming, and Montana after the Civil War wreaked havoc on a culture that required millions of acres of open land to sustain itself.

Unhappily, the reservation system established during the 1860s and 1870s for Indian refugees from the Great Plains was inadequate to begin with and grew steadily worse. It incorporated all the ills of its predecessors in the East and in Kansas and Oklahoma, as well as a degree of corruption that was virtually intolerable. Broken treaties, inadequate supplies, and humiliating treatment so curtailed traditional activities and destroyed morale that reformers and well-meaning government officials, intent on rehabilitating Plains tribes, sought to abandon the system a decade later. Despite warnings from the BAE, they advocated immediate acculturation and persuaded Congress to pass the General Allotment Act of 1887, allowing individual land ownership and full citizenship for Plains Indians.[24] If the latter were to survive in a white man's world, the bill implied, they must do so on white men's terms.

Perhaps the ultimate expression of this attitude came from the Carlisle Indian School, established in 1879 in Carlisle, Pennsylvania. Charged with preparing young boys and girls to make the transition from Indian to white society, the school forbade students to dress in native costumes, speak in native tongues, or practice Indian religions. The curriculum included a sort of pep rally every

Saturday night during which the director of the school, attired in a Prince Albert coat, shouted from the stage of the assembly hall questions like "How shall we solve the Indian problem?" The response from the obedient students was "Abolish the reservation system! Abolish the ration system!"[25] Remarkably, Plains culture managed to sustain itself through these ordeals, but it was at low ebb during the 1890s. Predictions of its demise came both from the reservations and government officials, some of whom showed concern, but most, like Theodore Roosevelt, thought it was about time.

Anthropologists opposed to wholesale acculturation did much to keep the spark alive during this period, arguing that even in its beleaguered state, Plains culture was functioning in traditional, if unorthodox, ways. Plains tribes were also featured at fairs and expositions, more frequently, in fact, than southwestern tribes and in a context that attempted to show the differences between the two. Anthropologists believed that the comparison of life-styles might even serve to justify the nomadic aspect of Plains culture, often cast as divisive and immoral by leading reformers of the day.[26]

The results, however, were not what the anthropologists had hoped for. The domestic aims of Pueblo life were more readily understood and hence more favorably appraised; the aspect of Plains culture that most intrigued the general public was its war-making capacity, its proud chiefs and skillful tacticians ready to die for a cause. Once U.S. Army propaganda abated, warriors like Chief Joseph, Crazy Horse, and Sitting Bull suddenly were admired for a valiant, protracted stand against cavalry forces that were superior in manpower and equipment.

(For over two decades following the Civil War, these battles engaged a majority of the army's 25,000 troops.) Thus in the aftermath of the Plains Wars, objective attempts to understand Plains culture were again thwarted, this time by a backlash of guilt, sentimentality, and hero worship that raised the Indian to the status of national martyr. This surge of emotion, which reached its peak between 1900 and 1910, is perhaps best measured by the number of idealized warriors, more or less in Plains dress, featured on American medals and coins and atop pedestals in parks and squares during that decade, more than appeared during the entire previous century.

The turning point in the public's response to the plight of native tribes generally coincided with the publication of Helen Hunt Jackson's *A Century of Dishonor* in 1881. A childhood friend of Emily Dickinson who embarked on a literary career in mid-life, Mrs. Jackson came to champion the Indians' cause after she settled in Colorado in 1875. Her book chronicles the mistreatment of Indian tribes, from the injustices suffered by the Delaware immediately after the Revolution to the more recent fate of the Sioux, Nez Percé, and Cheyenne. One of the last chapters is devoted to descriptions of massacres of Indians by whites. In her conclusion, Mrs. Jackson distilled her message to a fine sarcasm:

It makes little difference . . . where one opens the record of the history of the Indians; every page and every year has its dark stain. The story of one tribe is the story of all, varied only by differences of time and place; but neither time nor place makes any difference in the main facts. Colorado is as greedy and unjust in 1880 as was Georgia in 1830, and Ohio in 1795; and the United States

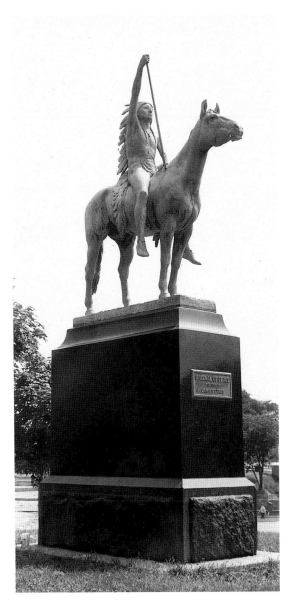

16. Cyrus Dallin
(1861–1944), A Signal of
Peace, ca. 1894, bronze.
Lincoln Park, Chicago Park
District

Government breaks promises now as deftly as then, and with an added ingenuity from long practice.[27]

A Century of Dishonor did for the Indian cause what *Uncle Tom's Cabin* had done for the emancipation of blacks: it dramatized the issue to the extent that neither the public nor politicians and officials could dismiss it. The Indian emerged as a tragic figure who not only deserved fair treatment by the government, but also recognition for the major role he had played in American history. No doubt spurred by the shock and disbelief (at least in some quarters) following reports of the Wounded Knee massacre, the apotheosis continued, until by 1894 Judge Lambert True of Chicago was convinced that soon the artist would be the only one able to convey the true spirit of the Indian. Having donated Cyrus Dallin's *Signal of Peace* to Lincoln Park that year (fig. 16), Judge True wrote to the Chicago park commissioners:

I fear the time is not far distant when our descendants will only know through the chisel and brush of the artist these simple, untutored children of nature. . . . Pilfered by the advance-guards of the whites, oppressed and robbed by government agents, deprived of their land by the government itself, with only scant compensation, shot down by soldiery in wars fomented for the purpose of plundering and destroying their race, and finally drowned by the ever westward tide of population, it is evident there is no future for them except as . . . a memory in the sculptor's bronze or stone and the painter's canvas.[28]

Despite his downtrodden circumstances—or, ironically, *because* of them—the Indian became an increasingly mythical figure. Except for images of the southwestern tribes,

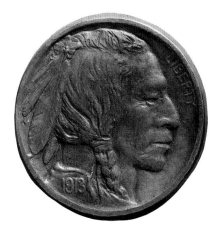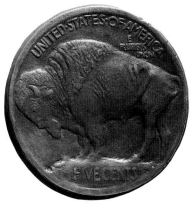

17. James Earle Fraser,
Buffalo Nickel, *bronze, 4½*
in. diameter. Private collection

few works of the period dealt directly with Indian life. On the one hand, the race was consigned to some misty realm in the past, where in full glory it evoked a haunting view of aboriginal America. Walt Whitman offered an example of this in a passage from "Yonnondio" (1883):

I see, far in the west or north, a limitless ravine,
 with plains and mountains dark,
I see swarms of stalwart chieftains, medicine-
 men, and warriors,
As flitting by like clouds of ghosts, they pass and
 are gone in the twilight[29]

George de Forest Brush, on the other hand, sought a more timeless image, an abstraction that would convey to his own age some universal notion of Indian life. "In choosing Indians as subjects for art I do not paint from the historian's or antiquary's point of view," he wrote in *Century Magazine* in 1885. "I do not care to represent them in any curious habits which could not be comprehended by us; I am interested in those habits and deeds in which we have feelings in common. Therefore, I hesitate to attempt to add any interest to my pictures by supplying historical facts. If I were required to resort

to this in order to bring out the poetry, I would drop the subject at once."[30]

Both viewpoints, of course, were based on an ideal conception of what Indian life once was. Whitman glorified the warrior chieftains of the past, the fading dream of a free and untrammeled existence; Brush drew a parallel between Indian subjects and the refined spirit of antiquity. In either case an image emerged that attributed extravagant virtues to Indian life, virtues that had little basis in contemporary reality, that were in fact an amalgam of sympathy and propaganda created to provide an acceptable view of a beleaguered race. "The Indians as we see them today . . . have no significance either to historian or artist," remarked a contemporary critic, "whereas the race from which they descended, the once rulers of the continent, were men of joy and spiritual contentment, of personal dignity and beauty, and of wise simplicity of existence."[31] With each monument erected to the Indian, such romanticized attributes became more thoroughly nationalized until the Indian became no less a hero than the Founding Fathers.

James Earle Fraser's buffalo nickel became the ultimate emblem of this trend (fig. 17). Designed in 1914, it was created not only to honor the Indian, but as a distinctly national image. "In designing it," Fraser wrote, "my objective was to achieve a coin which would be truly America, that could not be confused with the currency of any other country."[32] The irony of his statement is overwhelming: after a brutal campaign to subdue the Indian (and a corresponding subversion of history), the white man had chosen him to represent the virtues of the American nation.

18. Adam Clark Vroman,
Hopi Towns, Grinding
Corn, Tewa, 1895, modern
print from original negative, 7
x 9½ in. Adam Clark Vroman
Collection, Seaver Center,
Natural History Museum of
Los Angeles County

and untamed, was passed along from one artistic generation to the next until the image hardened into a cliché during the era of dime novels and Wild West shows. By then the Plains Indian had come to represent *all* American Indians,[33] whom the public considered essentially alike, despite findings to the contrary by archaeologists and anthropologists. Frederic Remington, for example, the best-known purveyor of Plains imagery at the turn of the century, disdained the picturesque qualities of Pueblo tribes. "They don't appeal to me," he wrote, "too decorative—and too easily in reach of every tenderfoot"—which was simply his way of saying that he didn't believe they were "honest-to-goodness" Indians.[34] So effectively did Remington exploit his singular view of Indian life that for many it still holds true today. Even for those better informed during Remington's own era, it was an influence not easily overcome, and many first-generation Taos painters were affected by it. Formulas for painting Plains Indians inevitably crept into numerous Pueblo scenes.

It is now safe to say that Plains culture was never as defunct as it appeared in the first decade of the twentieth century, and that critics had underestimated the attraction of Pueblo culture for a new generation of artists and writers. Between 1880 and 1900, however, artists generally cast the Plains tribes in a more ideal, timeless world emphasizing the heroic aspects of their past; while illustrators and roving photographers doing field work in Pueblo country abstained from such deification and portrayed the southwestern tribes in modest, daily pursuits (fig. 18).

Complicating the disparity in the visual record of the tribes is a prior tradition, begun by George Catlin, Karl Bodmer, and Alfred Jacob Miller, that focused on Plains tribes that had remained beyond the influence of civilization. The resulting image of "Indian-ness," of a spirit free, courageous,

Plains Indian images between 1880 and 1900 can be divided into two separate, but related, groups, obverse sides of the same coin. The first is typified by Fraser's *End of the Trail* (fig. 13): essentially the Fallen Hero, defeated by the white man's civilization, unable and unwilling to transfer his allegiance to a more peaceful course. The second, which developed several years later, might be called the Indian Redivivus: he appears to rise from the ashes of the Fallen Hero, a stronger, more stalwart figure, godlike in his classical form, a symbol of power more American than Indian and more mythological than anthropological. Hermon Atkins MacNeil's *A Chief of the Multnomah*

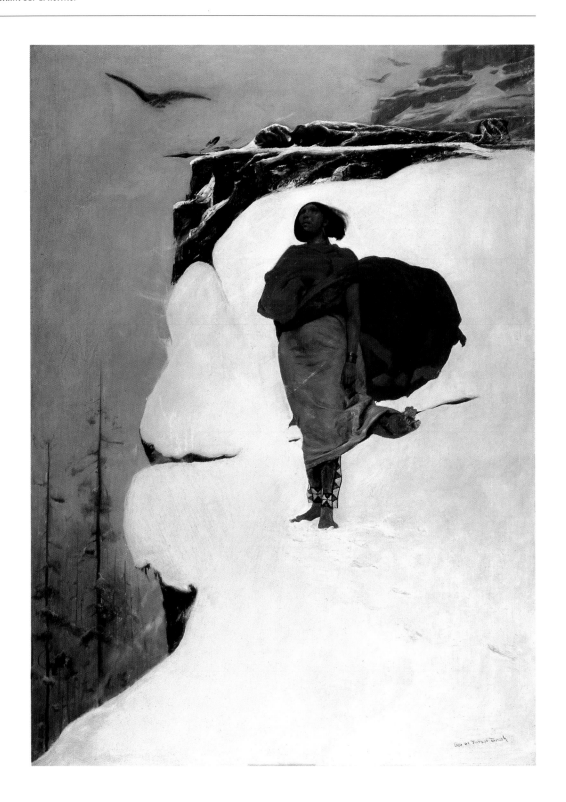

19. Hermon Atkins MacNeil, A Chief of the Multnomah Tribe, 1907, bronze, 32 x 10 x 9¼ in. Thomas Gilcrease Institute of American History and Art, Tulsa, Oklahoma

20. George de Forest Brush, Mourning Her Brave, 1885, oil on board, 35½ x 25½ in. Private collection

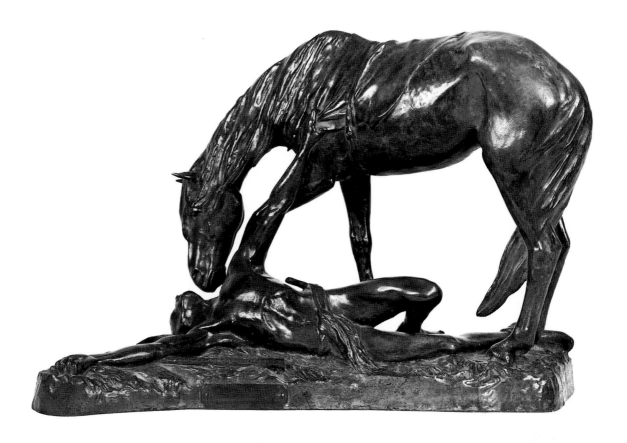

21. Gutzon Borglum, The Fallen Warrior, *ca. 1891, bronze, 10⅞ x 15⅝ x 7⁵⁄₁₆ in. Thomas Gilcrease Institute of American History and Art, Tulsa, Oklahoma*

Tribe (fig. 19) typifies this second group.

Examples of both themes, as well as variations on them, abound. George de Forest Brush's *Mourning Her Brave* (fig. 20) and Gutzon Borglum's *Fallen Warrior* (fig. 21) convey the same sense of tragic defeat as *End of the Trail*, but their titles have reduced the circumstances to a more personal and direct experience. *Song of the Talking Wire* (fig. 22) by Henry Farny predicts the demise of the race by pitting a lone Indian in a cold, darkening landscape against the technology that would soon rule the West. Remington's *Indian Dream* (fig. 23), an intriguing visual parallel to the passage by Whitman, is perhaps best interpreted as a transitional work between the two groups. Another lone warrior, trailing across a snowy landscape,

makes a spirited attempt to stall fate by calling forth the glories of past Indian warfare. Charles Russell, firmly planted in the opposite camp from Farny, refuses even to acknowledge the possibility of failure. Sun River warriors (fig. 7), animated versions of the Multnomah Chief, sally forth unchallenged across the plains, a broad, clear light symbolizing the heroic spell they cast. Brush's *Shield Maker* (fig. 24) restates the proud image of the MacNeil sculpture with a tone of aesthetic refinement suitable to a Parisian studio (an attitude and approach more thoroughly discussed in the next chapter).

Despite the impact of each of these works, none deals directly with the present reality. One glance at the twisted, frozen corpses

22. *Henry F. Farny*, The
Song of the Talking Wire,
*1904, oil on canvas, 22¹/₁₆ x
40 in. Taft Museum,
Cincinnati*

23. *Frederic Remington*, An
Indian Dream, *ca. 1899, oil
on canvas, 40 x 27½ in.
Thomas Gilcrease Institute of
American History and Art,
Tulsa, Oklahoma*

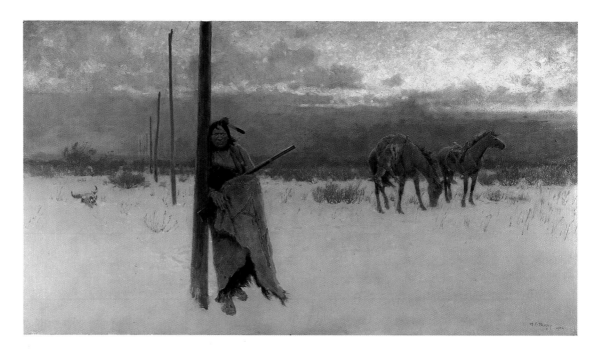

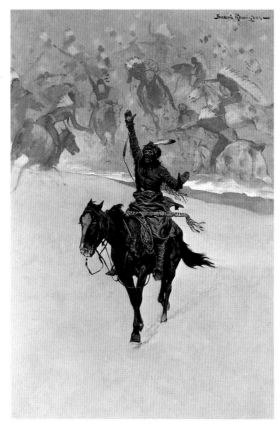

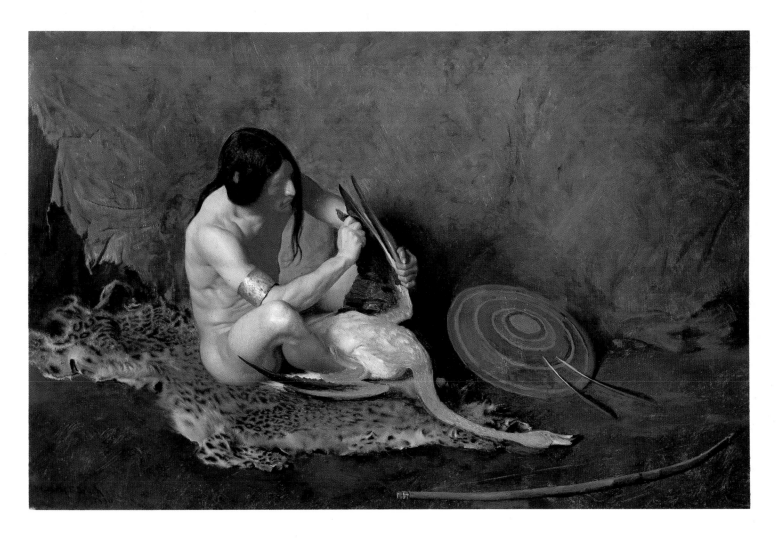

24. George de Forest Brush,
The Shield Maker, *1890, oil*
on canvas, 11 x 16 in. Mr.
and Mrs. Gerald Peters

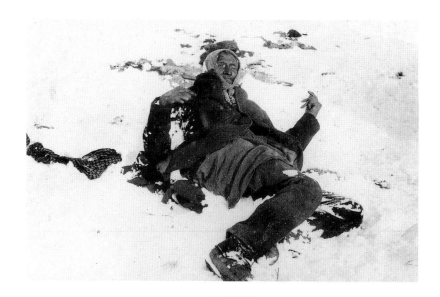

in Wounded Knee photographs proves how insulated Borglum's classical figure is from any such concern (fig. 25). The mythic character of MacNeil's Multnomah *Chief* is perhaps shrouded in some even more remote past.

In their depictions of Pueblo Indian culture, Willard Metcalf and Peter Moran were untouched by the drama of Plains Indian themes. Metcalf, who joined Cushing at Zuni in 1882, was as intrigued as the anthropologist with the vigorous, sustaining character of Indian life (fig. 26); and Moran's modest views of Pueblo activities (figs. 27, 28) are remarkable for their freshness and modernity. The work of William Henry Holmes (fig. 9) and DeLancey Gill (fig. 29) reveals the anthropologists' desire to measure and record their recent discoveries; and the photographers John K. Hillers, Adam Clark

27. Peter Moran, Indians Winnowing Wheat, *ca. 1879–90, watercolor on paper, 5½ x 13⅜ in. Amon Carter Museum, Fort Worth, Texas*

28. Peter Moran, Zia, *ca. 1879–90, watercolor on paper, 5⅞ x 9¾ in. Amon Carter Museum, Fort Worth, Texas*

29. DeLancey W. Gill, Street in the Pueblo of Oraibi, Tusayan, Arizona, *1888, watercolor and pencil on paper, 22 ³⁄₁₆ x 30 ¹⁄₁₆ in. National Museum of American Art, Smithsonian Institution, Washington, D.C., Gift of Mrs. Fran Roberts*

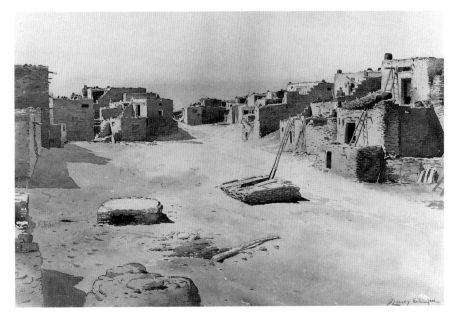

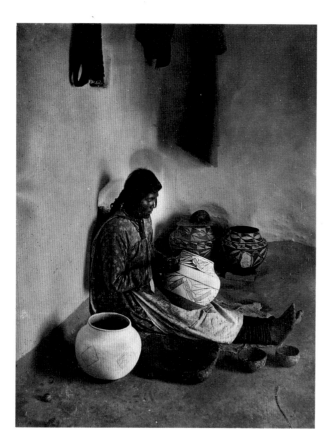

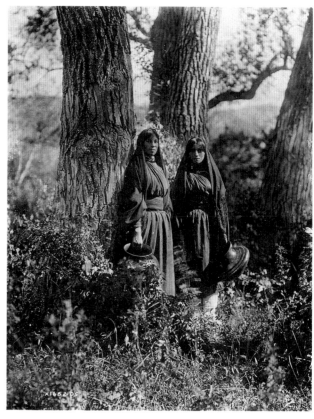

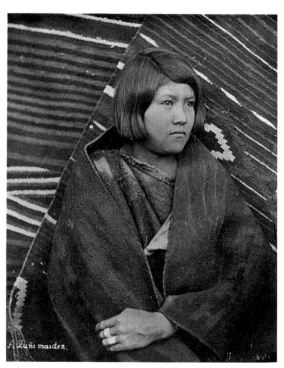

30. Adam Clark Vroman,
Acoma, Mary Painting
Pottery, *1902, modern print
from original negative, 9½ x
7⅛ in. Adam Clark Vroman
Collection, Seaver Center,
Natural History Museum of
Los Angeles County*

31. Edward S. Curtis, By the
Cottonwoods, *before 1905,
palladium silver print, 7⅞ x
5⅞ in. National
Anthropological Archives,
Smithsonian Institution,
Washington, D.C.*

*32. John K. Hillers, Zuni
Maiden, 1879, albumen silver
print, 9⁷⁄₁₆ x 7⅛ in. Amon Carter
Museum, Fort Worth, Texas*

Vroman, and Edward S. Curtis constituted
a sympathetic vanguard whose images most
directly correspond to subjects selected by
first- and second-generation Taos and Santa
Fe painters. *Acoma, Mary Painting Pottery* (fig.
30) and *By the Cottonwoods* (fig. 31), for
example, clearly anticipate works by Irving
Couse and Martin Hennings; and from
Hiller's *Zuni Maiden* (fig. 32) stems a
progression of images by Robert Henri,
Andrew Dasburg, and Victor Higgins (see
chapter 3).

 Despite the desire of each new generation
of artists to invent its own images, and the
conviction among painters in the Southwest
that they were creating a new artistic order,
the precedents for portraying Pueblo culture

were well established by the turn of the century. Subsequent generations in Taos and Santa Fe painted Indian life with an almost subconscious awareness of recent anthropological discoveries and the new status accorded to Plains tribes. The effect was immediately discernible in their work, a blend of subjects and attitudes from both sources that would form a distinct iconography, as well as a revealing guide to Anglo perceptions of southwestern Indian life, over the next four decades.

Notes

1. Ortiz, *Handbook of North American Indians*, p. 14.

2. Goetzmann, *Exploration and Empire*, pp. 326–27.

3. Goetzmann, p. 525.

4. Hayden, *Tenth Annual Report of the United States Geological and Geographic Survey of the Territories*, pp. 381–450.

5. Hinsley, *Savages and Scientists*, p. 192.

6. Hinsley, pp. 262–89.

7. Mitchell, *Witnesses to a Vanishing America*, p. 247.

8. Stocking, *Race, Culture, and Evolution*, p. 117.

9. Stocking, p. 217. This practice was still going strong in 1904.

10. Quoted in Hinsley, *Savages and Scientists*, p. 150.

11. Mitchell, *Witnesses to a Vanishing America*, p. 262.

12. Cushing, *Zuñi: Selected Writings of Frank Hamilton Cushing*, p. 418.

13. Cushing, "My Adventures in Zuñi," p. 198.

14. Baxter, "The Father of the Pueblos," pp. 72–91.

15. Lummis, *The Land of Poco Tiempo*, p. 5.

16. At the Cincinnati Industrial Exhibition of 1888, for example, the artist Henry Farny noted that he was able to gather "from casts, photographs, trophies and implements of the Indians exhibited here . . . detailed information that I could never have obtained without a trip to Arizona" (*Cincinnati Commercial Gazette*, July 31, 1888, p. 8). Denny Carter Young very kindly supplied this information.

17. Rydell, "The World's Columbian Exposition of 1893," p. 269.

18. Frost, "The Romantic Inflation of Pueblo Culture," p. 58.

19. Bryant, "The Atchison, Topeka and Santa Fe Railway," pp. 437–53.

20. Frisbie, "The Influence of J. Walter Fewkes on Nampeyo: Fact or Fancy?" in *The Changing Ways of Southwestern Indians*, p. 236.

21. Dorsey, *Indians of the Southwest*.

22. Monsen, "Picturing Indians with the Camera," p. 170.

23. James, "The Snake Dance of the Hopis," p. 119.

24. Washburn, *The Indian in America*, p. 243. More commonly called the Dawes Act, the legislation had disastrous effects on Indian culture, which "reformers" meant to eradicate through educational and social policies. Tribal lands were reduced by 60 percent over the next four decades, and a generation of Indian children moved uncertainly between Indian and white values, often at odds with both. Oliver La Farge's *Laughing Boy* is the most poignant fictional account of the consequences of this era of federal Indian policy. For specific effects of the Dawes Act in the Southwest, see Ortiz, *Handbook of North American Indians*, pp. 526–27.

25. Washburn, *The Indian in America*, p. 241.

26. Bannan, "American Indian Policy Reformers in the 1880s," p. 790.

27. Jackson, *A Century of Dishonor*, pp. 337–38.

28. Francis, *Cyrus E. Dallin*, p. 40.

29. Walt Whitman, *Leaves of Grass* (New York: Aventine Press, 1931), p. 526.

30. Brush, "An Artist among the Indians," p. 57.

31. Walsh, *Edwin Willard Deming*, p. 39.

32. Krakel, *End of the Trail*, p. 25.

33. Ewers, *Indian Life on the Upper Missouri*, pp. 185–203.

34. Hassrick, *Frederic Remington*, p. 39.

Julie Schimmel

From Salon to Pueblo

The First Generation

The artists who came to New Mexico from the late 1890s to about 1940 are typically divided into first and second generations. The distinction is based on style, with the year 1917 roughly marking the division: the first generation was largely in place by then; the second, beginning to arrive in numbers. Fifteen years after artist Joseph Henry Sharp discovered the Southwest (1883), Ernest L. Blumenschein and Bert Geer Phillips first came to Taos. They were followed by Oscar E. Berninghaus in 1899, E. Irving Couse in 1902, W. Herbert Dunton in 1912, Victor Higgins and Walter Ufer in 1914, Julius Rolshoven in 1916, and E. Martin Hennings in 1917. The artistic direction of this group, all of whom became members of the Taos Society of Artists, was variously described as moderate to conservative. The second generation included Andrew Dasburg, Marsden Hartley, Robert Henri (who in fact arrived in 1916 and was an associate member of the Taos Society), John Marin, Georgia O'Keeffe, and John Sloan. They were the modernists.

In truth, the distinction between the first and second generations was never quite this clear. Many of the early arrivals, often presumed to be conventional artists, were struck forcibly by modernism, particularly Blumenschein, Higgins, and Dunton. And conversely, few of the modernists departed any great distance from a representational vision. There are other blurrings of the two groups as well. For example, although Henri's leadership of The Eight (sometimes called The Ash Can School) marked him as a radical, his painterly style and frequent sentimentality more often positioned him in

the company of the first generation.

Nevertheless, the distinction between the two generations is one that the artists themselves acknowledged, albeit sometimes with disdain. Considering the Southwest insufficiently progressive for his taste, Hartley remarked: "Lovely landscape here and there, but the society of cheap artists from Chicago and New York makes the place impossible, and they tell themselves that the great art of America is to come from Taos. Well there will have to be godlike changes for the better in this case."[1] On the other hand, the Taos Society decided against accepting Jozef Bakos as a member, because they found his work too modern—a view difficult to understand today (fig. 149).[2]

At first glance, the migration to New Mexico seems to have brought about a resurgence of artistic vitality among the first generation. Certainly they found unique subject matter and an environment that, in many instances, caused them to broaden their brushwork and brighten their palettes. These changes, however, did not radically alter the techniques and values acquired during the artists' student years. Contemporary academic training, which many of them pursued, had a lasting effect on their art, as did other turn-of-the-century artistic conventions absorbed during their impressionable years.

Whether or not they actually attended academies, members of the first generation were dedicated to academic standards. The passwords to modernism—*sensation, personal emotion, intuition*—were not foreign to these artists, but they were frequently secondary to their drive for mastery of traditional skills: proficiency in drawing and composition, an understanding of anatomy and perspective, and the ability to reproduce

appearances with accuracy and conviction.

The academies and schools they attended were numerous.[3] In Paris they studied at the Académie Colorossi, Académie Julian, and Académie de la Grande Chaumière; in Germany, at the Dresden Royal Academy of Fine Arts, Royal Academy in Munich, and Düsseldorf Academy; in the United States, at the Art Institute of Chicago, Art Students League, National Academy of Design, and Pennsylvania Academy of the Fine Arts. Frequently, artists trained at more than one institution. Both Phillips and Couse, for example, studied at the popular Académie Julian and the National Academy of Design, and Phillips also attended the Art Students League.

Although the methods and priorities of individual institutions no doubt differed— and much research is needed in this area— essentially academies and schools at the turn of the century took a systematic approach to art training. Standards were set in Paris, particularly at the Ecole des Beaux-Arts, preeminent during the 1870s and still refining its teaching methods through the 1880s.[4] Although the Ecole was a training ground for numerous Americans, Couse was the only first-generation Taos/Santa Fe artist who might have briefly attended it. The school that did attract many of them, however, was similar in its orientation and practices. This was the Académie Julian, founded in 1868 by Rodolphe Julian, a painter of moderate skill but a director of marked ability, whose reputation during the 1880s and 1890s attracted an impressive array of international talent.

Popularly construed as a place of informal education, the Académie had, as a writer for *American Art News* commented in 1907, "the approval of a large number who

33. E. Martin Hennings,
Female Figure, ca. 1912–15,
pencil on paper, 14¾ x 11¾
in. Museum of Fine Arts,
Museum of New Mexico,
Santa Fe

34. E. Martin Hennings,
Bone Studies, ca. 1912–15,
pencil on paper, 16¼ x 16¼
in. Museum of Fine Arts,
Museum of New Mexico,
Santa Fe

are opposed to rigorous teaching in art."[5] The effect was not lost on Blumenschein, who attended Julian's in 1895: "I must describe that room. It was crowded with male students from all over the world—most of them wearing heavy beards and large flowing black neckties. They were a jolly lot; insolent, disrespectful, proud to defy most of society's conventions."[6]

In truth, the Académie Julian was far more traditional. Julian and many of the teachers who directed the *ateliers* that composed the Académie had studied at the Ecole des Beaux-Arts, won its coveted Prix de Rome, and exhibited in the Salons.[7] Like the Ecole, the Académie encouraged contests to prepare its students for the Prix de Rome, a competition that offered winners a four- or five-year residence at the French Academy in Rome. Course work was deliberate, dividing the process of art making into

systematic steps designed to develop drawing technique. By the 1870s, the method was in use in art schools throughout Europe and America. In Cincinnati, for example, at the McMicken School of Design (later the Cincinnati Art Academy), where both Sharp and Blumenschein first studied, a very similar approach was employed. A description by a former director of the school might in spirit just as easily have come from a Parisian master: "We keep the pupil upon the simplist [sic] forms, drawing in outline until the greatest possible accuracy is secured before we begin to teach the effects of light and shade. The next step is still life, involving the heads, and then the antique and so on upward. The last stage before the academic course is portraiture. Then comes the study of the human form."[8]

The various stages of academic art instruction can be seen in drawings from the student years of E. Martin Hennings, in Munich from 1912 to 1915. One is of a female figure swathed in yards of billowing fabric (fig. 33). Allegorical and religious figures, typical of Salon painting, were characteristically attired in artful folds of drapery. Consequently, studies of drapery— on the model, festooned across walls and furniture, heaped on the floor—were standard assignments (from which Hennings later benefited when he sketched blankets draped across the shoulders of Taos Indians). Another of his drawings, a study of parts of a skeleton, suggests the lengths to which students went to understand the human form from the inside out (fig. 34). With a light touch, Blumenschein explained how one proceeded to put together such a study: "I got out a canvas that was under way, counted the fingers and toes on the principal figure, plumbed up his spinal

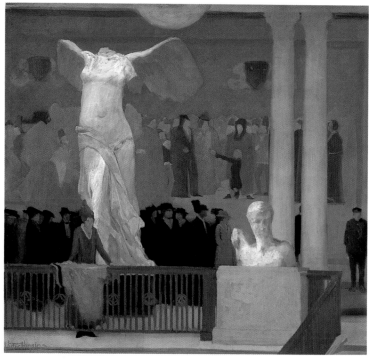

35. Sharp's Cincinnati studio
as it appeared in 1899. Charles
M. Russell Museum, Great
Falls, Montana

36. Victor Higgins, Winged
Victory, ca. 1910–14, oil
on canvas, 40 x 43 in.
Museum of Fine Arts, Museum
of New Mexico, Santa Fe

column, made him seven and a half heads high, as per Academy Julian, put his weight on his feet and his feet on the ground, blew fixative on the drawing, and started to paint along the lines that I hoped would lead me some day to the gates of Rembrandt—or thereabouts."[9]

Traditional art instruction also involved copying Old Master paintings. As Blumenschein wrote, "So much of an artist's education is the study of masterpieces produced by the great artists of history, that it is hard for him to approach a subject without feeling the influence of someone who had painted a picture similar to the one he was about to execute."[10] Despite this drawback, most first-generation Taos painters made their share of copies. A Cincinnati newspaper, for example, noting

Sharp's return from Europe in the late 1880s, commented that he was "loaded with costly relics, draperies and studies."[11] Among the latter were copies after Velázquez and perhaps Rembrandt, still visible in his studio in 1899 (fig. 35). Also suggesting the attraction of the Old Masters and classical art is Victor Higgins's striking oil of the Nike of Samothrace in the Louvre (fig. 36).

When academy students had finally mastered drawing and sketching techniques, they moved on to painting. First they sketched a composition, then continued with numerous pencil and oil studies of figures and details. The studies were adjusted and combined to create the final painting. In the case of W. Herbert Dunton, to cite one example, academic training is evidenced by the many preparatory studies he made for

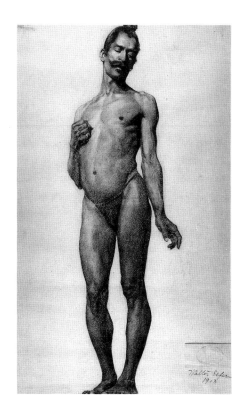

37. W. Herbert Dunton, New Mexican Vaquero, *pencil on paper, 8⁵⁄₁₆ x 8 in. Stark Museum of Art, Orange, Texas*

38. B. J. O. Nordfeldt, Standing Nude, *ca. 1900, charcoal on paper, 23 x 15 in. Van Deren Coke*

39. Walter Ufer, Life Class Drawing, *1903, charcoal on paper, 24 x 14½ in. Mr. and Mrs. Ramon Kelley*

his canvases and in his use of "squaring," the technique of dividing drawings horizontally, vertically, and diagonally in order to transfer them to a final support (fig. 37).

The academies were established to train artists to create large, figural paintings. Consequently, mastery of the human form was the prime focus of their curricula. So uniform was academic training that figure studies done in different institutions look remarkably alike. Nudes by B. J. O. Nordfeldt, trained at the Art Institute of Chicago, and Ufer, trained at the Art Institute, the Dresden Royal Academy of Fine Arts, and the Royal Academy in Munich, similarly suggest an intent to master contours, define structure and proportion, and convey the angle and

movement of a characteristic gesture (figs. 38, 39).

Devant Saint Antoine is a consummate statement of the art of the nude in the 1890s (fig. 40). In keeping with the title, Sharp has pushed the painting's namesake offstage to make ample room for his seductress. A hybrid of the ideal grace of Ingres and the fleshy realism of Courbet, the figure is posed against a dark background and carefully lit to heighten the illusion of volume and shape. The subject is reminiscent of academic Salon paintings, with their tantalizing eroticism peeking out beneath moral themes; indeed, *Devant Saint Antoine* appeared in the Salon of 1895. Hennings also treated the nude in *At Dusk* (fig. 41), an Arcadian image typical of his student years, but with characteristic touches in

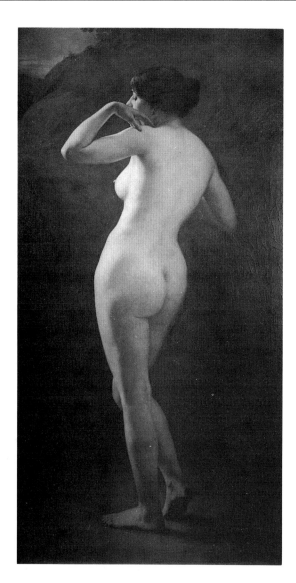

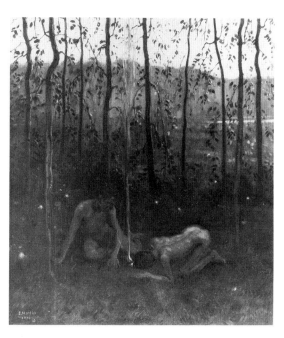

atmosphere and composition—particularly the screen of trees—that would appear in his later work.

Academic tradition also determined what constituted proper subject matter. History painting (comprising historical, biblical, and literary subjects), with its instructive and moral themes, was the premier category, but all subjects were intended to represent higher values and principles. While Berninghaus and Ufer were sometimes the exceptions, the first generation of southwestern artists aspired not simply to the representation of day-to-day reality but to the expression of universal truths. In their choice of Pueblo Indian and Hispanic subject matter, this truth frequently expressed itself in scenes of artisans at work, which were metaphors for creativity, and scenes of man in union with nature, which signified a quest for spirituality.

In an article weighing the virtues of contemporary art, Blumenschein voiced

dissatisfaction with Impressionism because of its realist bias and dismissed the art of the "ultramodern" Cubists and Futurists as meaningful only to the artists themselves. For himself, he chose the middle ground of Post-Impressionism, a movement he described as "being more a source of creation than, strictly speaking, holding the mirror up to nature."[12] Blumenschein thus chose not to describe nature exclusively in realistic terms or to elude it in abstraction; rather, he and his fellow artists intended an art of ideal and abstract values that were eternally and universally valid, even if sometimes expressed in a realist's "slice of life." By focusing on Indian and Hispanic cultures, they presented a standard of civilization they believed Anglos had lost in their quest for industrial progress and political domination. A gentle chiding rises from the paintings, that contemporary life could not equal the instinctive moral and spiritual outlook of the so-called primitive culture of the Pueblo Indians. Nobility and high purpose were as much a part of art in New Mexico as they were of academic painting; only the costumes and settings had changed.

Not all art created by the first generation was ideal, however. Many images blended high-minded concerns with immediate experience. The source of this, in part, was a school equally as popular among Taos artists as the Académie Julian, the Royal Academy in Munich, attended by first-generation artists Julius Rolshoven (1879–83), Joseph Sharp (1886 and 1889), Victor Higgins (ca. 1910–13), Walter Ufer (1911–12), and E. Martin Hennings (1912–15). As at the Académie, instruction was systematic, progressing from charcoal studies of antique sculpture and live models to elementary

painting (which emphasized portrait studies) and culminating in master classes that dealt with composition.[13] Unlike the Ecole, which was organized around independent *ateliers* directed by various masters, course work at the Munich Academy was more uniform; as a result, a style of painting emerged that was recognizable as the "Munich style." While the Académie Julian and the Ecole fostered idealism, the Munich Academy encouraged realism. When Cincinnati artist Frank Duveneck entered the school in the 1870s, he was advised by the influential teacher Wilhelm Diez "not to paint any more holy pictures, but to make . . . studies exclusively from nature." [14] The intense interest that surrounded an 1869 exhibition in Munich of paintings by Courbet and Manet coalesced artistic energy in the Academy around realism. The Academy's roster of admired artists ran from Old Masters—Hals, Van Dyck, Velázquez, and Jusepe de Ribera—through Courbet to Wilhelm Liebl, an instructor at the Academy. The resultant Munich style was characterized by a direct and spontaneous reaction to a subject, with no preliminary drawing, fluid brushwork, and rich paint surfaces—hallmarks conveying immediate contact with the physical world. Subject matter tended toward genre scenes, landscape, and portraiture. The broad brushwork and genre subjects of Ufer, and, to a lesser extent, Sharp, Hennings, and Higgins, are indebted to this tradition.

When the artists left behind student years in France and Germany, they sought broader inspiration. Blumenschein most effectively voiced the collective dilemma that existed before they discovered New Mexico: "We were ennuied with the hackneyed subject matter of thousands of painters; windmills

42. *Walter Ufer,* Woman from Dachau, *1912, oil on canvas, 21½ x 17¼ in. Charles J. Murphy, Dubuque, Iowa*

43. *E. Irving Couse,* Russian Maid, *charcoal on paper, 18 x 12 in. Museum of Fine Arts, Museum of New Mexico, Santa Fe*

44. *Bert G. Phillips,* Sister Charlotte, *ca. 1894, oil on canvas, 23 x 14 in. Hancock Shaker Village, Pittsfield, Massachusetts*

45. E. Irving Couse, Sheep in France, *1890, oil on canvas, 36 x 30 in. Museum of Fine Arts, Museum of New Mexico, Santa Fe*

46. E. Irving Couse, Taos Indian Shepherd, *1907, oil on canvas, 35¼ x 46 in. The Santa Fe Collection of Southwestern Art—Santa Fe Railway*

in a Dutch landscape; Brittany peasants with sabots; French roads lined with Normandy poplars; lady in negligee reclining on a sumptuous divan; lady gazing in a mirror; lady powdering her nose; etc., etc. We felt the need of a stimulating subject."[15] Yet, even though Sharp no longer painted nudes as sumptuous as Saint Anthony's temptress, and Hennings ceased creating dark idylls like *At Dusk*, not all was to be left behind in Europe. With most of the artists, there was continuity of subject matter and style from their early to late works.

Paintings of European peasants were legion in the 1890s, whether from Munich or Paris, Bavaria or Brittany, and the subject had not escaped the first generation. Ufer painted Bavarian rustics (fig. 42); Phillips lived in a fisherman's shack in Devonshire,

sketching the local field workers; and Couse drew Russian serving maids (fig. 43) and visited Etaples in France between 1893 and 1896, to which he later referred as his "sheep period."[16]

Although the subject of Brittany peasants began to wear thin, the artists' interest in folk culture was long-lived. Even before Phillips's European study, he had admired the Shaker community in Hancock, Massachusetts, for the "simplicity, sincerity, and picturesqueness of their life" (fig. 44).[17] After returning from Europe, however, it was the mythic content, rather than the picturesque qualities of folk scenes and costumes, that attracted the artists. The similarities between Couse's *Sheep in France* (fig. 45), probably done while he was in Etaples, and *Taos Indian Shepherd* (fig. 46) are

47. *Joseph Henry Sharp,* In
the Studio, *1897, oil on
canvas, 32¾ x 22¼ in.
Private collection*

48. *E. Irving Couse,* In the
Studio, *1889, oil on canvas,*
25 x 31½ in. Mrs. Scott
Leighton Libby, Jr.

of beautiful objects and lush environments, as seen in two paintings, both entitled *In the Studio*, by Sharp and Couse (figs. 47, 48). On every surface and in every niche of the confined space in the Sharp painting is an extraordinary array of decorative objects: European statuary, Wild West bows and arrows, and Moorish woodwork. The Couse painting, richer and more refined in its visual effect, recalls a Whistlerian environment of precious objects: to the left, an oil painting of a Breton peasant; below it, a collection of exquisite dolls (one oriental) that form the subject of the canvas on the easel; on the right wall, a painting reminiscent of Whistler's nocturnes, with a fan tucked beneath it; and, perhaps the most genteel note of all, an elegant greyhound, whose delicate sleekness is in striking contrast to the beast beneath his paws.

The cult of the beautiful object was intrinsic to several nineteenth-century movements. The Aesthetic Movement of the 1880s, the Arts and Crafts Movement of the late 1880s, and Art Nouveau and Jugendstil at the turn of the century espoused an integration of art into everyday life through fine design and craftsmanship. The driving force was not simply the interest of good taste, but a moral imperative: unique, handmade objects would counter the lowering of values—from bad design to the use of poor materials and construction—due to mass production and industrialization. By surrounding themselves with art and beauty, artists and artisans sought to redefine and improve the quality of "everyday life"—and in so doing they frequently left it behind. Similarly, art colonies arose that were more than just pleasant gatherings in picturesque settings; they often stressed alternative life-styles.

immediately apparent: the protected forest settings, massive trees silhouetted against distant skies, grazing sheep, and shepherds at peace among their flocks convey a Barbizon mood. Yet the focus of the works is different: in *Sheep in France*, the shepherd is barely seen; while in the later painting, the Indian is the main subject. Like Orpheus, who wooed man and beast with his lyre, he wears a laurel wreath—at least its southwestern equivalent—and tends his flock with a flute. Given the idealization of the New Mexican subject, one suspects Couse intended the Pueblo Indian, cast in mythic guise, to impart greater meaning than the Breton peasant.

The force of nineteenth-century traditions continued in other guises as well. Europe had also embodied a world of aestheticism,

49. *Walter Ufer,* The
Listeners, *ca. 1920, oil on
canvas, 25 x 30 in. Philbrook
Art Center, Tulsa, Oklahoma*

The German Nazarenes, founded in 1809 and based in Rome, and the Pre-Raphaelite Brotherhood, founded in 1848, were reactions against industrialized society. The artists of Taos and Santa Fe, too, sought refuge from the commercialism of the urban and industrial world. Although they abandoned exotically attired females, greyhounds, and oriental bibelots, they created another special, insulated environment in the Southwest.

Photographs and paintings of their studies, like Sharp's depiction of his cluttered New York rooms, reveal surroundings only a bit less precious than those in Paris, but with Indian objects now added to the display. Ufer's *The Listeners* (fig. 49) carries the phenomenon directly to

the Southwest, where artists created studios in painstakingly reconstructed adobes, which they decorated with collections of Indian and Hispanic crafts instead of oriental rugs and *chinoiserie*. Aestheticism is evident in the artists' paintings as well, as many images lovingly capture the shape, design, and color of pots, blankets, jewelry, and Hispanic carvings.

The urge to escape led not only to richly decorated interiors, but to exotic places. Nineteenth-century artists traveled widely in Mediterranean and Near Eastern countries. North Africa inspired the odalisques of Eugène Delacroix, Jean-Auguste-Dominique Ingres, Auguste Renoir, and Jean-Léon Gérôme, and from farther east came the Salomes and sheiks of the artists designated "Orientalists." Exoticism characterizes the art of New Mexico as well, having been present in the student work of several Taos painters. Hennings painted a bare-chested, sarong-wrapped *Man with Turban*, presumably during his years in Munich (fig. 50). The image speaks of foreign lands, even though the static pose and simple background are those of a studio production. The note of faraway places is also sounded in *Tunisian Bedouins* by Julius Rolshoven, a frequently overlooked member of the Taos Society who traveled to North Africa in 1910, the date of this work (fig. 51).

While the composition and dark-skinned figures of the Rolshoven painting recall later images of Pueblo Indians, the sensual side of exoticism was foreign to both generations of painters in New Mexico; unlike some European counterparts, they eschewed titillation or extravagance. Artists attending Indian dances, for example, were less apt to comment on lithesome bodies than to extol a ceremony in which visual beauty and

spiritual resonance were subtly joined.

Evidence of the first generation's academic training lies not only in their style and subject matter, but also in their assumption that professional stature and credibility derived from institutions; for the academies conditioned these artists to seek recognition through an official system of prizes and exhibitions. In Paris, at least among the academically minded, the greatest status derived from having works accepted for exhibition in the annual Salons. Blumenschein, Couse, and Sharp were among those so honored.[18] Once a student left France, the award system continued in America in the form of honorary and cash prizes given at the annual exhibitions of major academies and museums. Each artist eagerly submitted work to the Art Institute of Chicago, the Carnegie Institute, the National Academy of Design, and the Pennsylvania Academy of the Fine Arts for their juried annuals, and each listed in his biography all prizes won. Election to associate or full membership in the National Academy of Design was yet another credential eagerly sought.

The student years of the first generation of Taos artists ran roughly from 1885 to 1915. During this period, the academies and schools they attended did not always attract the best talent America had to offer, nor did they give lasting inspiration to a number of progressive artists who began within their ranks. Georgia O'Keeffe studied at the Art Institute of Chicago but was soon following more contemporary trends. Childe Hassam's development was similar; several years at the Académie Julian had less impact on his career than subsequent exposure to the art of Degas, Sisley, and Monet. Robert Henri, more critical of academic training than many

of his colleagues in New Mexico, noted in 1891 the waning influence of the Académie Julian: "The best of the old fellows are gone. The place which once seemed to reach the very utmost in everything, noise, work and smoke[,] is no longer in its full bloom. The old leaders have been replaced by most inferior ones." Henri had even less patience with architectural drawing classes at the Ecole des Beaux-Arts: "I don't ever expect to paint Academic architectural historical subjects. I hope I may never have any more use for a T-square than a fiddler has—pure go-easy unplumbed nature's enough for me."[19]

The quality of instruction at Julian's was probably less an issue than Henri made out, but his gloomy assessment did forecast the ebb tide for academic methods. Nevertheless, the first generation who went to New Mexico emerged well trained from Parisian *ateliers*, and however close they stayed to their academic roots, none remained indifferent to contemporary developments in art, even if they were a bit late in taking note. Certainly the light that flooded American art from the 1880s onward, under the influence of *plein-air* painting and Impressionism, eluded none, particularly once the sun of New Mexico struck their canvases. Cézanne may not have touched them, but Van Gogh and Gauguin did, as the decorative strength of post-1920 work by Blumenschein, Dunton, and Hennings indicates. Despite modifications, however, there remained among the first generation a devotion to an art based on the figure, rooted in nature, and expressing, in a style that was neither ambiguous nor extreme, the visual appeal of the local environment. With every Indian and Hispanic subject that suggested

harmony of life and art drawn from nature, a New Mexican Parnassus was created to celebrate longed-for moral order and ethical purpose. More than any other characteristic, this idealistic yearning marked the nineteenth-century roots that nourished the first generation of artists in New Mexico.

Notes

1. Hartley quoted in Udall, *Modernist Painting in New Mexico*, p. 41.

2. The rejection of Bakos's work is not mentioned in Taos Society minutes. The information is based on interviews with Bakos some years later ("Gallery of Modern Art Shows J. Bakos Work," *New Mexican*, 24 September 1961, pp. 1, 4; Robert Bright, "About the Arts: Jozef Bakos," *New Mexican*, 1 October 1961, p. 4; and Peter Brown, "Bakos: He Branded Local Art," *New Mexican*, 21 March 1976, pp. 8–9). My appreciation to Sharyn R. Udall for bringing this material to my attention.

3. Current research indicates first-generation Taos artists were trained by the following institutions and individuals: *Oscar E. Berninghaus*, St. Louis School of Fine Arts (Washington University School of Fine Arts), ca. 1900. *Ernest L. Blumenschein*, Cincinnati Art Academy (Fernand Lungren), 1892; Art Students League, 1893–94; Académie Julian (Benjamin Constant, Louis-Joseph-Raphaël Collin, Jean-Paul Laurens), 1894–96, 1899–1901, and 1902–9 (periodically). *E. I. Couse*, Art Institute of Chicago, 1882 (three months); National Academy of Design, 1884–85; Ecole des Beaux-Arts (matriculated), 1888; Académie Julian (Tony Robert-Fleury, William-Adolphe Bouguereau), 1886–91, 1892–93. *W. Herbert Dunton*, Cowles Art School, ca. 1897; Andreas M. Andersen, Joseph DeCamp, and William Ladd Taylor in Boston, ca. 1897–1903; Art Students League, ca. 1903 (Frank V. DuMond) and 1911 (Ernest L. Blumenschein); Frederic C. Yohn in New York, ca. 1903. *E. Martin Hennings*, Art Institute of Chicago, 1901–4 (degree), 1904–12 (periodically); Royal Academy in Munich (Walter Thor, Angelo Janck, Franz von Stuck), 1912–15. *Victor Higgins*, Art Institute of Chicago, 1902–9; Royal Academy in Munich (Hans von Hayek), ca. 1910–13; Académie de la Grande Chaumière (René-Joseph Ménard and Lucien Simon), ca. 1910–13. *Bert Geer Phillips*, Art Students

League, 1886–89; National Academy of Design, ca. 1889–94; Académie Julian (Benjamin Constant and Jean-Paul Laurens), ca. 1895/96–ca. 1897. *Julius Rolshoven*, Cooper Union Art School, ca. 1876–78; Plassman Academy in New York, ca. 1876–78(?); Düsseldorf Academy (Hugo Crola), 1878; Royal Academy in Munich (Ludwig von Lofftz), 1879–83; Académie Julian (William-Adolphe Bouguereau, Tony Robert-Fleury), late 1880s(?). *Joseph Henry Sharp*, Antwerp Academy of Fine Arts (Charles Verlat), 1881–82; Cincinnati Art Academy, 1885; Royal Academy in Munich, 1886 (Nicolas Gysis) and 1889 (Carl von Marr); Académie Julian (Benjamin Constant and Jean-Paul Laurens), ca. 1887–88 and 1894–96; Colorossi School (J. André Castaigne, Gustave-Claude-Etienne Courtois, and Louis Girardot), 1894–96. *Walter Ufer*, Royal Applied Art School, 1893–ca. 1894; Royal Academy of Fine Arts, 1895–98; Art Institute of Chicago, 1889–1900; J. Francis Smith School (affiliated with Académie Julian), ca. 1900; Royal Academy in Munich (Walter Thor), 1911–12.

4. For a discussion of the Ecole des Beaux-Arts, see Weinberg, "Nineteenth-Century American Painters at the Ecole des Beaux-Arts," pp. 66–84.

5. *American Art News* 5 (23 February 1907):4.

6. Blumenschein quoted in Bickerstaff, *Pioneer Artists of Taos*, p. 33.

7. The Académie's traditional aspects are discussed in Catherine Fehrer, "New Light on the Académie Julian and Its Founder (Rodolphe Julian)," pp. 208–9.

8. Quoted in Cincinnati Art Museum, *The Golden Age: Cincinnati Painters of the Nineteenth Century*, p. 25.

9. Blumenschein, "The Painting of Tomorrow," p. 848.

10. "Blumenschein Is Interviewed," p. 85.

11. Outcalt, "Among the Artists," p. 135.

12. Blumenschein, "The Painting of Tomorrow," p. 850.

13. E. B. Crocker Art Gallery, *Munich and American Realism*, p. 23.

14. Quoted in Bruce Webber, "Frank Duveneck and the Art Life of Cincinnati, 1865–1900," in Cincinnati Art Museum, *The Golden Age: Cincinnati Painters of the Nineteenth Century*, p. 23.

15. Blumenschein, "Origin of the Taos Art Colony," pp. 190–92.

16. Bickerstaff, *Pioneer Artists of Taos*, pp. 52, 78.

17. Phillips, "The Picturesque Shakers," p. 7.

18. In the Salons organized by the Société Nationale des Artistes Français, Blumenschein exhibited *Le Flutiste* and *Le Lac*, 1896; *Portrait de Mme Tarkington*, 1907; *Portrait d'un artiste dramatique*, *Dessinateurs chinois*, and *Tacoma*, 1908; *Peaux-Rouges du Nouveau-Mexique* and *Château de Bonneville*, 1909. Couse exhibited *Fleur de prison*, 1888; *La Jeune Institutrice* and *La Première Etoile*, 1889; *"Ma Première-née"* and *Un Soir d'été*, 1890; *A l'agonie* and *Un Rendez-vous*, 1891; *La Captive*, 1892; *Pleurant le chef du tribu* and *Le Crépuscule*, 1893. Sharp exhibited *Devant Saint Antoine*, *Portrait de Mme S*, and *La Paresseuse*, 1896. In the "Champ de Mars" Salons organized by the Société Nationale des Beaux-Arts, Couse exhibited *Maternité*, *La Soupe*, and *Le Soir*, 1894; *Déchargement des bateaux* and *Maternité*, 1896; *Iaaloxit, peau rouge*, 1898; *Le Poney de guerre*, 1899.

19. Quoted in Homer and Organ, *Robert Henri and His Circle*, pp. 60–61. In fairness to the Ecole, Henri's attitude proved more radical than his art.

William H. Truettner

The Art of Pueblo Life

"When Trinidad, the Indian boy, and I planted corn at my ranch," D. H. Lawrence wrote after his New Mexican sojourn, "my soul paused to see his brown hands softly moving the earth over the maize in pure ritual." During most of the years he spent in Taos, to which he had come at the request of Mabel Dodge in 1922, the English novelist was obsessed with the "strange blind unanimity" of thought and action he perceived in Indian life—the unconscious poise that seemingly led Indians to plant corn with the same mystical absorption that they performed sacred ritual. Their actions, Lawrence maintained, revealed a spirit that was absolutely lacking in contemporary society, in which men were at odds with nature, and in which he personally felt "dead, dark, and buried."[1]

Lawrence's reaction to Indian life in New Mexico, and his need to compare it to the urban, industrial world from which he had come, was based on themes espoused by American and European authors during much of the nineteenth century. Indians of that era, especially those who roamed across the American West, came to personify the virtues of an untouched wilderness, their behavior governed by an intuitive comprehension of natural law. This view remained intact, at least as a literary phenomenon, until the last decades of the century, when the discovery of southwestern Indian art and culture caused it to change. The result was a new perspective on Indian morality: aesthetic instinct, rather than cosmic authority, was the mechanism now presumed to govern their lives. The Indian's innate ability to sense the harmony of nature, to perceive

its beauty as a religious phenomenon that pervaded all phases of daily life, to dance and sing in a way that spontaneously evoked a community soul, and to create from an ancient tradition new objects of enduring artistic merit, these became the virtues for which his life was celebrated.

These new attributes were not totally divorced from literary ideals, but they were more often derived from anthropological studies (see chapter 1), which continued with even greater frequency during the first three decades of the new century. One of the most comprehensive of these, conducted by University of Chicago scholar Elsie Clews Parsons between 1915 and 1932, resulted in her pioneering volumes *Pueblo Indian Religion* (1939), several passages of which clarify attitudes toward Indian life that had prevailed for several decades among Anglo painters in New Mexico. Commenting on the relationship between the ritualistic and creative aspects of Pueblo religion, Parsons defined it as a largely "magical" process by which Pueblo arts had become the "servants" of an "undeliberate kind of utilitarianism—words, rhythms, motions, color, and line all contributing to the control of the Spirits. Poetry and song, dance and music and steps, mask, figurine, fresco and ground painting, beautiful featherwork, weaving and embroidery, whatever else they are, also are measures to invoke and coerce, to gratify or pay, the Spirits."[2]

Pueblo religion, in this sense, was an attempt to make the unpredictable elements of nature more responsive to human needs, with the aid of art forms created to placate the natural spirits that inhabited the Indian universe. While ritual had gained validity as a catalyst of Pueblo art in many previous studies, rarely had the connection

been so closely defined. Like all careful scholars, Parsons shied away from claiming aesthetic merit for the objects she named, but others were less objective. The Indian had already been touted by some as the artistic genius of the twentieth century, such that by 1910, when the message of anthropologists began to affect painters and writers in the Southwest, Pueblo life had taken on considerable status—different, to be sure, from that of Plains Indians, but informed by a myth-making process that may well have been transferred from it.

Soon after he arrived in Taos, Joseph Henry Sharp, who had worked previously at Crow Agency, Montana, sent back to the Cincinnati *Commercial Tribune* a description of a visit to Tesuque Pueblo. It was not the sort of material that ever found its way into his paintings. "In the huts," Sharp wrote,

the squaws were busy grinding corn or making clay [rain] gods and pottery, while the poor, bony dogs were under one's feet or slunk away with tail drawn under; kittens, so poor their heads looked abnormally large, could not resist the instinct to play, and fell over from weakness after a too-daring strike with the paw.

In front of one of the doors an old man lay straight and flat, almost nude, imbecile, covered with sores and oblivious to surroundings—a veritable Job, minus the bewailers.

One loses a vast amount of sympathy in these places, and the heartless cruelty to animals of all kinds is terrible. I have seen horses and the meek, patient burros pounded over the heads with big clubs until it was sickening—one's regard for his own head preventing interference. [3]

Clearly Sharp preferred to turn his back on unpleasant scenes in and around the pueblos, as did most of the painters who

52. *Walter Ufer*, Coming from the Spring, *1927, oil on canvas, 24 x 30 in. Wunderlich & Company, Inc., New York*

followed him. So influenced were they by other factors that the everyday conditions of Indian life never received a legitimate artistic appraisal.[4] Instead the artists took a distant view—sometimes quite literally. The appearance of the pueblos, dramatically situated in the barren New Mexican landscape, enhanced the romantic appeal of their occupants. So, too, did the fact that the Pueblo tribes had preserved intact their ancient customs longer than any other Indian group in the United States.

At the same time, Pueblo life was threatened. Federal government acculturation objectives, launched with the Dawes Act in 1887, had made serious inroads into Pueblo culture by the 1920s. Those who fought back, including Mabel Dodge, Mary Austin, dean of Santa Fe writers, John Collier, later named Commissioner of Indian Affairs under Franklin Roosevelt, and artist members of the Taos/Santa Fe colonies ultimately triumphed, with rhetoric that again described Indian life in glowing terms.[5] The most important factor, however, was the recognition of Indian artistic skill just at the moment American artists, weary of the influx of cosmopolitan styles, once again became concerned about an indigenous tradition. Indian art, with its bold designs and colors, was touted as the answer, even to the extent that Edgar L. Hewett, the bustling director of the Museum of Fine Arts in Santa Fe, stated: "It is gradually dawning upon us that the Indians' race is a race of artists, and that their esthetic culture towers above anything Caucasian, if we except a few points of supernormal development, such as Greece and Italy."[6] Extravagant as Hewett's comment sounds, there were members of the Taos/Santa Fe colonies who seconded it. Ernest Blumenschein and Marsden Hartley claimed that Indian art was superior to anything thus far produced by American artists, simply because it constituted a direct and unlearned response to their native environment.

Natalie Curtis, the anthropologist wife of artist Paul Burlin, devoted much of her career to recording and interpreting Indian songs and chants. On occasion, she revealed how deeply affected she was by the atmosphere of Pueblo life and by theories similar to those held by Lawrence, Blumenschein, and Hartley. Approaching Laguna one morning, she described a picture that any one of the first generation of Taos artists might have included in their repertoire (fig. 52):

53. Bert G. Phillips, Song
of the Aspen, *ca. 1926–28,*
oil on canvas, 40 x 27 in.
Harrison Eiteljorg Collection

*The trail was a deep groove in the living rock,
worn by the tread of countless moccasined feet;
and though the morning was still early, the way
was dotted with Indian women, their earthen
jars on their heads, going to the springs. The
white walls of the village above us glistened
against the blue sky like a fleet of sails on a
summer sea. The shaded gold of the desert
stretched away on every side, broken by a flash of
green where the Rio Grande spread fertility
through the valley. An ox cart rumbled by, and a
group of Indian men passed me on the way to
their fields, the same fields that these pastoral
and agricultural people have tilled for
centuries. . . .*

*I made my way through the streets and courts
of the old town and across the dance-plaza till
suddenly I paused, caught by the tones of a
strange and lovely melody that rose high above
the scraping sound of corn-grinding in a house
nearby. I knew the house; the woman who lived
there was my friend and I had often visited her
to listen to the songs with which the Pueblo
Indian women lighten their hard labor at the
grinding-bin. The unusual intervals of this song
and a certain archaic outline of melody fascinated
me; and as I entered the house, my friend looked
up from her work with a smile.*

The Indian woman described for Curtis
the songs she sang at certain times of the
day to ensure the prospering of the crop.
Comparing the Indian's songs to Hindu
ragas and the "rhythm of her grinding
stones" to "the turning of the planet,"
Curtis continued: "I thought of our complex
city life, and of the songs of the paid singers
to whom we listen when our day's work is
done; singers whose art, with all its beauty,
is yet but a gaslit luxury for a few. And I had
a new respect for this Pueblo woman who
awoke with the sun and toiled with the sun

and sang with the sun, all her life in harmony with the cosmic world about her.''[7]

Perhaps the myth of Pueblo life began right there. Comparison to white civilization inevitably benefited the Indian, for most of the anthropologists, artists, and writers who had settled in the Taos/Santa Fe colonies were critical of the world they had left behind. No matter how objective their analysis of Pueblo culture, it was filtered through a screen of discontent, of longing for a simpler, more fundamental way of life. The phenomenon, best described as a mild form of primitivism, conditioned Anglos to view Pueblo life in idyllic terms. Consequently, they rarely noted scenes like those witnessed by Sharp at Tesuque Pueblo and instead carefully selected subjects that conveyed the experience of Natalie Curtis at Laguna.[8]

Paintings such as Bert Phillips's *Song of the Aspen* (fig. 53) and Sharp's *Crucita, A Taos Indian Girl* (fig. 54), for example, reveal much more about Anglo attitudes than they do about Indian life. By the 1920s, flute serenading, a courtship ritual, was rarely

55. Anonymous, Hopi, Embroidered Manta, late 19th century, cotton with wool embroidery, 40⅛ x 49⁹⁄₁₆ in.; Pueblo, Woven Sash, ca. 1900, wool and cotton, 110¼ x 4 in. Thomas Gilcrease Institute of American History and Art, Tulsa, Oklahoma

56. Joseph R. DeCamp (1858–1923), The Red Kimono, 1920, oil on canvas, 48¼ x 40¼ in. Cummer Gallery of Art, Jacksonville, Florida

practiced among the Pueblos[9]—and Taos beaus were not likely to wear such elaborate Plains leggings—but the image enabled Anglo painters to impose on Indian life the sense of order and harmony they themselves were seeking. Sharp's *Crucita* is in more authentic garb, a beautiful Hopi wedding dress gathered at the waist by a brightly colored woven sash (fig. 55). But at her feet is an earthen bowl containing zinnias (not native to the Southwest) and a variety of other flowers. Such a floral arrangement would not have been part of an Indian household; in fact, the picture is an Anglo conceit, meant to advertise the aesthetic sensibilities of an Indian in a way that an Anglo audience could understand. Its

progenitors are those refined interiors by artists like Edmund Tarbell and Joseph DeCamp (fig. 56), in which gentle, well-bred females created a similar aesthetic mood.

Yet there remains a crucial difference: DeCamp's figure, in Japanese kimono, represents acquired taste; Crucita's response to the flowers she arranges is intended to be as instinctive as the talent that produced her dress. Moreover, paintings like *Crucita* established a theme played upon by artists of *both* the academic and modernist generations in New Mexico. It led directly to works like Victor Higgins's *Nude Study* (fig. 57), in which the artist relied less on overt gestures than on bold design to connect the figure to surrounding motifs. The

57. *Victor Higgins*, Nude Study, *ca. 1937, watercolor on paper, 24 x 19 in. Museum of Fine Arts, Museum of New Mexico, Santa Fe*

composition strikingly identifies the figure with the primitive design of Indian blankets in the background, thus illustrating the union of life and art in Pueblo Indian culture.

The Anglo painters who went to New Mexico in the late nineteenth century were not necessarily seeking Pueblo Indians. Ernest Blumenschein and Bert Phillips arrived in 1898—Blumenschein first, in search of a blacksmith to repair the wagon wheel that had broken twenty miles short of their destination. The closer Blumenschein got to the Taos valley, the more the country appealed to him. "No artist had ever recorded the New Mexico I was seeing," he wrote some years later: "The color, the effective character of the landscape, the drama of the vast spaces, the superb beauty and serenity of the hills, stirred me deeply. I realized I was getting my own impressions from nature, seeing it for the first time with my own eyes, uninfluenced by the art of any man."[10]

It was the remoteness, the "otherness" of the Taos environment that seemed to affect the first group of artists who settled there, and to renew those who came later. No one claimed that it was "untouched," as landscape painters had claimed of the West during much of the nineteenth century. Indeed, the pueblos and their surroundings suggested the opposite: an ancient, neglected world in which centuries of occupation by Indians and Hispanics and the course of geological events had left their marks. It *looked* old, it exuded history and tradition—features coveted by those coming from the relatively new and urban East. The strong, primitive flavor of the land and the

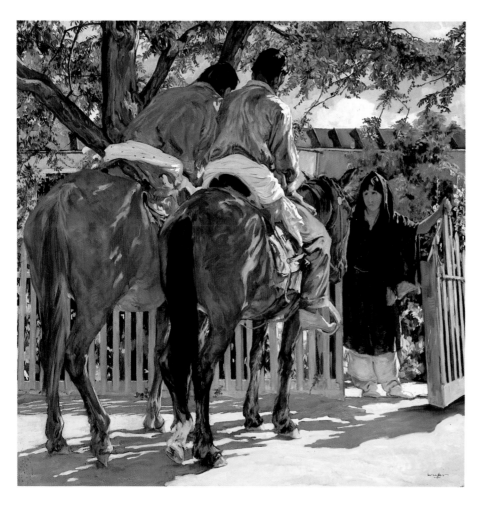

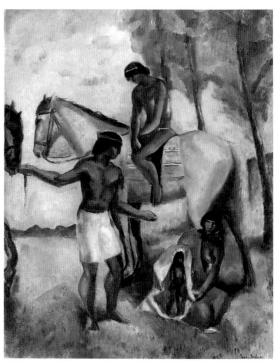

people would free artists from a past that had infringed upon their creative potential, a past (in Blumenschein's words) encumbered by "the hackneyed subject matter of thousands of painters."[11]

The first generation of Taos painters may not have been willing to accept the progressive stance taken by Robert Henri and his followers in 1908, but they were genuinely bored with Barbizon scenery and genteel society. They sought instead subjects of more direct and vigorous appeal. Their break with the past, we now realize, was not quite as clean as they wished to think, their exotic Indians having to some extent been modeled on the very prototypes they were trying to avoid. Nevertheless, their dedication to finding a new and national idiom was a powerful force in the movement to the Southwest; and for the second

generation, as finely attuned to the splendid landscape, the mission had even greater meaning. "America extends the superb invitation to the American painter to be for once original," Marsden Hartley observed in 1918. "It will not satisfy the intelligent eye to paint a lone mesa like an inflated haystack of Monet. . . . The sense of form in New Mexico is for me one of the profoundest, most original and most beautiful I have personally experienced."[12]

Once arrived in this dazzling new environment, however, the painters discovered the Indians, who quickly became even more of an attraction than the landscape. At first their appeal was based on their exotic appearance. During the decades before and after the turn of the century, American trainees in European studios had been introduced to an aesthetic environment that placed a premium on colorful subjects. It was not difficult to transfer allegiance from Arab chieftains to tall, proud Pueblo men wrapped in white cotton blankets. Figures on horseback, like those in Ufer's *Callers* (fig. 58), are also susceptible to such comparisons, if one disregards the intense hues of the southwestern landscape. The concept of exotic Indians lasted longer among some artists than others. Certainly Sharp, Phillips, Couse, Ufer, and Hennings clung to it for years, but even an early modernist like Paul Burlin used parts of the formula in his *Apache Braves* (fig. 59).

If Anglo painters first appreciated Pueblos for their exoticism, it was not long before their interpretation took a deeper turn, with Indians and Hispanics suddenly becoming more American than descendants of the *Mayflower* colonists. *Why* it took this turn is a question that touches many different aspects of contemporary American culture (see

chapters 1 and 4). But the spirit that made artists in New Mexico embrace what they saw as the intensely native quality of the environment was a need for a focus they found lacking in contemporary American art. No doubt the eclecticism that had troubled Blumenschein, and that characterized much of American architecture, painting, and sculpture from 1893 to 1910, made New Mexico seem more authentic than anything these American artists had encountered in years. The architecture was composed of the earth itself; Pueblo tribes had flourished before Coronado's expedition; the Hispanic people, in temperament and religion, reflected the austerity of the desert landscape; and the primitive environment was an elemental, physical challenge. New Mexico, defined by its ancient and enduring appearance, became the cornerstone of America, with the result, according to one writer, that "men and women of vision look to the Southwest for the roots of American Art."[13]

Clearly the roots were not confined to Pueblo subjects, yet from the beginning, Indian life most often symbolized native America. As Victor Higgins observed: "There is in the mind of every member of the Taos art colony the knowledge that here is the oldest of American civilizations. The manners and customs and style of architecture are the same today that they were before Christ was born. They offer the painter a subject as full of the fundamental qualities of life as did the Holy Land of long ago."[14]

These "fundamental qualities" (which often did have religious overtones) were exactly what the early painters wished to get back to. They were fundamental in the sense that they represented the generative spirit of

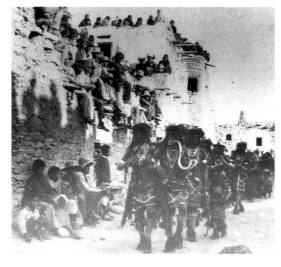

60. John K. Hillers, View of
Taos, *1879, albumen silver
print, image 9⅞ x 12¹³/₁₆ in.
National Anthropological
Archives, Smithsonian
Institution, Washington, D.C.*

61. Charles H. Carpenter,
The Snake Dance, *1901.
National Anthropological
Archives, Smithsonian
Institution, Washington, D.C.*

Pueblo life, a spirit the artists hoped to reintroduce into the mainstream of American art. The next generation was no different in its aims. Henri came to Santa Fe saying that he wanted only to find "whatever of the great spirit there is in the Southwest."¹⁵ Like the rest, he sought refuge; he came west with a perception that Indian life would enable him to express freely and spontaneously in his work a new sense of national purpose. To accomplish this, Anglo painters felt a need to live in a land distant from urban civilization and to absorb the meaning of Indian art and ritual.

The source for their inspiration was eighteen Pueblo villages located in the vicinity of the Rio Grande (except for Acoma and Zuni, which were some distance west) between Albuquerque and Taos. These had been constructed centuries earlier when the Anasazi, or "ancient ones," had given up their dwellings in the canyons of the surrounding area and developed more open communities dependent upon agriculture as well as hunting and gathering for their subsistence. By 1300 many pueblos were flourishing, and a few lasted through the 1920s and 1930s without radical change.

Despite occasional intrusions from their nomadic neighbors, who were much more warlike, the Pueblo tribes had enjoyed relative peace. They rarely fought against one another, more often banding together to ward off common enemies: the Navajo, Comanche, and Apache. Yet for all their unified defense efforts and similarity of cultures, each village maintained a separate existence; collectively, they did not consider themselves a tribe or confederation. Hence, their dress, pottery and blankets, dances

and ceremonies all varied to a certain degree, adding to their appeal to outsiders.

The pueblo at Taos (fig. 60), framed by the geometry of Taos Mountain, was usually singled out as the most architecturally distinctive, but others were equally alluring. Acoma had the most spectacular setting (fig. 12), perched high on a mesa and reached only by a winding stairway carved out of solid rock. At San Ildefonso was a thriving pottery tradition, recently revived by Maria Martinez and her husband, Julian. The dances at Santo Domingo, the largest of the pueblos, were another attraction. The poet Witter Bynner remembered when he and the Hendersons (Alice Corbin and the painter William Penhallow) attended these Pueblo ceremonials together. "In those days," Bynner wrote,

we liked to watch singly and to absorb the dances, or to be absorbed by them, rather than to make them the social occasions they are now; and when the Easter dance or the August dance came to Santo Domingo, each lasting three days, we would last the three days with them, sleeping on the schoolhouse floor, and be up at dawn to see the first Koshare, with Alice Corbin as alert and hardy as any of us. Sometimes we were the only white watchers. Sometimes we took with us a visiting writer like . . . Edna Millay, or a composer like Ernest Bloch.[16]

The major Zuni dances featured Shalakos, tall, richly attired figures who impersonated spirits bringing health and prosperity to the ancient community. At the Hopi villages, the famous Snake Dance (fig. 61), in which live poisonous snakes were held in the mouths of performers, had fascinated visitors long before the arrival of the Anglo painters. At other pueblos, clothing and textiles of a distinctive texture and weave were a highlight, along with handsome silver jewelry.

Equally important to the Anglo painters was the bond that existed between the Indian and his pueblo.[17] Each individual was united to his tribe by a sacred relationship that extended from family to clan to one or more governing bodies that exerted subtle, but absolute, control over pueblo affairs. The bond functioned like an invisible safety net; no member of the tribe was ever without adequate means of support. A sharing of dwelling space and agricultural land was also common, as well as an obligation to assist with a variety of civil and religious duties. An Indian did not fight for personal space or freedom; instead, he was dedicated to maintaining an established order. At the heart of this community concept was a religion more transcendental than pantheistic. No Indian saw himself as guided by an omnipotent being; rather, he sought to merge himself with a life force that permeated all animate and inanimate objects. "All is god" in this "vast old religion," Lawrence wrote.[18] Legends, ceremonies, and customs appeared to grow out of a natural harmony so profound that they dominated Pueblo life more efficiently than institutional government. From the same source, it was argued, emerged the creative spirit of the Indian. It was not a function of his ego but of his mystical kinship to his physical surroundings. As Marsden Hartley observed, "The Red Man is the one truly indigenous religionist and esthete in America."[19]

These perceptions of Indian culture were not necessarily ones that artists brought with them to the Southwest, although an inclination toward primitivism, absorbed

from European sources during the first decade of the twentieth century, must have made Hartley, Burlin, Jan Matulka, and others more receptive to such ideas. Anthropologists of national reputation also played a role in promoting these views, as already noted. But for the two generations of Anglo painters who frequented Taos and Santa Fe from 1900 to 1945, there was one source far more important than the rest: the School of American Research (known between 1907 and 1917 as the School of American Archaeology), headed by the indefatigable Edgar L. Hewett. One can hardly overestimate the role Hewett played in giving institutional credence to the attitudes adopted by Anglo painters of that era. He was a man of boundless ambition— part scholar, part cultural entrepreneur— dedicated to imposing his vision of ancient America upon contemporary Santa Fe.

Even before he settled in New Mexico (1898), Hewett had been involved in the study and preservation of pueblo ruins. Several years later, this took a more scholarly turn, leading to professional contact with such anthropological notables as William Henry Holmes, Alice Fletcher, and J. Walter Fewkes. With their support, he persuaded the Archaeological Institute of America (which had sponsored Bandelier's field work in the Southwest in the 1880s) to found the School of American Archaeology, the institution that eventually gave birth to a number of organizations dedicated to studying and preserving Indian life in the Southwest. Once the school was under way (1907), Hewett lobbied to make the Palace of the Governors in Santa Fe its permanent home. Again he was successful, creating the Museum of New Mexico in 1909 to renovate and administer the palace as a

combined historical museum and archaeological headquarters. Until his death in 1946, he remained director of both institutions, the cultural arbiter of Santa Fe for forty years.

Fortunately, professional politics did not absorb all of Hewett's career; he spent enough time in the field to have a solid grasp of contemporary anthropological theory and a more than tolerant view of Indian life. In his role as spokesman for the archaeological and anthropological communities in Santa Fe, he communicated to Anglo painters, both directly and indirectly, many of the concepts regarding Indian life seen in their paintings. Above all, he believed that the time had come to investigate Indian culture in all its phases, that too much effort had been spent on the "material side" and not enough "in the recovery and interpretation of purely spiritual survivals." The latter he designated as the most "inviting and promising phase of American anthropological research." But Hewett felt that the entire burden should not fall to the anthropologists. "It is the problem of artist and poet, as well as of historian and scientist, to do justice to the race which has given to the world its best example of orderly, integrated racial life," he wrote.

A Pueblo Indian at an afternoon tea in New York is out of place. In his own Southwest he is a harmonious element in a landscape that is incomparable in its nobility of color and mass and feeling of the Unchangeable. He never dominates it, as does the European his environment, but belongs there like the mesas, skies, sunshine, spaces and the other living creatures. He takes his part in it with the clouds, winds, rocks, plants, birds and beasts: with the drum-beat and chant

and symbolic gesture keeping time with the seasons, moving in orderly procession with nature, holding to the unity of life in all things, seeking no superior place for himself but merely a state of harmony with all created things—the most rhythmic life, so far as I know, that is lived among the races of men.[20]

When it came to cultural comparisons, Hewett also took a familiar stand. He condemned current anthropological theory, and by extension modern civilization, for its inherent racism, stating, "We have acted strictly upon . . . the theory that only peoples of high material achievement constitute the superior group; that lack of material advancement is the index by which races are to be classified as backward." Having impugned his colleagues, Hewett then took on the whole social order:

Our passion for organization, for offensive and defensive alliances among societies and states, grows out of the propensity for meddling in one another's affairs which seems inherent in European peoples, including modern Americans. . . . Whatever the forces were that directed the evolutionary processes in the European race to the white skin, the contentious spirit, the passion for individual glory, the determination to rule, they were and are inescapable. It is not possible for the European to conceive of a better state of society than that attained by way of mighty ambitions, mighty conflicts, mighty individual power.[21]

There is, of course, a certain irony in these statements in view of Hewett's own driving ambition. Nonetheless, they correspond to ideas put forth by colleagues who were equally concerned about the conflict of cultural values between white and Indian races. The conflict surfaced in the Southwest

with Frank Hamilton Cushing, it was gently reiterated by Alice Fletcher, and Hewett gave it a final, resounding emphasis. None who sympathized with Pueblo culture viewed it in isolation. In almost all cases, and to a man among the Anglo painters, it represented the ideal alternative to white civilization.

Once restoration of the Palace of the Governors was completed, Hewett lost no time in making space available to painters, who he strongly believed complemented his archaeological investigations with a record of living tribes. At one time or another, Henri (whom Hewett personally invited to Santa Fe in 1916), John Sloan, George Bellows, Randall Davey, Willard Nash, Paul Burlin, Warren Rollins, Gustave Baumann, Marsden Hartley, Andrew Dasburg, William P. Henderson, Gerald Cassidy, Julius Rolshoven, Sheldon Parsons, Kenneth Chapman, and Carlos Vierra occupied studios in the palace and had access to the exhibition area Hewett set aside for resident artists. It was soon evident, however, that space was inadequate for the wide-ranging program the director had in mind. So in 1912, even before workmen had vacated the palace, he launched a campaign to build a separate museum that would provide superior facilities. Appeals to the New Mexican legislature were begun in 1915, and by 1917 Hewett had maneuvered to completion the Museum of Fine Arts (fig. 116). At the same time, he managed to refashion the School of American Archaeology into the School of American Research, with a new charter that placed a premium on collecting Indian material. Olive Rush, a pioneer of the Santa Fe colony, may have summed up best the support now available through the expanded facilities:

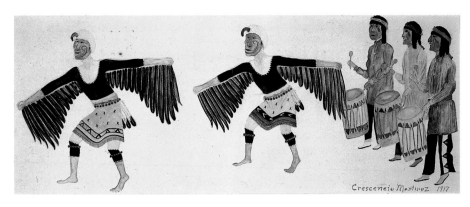

Many of us came out here to find ourselves. I know of no institution anywhere better tuned to help an artist to do that very thing than the Museum of New Mexico, and none so well tuned to its own environment of great spaces. . . . Some may prefer that you should copy the Academies and put hobbles on the artists, but they are not of those who seek the light. Seekers have no patience with hobbles. The Air . . . and Freedom of Action . . . we fled the East for them.[22]

For Hewett, as well as for the Anglo painters, the great connecting point between the past and the present in the Southwest was the continuity of Indian culture, the unchanging pattern of their ceremonial and domestic life. The most striking evidence of this was found in Indian art, or more specifically, in the artistic concern bestowed upon domestic objects. Pots, blankets, baskets, and jewelry assumed almost sacred significance for the Anglo community; their traditional beauty and function seemed a sure guide to a sustaining, creative spirit.

During the second half of the nineteenth century, however, trade goods, introduced into the southwestern economy following the war with Mexico, caused a serious decline in the production of domestic articles among Pueblo tribes. Anthropologists, alarmed that craft traditions might cease altogether, led concerned individuals in the Taos and Santa Fe colonies to initiate measures for an Indian arts revival, which ultimately had far-reaching consequences for Anglo painters. Even before this campaign had begun, the completion of the railroad had started to reverse the decline in crafts production;[23] but scholars more often point to the meeting between Kenneth Chapman and the Navajo Apie Begay as the moment Anglo sponsorship of the movement commenced.

Chapman, an associate of Hewett who was destined to become one of the leading authorities on southwestern Indian art, discovered Apie Begay about 1902 converting traditional sand-painting designs into two-tone drawings. When Chapman provided additional colors, the Indian artist improved, convincing Chapman that even

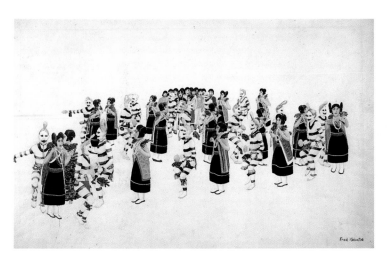

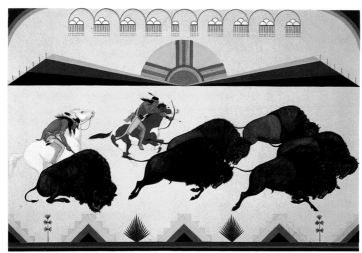

64. *Fred Kabotie,* Dance of
the Corn Maidens, *ca. 1920,*
watercolor on paper, 14 x
22 in. School of American
Research Collections at the
Museum of Fine Arts,
Museum of New Mexico,
Santa Fe

65. *Ma-Pe-Wi (Velino Shije*
Herrera), Buffalo Hunt, *ca.*
1930, watercolor on paper, 20
x 29 in. School of American
Research, Santa Fe

talent in painting (as opposed to decorative arts and crafts) was not lacking among the southwestern tribes. Several years later (ca. 1909), Hewett became more actively involved in the revival as a result of excavations he was conducting in Frijoles Canyon, near San Ildefonso. Prehistoric mural fragments were discovered, which Indian laborers copied with such success that their work was immediately acquired by School of American Archaeology personnel.[24]

At Chapman's urging, Hewett brought the most skillful of these draftsmen, Crescencio Martinez (fig. 62) and Awa Tsireh (fig. 63), back to Santa Fe, where they were given studios in the Palace of the Governors. The same was done for other aspiring painters from Tesuque, Taos, Hopi, and Zia, several of whom—Fred Kabotie and Ma-Pe-Wi in particular (figs. 64, 65)—achieved considerable success in the years that followed. More important, however, was the exchange among Pueblo artists in the palace, where an abundance of Indian material was already stored, and their close contact with Anglo painters working in

adjacent studios, who were inspired by, and in turn influenced, their Indian colleagues. John Sloan, who occupied studio space in the School of American Research in 1919, when he first came to Santa Fe, was so taken by the Indians' watercolors that he arranged for a group to be shown the next year at the Society of Independent Artists in New York.

In many ways, Dorothy Dunn's studio classes, begun at the Santa Fe Indian School in 1932, represent the culmination of the Anglo movement to encourage Indian watercolor painting. Dunn, a young art student from Chicago, was committed to fostering an appreciation among Indians of their traditional arts, and to developing "new motifs, styles, and techniques in character with the old."[25] In her five years at the school, she trained a number of talented Indian watercolorists who otherwise might not have developed their creative potential— and in so doing, provided yet another link between Anglo painters, who assisted in her classes, and the Indian arts revival.

Through Julian Martinez, the watercolor tradition interacted with pottery production

66

67

68

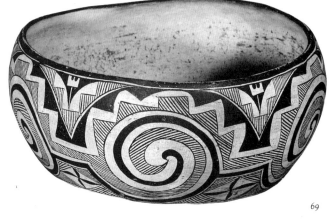

69

66. *Maria and Julian Martinez, Blackware Plate, late 1930s, oxidized earthenware and slip, 14⅞ in. diameter. The Denver Art Museum, Denver*

67. *Anonymous, Santa Clara, Water Jar, ca. 1890, oxidized earthenware, 12½ x 14¾ in. Kent Denver Country Day School, Englewood, Colorado, Gift of Mrs. Lucius Hallet to the Kent School*

68. *Anonymous, Zia, Water Jar, before 1890, polychromed earthenware, 9½ x 10⅝ in. National Museum of Natural History, Smithsonian Institution, Washington, D.C.*

69. *Anonymous, Acoma, Dough Bowl, ca. 1920, earthenware, 8½ x 14 in. School of American Research, Santa Fe*

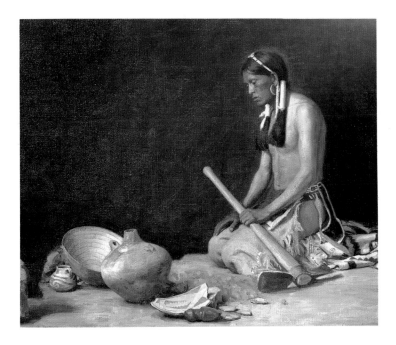

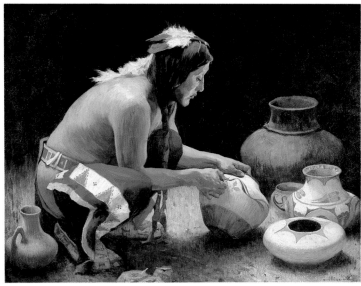

70. Bert G. Phillips, Relics of His Ancestors, *before 1917, oil on canvas, 34 x 40 in. James F. Burshears*

71. E. Irving Couse, The Pottery Decorator, *oil on canvas, 35 x 46 in. Private collection*

at San Ildefonso, which gained new momentum about 1909, when he and his wife, Maria, began producing polychrome ware based on the contour and decoration of shards dug up in Frijoles Canyon. Maria shaped and fired the pots while Julian decorated them with an imaginative combination of traditional designs. Shortly before 1920, again with Hewett's encouragement, the couple developed the lustrous black-on-black ware (fig. 66), the most successful pottery style to emerge from the Southwest during the next twenty years. The appeal of the Martinezes' work was doubtless based on its "modern" look, its combination of abstract and traditional elements that allowed collectors to place the pieces in almost any context. But the Martinezes' success was also shared by potters at other pueblos—Santa Clara (fig. 67), Santo Domingo, Zia (fig. 68), Acoma (fig. 69), and Cochiti—who were

reproducing ancient designs. Bert Phillips's *Relics of His Ancestors* may well document the beginning of the pottery revival (fig. 70); the subject probably refers to the excavations in Frijoles Canyon, for which Hewett employed Pueblos to assist in digging up relics of their ancestors. Like the Martinezes, who studied the ancient prototypes from Frijoles, the Indian in Phillips's painting is lost in contemplating the remains of a once-flourishing pottery tradition.

Many of the Anglo painters followed the pottery revival closely and collected numerous pieces as studio props, which they often featured in their paintings.[26] Both Couse and Sharp, for example, had a knowledgeable passion for Indian objects, expressed not only in terms of personal ownership, but also in their appreciation of the artistic skills of Pueblo tribes. Opposite the figure in Couse's *Pottery Decorator*

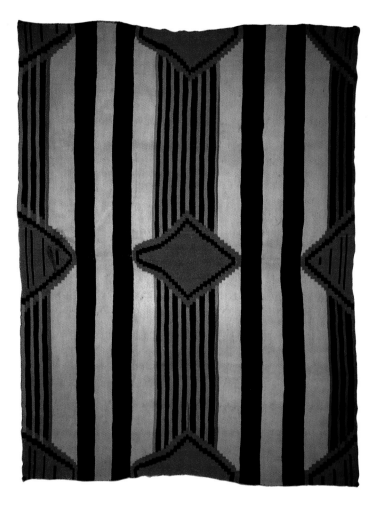

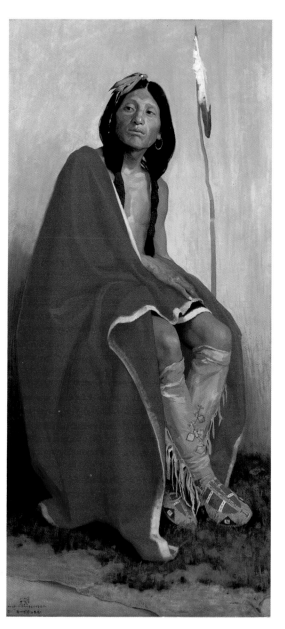

72. *Anonymous, Navajo,*
Chief Blanket, Third
Phase, ca. 1860–80, wool,
76 x 59 in. National Museum
of Natural History,
Smithsonian Institution,
Washington, D.C., The Victor
Justice Evans Collection

73. *E. Irving Couse, Elk-Foot*
of the Taos Tribe, ca. 1909,
oil on canvas, 78¼ x 36⅜ in.
National Museum of American
Art, Smithsonian Institution,
Washington, D.C., Gift of
William T. Evans

(fig. 71) are distinctive pieces of Zuni, Zia, and Hopi polychrome ware, while a handsome storage jar, gold-and-buff colored, from Taos or Picuris, is placed at the feet of Sharp's Crucita (fig. 54). Not only is the pottery intended to remind us of the talented hands that produced it, but the highly decorative design of the polychrome ware (along with the beaded Plains leggings of the potter) enabled Couse to introduce bold design and color into an otherwise academic conception. The storage jar in the Sharp painting functions in an almost opposite way, providing an earthy

74. *Anonymous, Pueblo,
Striped Blanket, ca. 1870s,
wool, 47 x 68 in. School of
American Research, Santa Fe*

75. *Anonymous, Navajo,
Wedge-weave Blanket, ca.
1880–1900, wool, 52 x
67½ in. Maxwell Museum of
Anthropology, University of
New Mexico, Albuquerque*

complement to the brightly colored zinnias and wedding dress.

Pots, blankets, baskets, and jewelry were interchangeable as pictorial representations of Pueblo skills—though the last three were not as closely connected to archaeological activities as the first. Little survived of the ancient Pueblo textile and basket-making traditions because the objects were less durable, and silversmithing among the Pueblos and the Navajo was a relatively recent craft learned from Spanish blacksmiths in the mid nineteenth century.[27] In each case, the commercial market was perhaps a stronger influence in causing the craft to flourish by the 1920s, returning to southwestern tribes a considerable income.

Lorenzo Hubbell, a trader at Ganado, Arizona, with an eye for Arts and Crafts textiles, upgraded standards of quality and design in Transitional-phase (1880–1910) Navajo blankets to make them more acceptable to tourists and collectors.[28] Hubbell also helped revive interest in earlier, more traditional Navajo textile designs (fig. 72). As Navajo looms became more productive, those of the Pueblos all but stopped—with the exception of Hopi, which continued to produce finely woven, decorative garments (fig. 55). In some cases, commercially supplied material took over; hence Irving Couse's impressive figure of Elk-Foot is wrapped in strouding (fig. 73), a textile imported from England, around which white ribbon has been sewn. By the 1920s, more elaborate commercial blankets were available, but Indians continued to produce traditional designs, especially the standard Pueblo striped blankets (fig. 74), which had been in use throughout the nineteenth century. Wedge-weave patterns (fig. 75), made from aniline-dyed yarns at the end of

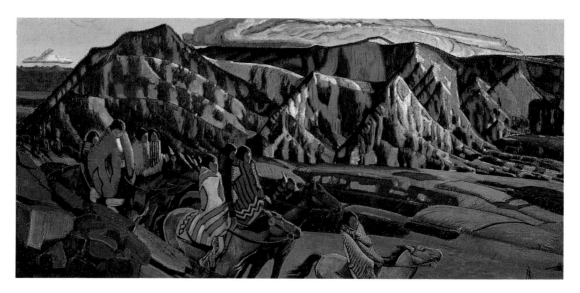

the century, were also popular during the 1920s, at least around the shoulders of Indian models who posed for artists and photographers. The mix is illustrated in Higgins's *Pueblo of Taos* (fig. 89), in which a variety of traditional and commercial blankets appear, some rendered with fidelity, others drawn from the artist's imagination.

Henri's *Ricardo* (fig. 76) exploits the potential of a boldly patterned blanket in an even more forceful way, repeating the motifs in the planar structure of the subject's face and in the angle of the forelock that falls across his left eyebrow. *Indians in the Mountains* by Blumenschein (fig. 77) also focuses on the design of Indian blankets, which is echoed in the snow-filled

78. *Anonymous, Hopi, Coiled Basketry Tray, early 20th century, yucca and aniline dyes, 20¼ in. diameter. National Museum of Natural History, Smithsonian Institution, Washington, D.C., The Victor Justice Evans Collection*

79. *Anonymous, Jicarilla Apache, Basketry Bowl, ca. 1920, split sumac and aniline dye, 8 x 20 in. Millicent Rogers Museum, Taos*

80. *Anonymous, Papago, Basketry Bowl, before 1884, yucca and martynia ("devil's claw") seed-pod skin, 7¾ x 18½ in. National Museum of Natural History, Smithsonian Institution, Washington, D.C.*

crevasses of the range beyond. One is hard put to say whether art is imitating nature or vice versa, so close is the parallel, so implicit the connection between the two. Higgins goes one step further in the watercolor version of his *Nude Study* (fig. 57). Here the pattern of the blanket is even more central to the design of the painting, its angular, expressive quality dominating the entire image. Few paintings of the period better illustrate the desire of Anglo artists to incorporate the vitality of Indian design into their work. Yet the germ of Higgins's conception must be noted in paintings like Couse's *Pottery Decorator* (fig. 71), in which the imagery was first introduced. Couse may have been more intrigued by the exotic aspect of Indian life, Higgins by the abstract potential of Indian design, but each responded with images that document the spell cast by the revival of Indian arts.

The tourist trade contributed as well to the increased demand for Indian baskets and jewelry, although baskets had become rare among Pueblo villages. The Hopi still produced striking, geometric trays (fig. 78), but the utility baskets seen in Oscar Berninghaus's *Peace and Plenty* (fig. 90) and Phillips's *Our Washerwoman's Family* (fig. 135) were probably acquired through trade with the Apache (fig. 79) and the Papago (fig. 80). As basket making and textile weaving declined among the Pueblo tribes, native craftsmen turned their attention to jewelry. Laguna, Acoma, and Zuni were particularly active in establishing jewelry-making techniques, although the Navajo were the most accomplished silversmiths among the southwestern tribes. The Indians themselves attached great importance to the ownership of jewelry, especially after the 1890s, when silver and turquoise pieces were worn as an indication of status and wealth. From about 1880 to 1910, simple, well-crafted pieces (fig. 81) were as likely to be made for other Indians as for tourists. After that time, the tourist market expanded, chiefly through the influence of Fred Harvey Company agent Herman Schweizer, who commissioned lighter, more decorative jewelry from the Navajo (fig. 82).

81. Anonymous, Navajo, Bracelets, left: ca. 1900, silver, 2⅜ x 1 in., National Museum of Natural History, The Victor Justice Evans Collections; right: before 1890, silver, 2¾ x ⅜ in., National Museum of Natural History, Smithsonian Institution, Washington, D.C.

82. Anonymous, Navajo, Bracelets, left: ca. 1930, silver and turquoise, 2¾ x ½ in.; right: ca. 1920, silver and turquoise, 2½ x ½ in. National Museum of Natural History, Smithsonian Institution, Washington, D.C., Gifts of Dr. Lucinda de Leftwich Templin

83. Walter Ufer, Daughter of San Juan Pueblo, 1914, oil on canvas, 30 x 25 in. Private collection

84. Anonymous, Navajo, Squash-Blossom Necklace, ca. 1910, silver on cotton cord, 26 in. long. National Museum of Natural History, Smithsonian Institution, Washington, D.C., The Victor Justice Evans Collection

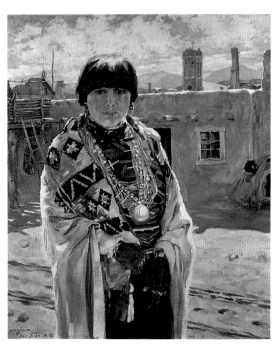

By the 1920s, the use and appreciation of jewelry was widespread in the Taos and Santa Fe colonies: Mabel Dodge Luhan never appeared without it; John Marin took some home to New York, where he thought it looked a bit out of place; Witter Bynner, the poet-aesthete of Santa Fe, amassed a superb collection, which he eventually donated to the Museum of New Mexico; and Walter Ufer painted *A Daughter of San Juan Pueblo* (fig. 83), showing off a handsome Pueblo necklace, modeled after those made by the Navajo (fig. 84).

The role of commerce in promoting Indian arts and crafts also brought the public into closer contact with Pueblo life. Access was provided not only by dealers, but increasingly by carefully orchestrated tours to Indian villages and archaeological sites in all corners of New Mexico and Arizona. The railroads had brought a good many tourists to the Southwest before 1920, but travel to more remote locations was difficult until the advent of motor coaches and large touring cars, which, again under the auspices of the Fred Harvey Company, came into service in 1926. Operated from railway depots, these followed prescribed circuits that offered idyllic views of Indian and Hispanic life. Harvey guides emphasized many of the same themes that simultaneously appeared in the work of the Anglo painters. A sampling of these is found in a brochure issued by the company in 1928:

New Mexico's mystifying ruins were left by the oldest races of America. Her changeless inhabited Indian pueblos were rooted in antiquity before Columbus sailed. Her picturesque adobe villages have been built by the descendants of the Spanish Conquistadores who fought their way northward from Old Mexico nearly four centuries ago. Many of her quaint Mission churches antedate those of California by 150 years. Here history is the thrilling, little-told record of a remote and endless frontier. . . .

Where to go and what to do when there are the two problems. First, it is usually worth while to visit every Indian village. Even if no dance is in progress other things will repay the time. Potters and basketmakers and workers in turquoise are interesting to see. It is worth while, too, just to make friends with a shy, proud people in their homes. . . . Motorists crossing the

southwestern states are nearer to the primitive than anywhere else on the continent.[29]

By the late 1920s, the market for Indian crafts was flourishing. Tourism accounted for much of its growth, but a decade earlier, as previously mentioned, Anglo activists in the Taos and Santa Fe colonies had helped to create the demand. Artists in particular had played a major role; paintings of Indian subjects by members of the Taos Society of Artists had been sent on national tours,[30] exhibitions of Indian crafts had been encouraged and in some cases sponsored, and outstanding personal and institutional collections had been assembled. Moreover, artists had aided local sales, Andrew Dasburg in particular. In 1926 he established a trading company that, over the next few years, became so prosperous it provided him more income than the sale of his paintings.

The success of these ventures led in two directions. By 1931 Indian art had gained sufficient national status to warrant a major exhibition in New York at Grand Central Galleries. John Sloan served as president of the sponsoring organization, called the Exposition of Indian Tribal Arts, and the major contributors, both of objects and of funds, were Amelia and Martha White of Santa Fe. Southwestern objects outnumbered those from elsewhere in the country (Plains, Northwest Coast, Alaska, New York, and Ohio) by a significant margin. Sloan and anthropologist-author Oliver La Farge wrote the introduction to the catalogue, which began with the statement, "The American Indian race possesses an innate talent in the fine and applied arts," went on to stress that the Indian artist deserved to be classed as a "Modernist" because "his art is old, yet

85. John Sloan, Indian
Detour, *1927, etching on
paper, 6 x 7 in. Kraushaar
Galleries, New York*

alive and dynamic,'' and concluded with the
observation: "The Exposition . . . is expected
to give thousands of white Americans their
first chance to see really fine Indian work
exhibited as art."[31]

Much credit must go to Sloan and
La Farge for recognizing the intrinsic merit
of Indian art. Their desire to display it out of
context—that is, removed from the didactic
surroundings in which it was exhibited at
the turn of the century—was indeed a major
advance. It represented the culmination of
a campaign begun in the 1880s to revise
public attitudes toward Indian art. Although
anthropologists had sparked the campaign,
the two generations of Anglo painters in
New Mexico were a greater factor in its

success. They bestowed upon Pueblo life an
artistic significance that gave independent
status to skillfully crafted domestic objects.

Unhappily, the success of the revival had
a darker side. The Southwest, and Santa Fe
in particular, had become such a tourist
Mecca by the mid twenties (fig. 85) that two
problems arose: the strength of the market
encouraged hasty workmanship and poor
design, and the area was being emptied of
vintage Indian objects at an alarming rate. In
response, patrons and artists of Taos and
Santa Fe created the Indian Arts Fund, an
organization dedicated to preserving the
ancient and modern heritage of the Pueblo
tribes. The list of founding members reads
like a *Who's Who* of both colonies: Frank
Applegate, Mary Austin, Kenneth
Chapman, Andrew Dasburg, Mabel Dodge,
B. J. O. Nordfeldt, Amelia White, and a
number of prominent archaeologists, all of
whom were or had been involved in
southwestern sites. As contributions
increased, one superb object after another
entered the collection, bringing added
recognition and new problems. More space
was needed and more tact. As one founder
remarked: "To dictate to an Indian how and
what he should make, even when couched
in the best educational vocabulary, was nigh
on the verge of tyranny."[32] To remedy the
situation, the Laboratory of Anthropology
was constructed in 1931 as a storage and
teaching institution, where Indians, artists,
and the public could gain further inspiration
from an ancient tradition. Eventually the
Indian Arts Fund merged with the School of
American Research, which by then had
reclaimed treasures from the Museum of
New Mexico. The combined collections, the
most impressive array of southwestern
Indian art in existence, are conclusive

86. *George de Forest Brush,*
The Indian and the Lily,
*1887, oil on canvas, 21¼ x
19⅞ in. Private collection*

evidence of the impact of Indian art on Anglo artists in New Mexico, and of the artists' role in fostering its revival and preservation.

Among the first generation of artists who came to Taos, Couse and Phillips, who overlapped as students at the Académie Julian in Paris (1895–96), borrowed most heavily from traditional sources: French academic masters and images of Plains Indians. Couse's heroic portrait of Elk-Foot (fig. 73) shows both influences: the pose is studied, the modeling is firm, and the robe and leggings are worn with an exotic flair more characteristic of a studio than a reservation; the size of the image and Elk-Foot's dignified bearing are variations on Indian stereotypes by George de Forest Brush (fig. 86) and Hermon Atkins MacNeil (fig. 19; discussed in chapter 1). Yet the portrait also reveals Couse reacting to his environment: his palette is stronger and

more dependent on contrasts than those of his predecessors, and his brushwork flexes perceptibly, in response to the intense light and color of the Southwest. In Couse's *Pottery Decorator* (fig. 71), these trends are carried even further, while the subject recalls an additional influence on the first generation: photographs taken at the turn of the century by members of the Pasadena Eight (fig. 30).

The image of Elk-Foot has much in common with Phillips's *Relics of His Ancestors* (fig. 70), painted somewhat later but composed from similar sources. Phillips modeled with the same care as Couse, but used a more subdued palette to suggest the atmosphere of the cave interiors in which such archaeological activities were taking place. *Song of the Aspen* (fig. 53), a later work by Phillips, is essentially an Arcadian conceit. The Indian, set in profile against a brilliantly colored grove of aspen, is a descendant of the ubiquitous flute players who inhabited the forest of Fontainebleau and other idyllic nineteenth-century woodlands. Like Couse, Phillips responded to the environment of Taos by loosening his brushwork and adopting a more vibrant range of color, but his images retain the ideal overtones of Plains Indian legend, tastefully adjusted to local scenery.

Walter Ufer's major claim may be that he broke this tradition, casting a more objective eye on the Taos scene when he arrived from Chicago in 1914. His patron, former Mayor Carter Harrison of Chicago, had advised him that "abundant artistic material could be found in painting Indians as they are today—plowing with their scrubby Indian ponies, digging in the fields, on horseback, and lying around the pueblo.

87. Joseph Henry Sharp,
Sunset Dance—Ceremony
to the Evening Sun, 1924,
oil on canvas, 25 x 30 in. The
Arvin Gottlieb Collection

88. Walter Ufer, The Bakers,
1917, oil on canvas, 50¼
x 50¼ in. Mr. and Mrs. L. D.
Johnson

This phase of Indian life has not yet received artistic treatment. The hunting with bows and arrows, stalking game in the costumes of the past, etc., has been done to death by talented men."[33] Ufer seems to have taken the advice to heart (it was an idea already implicit in photographs of the Southwest), and he concentrated on subjects like *Callers* (fig. 58), which afforded a more up-to-date version of Pueblo life. His vision did not, perhaps, penetrate far beneath dazzling surfaces, but his ability to recreate the strong patterns and colors of southwestern light brought him considerable prominence during the 1920s.

In turn, Ufer probably influenced older colleagues to venture forth more often from their studios. Sharp's *Sunset Dance* (fig. 87) is pervaded by a soft evening light that achieves a measure of unity in the composition, spiritual as well as formal. By this time, Sharp's eye was much more alert to outdoor effects. One senses in the subject, however, a grander purpose: church and pueblo are joined under the looming shadow of Taos Mountain, suggesting that the embrace of nature would bring the two into harmony. Once more the scene reveals much about the artist but little about Pueblo religion; it is simply an Anglo's attempt to reconstitute Indian life according to his own religious beliefs. Sharp, who refused to paint the beggars he had seen at Taos Pueblo, also refused to believe that Indians could achieve a state of grace without the aid of Christianity. His view was undoubtedly shared by other members of the Taos colony.

The formula used in *Sunset Dance*—presenting the Indian in an architectural setting enframed by the surrounding landscape—reappears in Ufer's *Bakers*

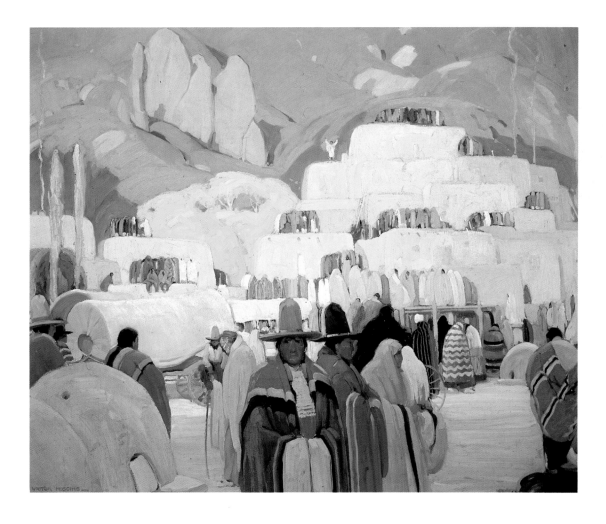

(fig. 88) and Victor Higgins's *Pueblo of Taos*
(fig. 89). In *Bakers*, five Indian women
wearing brightly colored capes across their
shoulders are variously posed before large
ovens, the shapes of which echo the
geometry of the pueblo (Laguna) beyond.
Embracing the scene is a broad expanse of
sky, from which falls a strong light that
seems to bless and clarify the simple
domestic activity below. Higgins resorts to a
stylized geometry to achieve a similar effect.
On the terraces of the legendary Taos Pueblo
(somewhat altered for artistic convenience),
figures in colorful native blankets are
gathered in groups that correspond to the
architecture, which is in turn modeled on
the shape of Taos Mountain in the
background. A sense of order and harmony
prevails, based on the geometric progression
toward the enduring natural formation that
secures the composition. No image could
more effectively demonstrate the view of
Pueblo life held by the Anglo painters.

Oscar Berninghaus, another pioneer of
the Taos colony, shared the same attitudes
as Couse, Phillips, and Sharp, but his style
was flatter and more decorative than that
of his Paris-trained colleagues. *Peace and*

90. Oscar E. Berninghaus,
Peace and Plenty, 1925, oil
on canvas, 35 x 39½ in. The
Saint Louis Art Museum,
Saint Louis

91. Oscar E. Berninghaus, An
Indian Farmer, ca. 1925,
oil on canvas, 35 x 40 in.
Private collection

92. E. Martin Hennings,
Passing By, 1924, oil on
canvas, 44 x 49 in. The
Museum of Fine Arts,
Houston, Gift of the Ranger
Fund, National Academy of
Design

Plenty (fig. 90) represents a whole genre of Indian harvests, which can be broadened to include farming (fig. 91) and hunting scenes. These essentially stress the Pueblo's easy access to nature and his dedication to a peaceful, primarily agricultural existence—thus distinguishing him from his Plains neighbors. The symbolism of *Peace and Plenty* is readily apparent: the bow, quiver, and war bonnet, probably belonging to the old man, hang unused on the wall, while the young woman admires the corn, a staple of Indian life, in the beautifully woven Apache basket. Pumpkins and squash in the background add to the sense of abundance, which, we are reminded by the crucifix

above the woman's head, is the direct benefit of a peaceful Christian attitude. The elliptical form of the composition, set in motion by the downward slant of the bow and quiver, ties together these separate symbols, as if they were part of some inevitable sacred system, destined to remain unchanged.

The relationship between the Indian and nature was explored in even more subtle ways, as seen in Martin Hennings's *Passing By* (fig. 92) and Blumenschein's *Indians in the Mountains* (fig. 77). Hennings had also trained abroad, but was never as dedicated an academic as Sharp, Couse, or Phillips. He painted landscapes as often as figures, and his style, as it developed, was linear and flat, uniquely suited to his specialty of blending figures with patterns of foliage (which again may be indebted to photographic precedents; see fig. 31). *Passing By* features a giant cottonwood whose branches and leaves resemble the configurations of an oriental tapestry. The refined atmosphere quietly envelops the blanket-clad figures in the foreground; horses and riders proceed across the scene with an almost dreamlike detachment, so much is their mood in sympathy with their surroundings. A similar concept is evident in *Indians in the Mountains*. The bold patterns of native blankets worn by the riders in the foreground reappear in the stylized contours of the landscape and the cloud formations above.

Blumenschein was perhaps the most versatile painter among the first generation in Taos, although his academic instruction had not differed greatly from that of his colleagues. He went back to New York more often, however, and maintained a relatively open mind about new trends from Europe.

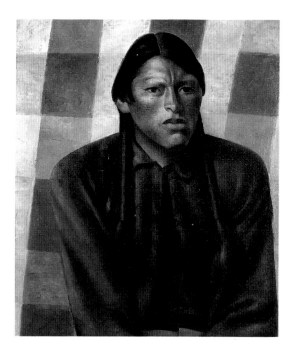

If he never lost his representational style, it became modified during the twenties and thirties; narrative gave way to bolder, more aggressive compositions, the design of which often carried a message more basic than the painting's immediate content. Blumenschein's progressive phase represents a natural link between the two generations of New Mexican painters, who clung to the same ideals and subjects but used increasingly less narrative to probe the art and life of Pueblo Indians. What the first generation considered a breath-taking view of an ancient world, the next read as a powerful new index of design. They came to the Southwest free of academic scruples, ready to bow to principles they thought to be at the very basis of modernism or at least running on a course parallel with it.

The new approach of the second generation took over quickly, noticeably affecting the style of first-generation painters like Higgins. But even the modernists remained to some extent dependent upon the iconography established by photographers at the turn of the century (fig. 32). Robert Henri, who was invited to occupy space in the Palace of the Governors in 1916, planted the seeds of change when he brought with him from his Ash Can days the progressive style seen in such broadly brushed portraits as *Ricardo* (fig. 76). The distance between *Ricardo* and *Bonnie Concha* (fig. 93) by Andrew Dasburg, whose "liberated" Cubism reordered the New Mexican landscape for many younger painters, is marked by Dasburg's concern with formal structure. The geometric patterns of the southwestern blanket reinforce the background of the composition, against which the monumental form of the sitter takes on the image of a primitive icon. Yet the myth still operates; Bonnie's steady gaze can be read as the equivalent of Dasburg's statement: "Perhaps it is [the Indians'] great poise that gives them a quality of superiority over the white man, who so rarely has any whatsoever."[34] In Higgins's *Nude Study* (fig. 57), clearly indebted to the work of earlier photographers, the spirit of the dark-skinned model is evoked by the brilliant blanket patterns that surround her in the form of a primitive halo.

While the distinction between the two generations could be broadly defined, individual artists were more difficult to categorize. Some followed the academic figure tradition well into the thirties, but Paul Burlin and Jan Matulka had painted subjects more abstract than Higgins's *Nude Study* at least twenty years earlier. The overlap is most clearly evident in Indian dance scenes. Of all the new experiences

encountered by incoming artists, Indian dances were the most compelling, the subject most frequently mentioned and painted. With religious ritual such an intrinsic part of Pueblo life, dances occurred at regular intervals throughout the year, in celebrations closely tied to the cycles of nature. Agricultural themes predominated in summer ceremonies, hunting activities during the winter.

Taking their lead from anthropologists, the Anglo painters believed that the color and rhythm of Indian dances incorporated the essential mysteries that wedded Indians to their natural surroundings. From this relationship came an instinctive understanding of beauty, the most direct and open expression of which was manifested in ceremony. "For [the Pueblos] art *is* life, an intensified form of it," wrote Alice Corbin Henderson.[35] After witnessing a Tesuque Buffalo Dance, Marsden Hartley agreed: "It is the incomparable understanding of their own inventive rhythms that inspire and impress you as spectator. . . . They know, as perfect artists would know, the essential value of the materials at their disposal, and the eye for harmonic relationships is as keen as the impeccable gift for rhythm which is theirs."[36]

No consistent approach is discernible in the paintings of dance scenes, only a desire to capture pictorially their mysterious, aesthetic content. The first group, in which representational fidelity predominates, comprises works by Gerald Cassidy, John Sloan, B. J. O. Nordfeldt, Ernest Blumenschein, and Norman Chamberlain. Cassidy's *Buffalo Dancers* (fig. 94) is reminiscent of the more academic approach taken by Sharp and Couse, although he

displays a vitality of line and color clearly in advance of his colleagues. The dancing figure is almost surely taken from earlier photographs (fig. 95), the source, or at least the inspiration, for a number of these works. Sloan's lively *Ancestral Spirits* (fig. 96) employs macabre little figures, animated gestures, and direct brushwork to suggest the emotional impact of the scene, while Nordfeldt's *Antelope Dance* (fig. 97), a Cézanne-like interpretation of the ritual, emphasizes a heavy, more powerful rhythm, concentrated in the repetition of shapes and alternating tones of the figures. Trees arch above the dancers to suggest an almost natural shrine for the ceremony. In *Dance at Taos* (fig. 98), Blumenschein has assumed a higher viewpoint, as if he were a spectator seated on the walls of the pueblo; the angle is again reminiscent of turn-of-the-century photographs (fig. 99). Long, sinuous lines, composed of dancers moving in unison toward the viewer, express the color and vitality of the ceremony.

During the fall of 1930, Emil Bisttram spent several months with Diego Rivera in Mexico City. *Hopi Snake Dance* (fig. 100), painted several years later, combines the monumental style of Mexican murals with the brutal gestures and expressions of archaic ritual. Hot, dark colors, contrasting with pink headdresses, and the abrupt alternation of tones give the image an added strangeness—a reflection, no doubt, of how gruesome the spectacle appeared to Anglo visitors. From the 1890s on, the Snake Dance was the most frequently described and photographed Indian ceremony in the Southwest and was regarded by many as "the most complete survival of the olden days to be found among American Indians."[37] Norman Chamberlain's *Corn Dance*

94. *Gerald Cassidy,* The
Buffalo Dancer, *before 1922,*
oil on canvas, 57 x 47 in.
The Anschutz Collection

95. *Herbert F. Robinson,*
Corn Dance, Santa Clara
Pueblo, *ca. 1915, modern*
silver print from an original
negative in the collection of the
Museum of New Mexico,
Santa Fe. University Art
Museum, University of New
Mexico, Albuquerque

96. John Sloan, Ancestral
Spirits, *1919, oil on canvas,
24 x 20 in. Museum of Fine
Arts, Museum of New Mexico,
Santa Fe*

97. B. J. O. Nordfeldt,
Antelope Dance, *1919, oil on
canvas, 35⅝ x 43 in. Museum
of Fine Arts, Museum of New
Mexico, Santa Fe*

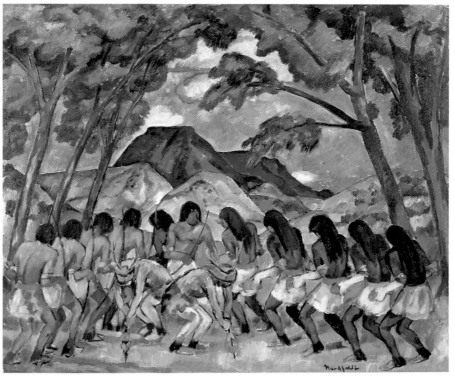

98. *Ernest L. Blumenschein,*
Dance at Taos, *1923, oil on*
canvas, *24 x 27 in. Museum of*
Fine Arts, Museum of New
Mexico, Santa Fe

99. *Adam Clark Vroman,*
Hopi Towns, The Niman
Dance, Shungopavi, *1901,*
modern print from original
negative, 7⅛ x 9½ in. Adam
Clark Vroman Collection,
Seaver Center, Natural
History Museum of Los
Angeles County

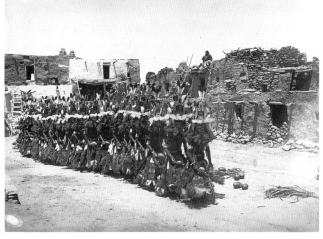

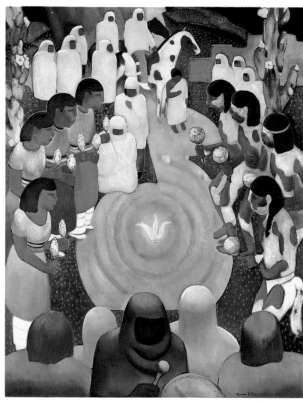

100. Emil J. Bisttram, Hopi Snake Dance, 1933, oil on canvas, 41 x 45 in. Museum of Fine Arts, Museum of New Mexico, Santa Fe

101. Norman Chamberlain, Corn Dance, Taos Pueblo, 1934, oil on canvas, 50¼ x 40¼ in. National Museum of American Art, Smithsonian Institution, Washington, D.C., Transfer from the U.S. Department of Labor

(fig. 101), in contrast, takes on the character of a folk ceremony, in which innocent maidens face their spotted partners in a ritual as naive as the Snake Dance is menacing. Chamberlain's stint as a New Deal mural painter no doubt developed his interest in decorative shapes and colors, the most striking feature of this composition.

The second group of dance scenes reflects a more abstract interpretation of the elements in the ceremony, even though the works were executed in almost the same period. Jan Matulka's brief interlude in the Southwest produced *Indian Dancers* (fig. 102), a composition of angular shapes and colors (somewhat indebted to Synchromism) that offers a dynamic interpretation of performances he witnessed.

John Marin was intrigued by the Corn Dance at Santo Domingo. "Certain passages in the dance itself," he wrote to Alfred Stieglitz, "are so beautiful that to produce something having seen it—becomes well nigh worthless—it's like grafting on to perfection—it's like rewriting Bach."[38] Marin's composition has the appearance of glass shattered along diagonal lines by sound waves emanating from the small, circular drum at center right (fig. 103). Dancing figures are broken up into facets of color, suggestive of the rhythm and movement of the ceremony. Behind the figures are the more stable forms of the pueblo, and along the sides and bottom of the composition are motifs reminiscent of Indian designs. Once again, the image

102. *Jan Matulka*, Indian
Dancers, *ca. 1918, oil on
canvas, 26 x 16 in. The
Anschutz Collection*

appears to be a blend of direct observation
and photographic prototypes (fig. 104).

 Gustave Baumann's *Winter Ceremony—
Deer Dance* (fig. 105) features small dancing
figures taken from Frijoles Canyon murals,
moving to and fro across a flat, heavily
textured landscape. Figures, patterns, and
space are combined with almost magical
effect, less insistent on rhythm than on the
fantasy element of Indian ceremony.
Bisttram's untitled watercolor of Koshares
(fig. 106), the striped Indian jesters present
at many seasonal dances, was painted in
1933, the same year as his *Hopi Snake Dance*
(fig. 100). Unlike the latter, the watercolor is
a gay, brilliant design that takes apart and
reassembles the striped figures with a wit
and spirit evocative of their ceremonial role
(fig. 107). *Koshari—San Domingo Corn Dance*
(fig. 108), by Howard Cook, provides
another look at these same dance jesters.
Cook was a muralist and printmaker who
had taken up easel painting only a few years
earlier. The monumental figures and
contrasting patterns reflect that heritage, but
the circular composition is charged with an
energy much indebted to kinetic brushwork.
Koshari already reflects an expressionist
mode just then gathering force in New York.

Indian life in the Southwest continued to
be a source of inspiration for artists after
the conclusion of World War II, but the "art
of Pueblo life" was no longer a theme that
could be so easily grasped. Attitudes that
had sustained the Taos and Santa Fe art
colonists during the twenties and thirties
were difficult to recover in an increasingly
international world, the more unpleasant
features of which were no longer symbolized
by urban life but by the Cold War
technology being developed at Los Alamos,

103. John Marin, Dance of
the Santo Domingo Indians,
*1929, watercolor and charcoal
on paper, 22 x 30¾ in. The
Metropolitan Museum of Art,
New York, The Alfred Stieglitz
Collection*

104. Adam Clark Vroman,
Rain Dance with Clowns,
*1899, chlorobromide print by
William Webb from original
negative, 1972. University Art
Museum, University of New
Mexico, Albuquerque, Gift of
William Webb*

105. *Gustave Baumann,*
Winter Ceremony, Deer
Dance, 1922, oil on panel,
30½ x 52⅝ in. Museum of
Fine Arts, Museum of New
Mexico, Santa Fe

106. *Emil J. Bisttram,*
Koshares, 1933, watercolor on
paper, 22½ x 16¾ in.
Museum of Fine Arts, Museum
of New Mexico, Santa Fe

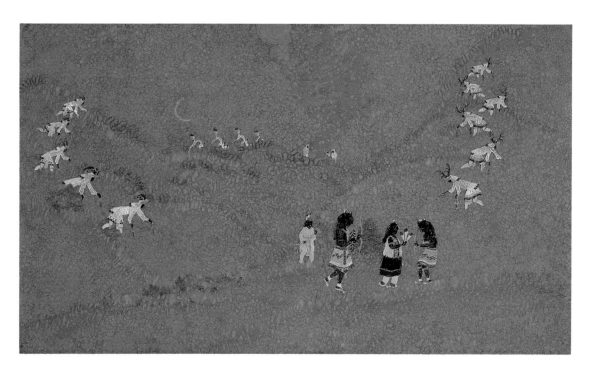

107. T. Harmon Parkhurst, Four K'ohsa Clowns, ca. 1935. Museum of New Mexico, Santa Fe

108. Howard Cook, Koshari—San Domingo Corn Dance, 1948, oil on canvas, 30 x 40 in. The Anschutz Collection

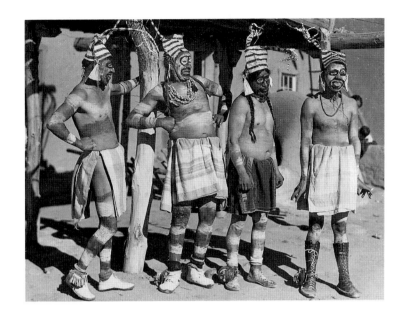

less than one hundred miles from the view that had induced Blumenschein's conversion fifty years earlier. Painting styles that reflected international tensions were not those with which one could summon forth an idyllic environment. Nor were the themes and perspectives that guided an earlier generation of artists necessarily those that would attract the next. By the 1950s, the focus had gone, replaced by a variety of subjects and styles that were less immediately linked to the local environment. For a determined few, the "art of Pueblo life" may still remain, high up on Taos Mountain, in the annual ceremonies performed beside Blue Lake, but the rest must seek it in the paintings and writings of the pre–World War II era, and in the collections those artists had the vision to build.

Notes

1. Lawrence, *Phoenix: The Posthumous Papers of D. H. Lawrence*, p. 147; Lawrence to Thomas Seltzer, 13 December 1923, D. H. Lawrence Collection.

2. Parsons, *Pueblo Indian Religion*, p. xi.

3. Fenn, *The Beat of the Drum and the Whoop of the Dance*, pp. 68, 70.

4. J. J. Brody, in particular, notes how limited was the view of Anglo painters. "Among the Santa Fe artists were Sloan, George Bellows, and Robert Henri, all of whom had dealt effectively with socially significant urban subjects. None attempted to search out the tensions, poverty, or any other theme that could have made Indian subject matter more than just an exotic attraction" (*Indian Painters and White Patrons*, p. 91).

5. Frost, "The Romantic Inflation of Pueblo Culture," p. 59. Despite their "selective" and "heightened" view of Indian life, Frost notes that the Anglo reformers in Taos and Santa Fe did accomplish much on behalf of the Pueblo tribes, including the defeat of the Bursum bill in 1922 and subsequent changes in policies governing Indian education. The artists' involvement in these activities is yet another unwritten chapter in the history of the two colonies. See Austin, *Earth Horizon*, pp. 360–62; Merriam, *The Problem of Indian Administration*; Philp, "Albert B. Fall and the Protest from the Pueblos," pp. 237–54; Brody, *Indian Painters and White Patrons*, pp. 47–83; Szasz, *Education and the American Indian*, pp. 60–80; Weigle and Fiore, *Santa Fe and Taos: The Writer's Era*, pp. 19–20.

6. Bandelier and Hewett, *Indians of the Rio Grande Valley*, p. 14.

7. Curtis, "The Pueblo Singer," pp. 400–401.

8. Oliver La Farge provides one of the best insights into the phenomenon. On the basis of his own experience in the Southwest, and that of numerous colleagues, he writes: "There are some people, such as traders and government officials, whose acquaintance with Indians and resultant fondness for them is solidly founded on the realities of life. Most of the rest of us, scientists (it's highly noticeable in them), serious amateurs, and the broad group that is known in the West as 'yearners,' are escapists. . . . As one goes deeper in after having succumbed to the initial attraction and the well-established glamour, the appeals to the escapist become ever stronger. As a result Indians are surrounded by a cult with a series of degrees of initiation, elaborated and maintained by people with an instinct for avoiding reality" (*Raw Material*, p. 153).

9. Parsons, *Pueblo Indian Religion*, p. 41.

10. Bickerstaff, *Pioneer Artists of Taos*, p. 31.

11. For Blumenschein's remark, see pp. 49–51.

12. Hartley, "Aesthetic Sincerity," pp. 332–33.

13. "New Mexico Mission Churches," p. 115.

14. Bickerstaff, *Pioneer Artists of Taos*, p. 180.

15. Henri, *The Art Spirit*, p. 148.

16. Bynner, *The Works of Witter Bynner*, p. 134.

17. The discussion that follows in this paragraph is based on Kay A. Reeve, "Pueblos, Poets, and Painters," pp. 12–14.

18. Lawrence, *Phoenix: The Posthumous Papers of D. H. Lawrence*, p. 146.

19. Hartley, "Red Man Ceremonials," p. 7.

20. Hewett, *Ancient Life in the American Southwest*, pp. 27, 160.

21. Hewett, pp. 49, 43–44.

22. Gibson, *The Santa Fe and Taos Colonies*, p. 48.

23. Harlow, *Modern Pueblo Pottery, 1880–1960*, p. 34.

24. Brody, *Indian Painters and White Patrons*, p. 81; Gibson, *The Santa Fe and Taos Colonies*, p. 152.

25. Brody, p. 129.

26. See Bickerstaff, *Pioneer Artists of Taos*, p. 61, for a description of Bert Phillips's studio.

27. Frank, *Indian Silver Jewelry*, p. 19.

28. By 1890 access to aniline dyes and commercially produced blankets caused Navajo weavers to experiment with a wider range of patterns and colors. Techniques and designs developed during this transitional period eventually led to the distinctive regional styles predominant after 1900.

The relationship of Indian design, the Arts and Crafts movement, and the Anglo painters needs further investigation. *The Craftsman*, a major periodical of the Arts and Crafts movement, for example, extolled the "sincerity" of Indian blankets and their "value" as a complement to a *Craftsman* room: "No form of drapery harmonizes quite so well with plain, sturdy forms in woodwork and furniture and with the mellow tones of the natural wood, as do these Indian blankets, for the reason that they are simply another expression of the same idea" (17 [February 1910]:589). Joseph Henry Sharp's cabin at Crow Agency was furnished with Roycroft pieces, and Taos/Santa Fe paintings of this era are often found in southwestern variations of Arts and Crafts frames.

29. Thomas, *The Southwestern Indian Detours*, p. 189.

30. See White, *The Taos Society of Artists*, which gives considerable information on these tours.

31. Sloan and La Farge, *Introduction to American Indian Art*, pp. 13, 15, 61.

32. Amon Carter Museum of Western Art, *Quiet Triumph*, p. 7.

33. Bickerstaff, *Pioneer Artists of Taos*, p. 126.

34. Coke, *Andrew Dasburg*, p. 49.

35. Henderson, "The Dance Rituals of the Pueblo Indians," p. 109.

36. Hartley, "Red Man Ceremonials," p. 10.

37. Garland, *Hamlin Garland's Observations on the American Indian*, p. 103.

38. Marin, *The Selected Writings of John Marin*, p. 134.

Julie Schimmel

The Hispanic Southwest

Artists as diverse in attitude and style as
Ernest L. Blumenschein, Kenneth M.
Adams, William Penhallow Henderson,
B. J. O. Nordfeldt, and Bert Phillips had
particular affinity for Hispanic culture. For
others—including Carlos Vierra, intrigued by
the Catholic missions, Marsden Hartley,
drawn to *santo* figures, and especially
Georgia O'Keeffe, who repeatedly focused
on the cross and church at Ranchos de
Taos—there were specific aspects of
Hispanic culture that commanded attention.
For many more artists, an occasional canvas
suggested at least an awareness of Hispanic
life in New Mexico. Whatever the frequency
or intensity of the images, however, artistic
response to Hispanic culture had a
consistency of viewpoint largely shaped by
prevailing, if sometimes contradictory,
intellectual currents of thought.

With the opening of the Santa Fe Trail in
the early 1820s, the regular arrival of Anglo-
Americans in New Mexico had dramatic

economic and cultural impact on the
indigenous Hispanic people. A once
relatively self-sufficient culture sustained by
a local system of barter, and augmented by
commerce with Mexico, increasingly gave
way to a mercantile system dependent on
the exchange of cash for goods. Traditional
means of keeping food on the table
crumbled as grazing and farm lands were
lost to federal forest reserves and Indian
land claims. Hispanics increasingly found
themselves depending on seasonal work
away from home or competing in hiring
markets where abundant cheap labor
precluded a power to negotiate reasonable
wages.

More significant to Hispanic life, Anglos
assumed the position of the principal culture
in New Mexico and, since they were
enamored of Pueblo customs more than
Hispanic, relegated the numerically and
once culturally dominant Hispanic
population to lowest status among the three

109. *Birge Harrison (1854–1929),* The Oldest Church in America, *from* Harper's Monthly *70 (May 1885):826.*

groups.[1] Anyone describing the attractions of New Mexico automatically included Hispanic culture, as did Walter Ufer when, in an attempt to persuade the El Paso Chamber of Commerce to exhibit the Taos Society of Artists, he wrote that these artists devoted themselves "to Southwestern Indians, Mexican life and the surrounding landscape."[2] However, despite such repeated nods to Spanish-speaking people, artists produced fewer images of this segment of New Mexican life; and although these paintings and prints suggest a response that is as complex in its assumptions and celebrations as that inspired by the Pueblo Indians, it is to journalists, illustrators, tourists, architects, and occasionally archaeologists—not artists—that one turns to discover the earliest popular recognition of Hispanic life in the Southwest.

The Anglo-American discovery of Pueblo Indian culture in New Mexico and southern Colorado dates to the 1870s with the investigations of William Henry Holmes, Adolph Bandelier, and Frank Hamilton Cushing. In the following decade, Hispanic culture began to receive attention, not from the scientific community but from editors of popular publications who sent illustrators and writers to the Southwest on assignment. Some of the first notices appeared in general-interest magazines that customarily included accounts of exotic points of travel, from England to Egypt. Among these travelogues were descriptions of New Mexico, including "Española and Its Environs," which appeared in an 1885 issue of *Harper's*. The artist Birge Harrison wrote and illustrated the article based on a spring interlude with his wife in the small town of Española, just north of Santa Fe. In a manner typical of these travelogues, Harrison enthusiastically referred to the picturesque features of New Mexico, illustrating what he mistakenly identified as the "oldest church in America" at Santa Cruz (fig. 109). His language was quaintly inviting: "Everything here is flashing, scintillating, iridescent with color. Each adobe, each stray figure, frames itself into a brilliant little *genre* picture."[3]

The greatest early booster of the area was Charles F. Lummis, whose expansive interest led him to mix journalism with archaeology, preservation, and history. Living in New Mexico in the late 1880s, Lummis began to write articles and books dedicated to promoting his new surroundings. The first of these was *The Land of Poco Tiempo*, published in part as an article in 1891, then as a book in 1893. While Pueblo culture received his greatest praise, Hispanic culture attracted his attention as a waning phenomenon:

The flat Mexican towns themselves are picturesque—for the ardent sun of the Southwest makes even an adobe beautiful when it can pick it out in violent antithesis of light and shade.

Their people—ragged courtiers, unlettered diplomats—are fast losing their pictorial possibilities. The queue and the knee-breeches, the home-woven poncho, with a hole in the centre whereby the owner may thrust his head through the roof of his combined umbrella and overcoat, are past or passing away.[4]

Waning or not, behind every description written by Lummis and others was an invitation to see New Mexico and its peoples. The construction of the railroad there in the late 1870s and early 1880s made this extension of hospitality feasible. Española itself was a railroad town, built by the Denver and Rio Grande Railroad as its New Mexico terminal. While beyond the tracks many a bumpy road would await the tourists for decades to come, trains marked a

new era for the state. This was a fact New Mexican boosters quickly realized, and promotion of the state as a haven for tourists as well as for health-seekers soon followed. In 1880, the territorial legislature established the Bureau of Immigration to attract settlers, and as early as 1885 W. M. G. Ritch in his *Illustrated New Mexico* could claim that "the antiquity of Santa Fe has a world-wide reputation, which attracts to the city individuals, families, parties, and train loads of excursionists, composed of people in every walk of life, from every portion of both Europe and America. Many victims of consumption and asthma become residents, find relief, and live to a ripe old age."[5]

While numerous images of "The West" had appeared and would appear in popular magazines, the emphasis in a majority of these scenes was either dramatized action or documentary views. The former suggested adventure and daring; the latter, bustling, young communities on the ascent. In contrast to these, illustrations of New Mexico frequently had a sense of stateliness and calm, featuring picturesque scenes. Charles Graham, an illustrator for *Harper's* who produced a number of images of New Mexico in the early 1890s, created one of the most striking scenes in this more reflective mood: a Catholic mission built by the Franciscans at Acoma Pueblo in the seventeenth century (fig. 110). This surely suggested an atmosphere to attract a tourist or a tubercular patient in need of rest to "the land of enchantment," as it was (and is) frequently called. When these early illustrations are compared to the work of the first generation of artists to settle in Taos, many of whom were illustrators, there is—one is somewhat startled to discover—shared emphasis on atmosphere and character rather than on action (fig. 111).

112. San Luis Rey Mission, ca. 1880s. The Denver Public Library, Denver, Western History Department

Once Spain lost hope of discovering cities of gold, Franciscan friars lingered on after conquistadores retired to *encomiendas* in central Mexico (New Spain), and political and spiritual, rather than commercial, values led men to settle the Southwest. Beginning in New Mexico in the early seventeenth century, spreading through south central Texas in the mid eighteenth century, and continuing in California in the late eighteenth century, Catholic missions were built to convert the Indians and politically control the territories. While church interests in the Southwest remained strong during Spanish rule, the independence of Mexico from Spain in 1821 led to the withdrawal of clergymen from Spain and a subsequent weakening of the Church. The American occupation of these lands in 1846 led to the financial withdrawal of the Church from the area and to further decay of the missions. It was not until the early 1850s that the efforts

of Jean Baptiste Lamy, made Bishop of Santa Fe in 1853, reorganized the Catholic church there. However, Lamy's well-intended, but often aesthetically and culturally misguided, renovations of Hispanic missions, much less his patronage of the French-inspired cathedral in Santa Fe, did not always serve Hispanic tradition well.

Focused first on California and then on New Mexico, interest in southwestern missions spread through both local and national audiences. Initially, the concern was to preserve and, in some contested instances, to restore existing missions built by Franciscan priests. However, the spirit of preservation eventually led to the establishment of indigenous contemporary styles that deeply affected architecture in the region.[6]

The preservation movement in California began in earnest with the publication in 1884 of Helen Hunt Jackson's novel *Ramona*, an account of the deterioration of both Spanish and Indian culture in California following the Mexican War. Her call to preservation was answered by the southwestern knight Charles F. Lummis, newly arrived to Los Angeles in 1885, when he became the first city editor of the Los Angeles *Daily Times*, and George Wharton James, editor and prolific author, who would later publish many accounts of California.

Architects, too, were drawn to California's ancient buildings, especially the twenty-one missions built by the Franciscans between 1769 and 1823, including San Luis Rey (fig. 112). Beginning in the 1880s, they developed the California Mission style, a revival architecture based on Spanish prototypes. Some of the first attempts to construct architecture sympathetic to New Mexico's building traditions were in this

113. *Alvarado Hotel,
Albuquerque, ca. 1915.
Museum of New Mexico,
Santa Fe*

mode, but New Mexican historians and preservationists would soon move to develop a style that was truly indigenous to their adopted state.

Unlike its California counterpart, New Mexican architecture—variously called "Santa Fe," "Spanish-Pueblo," or "Spanish-American" style—drew its character from Indian as well as Hispanic culture. When the Spanish in New Mexico began to build missions in the early seventeenth century, the Indians were already familiar with a kind of adobe architecture; but the Spanish introduced metal tools, the adobe brick and use of brick mold, and, most significantly, a different sense of architectural proportion and form. The Franciscans constructed vertical walls that eliminated the Pueblos' stacked, setback stories; and the spaciousness of traditional, lofty naves was different from the intimate, low-ceilinged rooms typical of the Pueblos' architecture. From the latter came the broken silhouette, contrasting planes, and bold but irregular massing of the house blocks; from the missions, the simple, dramatic sculptural shape required by Catholic liturgy and

Spanish traditions. Almost bare of detail or windows, both Pueblo house blocks and Spanish missions had rough surfaces, rounded corners, and massive walls that supported hand-hewn timbers, or *vigas*, on which flat roofs rested. Essentially of post-and-lintel construction, buildings were rectangular in design with few arches and no domes. Other elements contributed by the Spanish tradition included *portales* (colonnaded porches), *espadañas* (bell walls), hung doors with hardware, enclosed *patios*, and wrought-iron work.

In contrast to California, the impetus to develop an indigenous architectural style in New Mexico came not just from preservationists and historians, but also from commercial entrepreneurs with an eye to the profits of tourism. Fred Harvey's well-known restaurants and hotels, the Santa Fe Railway (with which Harvey worked hand in hand), and the Santa Fe Chamber of Commerce, incorporated in 1914, worked in a like-mannered spirit to develop New Mexico as a tourist attraction.

Harvey representatives collected Spanish and Hispanic materials in Mexico and southern New Mexico, although the results of their buying trips formed only a minor part of the company's fine-arts collection, which was predominantly Indian artifacts.[7] In contrast, mission architecture attracted more substantial interest among those responsible for Harvey expansion. The first notable examples of contemporary architecture based on Spanish traditions were two Harvey hotels built between 1901 and 1910, the El Ortiz in Lamy and the Alvarado in Albuquerque (fig. 113). While the architectural vocabulary was California Mission style, frequently viewed as alien by devotees of the New Mexican Spanish-

Pueblo style, it was sympathetic to southwestern culture and an alternative to the Victorian, Romanesque, and Beaux-Arts styles then popular in the East and imported to the Southwest.

The first consistent effort to create buildings that drew on Pueblo Indian and Hispanic culture was made at the University of New Mexico. The instigator was an Ohio-born geologist, William George Tight, who in 1901 became president of the university. He and Edward B. Cristy, a faculty member and part-time architect, created a master plan for the school, the architectural vocabulary of which was based on Tight's newly acquired enthusiasm for Pueblo architecture but included Hispanic details as well. The first building went up in 1905; three more were built and yet another renovated before Tight's independent, liberal spirit led to his dismissal in 1909. Despite its early appearance, the local Pueblo style did not gain official status at the university until 1927, when the regents finally approved it.[8]

The next major push for Spanish-Pueblo architecture occurred in Santa Fe. Energized by preservationist ideals, the leaders of the movement were Edgar L. Hewett and his associates: Paul A. F. Walter, newspaperman and later associate director and secretary of the Museum of New Mexico and founder of *El Palacio*; Frank Springer, a lawyer and contributor of half the money needed to build the museum; Jesse L. Nusbaum, an archaeologist and director of the remodeling of the Palace of the Governors; and Kenneth M. Chapman, a painter, student of Indian life, and museum staff member.

Hewett was an archaeologist by training and an advocate of New Mexican culture by natural impulse. Although his energies would be centered primarily on Pueblo culture, his view of New Mexico was expansive. He did not see the artist's and the archaeologist's response to the area as essentially different. Both were inspired by the presence of cultures in which all aspects of spiritual and daily life were unified. It was inevitable that Hewett in 1909 became director of both the School of American Archaeology and the Museum of New Mexico, the former a center for scientific activity, the latter a fine-arts museum and, initially, a haven for artists. In this position, he advocated the preservation and restoration of New Mexico's past, particularly its architecture, and in various ways promoted the Santa Fe style.

Through the urging of Hewett and other preservationists, residential and public architecture in Santa Fe began to spurn turn-of-the-century details and return to simpler adobe styles. As one writer observed in a 1922 *House and Garden* article on New Mexican architectural developments, "Building has begun to emerge from that horrid period following the picturesque frontier days; a period when a 'dobe' house was scorned as 'Mexican' and pretentious brick, or later gingerbready bungalows, were admired by affluent and moderately well-to-do alike."[9] The impetus to achieve architectural homogeneity gained strength through both historical societies and building projects. From 1909 to 1913, the Palace of the Governors underwent restoration to obliterate the modern "disfigurements," as Hewett quipped of the building's Victorian embellishments, and return the structure to its assumed original Hispanic style (figs. 114, 115).[10] In 1913 the Society for the Preservation of Spanish Antiquities in New Mexico was founded,

114. *George C. Bennett, Palace of the Governors before restoration, ca. 1881. Museum of New Mexico, Santa Fe*

115. *Palace of the Governors after restoration, ca. 1915. Museum of New Mexico, Santa Fe*

116. *Museum of Fine Arts, 1917. Museum of New Mexico, Santa Fe*

followed around 1922 by the more successful and longer-lived Committee for the Preservation and Restoration of the New Mexico Missions. In 1915 the state's entry in the Panama–California Exposition at San Diego—conceived by historian Ralph E. Twitchell, spearheaded by Hewett, and designed by architects I. H. and W. M. Rapp—was based on the Acoma church and convent. Genesis continued, and, inspired by the New Mexico state building in the Panama–California Exposition, the Museum of Fine Arts in Santa Fe was inaugurated in 1917 (fig. 116). Following the successful housing of the School of American Archaeology in the renovated Palace of the Governors and anticipating the new museum, Hewett wrote of the historical prototypes he treasured for growing Santa Fe:

The earlier plans of the School contemplated the preservation of all ancient landmarks of the Southwest and especially a revival of the early Spanish architecture. The building of the new art museum is an effort to recover and embody in one imperishable example all that was fine in the seventeenth-century missions in New Mexico. There is something in it of old Mexico, something of Spain, something of Italy; but mostly it is of the Rio Grande, and the children of its soil who for ages have been building their habitations and sanctuaries out of the earth from which they were born. [11]

By 1920 the direction of Santa Fe architecture had been established, and it became a point of pride for preservationist and tourist booster alike. Carlos Vierra, whose own home was a landmark of Spanish-Pueblo style and whose paintings of the missions were reproduced in *El Palacio*

and exhibited in the Museum of New Mexico, could write:

We are only at the beginning of the development of this architecture—both the Mission and the Pueblo type, and its combinations and possibilities are fascinating, though it presents some problems. It is of the greatest importance for us to keep it pure in the beginning, to establish its character definitely on sound analysis and adhere to it. Its dignity and beauty will always depend on its native purity and simplicity.[12]

And the Chamber of Commerce could boast:

Santa Fe possesses and is cultivating what no other city in America has—a distinctive type of architecture—known far and wide as the "Santa Fe Type," the features of which are definitely Southwestern Spanish and Mexican colonial, with a touch of the Indian Pueblo, producing delightfully artistic results.[13]

Finally, in the 1920s, the Santa Fe style found its true proselytizer in architect John Gaw Meem, whose many public buildings, churches, and homes spread the style throughout New Mexico. Among other accomplishments, it was Meem who remodeled and enlarged Santa Fe's landmark La Fonda Hotel, commissioned in 1926 by the Harvey organization. Meem also designed many of the buildings that give the University of New Mexico its distinctive Spanish-Pueblo character.

Fortunately (although one suspects rarely), Anglos in New Mexico could view themselves with humor, as writer Erna Fergusson revealed: "Everybody had a pet pueblo, a pet Indian, a pet craft. Pet Indians with pottery, baskets, and weaving to sell were seated by the corner fireplace (copied from the pueblo), plied with tobacco and coffee, asked to sing and tell tales."[14] However, despite an excess of patronizing attitudes, which justly led to criticism of the sometimes heavy-handed Anglo guidance of Indian and Hispanic crafts, it was the Anglo population that largely instigated revivals of local craft traditions after decades of decline. As Pueblo Indian crafts had been revitalized beginning in the 1880s by archaeologists and anthropologists and by traders as well as others profiting from tourism (see chapter 3), so were later generations of artists and writers to affect Hispanic crafts.

Originally, Hispanic crafts in colonial New Mexico grew out of the need to provide Catholic churches and missions, family chapels and homes with both devotional objects and furnishings. Until about 1880, most of the furnishings were imported, with the exception of painted hides; but beginning about 1790, local image makers of New Mexico created the religious icons. Their carved and painted figures were of imposing scale and emotional expressiveness, from cadaverous-skinned, bleeding saviors on black crucifixes to sun-yellow garden settings of Saint Isidore, patron saint of the farmer (figs. 117, 118). In New Mexico, sacred images painted on flat, wood *retablos* or carved in three-dimensional figures called *bultos* were made by a few local artisans whose styles and skills were provincial reflections of the artistic traditions of Renaissance Spain and colonial New Mexico. Among the earliest works to combine European sources and local craftsmanship is a *retablo* of Saint Joseph, carrying a flowering staff and holding the

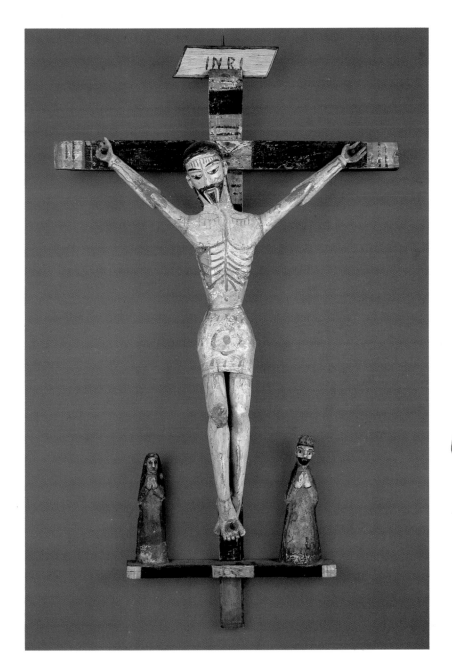

117. *José Benito Ortega,*
Christ with Mourning
Figures, *ca. 1880, paint and
gesso on wood, 36¾ x 22 in.
Millicent Rogers Museum,
Taos*

118. *Arroyo Hondo Carver,*
Saint Isidore, *1830–50, paint
on cottonwood figures and
pine framing, 21 x 16½ x 9
in. The Taylor Museum of
the Colorado Springs Fine Arts
Center, Colorado*

119. *Laguna Santero*, Saint Joseph, *ca. 1796–1808, paint on pine, 16¾ x 11¼ in. The Taylor Museum of the Colorado Springs Fine Arts Center, Colorado*

120. *Anonymous, Northern New Mexican,* Chest, *early 1800s, pine with iron hinges, 28⅜ x 26¾ x 15¾ in. Museum of International Folk Art, Museum of New Mexico, Santa Fe, Gift of the Historical Society of New Mexico*

121. *Anonymous, New Mexican,* Chair, *1880s, pine, 33⅛ x 18⅞ x 15¾ in. Museum of International Folk Art, Museum of New Mexico, Santa Fe, Gift of the Historical Society of New Mexico*

122. *Anonymous, Rio Grande,* Blanket, *ca. 1840, wool, 80¾ x 46⅞ in. Museum of International Folk Art, Museum of New Mexico, Santa Fe, Gift of Miss Florence Dibell Bartlett*

123. *Painting: Anonymous, Mexican,* Saint John of Nepomuk, *oil on canvas, ca. 1820–35. Frame: Anonymous, New Mexican, ca. 1830–50, tinned sheet iron, 28 x 21¾ in. Dr. and Mrs. Ward Alan Minge*

Christ Child, carved by the Laguna Santero, who worked briefly in western New Mexico from 1796 to 1810 (fig. 119). By the mid eighteenth century, itinerant or community-based craftsmen increasingly were the creators of the religious art of New Mexico. As traditions deepened and broadened, the chests, chairs, benches, and tables of woodcarvers, the floor coverings and blankets of weavers, and later the straw-inlaid candle sconces and tin *nichos* came to have a decorative style that was recognizably Hispanic New Mexican: strong but simple design and form, bold color and pattern, and relatively unsophisticated craftsmanship (figs. 120–23).

With the opening of the Santa Fe Trail in 1821, however, factory-made products began to replace handcrafted home furnishings in urban settings, and prints and mass-produced plaster statuary increasingly replaced religious objects even in remote mountain villages. This trend escalated with the occupation of the territory in 1846 by the United States and the arrival of the train around 1880. The Centennial Exposition in Philadelphia in 1876 celebrated industrial America, with its marvels of mechanical invention, but the advance of technology was to have worrisome impact on the availability of individually crafted objects and the value attributed to them. Among both Anglos and Hispanics, the products of industrial America provided status and additional comfort and convenience that local crafts presumably could not offer. And since older New Mexican Hispanic Catholics had primarily viewed *retablos* and *bultos* as devotional pieces, rather than works of art, they were more than satisfied with realistic, commercially manufactured icons imported from Mexico, Europe, and the East Coast.

During the 1920s and 1930s, however, a number of Anglo-Americans, working privately or through nonprofit organizations and state and federal projects, effected a revival of Hispanic crafts in New Mexico. Hispanic artisans had been encouraged earlier in the century by a few collectors and curio-shop owners, who either bought their wares or hired the artisans themselves to work on the premises. But a concentrated effort to preserve and revive Hispanic folk culture began only in the early twenties, with the enthusiasm and politicking of writer Mary Austin and artist-writer Frank Applegate. As Austin optimistically observed, "It takes more than a hundred years to destroy patterns in the blood."[15]

Austin and Applegate discovered Hispanic woodcarving when they visited Lorin W. Brown in Cordova during Lent. Brown, born of Hispanic and Anglo parents, lived in Cordova between 1922 and 1933, moving through the community variously as schoolteacher, deputy game warden, postmaster, and, when he returned from 1936 to 1941, as a materials collector for the Federal Writers' Project. The many who visited him in Cordova not only observed the Holy Week processions and rituals carried out by a lay order of Catholic men, widely called "Penitentes" by missionaries, a term that stuck, but they also met José Dolores Lopez, a woodcarver. Excited by Lopez's traditional images of saints, they encouraged his work, or, more accurately, they attempted to boost his sales by suggesting that he broaden his range of religious subjects, use less color, and make objects popular with Anglos, such as lazy Susans and record racks.[16] A three-part, honey-colored sculpture of Adam and Eve in the garden, the Devil concealed in an

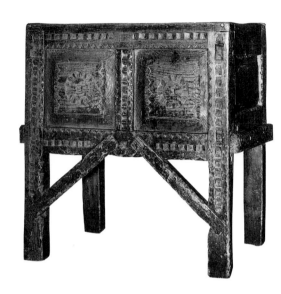

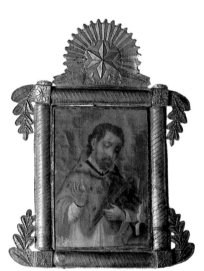

124. *José Dolores Lopez (1868–1938), Adam and Eve in the Garden of Eden, wood, figures 11½ in. tall; tree 21 in. tall. The Taylor Museum of the Colorado Springs Fine Arts Center, Colorado, On permanent loan from the U.S. Government*

intricately carved apple tree, typifies the style and skill Lopez achieved even working within this modified tradition (fig. 124).

Eventually, the growing concern for Hispanic culture led Austin, Applegate, and other Santa Feans to preserve earlier examples of Hispanic crafts, particularly through the creation of the Spanish Colonial Arts Society in 1925. Anglos also encouraged contemporary crafts through various sales outlets: the Spanish Market, held in conjunction with the Santa Fe Fiesta in 1925, and then in 1926 at the Spanish and Indian Trading Post, backed by Witter Bynner, Andrew Dasburg, Walter Mruk, B. J. O. Nordfelt, and John Evans (Mabel Dodge Luhan's son); the Spanish Arts shop (1930–33); and the Native Market, established in 1934.[17]

Between 1933 and 1943, various federal

programs came to the aid of an already strained Hispanic economy made worse by the Depression. Among the programs in New Mexico, Hispanics benefited most from the Works Progress Administration Federal Art Project begun in 1935, a work-relief program. Holger Cahill, a New York-based art critic, historian, and supporter of American folk art, was its national director. Under the local leadership of R. Vernon Hunter and a seven-member state advisory committee, the program promoted Hispanic crafts in a variety of ways.

One man in particular, already part of the New Mexican state bureaucracy by the early thirties, shrewdly manipulated various local, state, and federal funds to the particular advantage of Hispanic people. This was Brice H. Sewell, named Supervisor of Trade and Industrial Education for the State Department of Vocational Education in 1932. By combining resources, he was able to pay Hispanic men to build vocational schools that provided training for adults in a variety of Hispanic crafts, including tanning, carpentry, weaving, and iron and tin work. After training, the school functioned as a community workshop. During their heyday—by 1936 there were twenty-eight vocational centers in eight counties—the schools abetted the passing of skills from trained artisans to novitiates, thus significantly contributing to the revival and marketing of Hispanic crafts.[18]

Hispanic culture was promoted by federal money in other areas as well. The Federal Art Project supported the carving of Patrocinio Barela, among others; and under its auspices, E. Boyd—trained as an artist but later a curator for the Museum of New Mexico, where her work formed the basis for future studies of Hispanic crafts—

researched and wrote the *Portfolio of Spanish Colonial Design in New Mexico*, a collection of watercolors by more than forty artists depicting characteristic folk objects.[19] In a similar federal project, field workers, including Boyd, carried out research for the *Index of American Design*, a nation-wide documentation of folk art made by American people of European origin. As part of this effort, ten New Mexican artists rendered watercolor drawings of various Hispanic crafts, including *bultos, retablos*, painted chests, tinware, weavings, and *colchas* (traditionally, embroidered coverlets).[20]

By the early 1940s, the fate of Hispanic crafts looked less promising. The need for wartime materials changed the focus of the vocational schools, federal programs came to an end, key people had moved on—Frank Applegate and Mary Austin had both died in the early thirties, and Lorin W. Brown left the area in the early forties—the Hispanic craft shops had failed, and the artistic climate that had supported folk-art traditions had changed. Despite diminished attention, however, Hispanic crafts did not die. In 1951 the artist Cady Wells decided to give his collection of *santos* to the Museum of New Mexico with the condition that a separate department be established for Spanish colonial art. He recommended E. Boyd for the job of curator, a position she filled in 1952. Subsequently, she reactivated the Spanish Colonial Arts Society, which in the mid 1960s contributed to the regeneration of the Spanish Market. Since then, new scholars and artisans have again been drawn to the spiritual and visual strength of Hispanic crafts.

Although the history of Hispanic crafts in New Mexico is frequently told as a regional phenomenon, its wavering fortunes in fact parallel the broader history of American folk art. The discovery and appreciation of the latter began in the 1920s with contemporary artists, among them Ralph Laurens, Marsden Hartley, Charles Sheeler, and Elie Nadelman. Quickly dealers, collectors, and museums followed suit, so that between 1924 and 1932, American folk art gained considerable cachet—at least in the East. In 1924 Elie Nadelman opened a museum of folk art on his estate in Riverdale-on-Hudson, New York (subsequently disbanded); that same year the Whitney Studio Club, the inspiration of Gertrude Vanderbilt Whitney, exhibited *Early American Art*; and in 1929 Edith Gregor Halpert began selling folk art at the Downtown Gallery, where in 1931 she opened a separate floor for the American Folk Art Gallery. It was Edith Halpert and Holger Cahill, the director of the WPA Federal Art Project, who were crucial in the formation of Abby Aldrich Rockefeller's collection of American folk art, which began in the late 1920s. When it was exhibited anonymously at the Newark Museum in 1930 and 1931 and then in a landmark show at the Museum of Modern Art in 1932, the Rockefeller collection officially announced the arrival of American folk art. It was as part of this trend, which did not make distinctions among ethnic, primitive, or folk art, that Hispanic crafts were exhibited in *Religious Folk Art of the Southwest* at the Museum of Modern Art in 1934, with the catalogue stating that the exhibition was "an acknowledgement of the growing appreciation of the isolated and remarkably productive folk culture which flourished in the farming communities of New Mexico during the eighteenth and nineteenth centuries."[21]

The magazine articles, newspaper accounts, and catalogues that accompanied many of these exhibitions of American folk art only rarely acknowledged its presence outside of the Northeast and, sometimes, the South. The extraordinarily rich folk traditions of New Mexico, often exhibiting an emotional intensity not characteristic of eastern crafts, received little scrutiny from the East Coast art establishment, although during this same period, from the mid 1920s to the mid 1930s, Hispanic crafts were studied, admired, preserved, and consciously revived by artists and scholars working in the Southwest.

While the East may have failed to acknowledge the Southwest, the two arenas had much in common. Participants in each were to claim that the recognition of folk-art traditions amounted to the retrieval of American history. As Holger Cahill wrote in the catalogue for the 1932 Museum of Modern Art exhibition: "This work gives a living quality to the story of American beginnings in the arts, and is a chapter, intimate and quaint, in the social history of this country."[22] Also, both easterner and westerner noted that craft traditions had been broken by the availability of mass-produced items. When Cahill wrote that "everywhere in the United States the machine was driving out the local craftsman," he could have been quoting any number of observers of New Mexican culture.

There was also a significant difference in the regions' attitudes toward folk culture. Easterners explicitly valued folk art as it validated or dignified contemporary American art. Typically, Edith Halpert wrote that "the interest in this phase of native

culture has been fostered chiefly by the modern artists who find in the accent on functionalism, on abstract design, and in the absence of superficiality, a spirit closely allied with contemporary expression, with current principles of aesthetics."[23] Oddly, while artists working in New Mexico included local crafts in their paintings and contributed to their preservation and revitalization, the impact of Hispanic crafts on the art of New Mexico went unarticulated. Although Marsden Hartley, John Sloan, and Ernest Blumenschein were inspired to write apologias for Indian art, no one did the same for Hispanic.[24] Obviously, the painters were sensitive to Hispanic crafts, since everything from textiles to images of saints to carved chests appears in their paintings (see, for example, Bert Phillips's *The Santero* [fig. 133], B. J. O. Nordfeldt's *Still Life with Santo* [fig. 138], Victor Higgins's *Shrine to Saint Anthony* [fig. 139], Marsden Hartley's *El Santo* [fig. 140] and *Santos: New Mexico* [fig. 141], and Raymond Jonson's *Santo* [fig. 142]). But without the artists' statements to quote, the historian is left simply to assume that Edith Halpert's suggestion was also valid in New Mexico, that folk and modern art had stylistic affinity. The intense colors and bold patterns evident in the paintings of New Mexico do indeed suggest not only sympathy with these qualities perceived by Americans in Hispanic crafts, but even possibly the source of influence.

The Anglo-American spoke rhapsodically of New Mexico, sometimes with grace, frequently by rote, but persistently with romantic fervor. Grandiloquent prose and

poetry may have sprung from authentic and unique features of New Mexican life, but there was a point at which enthusiastic language robbed the layered cultures of their complexity and made them appear poorer in ideas and history than they actually were. At times, though, even among the most smitten, there was a level of commentary that sidestepped idealization and perceptively observed not the quaint or aesthetic, but the jarring mixture that was and is New Mexico. Although the many efforts to conserve cultural traditions were largely initiated by Anglos, they rarely paused to reflect on their motivations or whose values they truly fostered. So it is almost shocking to read poet and essayist Witter Bynner's questioning of the Anglo initiative to make Santa Fe a homogeneous whole, rooted in the picturesque past. Bynner queried:

Why should old women be draped funereal before the velorio *[wake]? Why should artists, or merchants either, be grudged their livelihood? Why should Indians give their corn or their cattle for a song that fails to cure? Why should those dance faith who had rather dance jazz? . . . There are more kinds of vitality here after all than are dreamt of in a sentimental philosophy. It is an abode not only for a collector of pots but for a collector of life. And as Heraclitus noted long ago, and a collector of pots long after him [that is, Bynner], life changes.*[25]

The same shock of unsentimental observation is felt when reading Oliver La Farge, who certainly flew the flag of romanticism in his novel *Laughing Boy*, but who also commented on the Navajo without idealization or sentimentality: "I can clear

the decks here by stating that Indians are not idyllic, any more than I am. They are also not superior to us. They are just as stupid and just as intelligent as we are, just as noble and just as mean, just as good and just as bad."[26]

To be fair, New Mexican cultures and the art they inspired frequently deserved the adulation they received. Ufer's sunlit churches, Blumenschein's boldly patterned landscapes sheltering Penitente rituals, and Marsden Hartley's intense still lifes of *santos* justly celebrate certain aspects of Hispanic life. Out of genuine and well-intended enthusiasm, however, Anglos were often tempted to repeat the romance of New Mexico while ignoring, or not formulating, straightforward observation.

The disjuncture between artistic enthusiasm and day-to-day reality, between what was painted and what was actually experienced, and between consciously stated and unconsciously held attitudes also manifested itself in negative stereotyping. The well-known proselytizer of southwestern culture, Charles F. Lummis, described Hispanics in the 1890s as "isolation-shrunken descendants of the Castilian world-finders; living almost as much against the house as in it."[27] Perhaps, however, there was no single way in which Anglo-Americans deflated Indian or Hispanic culture more than by reducing it to tourist mementos. In 1919 Carter H. Harrison, the former mayor of Chicago who was an art patron instrumental in the arrival of Ufer, Higgins, and Hennings in New Mexico, wrote to Ufer: "Don't forget your promise to have your Mexicano mail me a Penitente crucifix and a few of the Santos—I mean the old religious paintings on boards

the natives hang up around their houses. If you could pick up a half dozen of the latter at something like a couple of pesos apiece I would be tickled silly."[28]

Beyond reducing historical and religious objects to entertaining trifles, some denigrated Hispanic culture by class stereotypes. Popular writers often cast their imaginations about the Hispanic poor in less than flattering terms. In a story that appeared in a widely circulated magazine, a cowboy protagonist, in language typical of the period, described two Hispanic musicians as "the regulation snaky, black-haired Mexicans in their tawdry plumage of black velvet and spangled brass."[29] On a similar note, author Harvey Fergusson introduced Ramon Delcasar, the central character in *The Blood of the Conquerors*, as someone who had frequently encountered racial slurs: "But his social footing was a peculiarly uncertain thing for the reason that he was a Mexican. This meant that he faced in every social contact the possibility of a more or less covert prejudice against his blood, and that he faced it with an unduly proud and sensitive spirit concealed beneath a manner of aristocratic indifference."[30] Women were rarely accorded greater charity. While sometimes cast as Madonna-like figures of unreal purity or strength, they were more often "Carmens," sirens who drew men from their true purpose. Of course, the accentuation of female purity or allure was hardly unique to the art of New Mexico.

The submersion of individuality was not simply a negative impulse based in prejudice and expressed in stereotype. It also derived from a powerful need to create ideal figures who suggested the wisdom or

continuity of virtue that late nineteenth-century society frequently felt was slipping away from modern life. Part stereotype, part ideal, the artistic image of Hispanic culture largely stemmed from an Anglo perception of the relationship between Hispanic people and land, labor, and the Catholic church.

Perhaps no perception of Hispanics was more routinely drawn in the visual arts than that of the persevering laborer, fatigued by servitude to the land, but somehow able to find repose in mere subsistence. These images suggest an extremely passive people, mute in contemplation of their fate, yet made heroic by their struggle to survive. Image after image depicted individual figures, usually elderly, sitting or standing with drooped shoulders, bowed head, and gnarled, worn hands that show strength but not energy: Adams's *Evening* (fig. 125), Bisttram's *Comadre Rafaelita* (fig. 126), Higgins's *The Widower* (fig. 127), Hennings's *The Goatherder* (fig. 130), Blumenschein's *The Plasterer* (fig. 131), Phillips's *Our Washerwoman's Family* (fig. 135), Van Soelen's *The World of Don Francisco* (fig. 137), and Henderson's *Lucero's Prayer* (fig. 162). The characterization was applied to even so young a subject as Dunton's sheepherder in *Pastor de Cabras* (fig. 129).

The land, its power and significance, was the basis for many portrayals of Hispanics and Pueblo Indians, but artists represented what meaning they presumed the land held for each culture quite differently. Of the two, the Pueblo Indian seems to have occupied the more providential world in which spiritual, creative, and physical strength was drawn from the land with ease. Even though Indians and Hispanics frequently trod the same mountains,

125. *Kenneth Adams,*
Evening, *ca. 1940, oil on*
canvas, 24 x 30 in. The Arvin
Gottlieb Collection

126. *Emil J. Bisttram,*
Comadre Rafaelita, *1934, oil*
on canvas, 72 x 44 in. The
Anschutz Collection

127. *Victor Higgins,* The
Widower, *ca. 1923, oil on
canvas, 57 x 60½ in.
Pennsylvania Academy of the
Fine Arts, Philadelphia,
Templer Fund Purchase*

streams, and deserts, the Hispanic people
were never depicted in a green, thriving
environment; this was reserved for Indians.
In Anglo art, Hispanics remained the poor,
if stalwart, descendants of conquistadores
who had been robbed of vitality by a harsh
environment and Anglo conquerors. And
although both Hispanics and Indians tended

fields, cared for livestock, and depended
on the good fortunes of nature for the year's
crops, the Pueblo Indian was less often
depicted as a farmer. Rather, his bond with
the land, or, as the artists construed it, with
Nature, was perceived as an elemental unity.
Typical of this perception is Witter Bynner's
"Indian Earth":

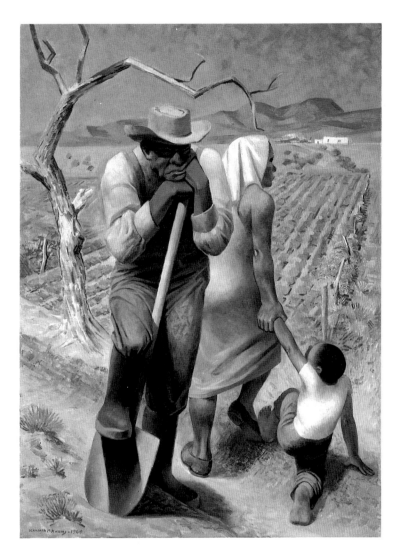

128. *Kenneth Adams*, The
Dry Ditch, *1964, oil on
canvas, 50 x 36 in. Harrison
Eiteljorg Collection*

*It is the earth itself that hems you round
Against intruders alien to the earth
That brings you heaven under a shadow tree,
Curves heaven to your arm and lets you lie
Close to its living thorn.*[31]

Hispanic ties to the earth did not go
unnoted. Perhaps no one wrote about this
subject with more intensity than Frank
Waters, who in a novel revealingly titled
People of the Valley, described the connection
through the words of the aged Hispanic
heroine:

*"Now what is a man but his earth? It rises in
walls to shelter him in life. It sinks to receive him
at death. By eating its corn he builds his flesh
into walls of this selfsame earth. He has its
granitic hardness or its soft resiliency. He is
different as each field even is different. Thus do I
know my own earth; I can know no other. I am
greedy for my land, and that is right. Does not a
child cry for its mother's breasts?"*[32]

In the hands of artists portraying Hispanic
subjects, however, the land was not always
providential; it might be a test to be met, a
trial to be endured. In Kenneth Adams's *The
Dry Ditch*, a family stands in a dry *acequia*,
or irrigation ditch (fig. 128). Without water,
the field behind yields sparse growth, and
Adams emphasizes the meagerness of the
crop and its effect on the family by the
leafless branch arching over them in a dry
embrace. The land is not, as with the
Indians, a source of inspiration; it is instead
a source of tribulation and bare survival.

Although this theme is elaborated more in
literature than painting, the struggle of
Hispanics to win a living from the land is
expressed clearly by artists in many other

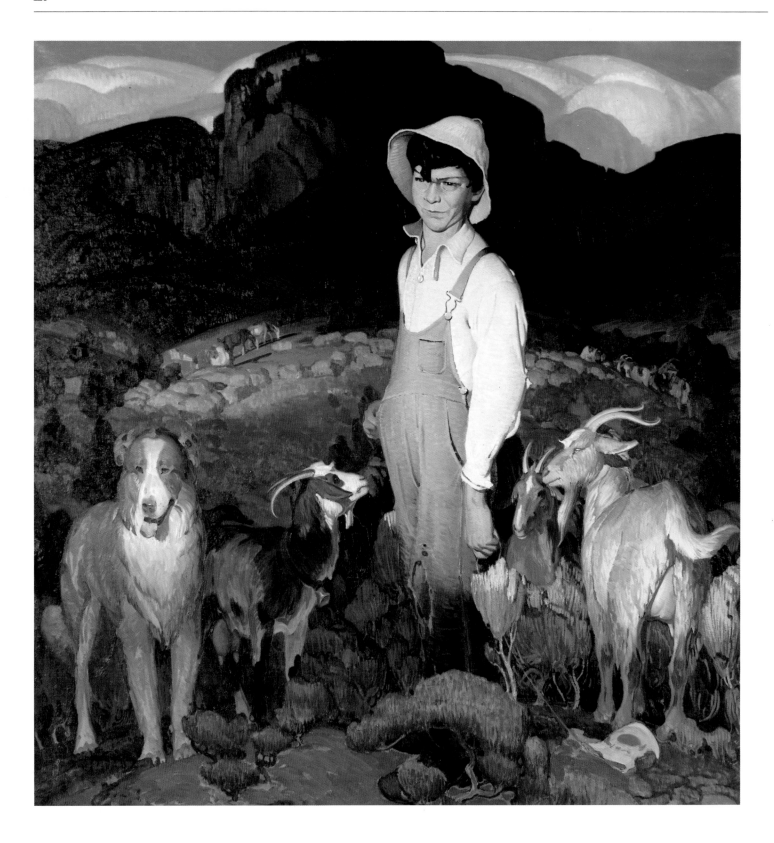

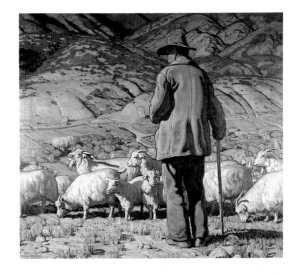

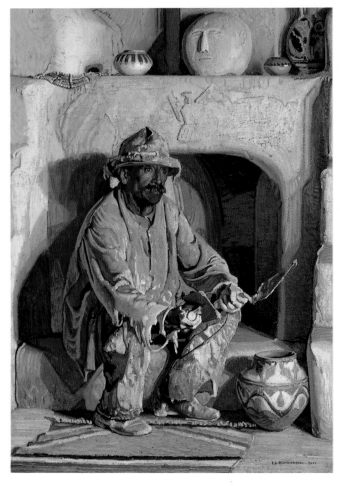

*129. W. Herbert Dunton,
Pastor de Cabras, ca. 1926,
oil on canvas, 50 x 52 in.
Private collection*

*130. E. Martin Hennings,
The Goatherder, 1925, oil on
canvas, 45 x 50 in. Private
collection*

*131. Ernest L. Blumenschein,
The Plasterer, 1921, oil on
canvas, 42 x 30 in. Harrison
Eiteljorg Collection*

images. In both Dunton's *Pastor de Cabras* and Hennings's *Goatherder* (figs. 129, 130), the intimate connection between the land and the herdsmen is suggested through consonant rhythm of form. The sloping lines of the elderly man's shoulders and the rounded shapes of his figure are echoed in his flock and the rolling hills beyond. Both boy and man work alone, and the impact of endless days of isolation is suggested by both artists: the two goatherders are not completely at peace with nature; with stooped shoulders and resigned posture, they appear worn by their livelihood. In a poem entitled "Juan Quintana," Mary Austin noted the sad effects of this lonely occupation:

*He is sunburnt like the hills,
And his eyes have a strong goat-look
And when I came on him alone,
He suddenly quivered and shook.*[33]

While Hennings and Dunton give a certain heroic dimension to their figures, they also ask for sympathy on their behalf.

This solemn note also appears in Blumenschein's portrayal of an Hispanic laborer. The adobe architecture of New Mexico required constant attention, particularly the plastering of outdoor surfaces to protect against rain and whitewashing of indoor walls to prevent flaking. Although Indian and Hispanic women had traditionally carried out this work, men increasingly shared in the job. Blumenschein painted several such figures, each based on a Taos handyman, Epimineo Tenorio.[34] In a painting of 1921, the workman appears as somber as the goatherders of Hennings and Dunton (fig. 131). Covered with plaster, he sits

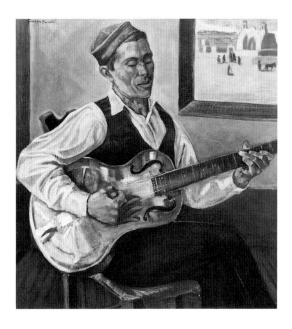

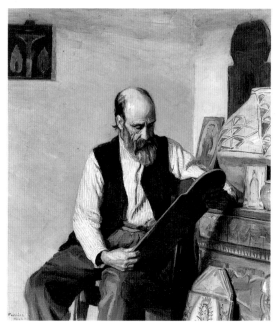

woodenly, staring with unseeing eyes, his
disheveled work clothes out of place in the
tastefully arranged room around him—yet
another figure who appears worn, not
ennobled, by his work.

Even when artists turned from manual
labor to the more refined skills of Hispanic
artisans, the sobriety in their images
remained. Creativity in Hispanic culture was
associated with music and woodcarving, in
particular, and descriptions of Hispanics
making music and dancing were common to
popular fiction. Typically, Robert Bright
described a dance in *The Life and Death of
Little Jo* in which "the dancers became
forgetful and daring, and the schoolhouse
floor bent and throbbed with the new
violence of the rhythm and movement."[35]
Yet the painters, particularly Bert Phillips
and Joseph Fleck, who portrayed Hispanics
as musicians, drained these scenes of joy.
In *The Guitarist* by Fleck, who first came to

New Mexico in 1924, the musician is
portrayed playing his instrument, his
concentration suggested by half-closed eyes
and tightly crossed legs (fig. 132). Despite
the dignity of the figure, there is, perhaps in
his very self-containment, a restrained,
melancholic mood. The same is true of *The
Santero* by Phillips (fig. 133). Surrounded
by objects of his culture, with an additional
Pueblo pot, probably from San Ildefonso,
the *santero* is seen in the broad, creative
context of the Southwest. Yet the mood of
the picture is not necessarily spiritual or
artistic. The creative act is not stressed; there
is only a passive contemplation of its results.

The artists' perception of Hispanics did
not derive solely from the themes of land
and labor. The Roman Catholic church was
the most apparent backdrop to much of New
Mexican life, and this fact is evident in the
images. Georgia O'Keeffe's paintings of
crosses, particularly those that fill the canvas

134. *Georgia O'Keeffe*, Black Cross with Stars and Blue, *1929, oil on canvas, 40 x 30 in. Mr. and Mrs. George Segal*

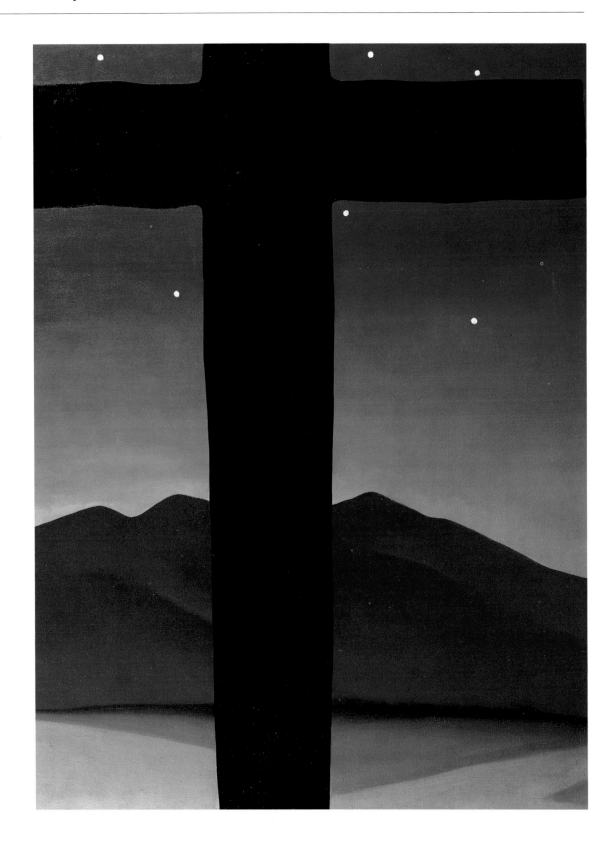

135. Bert G. Phillips, Our Washerwoman's Family, *ca. 1918, oil on canvas, 41 x 41½ in. Museum of Fine Arts, Museum of New Mexico, Santa Fe*

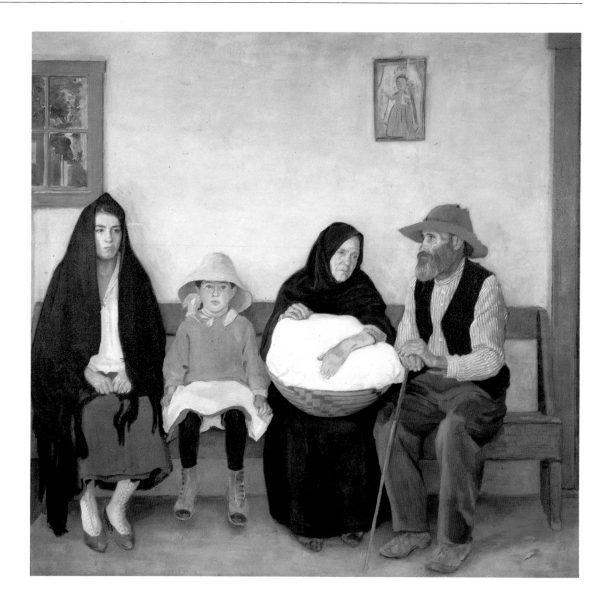

until their extremities are cropped by the frame, figure as stark evidence of the demanding presence of Catholicism in New Mexico (fig. 134). Less iconic are still lifes with devotional objects, sunny views of rural churches, and dramatic scenes of Penitente rituals. These also suggest that the artists perceived an integral relationship between Catholicism and Hispanic life. Sometimes reference to the Church is simply introduced as a small vignette in a larger scene, like the *retablo* on the wall behind the seated figures in Phillips's *Our Washerwoman's Family* (fig. 135). (In this instance, the *retablo* probably derives from one by José Rafael Aragon in Phillips's own collection [fig. 136]). An equally subtle reference to Catholicism exists in Bisttram's modernist conception of a madonna behind his subject in *Comadre Rafaelita,* and in the

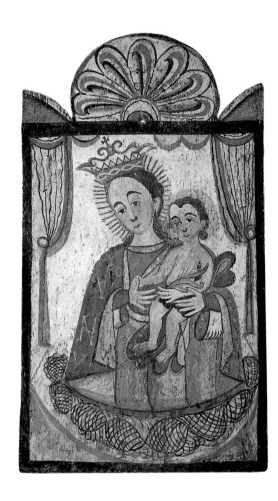

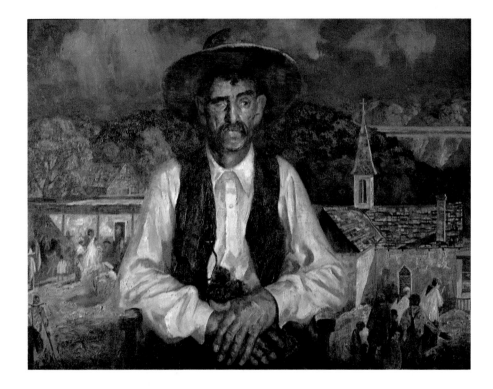

136. José Rafael Aragon,
Virgin and Child, *ca. 1816–*
62, tempera and gesso on pine,
24 x 14¼ in. Museum
of International Folk Art,
Museum of New Mexico,
Santa Fe, Charles D. Carroll
Bequest

137. Theodore Van Soelen,
The World of Don
Francisco, *1934, oil on*
canvas, 36 x 48 in. The
Museum, Texas Tech
University, Lubbock

138. B. J. O. Nordfeldt, Still Life with Santo, *ca. 1930, oil on canvas, 40 x 28 in. The Anschutz Collection*

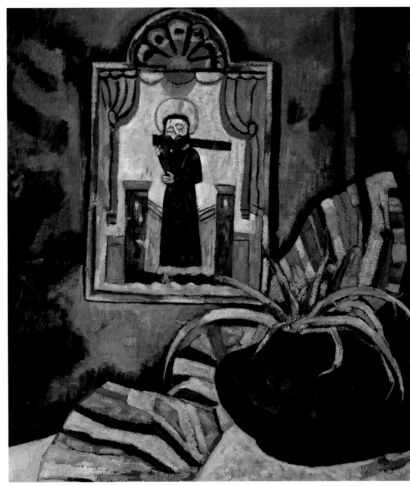

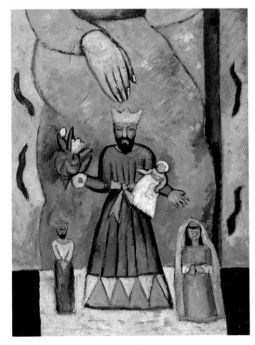

139. *Victor Higgins*, Shrine
to Saint Anthony, *ca. 1917,
oil on canvas, 40 x 43 in.
Private collection*

140. *Marsden Hartley*, El
Santo, *1919, oil on canvas, 36
x 32 in. Museum of Fine Arts,
Museum of New Mexico,
Santa Fe*

141. *Marsden Hartley*,
Santos: New Mexico, *ca.
1918–19, oil on composition
board, 31¾ x 23¾ in.
University Art Museum,
University of Minnesota,
Minneapolis. Bequest of
Hudson Walker from the Ione
and Hudson Walker Collection*

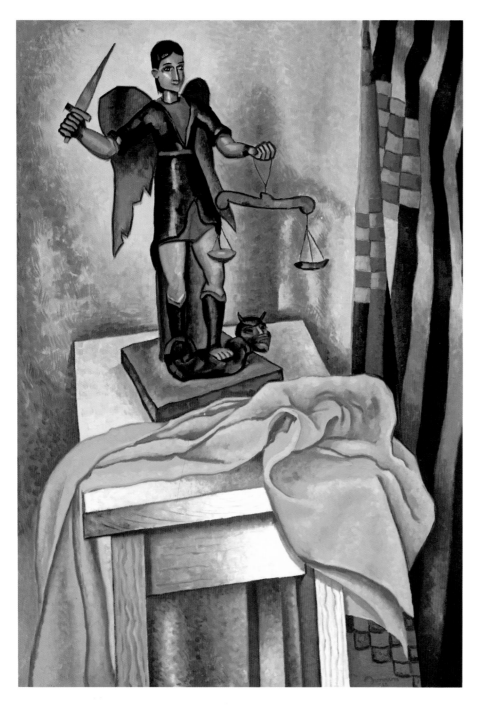

142. Raymond Jonson, Santo,
1928, oil on linen, 40 x 28
in. Roswell Museum and Art
Center, Roswell, New Mexico,
Gift of Arthur Jonson in
memory of his wife, Mary Van
Dyke

scene of religious activities behind Don Francisco in Van Soelen's *The World of Don Francisco* (fig. 137).

In still-life scenes, artists framed *retablos* and *bultos* in compressed spaces, thus capturing the intensity of feeling the images evoked in churches and family chapels. This is especially true of Nordfeldt's *Still Life with Santo*, in which the artist has encapsulated still-life objects in a niche created by framing arches, which energize the space between them (fig. 138). The same tension is evident in other interior scenes that include sacred figures: Higgins's *Shrine to Saint Anthony* (fig. 139), Hartley's *El Santo* (fig. 140) and *Santos: New Mexico* (fig. 141), and Jonson's *Santo* (fig. 142).

The *retablos* and *bultos* in these paintings suggest the variety of religious figures the artists portrayed. In contrast to the blue-robed figures with raised arms typically made by New Mexican carvers, the saint in *Shrine to Saint Anthony*, with its closed form and base, appears to be an example of plaster-cast religious statuary imported from the East. Truer to New Mexican craft traditions is the Saint Joseph of both Nordfeldt's *Still Life with Santo* and Hartley's *Santos: New Mexico*. Traditionally popular with image makers, Saint Joseph is represented in the work of the Laguna Santero (fig. 119), the Truchas Master (fig. 143; the seated figure and tile floor in this composition are similar to the *retablo* in the Nordfeldt painting), and the A. J. Santero (fig. 144). The figure of Saint Michael, who battles the Devil, is portrayed uniquely by Raymond Jonson. In comparison to many other saints, the greater activity and more complicated silhouette of Saint Michael—also clearly seen in a figure carved by the Santo Niño Santero—made

143. Truchas Master, Saint
Joseph, *ca. 1800–1840,*
tempera and gesso on pine, 12
x 9⅞ in. Museum of
International Folk Art,
Museum of New Mexico,
Santa Fe, Cady Wells Bequest

144. A. J. Santero, Saint
Joseph, *1820s, paint and straw*
on pine, 13⅜ x 10¾ in. The
Taylor Museum of the
Colorado Springs Fine Arts
Center, Colorado

145. Santo Niño Santero,
Saint Michael, *ca. 1830–60,*
paint on cottonwood, pine
base, figure 13⅜ x 7½ x 4 in.
The Taylor Museum of the
Colorado Springs Fine Arts
Center, Colorado

him a likely subject for Jonson's decorative and bold style (fig. 145).

The significance of each religious figure and the role it played in daily prayers and annual holy days is usually overwhelmed by both the decorative and expresssive qualities of the devotional items. In Hartley's *Santos: New Mexico*, for example, the play of shapes and preoccupation with color and texture are immediately evident, releasing the objects from an identifiable narrative (fig. 141). Yet the artist's selection of the subject is no formal accident, nor is it in the more conventionally rendered *Shrine to Saint Anthony* by Higgins (fig. 139), an interior scene in which the artist combines the rich color and texture of pottery, fabrics, and flowers with religious objects, including a

cross on the wall and the figure of Saint Anthony, patron saint of the home and animals and commonly represented by New Mexican *santeros* (fig. 146).[36] The scene is a genre study of an Hispanic home and equally an enjoyment of objects, particularly as they are touched by the sunlight that burns the edges of the flowers and windows, gently lights the surrounding area, and leaves the foreground in shadow.

The decorative strength of these still-life images is, in fact, often closely connected to their content. The items in Bert Phillips's *New Mexico Bulto* cannot be said to serve any function in relation to each other, but they are a striking visual array of bright and somber hues, soft fabric and rigid metal, curved form and straight line (fig. 147).

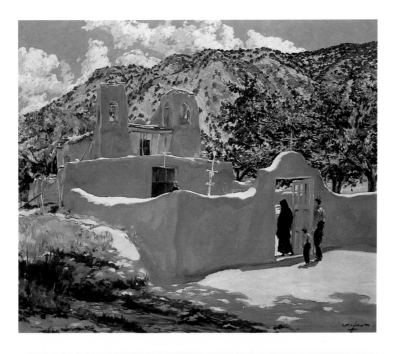

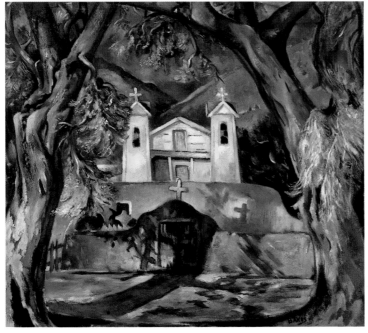

148. *Walter Ufer*, Oferta
para San Esquipula, *1918*,
oil on canvas, 25 x 30 in. The
Anschutz Collection

149. *Jozef G. Bakos*,
Sanctuario, Chimayo, *before*
1940, oil on canvas, 30 x
34 in. The Anschutz Collection

Beyond decoration, this sensual orchestration is a subtle overview of Hispanic history, religion, and craft: the rapier of the conquistadores, the *bulto* of the churches, a Majolican pitcher probably made in Mexico between 1880 and 1920, and a chair made during the 1920s in Taos and influenced by contemporary Mission furniture. Gently placed and barely noticeable, a few flowers lie scattered on the floor and chair, their delicate presence suggesting nostalgia for a culture whose values and customs were seriously threatened by the arrival of Anglo-Americans. The artist invites us to appreciate Hispanic culture in yet another guise, at the same time introducing another level of response—in this instance, pathos.

Finally, the content of the still lifes, in particular, but also of most paintings of Hispanic subjects, rests on an intent to portray a religious, or at least spiritual, environment accessible to the twentieth-century mind. The spirituality begins with Catholicism but is radically modified by the shape this religion took in New Mexico. The painters did not miss, or, perhaps more accurately, were drawn to, its pagan character, which stems from the deep ties Hispanics had to the land. Such details as the golden flowers in Higgins's *Shrine to Saint Anthony* (fig. 139), Nordfeldt's wildflowers in *Still Life with Santo* (fig. 138), and Hartley's greenery in a blackware pot in *El Santo* (fig. 140) are just a few examples of how Nature and Church were constantly associated in Anglo depictions of New Mexico. The relationship between religion and the day-to-day physical world is even more clearly indicated in two views (pre- and post-tin roof) of the church at Chimayo by Walter Ufer and Jozef Bakos (figs. 148,

*150. Georgia O'Keeffe,
Another Church,
Hernandez, New Mexico,
1931, oil on canvas, 10 x 24
in. The Anschutz Collection*

*151. Georgia O'Keeffe,
Ranchos Church No. 1,
1929, oil on canvas, 18¾ x 24
in. Norton Gallery and School
of Art, West Palm Beach,
Florida*

*152. Paul Strand (1890–
1976), Church, Ranchos de
Taos, New Mexico, 1931,
platinum print, Paul Strand
Archive and Library, Silver
Mountain Foundation,
Millerton, New York*

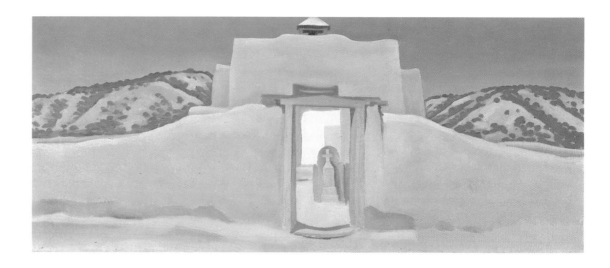

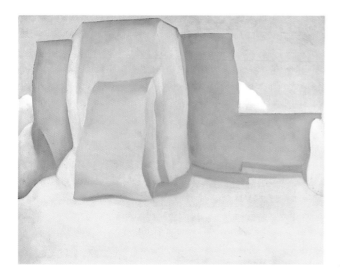

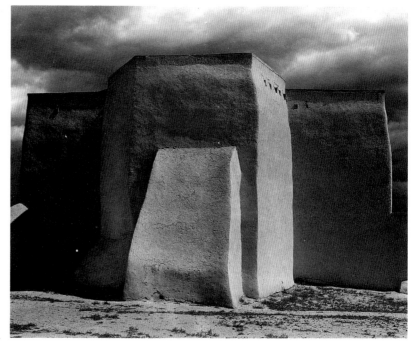

153. *Birge Harrison,* The Penitentes, *from* Harper's Monthly *70 (May 1885):833.*

149). The similarity of color, light, and form that both artists suggest between church and land indicates a natural harmony, as if Christianity in New Mexico literally grew out of the native earth. No painter, however, more clearly united these two themes than Georgia O'Keeffe, whose abstracted forms made church, sky, and land part of the same whole (figs. 150, 151). O'Keeffe's instincts were paralleled with equal pictorial force by photographer Paul Strand (fig. 152). While Catholic dogma would not have abided the suggestion that its principles derived from Nature, in the eyes of Anglo artists the Hispanic people appeared to have beseeched Nature as well as God for a merciful future.

The role of religion in Hispanic culture is apparent in other images as well. Although writers, journalists, and historians were to respond more frequently to the Penitente sect in New Mexico, artists also recorded this most dramatic manifestation of religious life in northern New Mexico and southern Colorado. La Fraternidad Piadosa de Nuestro Padre Jesus Nazareno (The Pious Fraternity of Our Father Jesus the Nazarene), commonly called Los Hermanos (The Brothers) or Los Penitentes, is a lay religious society that evolved during the late eighteenth century, when remote rural villages were left without adequate religious leadership because of a diminishing number of Franciscan priests. The Penitentes' religious beliefs and practices, largely a fundamentalist view of Catholic church dogma, center on a reenactment of the suffering, crucifixion, and death of Christ. While Penitente ritual focuses on the Passion of Jesus, the society is also dedicated to the communities it serves, commonly extending assistance to both members and

nonmembers in times of illness or death. It was not this side of Penitente activity, however, that drew comment. Rather, writers, artists, journalists, and tourists could not help but be intrigued—sometimes sympathetically, more often not—with flagellation and other forms of self-mortification that constituted penitential "discipline" during the Holy Week reenactment of the crucifixion.[37]

One of the first illustrations of the Penitentes appeared in the 1885 *Harper's* account of Birge Harrison's travels to Española, New Mexico (fig. 153).[38] In the illustration, three men wind their way through a trail of cactus—a practice common to acts of penance—toward what appears to be a crucifixion in the background. The scene appears factual, but touches have been added to heighten an already shocking subject. Traditionally, Penitentes undertaking penance wore hoods to ensure humility. But Harrison portrayed them without hoods, their flying, disheveled hair suggesting frenzy. Also, while commentator after commentator has noted the solemnity and measured rhythm established in Penitente processions—three steps and then a stroke of the *disciplinas* (a whip made of braided cactus fiber) across the back, accompanied by the solemn singing of *alabados* (hymns)—Harrison creates a theatrical melodrama, with the participants moving frantically to the different beats of their individual impulse. Other illustrations and photographs of the Penitente would follow Harrison's; it was not until the 1920s that more sympathetic images appeared.

Santa Fe was the center of Anglo interest in Hispanic culture. It was here that Mary Austin and Frank Applegate led the crusade to preserve Spanish colonial art and urged

Julie Schimmel

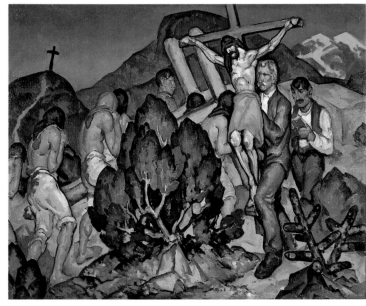

154. Ansel Adams (1902–1984), Interior, Penitente Morada, Northern New Mexico, ca. 1929–30, gelatin silver print, 13⅛ x 9⅞ in. University Art Museum, University of New Mexico, Albuquerque

155. William P. Henderson, Penitente Procession (formerly Holy Week in New Mexico), ca. 1918, oil on canvas, 32 x 40 in. Museum of Fine Arts, Museum of New Mexico, Santa Fe

contemporary craftsmen to revive carving traditions. It was here that John Gaw Meem encouraged Alice Bemis Taylor, his wife's aunt, to collect Hispanic material; here that Cady Wells, with the advice of E. Boyd, formed a similar assemblage. Respectively, these form the basis for the two finest collections of Hispanic New Mexican material available today, the former housed at the Colorado Springs Fine Arts Museum and the latter at the Museum of New Mexico. It was also here that Willa Cather, Alice Corbin Henderson, Witter Bynner, and Haniel H. Long, among others, wrote the

essays, novels, and poetry that marked in the 1920s and 1930s a new appreciation for Hispanic culture in American literature. Finally, it was here that the majority of artists lived who frequently painted Hispanic people and their customs, including the Penitente rituals.

Those painters who responded to the Penitentes formed a close group within the Santa Fe artistic community. Will Shuster and Willard Nash arrived in Santa Fe in 1920 and, in the following year, were founding members of Los Cinco Pintores, the group of artists who were among Lorin W. Brown's

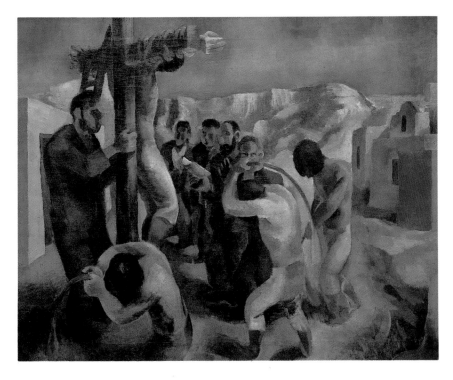

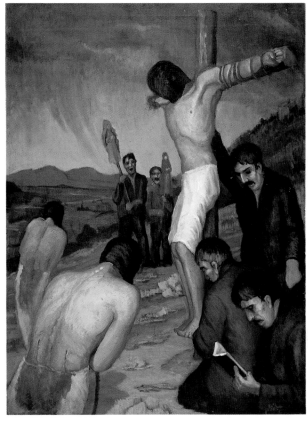

156. Willard Nash,
Penitentes, *ca. 1930, oil on*
canvas, 24 x 30 in. Museum of
the Southwest, Midland, Texas

157. Will Shuster,
Penitente Crucifixion, *oil on*
canvas, 40 x 30 in. The
Harmsen Collection

visitors to Cordova to witness the Penitentes during Lent. Their neighbors on the Camino del Monte Sol were William and Alice Corbin Henderson, who had arrived in 1916. The latter subsequently published *Brothers of Light*, one of the most influential studies of the Penitente movement. Whereas previous commentators were likely to describe Penitentes as fanatic or barbarous, Alice Henderson struck a different note: "The belief in the efficacy of this self-imposed penance is of course deeply devout—it is the old doctrine of suffering as an atonement for sin; and it is this sincere

faith which makes the *Penitente* ceremonies so moving." Her tolerance and respect are found in the paintings as well, including those by the Santa Fe artists already mentioned—Henderson, Nash, Nordfeldt, and Shuster—but also by Gerald Cassidy, who decorated his home with altar paintings from the ruined Nambe mission church, and the Taos painters Joseph Sharp and Thomas Duncan Benrimo.[39]

Among the visual responses to the Penitentes is Ansel Adams's photograph of a Penitente *morada*, or place of worship, which contrasts the stark planes of the entrance

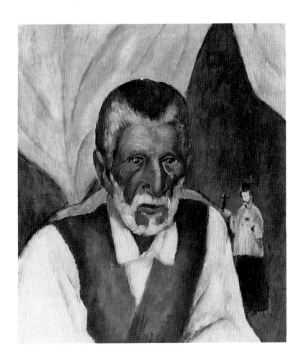

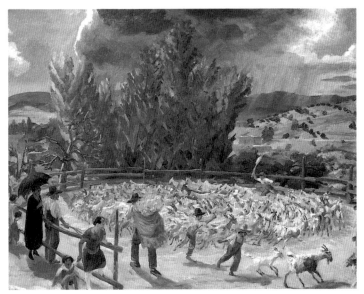

158. Thomas Benrimo, Death
of a Penitente, 1940,
watercolor over pencil on
paper, 9½ x 14³⁄₁₆ in.
Cincinnati Art Museum, Gift
of Mrs. Howard Wurlitzer

159. Style of Rafael Aragon,
Christ Carrying Cross, ca.
1816–62, tempera and gesso on
pine, 21¼ x 14⅜ in. Museum
of International Folk Art,
Museum of New Mexico,
Santa Fe

160. Paul Burlin, The
Sacristan of Trampas, ca.
1913–20, oil on canvas, 24 x
20 in. Museum of Fine Arts,
Museum of New Mexico,
Santa Fe

161. John Sloan, Threshing
Floor, Goats, Santa Fe,
1924 and 1945, oil on canvas,
30 x 40 in. Kraushaar
Galleries, New York

walls with the decorative texture of the religious figures, suggesting the emotional richness and physical austerity that characterize the paradoxical sect (fig. 154). Henderson's *Penitente Procession*, Nash's *Penitentes*, and Shuster's *Penitente Crucifixion* (figs. 155–57) all depict hooded flagellants wearing *calzones* (white cotton pants), who lash their bare backs with *disciplinas*. By turning the flagellants' profile to the spectator, Henderson, unlike Nash and Shuster, downplayed the bloody backs, emphasizing instead the procession of men moving between their chapter house and the *calvario*, the cross shown on the far distant hill. The procession is led by the *hermano mayor* holding a *bulto* of a crucified Christ. He is followed by a *rezador* (the reader of the prayers), two men who carry *maderos* (heavy wooden crosses), and an unhooded *acompañadore*, who assists the flagellants. Many of these figures are in the Nash and Shuster paintings as well, and their intent to portray the ritual accurately suggests the seriousness with which the artists treated this subject. They could not expunge its sensationalism, but through the grave demeanor of the figures and deliberateness of the compositions, they suggest a sympathetic response.

Beyond their subject matter, these paintings also indicate the stylistic range of artists in New Mexico. All three works are firmly rooted in visual reality, but each has been touched by more contemporary trends. There are echoes of Cézanne in the paintings of Henderson and Nash, while the intensity of emotion, rawness of paint, and dramatic viewpoint of the Shuster Crucifixion suggest the art of Soutine and Rouault, who painted religious subjects with similar crude and forceful brushwork.

The most radical treatment of a Penitente subject is by Thomas Duncan Benrimo, who arrived in Taos as late as 1939. In *Death of a Penitente* (fig. 158), Benrimo abandons rational treatment of space and subject; his moonlit setting suggests the unreason of dreams that characterized Surrealism. Grief for the shrouded corpse of a Penitente is expressed in the undulating sky and earth and in the fleeing woman, whose figure dissolves into swirls of drapery. The authenticity of experience that Henderson, Nash, and Shuster achieved through more realistic portrayals, Benrimo evokes through a haunting, irrational juxtaposition of figures and landscape.

In addition to paintings specifically of Penitente subjects are images that obliquely suggest the Brotherhood. In *El Santo* (fig. 140), Marsden Hartley included a *retablo* of Christ carrying a cross (fig. 159), a subject not often found in *retablos* but one that could well be observed in a passion play or in a Penitente procession. Paul Burlin includes a *bulto* of San Juan Nepomuceno characteristically clothed in white surplice, black cassock, and biretta in the background of *The Sacristan of Trampas* (fig. 160). San Juan was the patron saint of silence and secrecy and is typically found in Penitente *moradas*. Another work, *Sangre de Cristo Mountains* by Blumenschein, initially strikes one as a landscape but actually contains a Penitente procession in which a Brother, probably chosen to represent the crucified Christ, drags an enormous *madero* (fig. 176).

The artists were drawn to the toughness, solemnity, and intensity of Hispanic culture, particularly as it seemed to be shaped by Catholicism. John Sloan's painting *Threshing Floor, Goats, Santa Fe* is a scene of rare spontaneous energy, but even this family

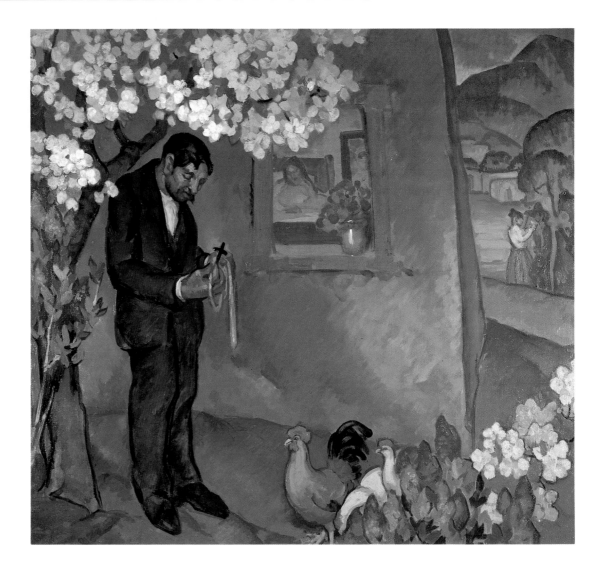

162. *William P. Henderson,*
Lucero's Prayer, *ca. 1921, oil*
on canvas, 36 x 40 in. Mrs.
Edgar L. Rossin

gathering is threatened by an approaching storm (fig. 161). More typically, Sloan painted solemn groups of black-shawled women in holy-day processions. Reflecting the fascination with the intensely emotional side of Hispanic culture, scenes associated with death were not uncommon. In a sentimental mood, Henderson painted *Lucero's Prayer*, with the subject, holding a small cross, praying outside the window of a room in which a woman lies ill (fig. 162).

His sadness is made more intense by the effusion of spring flowers around him and the young lovers in the background. Most dramatic is Emil Bisttram's *Mexican Wake*, in which the artist has placed across the foreground a rhythmic sequence of mourning village women, their backs to the spectator, recalling the dirgelike tempo of Penitente Holy Week processions (fig. 163). Against the stark silhouettes of figures and coffin appear the bleeding, crucified Christ

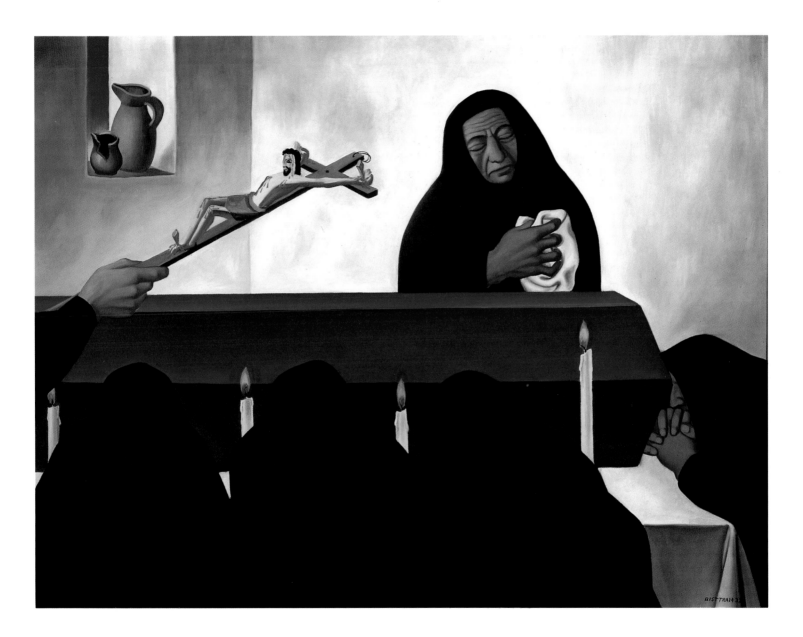

163. Emil J. Bisttram,
Mexican Wake, 1932, oil on
canvas, 36 x 48 in. University
Art Museum, University of
New Mexico, Albuquerque

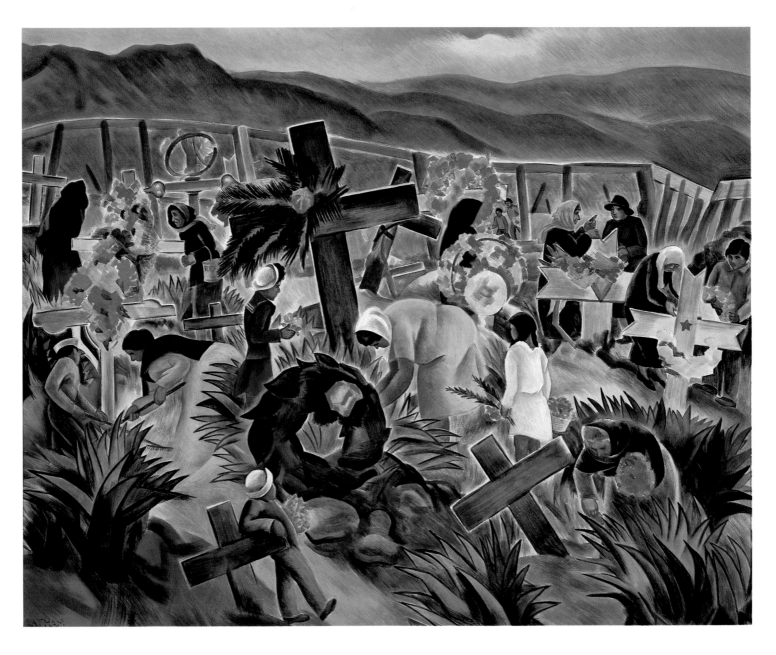

164. *Barbara Latham,*
Decoration Day, ca. 1940,
tempera on panel, 24½ x 29
in. The Harwood Foundation
Museum of Taos Art, Taos

and the anguished face of the principal mourner, her hands clutched in pain. In a lighter mood, Barbara Latham's *Decoration Day*, showing families come to decorate the graves of their dead, is made almost festive by her use of intense reds, greens, lavenders, and pinks (fig. 164).

The subjects found in the art of New Mexico reflect both Hispanic culture as it was and the preoccupations and cultural biases of the painters. The sources for the resignation, melancholy, and austerity that one repeatedly finds in these works are difficult to identify, although some explanation may be found in anti-Hispanic attitudes that had deep roots in Anglo-American culture.

During the early years of American occupation in New Mexico and before Bishop Lamy returned order and rigid propriety to the Catholic church in the 1850s, anti-Catholic opinions were clearly voiced. As one observer of New Mexican life, W. W. H. Davis, wrote in the 1850s:

They have an abiding faith in saints and images, and with the mass of the inhabitants their worship appears no more than a blind adoration of these insensible objects. Some of the most intelligent of the better class look upon these bits of wood as all-powerful in every emergency; and upon the occasion of a fire in Santa Fe a few years ago, a prominent Mexican gentleman was anxious that one of the wooden saints should be brought from the church to quench the flames.[40]

Anti-Catholicism in New Mexico, however, seems never to have been overt or intense—and with good reason, since Hispanics outnumbered Anglos until the 1930s, both in general population and the state legislature, and Catholics far outnumbered Protestants. Despite the lack of overt prejudice, however, one senses even among those most sympathetic to Hispanic culture a lingering wariness of the Catholic faith. This is true of Mary Austin, who, in her 1931 novel *Starry Adventure*, wrote of two Methodist children in New Mexico who patronize their Catholic maid, though with affection: "It gave them a wonderful secret sense of being allied with strange powers, just to pass Aloysia's door and see the whole family of Blessed Personages [*santo* figures] glimmering in the uncertain candle flame which burned there on Sundays and other days, incalculable except as they were associated with Aloysia's business of being a Cath'lic."[41] Perhaps Catholicism was judged at best to be slightly foolish, as Austin implies, and at worst, to be the blind hope of idiots. The latter attitude is suggested by Ufer in *Hunger*, a scene of prayer. He described the crucifix featured on the wall as a "dead carved thing [that] really can not give to anything living."[42]

Politics was another arena of tension, particularly in the late 1890s, when the first artists arrived in New Mexico. The decade was marked by the United States' newly emerging policy of imperialistic expansion and the drive by American businessmen for new markets. It was these factors that led to the American presence in Samoa, Hawaii, Cuba, and the Philippines. To encourage President McKinley and Congress to pursue the cause of justice (and, less readily acknowledged, to extend American enterprise in the Pacific), journalists and politicians formulated condemnations of Spain that were extreme in judgment and language, yet were characteristic of the stereotypes that had existed, in one form or

another, since the sixteenth century: "Spain has been tried and convicted in the forum of history. Her religion has been bigotry, whose sacraments have been solemnized by the faggot and the rack. Her statesmanship has been infamy: her diplomacy, hypocrisy: her wars have been massacres: her supremacy has been a blight and a curse, condemning continents to sterility, and their inhabitants to death."[43]

With more specific regard to New Mexico, perhaps the clearest example of American anti-Hispanic feeling is found in the territory's attempts to win statehood. The battle began in 1850, with the first request to Congress, but it was not won until 1912. Well into the struggle, during the late 1890s, one New Mexican journalist typically protested that statehood was not being granted because of class bias and the prejudice of Eastern politicians: "In the view of the people of New Mexico, in the opinion of every man who possesses a heart and soul and in whose character there exists nobility, one does not judge a whole people to be bad because they are poor or because they are ignorant, especially when the blame for their ignorance rests with the government under whose protection they live."[44]

To whatever extent the persistent stereotypes of Hispanic endurance and passivity can be ascribed to prevailing prejudices, the artists' points of view still reflected a degree of reality. The goal to endure, rather than to achieve, had historical roots among the class of Hispanics—the working poor—that the artists chose to represent. For example, generations of Hispanics had worked in servitude as peons. Sheep arrived in New Mexico with the first settlers and became the basis of the New Mexican agricultural economy. Under the Spanish system of land grants, extensive grazing areas were placed in the hands of relatively few *ricos*, or patrons. Many of the shepherds hired to care for the flocks worked under a *partido*, or tenant-herding system, that effectively bound them to their employers, in debt, for life. Although Congress abolished New Mexican peonage in 1867, the system continued, as the indefatigable collector of historical fact H. H. Bancroft observed in 1889. While noting the virtual absence of black slaves, Bancroft pointed to another form of slavery, peonage, "or voluntary servitude for debt, involving no loss of civil rights, no sale or transfer of service, and no legal obligation on the part of the children of peons" (in practice, sons did assume debt obligations). Even if not tenant-herders, Hispanics without land were still indebted to large land owners, since they paid fees per sheep for grazing rights.[45] Although herders obviously developed self-reliance in caring for their flocks, their essential means of economy left them in a subservient position and suggests a reason, in part, for the fatalism that is frequently associated with Hispanic people.

In addition, the dogma of the Catholic church encouraged Hispanics to view this life as simply a preparation for the next and to accept tribulation as deserved penance, not just for sins committed during one's lifetime but also for the original sin of Adam and Eve. This is suggested in the *alabados*, or hymns, of the Penitentes:

Penitence, penitence,
Sin no more, unfortunate man,
Examine your conscience,
Come to the temple and hear the Voice!

It is time to make penance,
You who have been too busy
To take warning to repent,
Examine your conscience![46]

Whatever their cultural or historical sources, artists did emphasize resignation and endurance in their portrayals of Hispanic peoples. It was not just these qualities alone that inspired images, however; artists drew equal inspiration from the intensity of feeling associated with the will to survive and the religion that sustained that will. At the foundation of Hispanic life was a faith patronizingly viewed as mystical, naive, and primitive. From the Anglo point of view, this spiritual life easily turned from folk religion to superstition, from priest to witch, with all deeply couched in the earth, as suggested by Charles Lummis in 1891: "There is, perhaps, no essential kinship between sheep and superstition; but here at least the twain are nextdoor neighbors. In this simple, restful, patriarchal, long-lonely world, the chief concerns of life are the field, the flock, and—the warding off of witches."[47]

The artists and writers of New Mexico discovered and celebrated the state's ethnic cultures just as America took its greatest vigor—and corruption—from industrial invention and urban development. While the signs of material progress captured the imaginations of many, others were less enchanted and in their pessimism were drawn to intuitive and primitive life-styles uncomplicated by the so-called advance of civilization. Gauguin's retreat to Brittany and Tahiti is the familiar touchstone for this period; but here, in this country, there were similar drives away from reality and realism, materialism and empiricism, toward subjective content, which was sometimes spiritual, sometimes psychological. This included the intuitive, poetic paintings of Albert Pinkham Ryder, the lyrical abstractions of Arthur Dove, and the emotionally vibrant landscapes and still lifes of Marsden Hartley. In New Mexico, however, there existed a world in which life held intensity, an intensity drawn from an impulse to survive and a mystical faith that mediated that survival. Even if the artists essentially remained witnesses to an experience they could not share, they did, at least, try to capture this courage and grace in their paintings. Writing in 1912, Hartley, who had recently become aware of African and other tribal art, wrote precisely of this experience, stating that "the more elemental and primitive the people, the more inwardly intense have been the modes of expression. It accounts I think very largely for the utter emptiness of modern art up to now when art is taking a plunge inward and men are revolting against the superficial ideas which have so been expressed and each man is trying to look in to himself and seeing what he finds there."[48]

In Catholic New Mexico, artists and writers discovered a spiritual force outside of gentility that replaced the pale golds and whites of their largely Protestant backgrounds with the intensely dramatic reds and blacks of sin, guilt, and expiation. Here was an abundance of emotion made visible in vivid ritual, and here was a powerful metaphor for creativity held before artists who had left genteel traditions in the East and Europe to create an art of spiritual strength.

Notes

1. For an extended discussion of the relationship between cultural groups in New Mexico, see Bodine, "A Tri-Ethnic Trap: The Spanish Americans in Taos," in *Spanish-Speaking People in the United States*, pp. 145–53.

2. 2 November 1919, Walter Ufer Papers.

3. Harrison, "Española and Its Environs," p. 828. For similar travelogues of the Southwest, also see Sylvester Baxter, "Along the Rio Grande," *Harper's Monthly* 70 (April 1885): 687–700, illus. by Willard Metcalf; Lee C. Harby, "Texan Types and Contrasts," *Harper's Monthly* 81 (July 1890): 229–47, illus. by Frederic Remington; Charles F. Lummis, "The Land of Poco Tiempo," *Scribner's* 10 (December 1891): 760–71, illus. by Victor Perard; and for illustrations of New Mexico, see Charles Graham, *Harper's Weekly* 34 (1890): 8 March, p. 73; 19 April, p. 293; 28 June, p. 496; 5 July, p. 520; 12 July, p. 544; 19 July, p. 561; 2 August, p. 592; 4 October, p. 765; and 35 (1 August 1891): 576.

4. Lummis, "The Land of Poco Tiempo," pp. 763–64.

5. Ritch, *Illustrated New Mexico*, p. 148.

6. Material in this section is based on Bunting, *Early Architecture in New Mexico*; Bunting, *John Gaw Meem*; Kessell, *The Missions of New Mexico since 1776*; and Kubler, *The Religious Architecture of New Mexico*.

7. Dutton, "Commerce on a New Frontier," in *Colonial Arts*, pp. 95–98.

8. See Kessell, *The Missions of New Mexico since 1776*, pp. 24–26.

9. Sims, "Pueblo—A Native American Architecture," p. 103.

10. Hewett, "The School of American Archaeology," *Art and Archaeology*, p. 319.

11. Hewett, p. 327.

12. Vierra, "New Mexico Architecture," pp. 45–46.

13. Chamber of Commerce, *Official Program, Santa Fe Fiesta*.

14. Fergusson, "Crusade from Santa Fe," *North American Review*, 1937, pp. 377–78; reprinted in Weigle and Fiore, *Santa Fe and Taos: The Writer's Era, 1916–1941*, p. 88.

15. Austin, *Earth Horizon*, p. 358.

16. Briggs, *The Wood Carvers of Cordova, New Mexico*, p. 53.

17. For a discussion of the marketing of Hispanic crafts, see Coke, *Andrew Dasburg*, p. 65; and Nestor, *The Native Market of the Spanish New Mexican Craftsmen*.

18. For a detailed discussion of the enterprising Brice H. Sewell and the vocational centers, see Wroth, "New Hope in Hard Times," pp. 22–31.

19. Claudia Larcombe, "E. Boyd: A Biographical Sketch," in Weigle with Larcombe and Larcombe, *Hispanic Arts and Ethnohistory in the Southwest* (Santa Fe: Ancient City Press, 1983), pp. 5–6. For additional discussion of the *Portfolio*, see Spurlock, "Federal Support for the Visual Arts in the State of New Mexico: 1933–1943," pp. 48–49.

20. For information and reproductions of New Mexican material recorded for the *Index of American Design*, see Spurlock and see Hornung, *Treasury of American Design and Antiques*, pp. 749–67.

21. Miller, "Religious Folk Art of the Southwest," p. 3.

22. Museum of Modern Art, *American Folk Art*, p. 3.

23. Quotation from Rumford, *The Abby Aldrich Rockefeller Folk Art Collection*.

24. Blumenschein and Phillips, "Appreciation of Indian Art," pp. 178–79; Hartley, "Aesthetic Sincerity," pp. 332–33, and "Red Man Ceremonials," pp. 7–14; and Sloan and La Farge, "Introduction to American Indian Art," in *Introduction to American Indian Art*.

25. "A City of Change," in Bynner, *The Works of Witter Bynner: Prose Pieces*, p. 49.

26. La Farge, *Raw Material*, pp. 153–54.

27. Lummis, *The Land of Poco Tiempo*, p. 3.

28. Harrison to Ufer, 23 September 1919, Walter Ufer Papers.

29. Bingham, "Sangre de Cristo," p. 302.

30. Fergusson, *The Blood of the Conquerors*, p. 8.

31. Bynner, *Indian Earth*, p. 44.

32. Waters, *People of the Valley*, p. 127.

33. From Austin, *Red Earth*, p. 52.

34. Hennings, *Ernest L. Blumenschein Retrospective*, p. 19.

35. Bright, *The Life and Death of Little Jo*, p. 81.

36. Steele, *Santos and Saints*, p. 198.

37. Information on the Penitentes is drawn from Weigle, *Brothers of Light, Brothers of Blood*, and Ahlborn, "The Penitente Moradas of Abiquiu," in *Contributions from the Museum of History and Technology*. For the benevolent role of the Penitentes, see Weigle, p. 151.

38. Harrison, "Española and Its Environs," p. 833.

39. Henderson, *Brothers of Light: The Penitentes of the Southwest*, p. 13. For Cassidy's use of altar paintings from Nambe, see E. Robertson and Nestor, *Artists of the Canyons and Caminos*, p. 36.

40. Cited in Rodriguez, "New Mexico in Transition," p. 201, n. 74.

41. Austin, *Starry Adventure*, p. 14.

42. Quoted in Stephen L. Good, "Walter Ufer: Munich to Taos, 1913–1918," in Bickerstaff, *Pioneer Artists of Taos*, p. 156.

43. John J. Ingalls, "America's War for Humanity, 1898," in Gibson, *The Black Legend*, p. 177.

44. Meyer, "Early Mexican-American Responses to Negative Stereotyping," p. 82.

45. Beck, *New Mexico: A History of Four Centuries*, p. 256; Bancroft, *History of Arizona and New Mexico, 1530–1888*, p. 681; Scurlock, "Pastores of the Valles Caldera," p. 4.

46. Henderson, *Brothers of Light*, p. 93.

47. Lummis, "The Land of Poco Tiempo," p. 771.

48. Cited in Levin, "Marsden Hartley and the European Avant-Garde," p. 159.

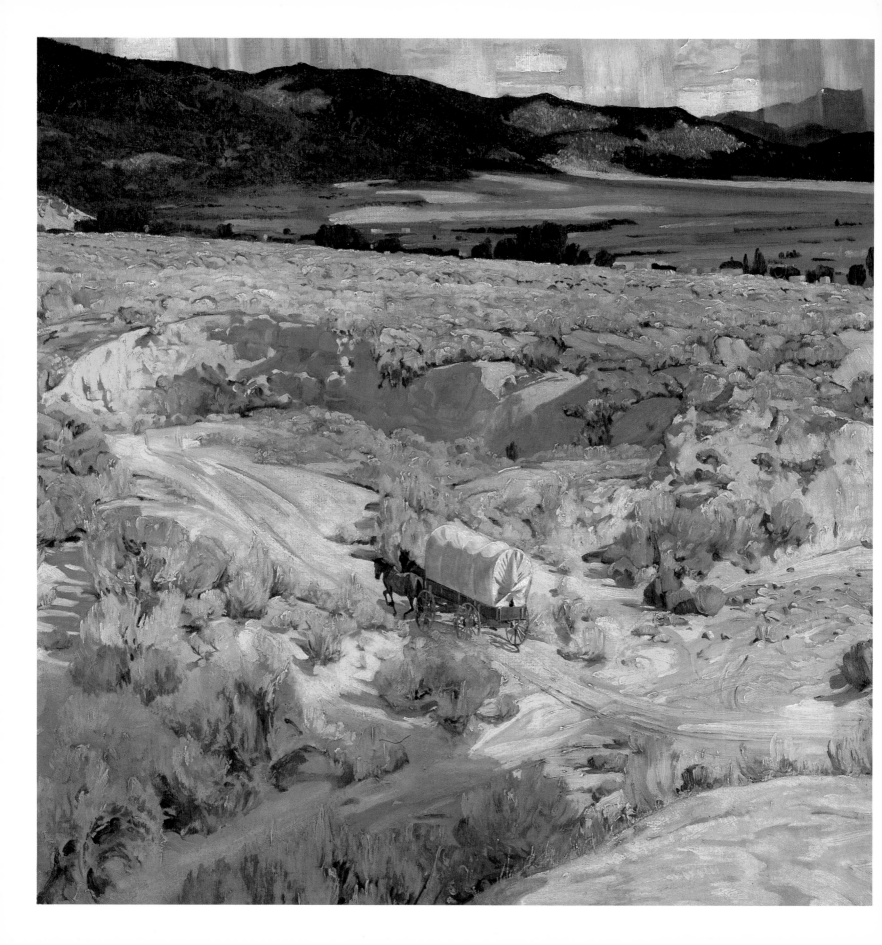

Charles C. Eldredge

The Faraway Nearby

New Mexico and the Modern Landscape

Walter Ufer, Where the Desert Meets the Mountain *(detail, see p. 173)*

Sometime between the early 1890s, when the United States Census Bureau concluded that the frontier was conquered, and 1918, when Versailles peacemakers declared the Kaiser vanquished, the American landscape disappeared from painters' easels. Or so the canon of American art history would have one believe. Contemporary chronicles and familiar histories of that tumultuous epoch suggest that somewhere in the protracted turn of the century, American landscape painting died. The modern nation would celebrate not the beneficent wilderness but the booming metropolis, replete with its newly artistic ash cans. A genteel aestheticism and a domesticated Impressionism would yield to innovations of form and color in a new spasm of borrowings from Europe. Man's created environment, rather than God's natural one, would motivate painters to form a new vocabulary, stressing visual analysis or personal expression over mimetics, cerebration over nature's celebration.

If failing health had not forced Frederic Church gradually to abandon his brush in the last decades of the nineteenth century, changing taste might have, for his grandiloquent treatment of natural scenery was by then quite out of vogue. And long before Albert Bierstadt's death in 1902, his theatrical landscapes had been replaced in the galleries by a new generation's more intimate, less bombastic depictions. In turn, even those Impressionist portrayals of a gentler terrain lost their novelty and some of their following; glimpses of domesticated pasture or garden, brushed with pastel

delicacy, persisted well after the century's turn but offered increasingly pale reflections of the style's initial impetus. New York studios, which a generation or so earlier had been populated by painters turning Catskill summer studies into finished landscapes for the winter's exhibitions, yielded a very different product after 1900: paintings of gritty cities, smoky saloons, and street mongers; arrangements of figures or still-life objects subjected to Cubist fracture or beastly coloring; and, eventually, pictures apparently without subject in the baffling phenomenon known as abstract art.

This brief recounting greatly simplifies a complicated quarter-century and the artists and the art historians whose tale it excerpts. Still, the question persists: What happened after the 1890s to the grand and noble tradition of landscape painting, by which the art of the American nation was largely defined for most of the preceding century?

Its apparent disappearance is partly attributable to the changing terms in which aesthetic debate was waged in the new century. Increasingly, innovation was defined by style rather than subject, which had been dear to nineteenth-century artists and writers. A picture's Cubist qualities, for instance, outweighed the importance of its subject. Whereas an earlier generation might have venerated a Hudson River or Luminist or Pre-Raphaelite *landscape*, the modern view emphasized the Fauvist or Cubist *technique*. Arthur Dove's organic abstractions, Marsden Hartley's expressive mountainscapes, and Rockwell Kent's stylized topography do not immediately call to mind the common denomination of "landscapist," particularly given the thematic variety attempted by each artist and the critical nomenclature applied to the work of each. Yet, the

eminence of such painters and their memorable images drawn from nature suggest that, though differently categorized or discussed, a landscape tradition persisted well into the new century.

It is self-evident that landscape painting requires a natural subject. In the burgeoning cities—which were home initially to the aesthetic revolutions and modern, "urban" styles—the traditional landscapist's inspiration was often lacking; but in the countryside—away from the metropolitan congregation of galleries, critics, and collectors—landscape painting flourished in proximity to nature. The seasonal migrations that had lured Cole, Durand, and their associates to the Catskills and beyond continued in the early twentieth century, allowing an urban master like Robert Henri to practice his landscape fluency at Shinnecock, New York, and in Pennsylvania's Wyoming Valley, as well as other venues remote from the street subjects for which he is commonly remembered.

The continuing lure of landscape in part explains the proliferation of art colonies in the decades surrounding the turn of the century. In her fine study of the Woodstock, New York, art colony, Karal Ann Marling argued that there were two primary motivations that gave rise to scores of such centers. The "intentional colonies," which were fewer in number, "arose as a result of advance planning on the part of founders with a mission—founders determined to construct countercultures, away from the blight and turmoil of industrial cities, where circumstances favorable to the creative life could be cultivated, and from which positive humanizing influences for social betterment would emanate."[1] The Utopian experiments at Peterborough, New

Hampshire's MacDowell Colony or the Roycroft Village in East Aurora, New York, exemplify this type of planned artistic community. Far more frequent were the serendipitous colonies, whose origins dated to the discovery of a beauteous spot by a scenery-seeking landscapist and whose survival depended upon the continuing cult of the picturesque. Most of the Atlantic coastal communities, as well as many art colonies farther afield, were of this second type.

In the 1890s at Shinnecock, near Long Island's eastern tip, William Merritt Chase established summer art classes, which soon led to an influx of artists and the "colonization" of outermost Suffolk County. Connecticut's Cos Cob and Old Lyme similarly offered summer refuge and inspiration to New York painters, as in time did Provincetown, Gloucester, and Cape Ann, Massachusetts; Woodstock, New York; Ogunquit, Maine; and New Hope and the Brandywine region of Pennsylvania. The seasonal gatherings of painters in these rural centers, and in others across the land— Carmel and the Monterey Peninsula in California; Brown County, Indiana; Taos and Santa Fe, New Mexico—were built upon the Hudson River School tradition of artistic rambles. The colonies encouraged painting *en plein air* and followed the models of artists living and working together that had evolved in European centers like Barbizon, Giverny, and Pont Aven. Common to each was an abundance of unspoiled scenery, an inexpensive existence, and a critical mass of artists. In these summer colonies, the traditional pursuits of landscape and figure painting retained their primacy.

The art colonists' retreat to nature coincided with the fashion for Impressionism and *plein-air* painting; but in some summer settlements, the persistence of that style and a growing anti-urbanism led painters to increasingly conservative approaches in their art. Tradition was well served by distance from metropolitan centers of invention.

Remote and difficult to reach, the New Mexican centers drew some of the most adventurous artists, and paradoxically some of the most conservative. Whereas Shinnecock or Woodstock was but a day trip from Manhattan, and therefore more susceptible to its influence, the road to Taos was long and arduous; for its initial art settlers, the distance blunted the impact of innovations from the East. Despite the cost and hardship of travel, Taos and Santa Fe attracted art visitors from the early 1900s on, and traffic grew dramatically after the First World War. From nearly every artist, whether short-term visitor or permanent settler, the desert beauty of these isolated towns elicited strong response. When to the natural drama of the settings were added the romance of the Hispanic and especially the indigenous Indian peoples and the region's dark and tortured history, a potent combination resulted.

The region's distinctive character was first portrayed by mid-nineteenth-century artists who accompanied expeditions to the New Mexican territory. Except for topographical delineations—lithographs of which were of use to their military patrons and subsequent settlers—most of these early painters did not tackle pure landscape, the unfamiliar terrain being too daunting a prospect for their training and background. Into the desert expanses they placed pueblos or adobe churches or native tribes, some comforting evidence of man's presence in this alien land. For instance, in the middle

165. *Amédée Joullin
(1862–1917),*
Rio Puerco, New Mexico,
*oil on canvas, 10 x 30 in.
California Historical Society,
San Francisco, Sloss Collection*

166. *Joseph Henry Sharp,*
Enchanted Mesa, *1915, oil
on canvas, 40 x 56 in. Thomas
Gilcrease Institute of American
History and Art, Tulsa,
Oklahoma*

formats, perhaps a reflection of the mid-century Luminists' predilection for that shape, but more likely a response to the vast lateral sweep of desert. The format was carried to exaggerated proportions in Amédée Joullin's long slice of *Rio Puerco, New Mexico* (fig. 165), featuring distant, silhouetted peaks floating over a vacant foreground of scruffy hillside, behind which two unlikely teepees are discreetly tucked. These early exercises suggest some of the landscapists' struggle to come to terms with the New Mexican subject, their solutions to problems of composition and format, and their tourist's-eye view of the unfamiliar world.

Perhaps the difficulty of recording the unfamiliar scenery led many of New Mexico's first tourists-turned-settlers to focus on figurative scenes inspired by the local inhabitants. This choice of subject not only built upon a well-established nineteenth-century tradition of Indian portrayals, but was also suited to the academic training and Salon experience that a number of them had received in Europe. In many respects, the New Mexican subjects were a native counterpart to the colorful Breton or Bavarian peasants, in whose mores and costumes a generation of American painters had delighted. The scenery of northern New Mexico did not escape interest, but for the first Taos painters it remained largely a background for narrative compositions and figure studies.

When the older generation did seek to record the spectacle of the land, so brilliantly illuminated by the challenging desert sun, they often resorted to a modified Impressionist stroke and palette. In 1915, for instance, in a relatively rare excursion into pure landscape painting, Joseph Sharp

ground of *Pecos Church, New Mexico* (1865), Worthington Whittredge featured a man-made adobe structure, which securely holds off the limitless desert beyond, the expanse of which is only suggested by the distant rim of peaks. *The Pueblo Laguna, New Mexico* (1882) by Thomas Moran repeated this basic formula, with buildings crowning a mount, set back in space yet safely accessible via the horse path traversed by a party of Indians.[2] In both cases the painters chose emphatically horizontal

167. Albert L. Groll (1868–1952), The Acoma Valley, New Mexico, before 1909, oil on canvas. Present whereabouts unknown

168. Sheldon Parsons (1866–1943), Clouds, 1943, oil on panel, 36 x 36 in. Museum of Fine Arts, Museum of New Mexico, Santa Fe

depicted the *Enchanted Mesa* (fig. 166) near the Acoma Pueblo, one of his favorite Indian sites. The rocky mass, which is centered within the large canvas, its near side in purplish shadow, is painted with loose strokes and pastel hues. It tamely suggests a haystack by Monet, to whose art and theory Sharp was introduced as a student in Paris in 1887.[3] Unlike the French Impressionists, however, Sharp did not use a divisionist palette, but captured the effects of light on land through the admixture of white pigments and a general lightening of hue. Similar effects were employed by Albert Groll in his views of the northern New Mexican desert in the years immediately preceding World War I. Groll's cloud-filled skies, arching over lowered horizons, convey the drama of Impressionist brushwork (fig. 167). This stylistic approach was eventually wrung dry in the

desert cloudscapes of Sheldon Parson's last years (fig. 168), which demonstrated the ultimate limitation of the Impressionist technique—developed in the humid valley of the Seine and happily transplanted to damp New England climes—in conveying the distinctive character of arid desert light.

If Monet's brush and palette proved inadequate for bold New Mexican scenes, other European styles were essayed to advantage by several of the first generation of Taos and Santa Fe painters. Walter Ufer made a considerable reputation with his Indian subjects, generally portrayed in the full light of midday. The artist eschewed the delicacy of Impressionist technique in favor of broad brushes, heavily laden with rich pigment of intense hue, and long strokes of silvery white to convey the sparkle of sunlight falling on his subjects. On occasion, as in *Going to the Water Hole, Santa Clara*

169. *Walter Ufer,* Going to the Waterhole, Santa Clara, *ca. 1920, oil on canvas, 25 x 30 in. Harrison Eiteljorg Collection*

170. *Ernest L. Blumenschein,* The Penitentes, *ca. 1935, oil on canvas, 22⅞ x 50⅛ in. Harrison Eiteljorg Collection*

(fig. 169), he borrowed from Neo-Impressionists like Henri-Edmond Cross the device of bright dabs of color in his airy skies, a sort of Pueblo pointillism. The polka-dotted plane flattened the composition, however, denying the natural sweep of western spaces, and consequently was soon discarded. Ernest Blumenschein's *The Penitentes* (fig. 170) used repeated, aligned strokes in the sky and mountain background to similar effect, compressing the landscape to a stage flat before which is played his Penitente ritual. Martin Hennings often interlaced boughs and foliage to provide a decorative screen and stabilize his subjects, which were struck by a sunlight whose intensity sometimes bleached his palette to blonds and aspen golds (fig. 92). Hennings provided compositional weight and emphasis by strengthening contours, creating *cloisonné* patterns that derived from the Jugendstil design he had learned as a student in Munich. Reliance upon such European stylistic developments of the 1890s was rare among the pioneering generation of painters in Taos and Santa Fe, however; their efforts to capture the landscape were generally conventional and secondary to their interest in figurative motifs. The full operatic grandeur of the desert's vacant acres and its dazzling light had to await interpretation by a new influx of artists.

The bright, blanching light, the unfamiliar desert clime, the view through thin, dry air across miles of gorges and varicolored badlands to distant blue mountains, these were daily reminders that New Mexico was no ordinary setting. "The moment I saw the brilliant, proud morning shine high up over Santa Fe," recalled D. H. Lawrence, "something stood still in my soul, and I started to attend. . . . In the magnificent

fierce morning of New Mexico one sprang awake, a new part of the soul woke up suddenly, and the old world gave way to a new."[4] Like Lawrence, many others came "to attend" in New Mexico's peculiar light, much harder, whiter, and brighter than that of the coast or the prairie. Mabel Dodge Luhan described the region's effect on one of her newly arrived guests: "Take an exquisite sensitive mortal like Georgia O'Keeffe . . . and suddenly lift her from sea level to the higher vibrations of a place such as Taos and you will have the extraordinary picture of her making whoopee!"[5] But while New Mexico might elicit whoopee and waken the soul, its light could also blind the eye and paralyze the hand, at least initially. Perhaps the artist most affected by the New Mexican environs was Jules Pascin. According to legend, upon debarking his train he was assaulted by the brilliant light— and promptly reboarded for the familiar East![6] John Sloan, who suffered from extreme nearsightedness, found the intense light so troublesome that he took to his Santa Fe studio and there produced his genre scenes and landscapes, safely shielded from the sun. For the *plein-air* painters, local conditions posed a definite challenge, which each tackled in his own way.

In 1918, twenty-five years after Joseph Sharp first painted at Taos, Marsden Hartley was lured there by the recent convert Mabel Dodge (Luhan). For him, it was to be a brief, but significant, experience in his restless career, during which he developed a distinctive response to the landscape, anticipating D. H. Lawrence's claim that in New Mexico the old world gives way to a new.

Hartley already enjoyed a measure of acclaim based on his exhibitions in New York and Europe and his ties with the avant-garde, including special praise from Gertrude Stein. His celebrity, and his vanity, did little to endear him to the established painters in Taos, which he in turn dismissed as "the stupidest place I ever fell into . . . a society of cheap artists from Chicago and New York." The locals scarcely appreciated his assault on their "pretense" and "spuriousness" or his blunt advice that "there is no use in attempting to apply the conventions of Paris or Munich or Dresden to the red-man, or to the incredibly beautiful landscape of New Mexico. . . . It will not satisfy the intelligent eye to paint a lone mesa like an inflated haystack of Monet."[7]

During his first long summer, Hartley was largely without companions, save for his hostess, her husband Maurice Sterne, and their occasional visitors; but he had always found inspiration individually rather than communally, and in Taos he was not disappointed. New Mexico proved the impetus for Hartley to return to his landscapist roots; increasingly, his own idiom tended away from personalized abstractions toward more dispassionate renditions. "I am an American discovering America," he wrote in 1918. "I like the position and I like the results." He predicted that the quest for native subjects, for him and his compatriots, would yield "a sturdier kind of realism, a something that shall approach the solidity of landscape itself and for the American painter the reality of his own America as Landscape."[8] His declarations ring with echoes of Thomas Cole's great "Essay on Scenery" (1835) and other nineteenth-century antecedents, connoting a new nativist strain in his art and tying him to a distinguished landscape tradition.

Hartley described the challenge of his

171. *Marsden Hartley*, The
Little Arroyo, Taos, *1918,*
pastel on paper, 16½ x 27 in.
University Art Museum,
University of Minnesota,
Minneapolis, Bequest of
Hudson Walker from the Ione
and Hudson Walker Collection

172. *Marsden Hartley,* Arroyo
Hondo, Valdez, *1918, pastel*
on paper, image 17 x 27½ in.
Phoenix Art Museum,
Arizona, Gift of Mrs. Oliver
B. James

unfamiliar surroundings to Alfred Stieglitz:
"This country is very beautiful and also
difficult. It needs a Courbet with a Renoir
eye." Courbet's sense of structure and form
would serve well in what Hartley called
"essentially a sculptural country." Renoir's
grasp of light and color *in* objects would
similarly assist, for Hartley recognized that
New Mexico "is not a country of light on
things. It is a country of things in light,
therefore it is a country of form, with a new
presentation of light as problem."[9]

To present this landscape of sculptural
form revealed through light, Hartley first
chose pastels. Remarkably, he was one of
the few artists (along with William P.
Henderson and, later, Andrew Dasburg) to
use this medium whose bright, dry, dusty
qualities were ideally suited to the arid
country. The beautiful arroyos and canyons
were of particular fascination to him—"I am
bewitched by their magnificence and their
austerity"[10]—and many of his pastels
provide intimate glimpses of these
formations, sketched with daring
abbreviation (fig. 171). As his familiarity
with the countryside grew, he turned to the
broader expanse of the Taos Valley, backed
by the sculptural mass of the Sangre de
Cristo Mountains (fig. 172). These pastels,
drawn in a comparably summary style,
inspired the painted recollections of the
countryside he made later in New York and
Europe. They also differed radically from
the work of other Taos artists in their
simplified forms and free color: initially
lustrous blue greens, later browns and
golds. New Mexico, Hartley wrote, "is of
course the only place in America where true
color exists," color that for him was
intensified rather than bleached by the New

173. Marsden Hartley,
Landscape, New Mexico,
1920, oil on composition board,
25⅝ x 29½ in. Roswell
Museum and Art Center,
Roswell, New Mexico, Gift of
Ione and Hudson D. Walker

Mexican light.[11] From the creases in the land glows the pure, unmixed hue of his pigments.

In Hartley's eyes the land became increasingly organic in shape. Paul Rosenfeld described his Sangre de Cristo range as "earth-forms fitting into each other like coupling organs; strawberry-pink mountains dotted by fuzzy green poison shrubs, recalling breasts and wombs of clay."[12] The roundness of his desert formations increased in the New Mexican landscapes painted in New York from 1919 to 1921 (fig. 173) and became even more expressive when recalled again in Europe in 1923 and 1924. These recollections of New Mexico, especially the ones done in Berlin in 1923, are more tortured in form, more agitated in composition than his views created *in situ*; and they have an emotional intensity and expressive distortion only rarely displayed by other artists' paintings of New Mexico

174. *Marsden Hartley,*
Landscape, New Mexico,
*1923, oil on canvas, 21¾ x
35¾ in. The Equitable Life
Assurance Society, New York*

(fig. 174). The later recollections are somber in hue, sometimes drab gray and olive, sometimes soaked in blood and black. Georgia O'Keeffe once said, "If you ever go to New Mexico, it will itch you for the rest of your life."[13] For Hartley, the affliction was slightly briefer; in Paris, five full years after leaving New Mexico, he finally exorcised the spirit.

Hartley's pastel mountainscapes, with their bright cleavages, softened and simplified the New Mexican range. Later, Victor Higgins similarly used slanting light to emphasize the soft contours of the peaks rather than their craggy "mountain" quality. In his painting *Taos, New Mexico* (fig. 175), the range lies gently piled and folded, like gigantic scoops of ice cream dropped on the Taos Valley floor. Ernest Blumenschein's *Sangre de Cristo Mountains* of 1924 (fig. 176) is composed of similar shapes proceeding in graduated grays up the picture plane and into the distance. The rounded forms are echoed in the bowed and blanketed processional figures and adobe buildings, whose contours are further softened by caps of snow; even the bare brush in the foreground, arranged in curving arcs, obeys

175. Victor Higgins, Taos,
New Mexico, *ca. 1921, oil on
canvas, 52 x 56 in. Dr. and
Mrs. George C. Peck*

176. Ernest L. Blumenschein,
Sangre de Cristo
Mountains, *1925, oil on
canvas, 50¼ x 60 in. The
Anschutz Collection*

177. Helen Pearce, New
Mexico Ribbon, *1946, oil on
canvas board, 21¾ x 27⅞
in. Mr. and Mrs. William P.
Albrecht*

178. Walter Mruk, The
Ghost of Carlsbad Caverns,
*ca. 1924–25, oil on canvas,
20 x 24 in. The Harmsen
Collection*

179. James S. Morris,
Lightning, *late 1930s, oil on
canvas, 20 x 24 in. Museum of
Fine Arts, Museum of New
Mexico, Santa Fe*

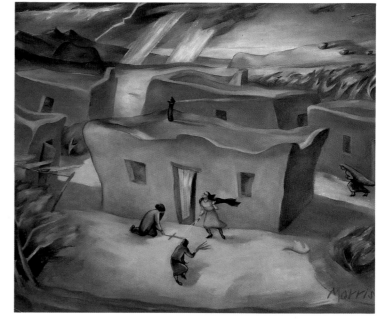

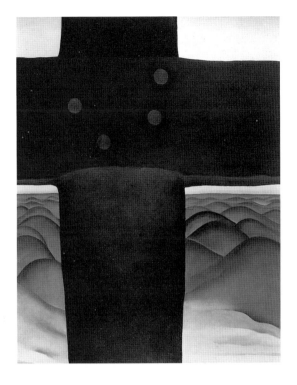

180. Georgia O'Keeffe, Black Cross, New Mexico, *1929, oil on canvas, 39 x 30¹⁄₁₆ in. The Art Institute of Chicago, The Art Institute Purchase Fund*

the compositional principle. Repeated curves and contours enliven Helen Pearce's *New Mexico Ribbon* (fig. 177), a glimpse of highway cutting across the dessicated land. Walter Mruk invented forms of a different type in paintings of New Mexico's Carlsbad Caverns, whose darkened grottoes writhe with abstract, organic shapes (fig. 178); James Morris distorted and animated the adobes of Sante Fe, which respond to the force of a desert storm (fig. 179).

The most stylized of these living land forms are doubtless the gray hills of Georgia O'Keeffe's badlands, which first appeared in her paintings of Black Crosses, created in 1929 (fig. 134). In these works, all vestiges of local detail—sagebrush and piñon, adobes, even suggestions of season or weather—are banished as she concentrates on the forms of cross and land. The crosses, viewed frontally and bonded to the picture plane, even truncated by the canvas's edge (fig. 180), contrast with the lobed hills that either peak behind them or march to distant horizons. When viewing the extraordinary contours that inspired these paintings, O'Keeffe once exclaimed, "Those hills! They go on and on—it was like looking at two miles of gray elephants."[14]

If for some the land was best rendered in rounded, organic forms, for others the setting was characterized by the crystalline, blocky masses in the canyons and on the desert floor. Volcanic activity of eons past had left the hard forms of mesa and butte amidst the weathered terrain; and as the river cut deeply into the land, it left chunky igneous boulders in the Rio Grande Gorge. These geological oddities were often recorded by early topographers, and their crisp geometries inspired modern painters as well.

In 1922 Raymond Jonson first painted in New Mexico and discovered a country that was to inspire him throughout the rest of his long career. Sketching the mesas, cliffs, and canyons of the desert around Santa Fe, he "realized that this was a turning point" and through his landscape studies "sensed a means of arriving at plastic design."[15] The angular shapes of the country, accentuated by crisp light and dark shadows, led him ultimately to a distinctive abstract style. In his views from the mid 1920s, desert sketches were translated in the studio into colorful, orderly patterns of flattened, angular shapes, separated by dark lines that at once enliven and stabilize the compositions. His *Earth Rhythms* series was the first to employ this device. In *Earth*

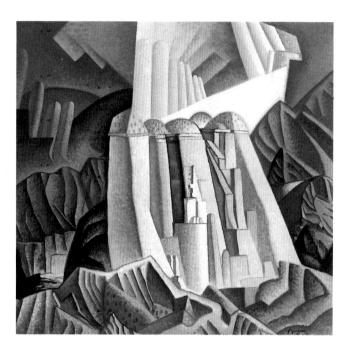

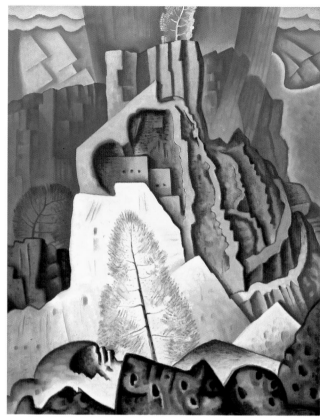

181. Raymond Jonson, Earth
Rhythms No. 6, *1925, oil on
canvas, 37 x 40 in. Jonson
Gallery of the University Art
Museum, University of New
Mexico, Albuquerque*

182. Raymond Jonson, Cliff
Dwellings No. 3, *1928, oil
on canvas, 48 x 38 in. The
Jonson Gallery of the
University Art Museum,
University of New Mexico,
Albuquerque*

Rhythms No. 6 (1925; fig. 181), Jonson
admitted there was "a slight degree of
abstraction," but insisted that the natural
"forms are easily recognized" even though
subordinated in a "semblance of order."[16]
Cliff Dwellings No. 3 (fig. 182) of two years
later shows the two-dimensional patterning
carried further, with silhouettes of trees and
houses simply suggesting the design's
origins in landscape. Jonson carried his
hard-edged style to complete abstraction in
the 1930s, moving from the southwestern
motifs of the preceding decade to more
universal themes.

 If Jonson's path to abstraction was
uncommon, his perception of landscape form
in terms of angular lights and shadows was

not. Visiting Taos in 1931, Maynard Dixon
conceived his *Earth Knower* (fig. 183),
featuring a blanketed Pueblo Indian before a
barren desert mesa. The slanting, harsh light
emphasizes the angular shapes of the
reddened countryside, creating patterns of
sharp black shadow, which are echoed in
the crisp folds of the Indian's garment. As
Dixon described it, "The major forms are
simplified and reduced to clean, geometric
patterns of light and dark," a "Cubist-
Realist" device inspired by the environs of
New Mexico. This bonds the figure formally
and psychologically to the ground and
manifests the artist's belief that American
Indians were "men of the earth."[17]

 Indians in the Mountains by Ernest

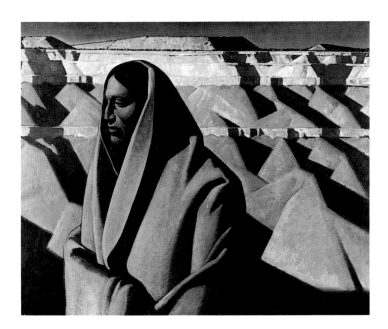

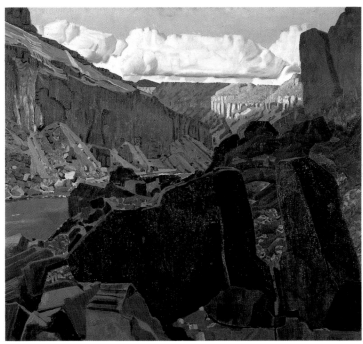

183. Maynard Dixon (1875–
1946), Earth Knower, ca.
1933, oil on canvas, 40 x 50
in. The Oakland Museum,
Oakland, California, Gift of
Dr. Abilio Reis

184. Ernest L. Blumenschein,
Canyon Red and Black,
1934, oil on canvas, 40 x 45
in. Dayton Art Institute,
Dayton, Ohio, Gift of Mr.
John G. Lowe

Blumenschein (fig. 77) similarly links figure and landscape. Whereas his earlier *Sangre de Cristo Mountains* (fig. 176) had suggested the rootedness of the Penitentes to their land through the repetition of languid curves, here the more staccato rhythm of the landscape's colored stripes and angular peaks is echoed in the Indians' woven blankets. Blumenschein discovered abstract patterns in the play of sun and shadow across the land, which in the 1930s led him to increasingly bold designs. In *Canyon Red and Black* of 1934 (fig. 184), for instance, a diagonal dramatically divides shadowed foreground from highlighted cliffs beyond, following the fracture line of a closely viewed boulder whose crisp contours

establish the scene's overall forms. By lowering his vantage point into the gorge and raising the horizon line, Blumenschein blocks the typical New Mexican sweep of space and concentrates instead on the balanced play of light, color, and geometry within a finite area. In this work of his maturity, the artist remained faithful to his youthful interest in the Post-Impressionists, whom he had acclaimed for their "flat masses of color" and their "decorative and imaginative" compositions.[18]

Blumenschein's organic and crystalline conceptions have parallels in the work of Victor Higgins. In his landscapes of the 1920s, fluid brushwork on occasion describes the swell of mountain and mesa, as in *Storm*

Charles C. Eldredge

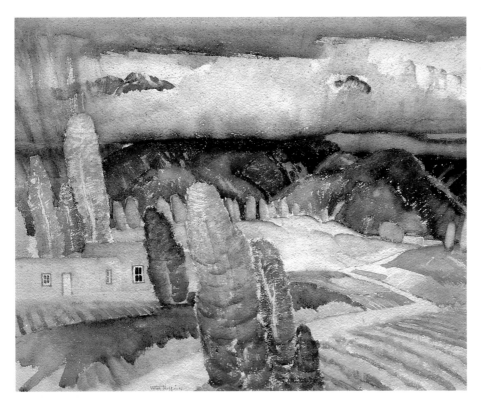

185. *Victor Higgins,* Storm
Approaching Adobe, *ca.
1920s, watercolor on paper,
19 x 23½ in. Mr. and
Mrs. Gerald Peters*

Approaching Adobe (fig. 185), with its bravura passages of rust and blue. At other times, Higgins rivals Blumenschein's Post-Impressionist designs, as in *Reflected Light* (fig. 186), a striking view of a snowbound stream. The artist eliminated the horizon entirely to concentrate on the stylized patterns of brown, blues, and white, rendered in broad strokes of rich pigment. Against the stark plane of snow, Higgins silhouetted with Whistlerian delicacy a foreground arabesque of dried twigs and foliage, whose tracery accentuates the flattened, nearly abstract simplicity of the landscape beyond. Higgins's propensity for heavily loaded brushes reached its climax in *Pueblo of Taos*, painted before 1927 (fig. 89). The flow of pigment, limning the peak that looms over the pueblo, cascades over the

adobe to the figures in the foreground; long strokes of buttery paint arc across the canvas in a decorative pattern of remarkable fluency.

These earlier works differ strikingly from his oils of the thirties and forties, in which strokes shorten and tend to align and landscape elements become more blocky and angular. *Taos Valley* (fig. 187), painted about 1935, demonstrates this new approach. Its stout forms are even reflected in the clouds, weighty, flat-bottomed masses that march across the sky, so different from his earlier *Storm* clouds and curving rhythms.

O'Keeffe's view is often considered different from that of her fellow artists in New Mexico. Yet even in her work of the 1930s, a tendency toward crisp form—although not toward Blumenschein's or Higgins's brushwork—is sometimes glimpsed, certainly in her skeleton paintings and even in landscapes, such as *Red and Orange Hills* (1938; fig. 188). In this painting the lava flow of her 1931 *Mountain, New Mexico* (fig. 189) seems to have crystallized across some sharp-ridged armature, yet without sacrificing the sense of pulsing, vital landscape. As she frequently did with her Black Crosses and other desert motifs, O'Keeffe departed from a conventional vantage point, viewing her subject not from ground level but from high overhead. As in Higgins's snow scene, this downcast angle of vision eliminates the horizon line and focuses attention solely on the pattern of land forms, here brightly tinted. As the eye travels across her tidy desert, it moves up arroyos and between mountains deep into space and, at the same time, is held by the painting's two-dimensional surface. Offering no secure foothold in the foreground or any escape into the sky's

186. Victor Higgins,
Reflected Light, *1921, oil on*
canvas, 52¼ x 56¼ in.
Private collection

187. Victor Higgins, Taos
Valley, *ca. 1935, oil on*
canvas, 54 x 60 in. The Snite
Museum of Art, University
of Notre Dame, Notre Dame,
Indiana, Gift of Mr. and Mrs.
John T. Higgins

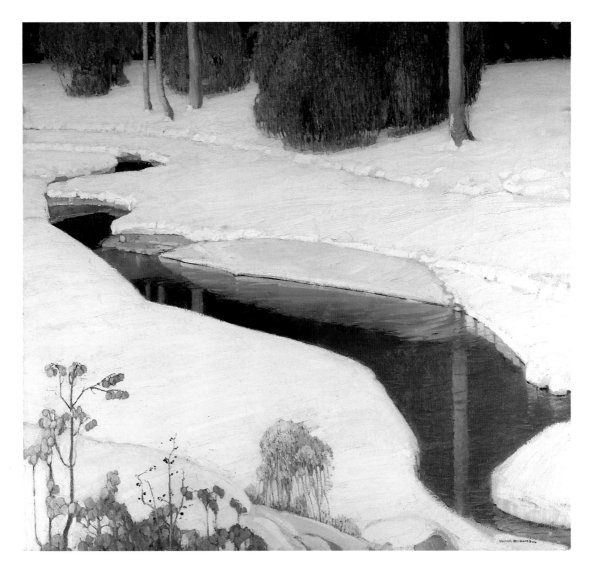

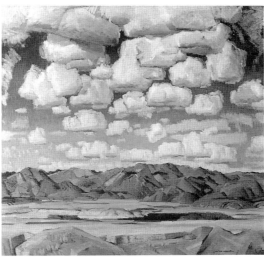

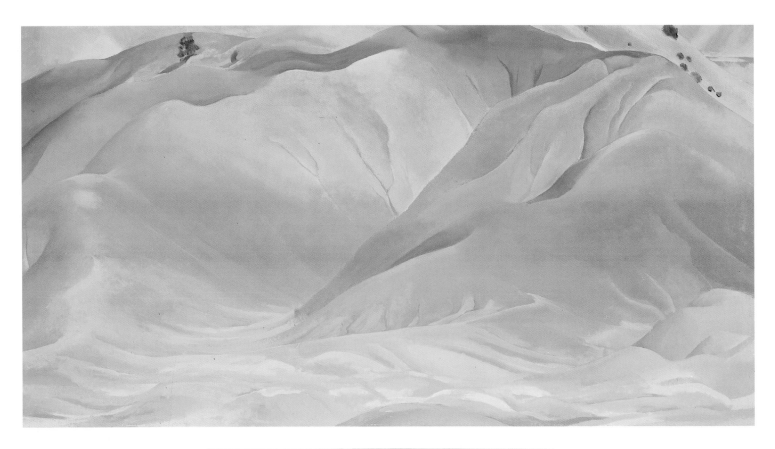

188. Georgia O'Keeffe, Red
and Orange Hills (formerly
My Red Hills), 1938, oil on
canvas, 20 x 36 in. Judge and
Mrs. Oliver Seth

189. Georgia O'Keeffe, The
Mountain, New Mexico,
1931, oil on canvas, 30 x 36
in. Whitney Museum of
American Art, New York

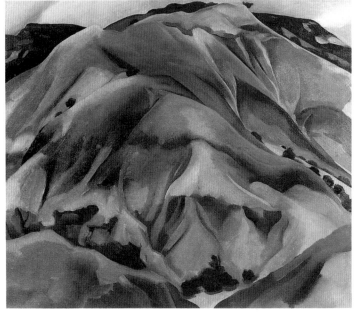

190. Georgia O'Keeffe, Black Hollyhock, Blue Larkspur, *1929, oil on canvas, 36 x 30 in. The Metropolitan Museum of Art, New York, George A. Hearn Fund*

191. Georgia O'Keeffe, After a Walk Back of Mabel's, *1929, oil on canvas, 40 x 30½ in. Philadelphia Museum of Art, Gift of Dr. and Mrs. Paul Todd Makler*

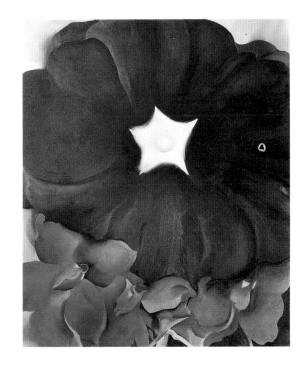

infinite blue, and illuminated in a way that reduces sharp shadows and emphasizes uniformity of shape and color, *Red and Orange Hills* creates and exploits a pictorial tension in a refined composition at once representational and abstract.

The red and orange hues, though of startling intensity, were nevertheless true to the subject. In the varicolored desert, O'Keeffe found an exceptional spectrum, whose effects were heightened by the clear New Mexican light. To New Yorkers unfamiliar with the setting, she once explained: "Badlands roll away outside my door—hill after hill—red hills of apparently the same sort of earth that you mix with oil to make paint. All the earth colors of the painter's palette are out there in the many miles of badlands. The light Naples yellow through the ochres—orange and red purple earth—even the soft earth greens."[19]

O'Keeffe's Black Crosses are backed by gray, black, or crimson, "with once in a while a hot-colored brown hill."[20] Her desert repertoire includes favorite places, which she designated "white" and "black"; gray hills and pink hills; cliffs and canyons of yellow, red, and rust. Bright blossoms and bleached bones inspired her New Mexican still lifes. The blue larkspur and black hollyhock, with its cherry and green throat, which appear in two close-up floral paintings (fig. 190), were found near Mabel Dodge Luhan's Taos home, where O'Keeffe was a guest in 1929; so too was the rock form that she painted in glowing color in *After a Walk Back of Mabel's* (fig. 191), a more abstract souvenir of her first New Mexican summer.

O'Keeffe's range of desert colors was unusually broad and uniquely suited to her decorative style, but most painters

192. John Sloan, Chama Running Red, *1927, oil on canvas, 29½ x 39½ in. The Anschutz Collection*

193. John Sloan, East at Sunset, *1921, oil on canvas, 26 x 32 in. Kraushaar Galleries, New York*

responded in some fashion to nature's unexpected palette. John Sloan's *Chama Running Red* (fig. 192), his best-known New Mexican view, uses brick reds similar to O'Keeffe's in combination with desert ochres, piñon greens, and intense sky blues, colors considerably more saturated than those of his New York works or even his Gloucester seascapes, which immediately preceded his discovery of the Southwest. Sloan's *East at Sunset* (fig. 193), painted from his Santa Fe studio looking toward the Sangre de Cristo Mountains, glows with the "blood of Christ."

Even such a traditional painter as Carlos Vierra succumbed to New Mexico's color. The first artist to establish himself permanently in Santa Fe, he made a specialty of painting the Spanish missions and played an instrumental role in the preservation of those and other historic structures. Although best known today for

his architectural subjects, he was also enamored of pure landscape, which he depicted in various seasons. His *Northern New Mexico in Winter* (fig. 194), for instance, is filled with the colorful drama of hibernal storms and light across rugged mountains. By contrast, Ward Lockwood consciously drained summer color from his palette when painting winter landscapes in the early thirties. In his journal he recorded the lesson of this seasonal motif: "A very important thing I believe is this black and white palette range—that is a dark and light breadth of scale." The stark New Mexican winter discredited the Impressionists' "neglect of this—playing most of the time in a tonal fog—ignoring the value of a sharp contrast to enhance a tonal passage. Ignoring also the passages of white between color areas— passages which allow certain combinations of color to play against themselves—like the passages between rests in music."[21]

*194. Carlos Vierra, Northern
New Mexico in Winter,
ca. 1922, oil on canvas,
28 x 38 in. Collection of
E. W. Sargent*

*195. J. Ward Lockwood,
Midwinter, 1933, oil on
canvas, 24¼ x 32½ in.
Addison Gallery of American
Art, Phillips Academy,
Andover, Massachusetts*

Lockwood's snowy views (fig. 195) offer the pictorial equivalent to Mabel Dodge Luhan's descriptions of "the frozen immunity of winter, [when] the earth . . . looks like blue glaciers, . . . interminably still except for a sudden splash of black, when a couple of crows land on the dark huddle of a carcass."[22]

William P. Henderson's New Mexican views of the 1930s evolved out of different principles. Departing from his early Whistlerian style, Henderson was moved by the desert's forms and colors and his interest in Dynamic Symmetry to the decorative style of *Espirito Santo Grant* (fig. 196). In this study of about 1938 for a mural in Santa Fe's Federal Building, the contours of mesa and mountain are described with thin, dark lines and their colorful, cut-out forms inserted like stage flats into the scenery along the Old Cuba Road. At the end of his career, Henderson used the luminous qualities of oil paint to try to replicate the subtle tones and textures of pastel, a medium in which he had maintained a life-long interest. Henderson's color and compositional experiments combined with his interest in oriental art and philosophy to create the distinctive, decorative style of his late landscapes—like chromatic Sung views of the desert.

Emil Armin turned to Fauve color and self-conscious primitivism to capture his anachronistic impression of Taos as the *Wild West* (fig. 197), in which ribbons of pink, green, and coral animate the landscape. Equally simplified in color were the desert views Stuart Davis painted during the summer of 1923 in Santa Fe. To the unfamiliar terrain Davis brought a style and an aesthetic conviction already well advanced; before his arrival he wrote of his wish "to recover the primary sense of vision" in his painting, and to do this he

196. *William P. Henderson*
Espirito Santo Grant, ca.
1938, oil on canvas, 18 x 30
in. Mrs. Edgar L. Rossin

197. *Emil Armin (1883–*
1971), Wild West, 1929, oil
on canvas, 18⅛ x 21⅛ in.
National Museum of American
Art, Smithsonian Institution,
Washington, D.C., Gift of
Hilda D. Armin

emphasized the primacy of the picture plane and the language of forms and colors, rather than allusive content or pictorial illusionism. "I do not want any illusions of light in the accepted symbolism," he explained, seeking instead "the actual light of the color itself."[23] In Santa Fe, however, Davis found that light and color in daunting abundance. He later complained of the scenery, "You always have to look at it." As a solver of formal problems, he found "not sufficient intellectual stimulus" in the landscape, rich only in its historical associations and "forms made to order, to imitate." Davis finally dismissed New Mexico as "a place for an ethnologist, not an artist."[24]

Despite Davis's reservations about his New Mexican works, in them he used color and light in color with an assurance and freedom unmatched since his Gloucester paintings of the late 1910s. His landscapes were essentially arrangements of simplified, "made-to-order" forms, drawn in shorthand (fig. 198). Sometimes he used descriptive hues, sometimes not, but always the colors were remarkable for their vibrancy and purity. Around the edges of his desert vignettes he painted double borders, as if to stabilize the images as well as to declare them as artifice. Davis, like Edward Hopper, remained essentially an uncommitted outsider in the New Mexican desert; he even parodied it in a still life of his studio, *Electric Bulb, New Mexico*, a jab at the vaunted light of the region.[25] To increase the irony, he painted this souvenir of the Southwest *en grisaille*.

John Marin first encountered New Mexico in 1929—like so many others as the guest of Mabel Dodge Luhan—and he returned the following summer as well. By the late

198. Stuart Davis, New Mexican Landscape, 1923, oil on canvas, 32 x 40¼ in. Amon Carter Museum, Fort Worth, Texas

1920s he was an acknowledged watercolor master and a central figure in Alfred Stieglitz's modernist coterie; but he was also bored with his New York/New England orbit. According to his biographer MacKinley Helm, Marin "felt the world was closing in on him. He was tired of 'living in herds,' of swimming in a 'common pool.' He found it hard to 'keep the spirit unsoiled' in the pool."[26] The year before his discovery of Taos, he had written that "the true artist must perforce go from time to time to the elemental big forms—Sky, Sea, Mountains, Plain . . . to sort of

re-true himself up, to recharge the battery."[27] During his two southwestern summers, he found the "big forms" to renew his creative spirit, which in turn invigorated a generation of Taos artists.

Marin brought to the desert a Cubist-derived style of slashing stroke and fractured form, developed in his years of depicting urban architecture, New England mountains, and Maine's coastal islands. However, his initial response to New Mexico was restrained, as he struggled to come to terms with the unsettling spaciousness of the Taos Valley. He later

199. John Marin, Aspen
Trees in Hondo Canyon,
New Mexico, *1929,*
watercolor on paper, 16½ x 14
in. Private collection

200. John Marin, Storm over
Taos, New Mexico, *1930,*
watercolor on composition
board, 15 x 20¹⁵⁄₁₆ in. National
Gallery of Art, Washington,
D.C., Alfred Stieglitz
Collection

wrote that by contrast "the East looks screened in." The first watercolors of 1929 featured the Sangre de Cristo Mountains in relatively straightforward representations; Marin also escaped the panorama by retreating into the depths of the canyons, where intimate tree and plant motifs were found (fig. 199), as well as his favorite trout fishing pools. "Particularly when the country is new," Marin explained, "I can't take liberties with it at the start—so I look and search and paint what I see."[28]

The artist tried to explain the Taos landscape to Stieglitz: "The *One* who made this country, this big level seeming desert table cut out slices. They are the canyons. Then here and there he put mountains atop. Astanding here you can see six or seven thunder storms going on at the same time. A big sun set seems to embrace the earth. Big sun heat. Big storm. Big everything. A leaving out that thing called *Man*."[29] His wonderment was shared by many. Aldous Huxley, for instance, agreed that "the New Mexican is an inhuman landscape. Man is either absent, . . . or, if present, seems oddly irrelevant. Nowhere are his works an essential part of the scene; nowhere has he succeeded in imposing his stamp on the country."[30]

In time Marin grew more at ease with the scale of the place and could "take

liberties," applying the striking technique that had early won him acclaim. *Storm over Taos* (fig. 200) captures the effect of "walking rain." A rectangular wash of gray depicts the torrent, and next to it the lightning's jagged course suggests some decorative Indian design. In *Canyon of the Hondo, New Mexico* (fig. 201), the drama shifts from sky to land. Like Blumenschein in *Canyon Red and Black* (fig. 184), Marin gazes from within a gorge toward distant land forms on a high horizon. Both artists also divide their compositions with a strong diagonal thrust; however, Marin uses the device not as a conventional entry plane or *repoussoir* but as a means of fracturing near and far. In his most advanced New Mexican works, he solved the pictorial problem of limitless space by eliding the middle ground, bringing closely viewed landscape elements into planar juxtaposition with distant horizons.

New Mexico's inhuman scale had been the undoing of more than a few artists. Emil Bisttram was initially overcome by the sight; he later admitted that "whenever I tried to paint what was before me I was frustrated by the grandeur of the scenery and the limitless space."[31] The unfamiliar scenery made Edward Hopper miserable, until he discovered in Santa Fe familiar motifs of sunstruck buildings (fig. 202) and derelict locomotives, of which he painted seven watercolors during the summer of

203. Walter Ufer, Where the
Desert Meets the Mountain,
*before 1922, oil on canvas,
36½ x 40½ in. The Anschutz
Collection*

1925. John Marin himself admitted that "the country is so damn big—so that if you succeed in expressing a little—one ought to be satisfied and proceed to pat oneself."[32] The immensity often became the subject of the painting, as in Walter Ufer's *Where the Desert Meets the Mountain* (fig. 203). Ufer's canvas seems almost to illustrate Frederic Remington's recollection of his journey to the Taos country in 1902: "Leaving the Rio Grande Railroad at Tres-padres . . . the driver and I trotted all day over the dry table-land, and yet the great blue wall of the Sangre de Cristo range seemed as near and as far as it had in the morning. It was as though we could not get near it."[33] So too Ufer's small wagon, lost amidst the rolling emptiness, seems unlikely ever to attain its destination.

The most consistent effort to plot the

204. *Leon Kroll,* Santa Fe
Hills, *1917, oil on canvas, 34
x 40 in. Museum of Fine Arts,
Museum of New Mexico,
Santa Fe*

205. *Andrew Dasburg,* Taos
Valley, *1928, oil on artist's
board, 13 x 16¼ in. Spencer
Museum of Art, The
University of Kansas,
Lawrence, The Ward and Clyde
Lockwood Collection*

206. Andrew Dasburg, New Mexican Village, *1926, oil on canvas, 24 x 30 in. Museum of Fine Arts, Museum of New Mexico, Santa Fe*

207. Emil J. Bisttram, Taos, *1933, watercolor on paper, 17 x 22½ in. Joslyn Art Museum, Omaha, Nebraska*

measureless tract of the Taos Valley was made by Andrew Dasburg, who first began to paint the area in 1918, as another of Mabel Dodge Luhan's house guests. Not even Dasburg's extensive study in New York, Woodstock, and Paris fully prepared him for the grandeur of the valley, which "seemed to [him] like the first day of creation."[34] Dasburg's abstract styles of the early 1910s were insufficient to encompass the view; and spatial coherence achieved through conventional perspective—as employed by Leon Kroll (fig. 204), for instance—held little appeal for this inventive artist. Dasburg instead reverted to Cézanne and used the patchwork fields, which local farmers had cultivated for generations, to measure the distance. As Cézanne had done with the Provençal landscape and the bay at l'Estaque, Dasburg tipped the quilted middle ground upward to align with the picture plane, flattening the composition and bridging the gap between near and far. The weighty mass of the Sangre de Cristo range sits on the top far edge, the modeled mountain sharply distinguished from the flat middle ground (fig. 205). The solution proved as felicitous with architecture as with patterned fields; in *New Mexican Village* (fig. 206), Dasburg measured the middle distance using as his surveyor's rod the Taos adobes, flattened into color planes.

Dasburg's example was important for a number of New Mexican painters, most notably Lockwood and Bisttram (fig. 207). Their subsequent ready response to Marin's more extreme liberties, to his reinvention of space, would have been unlikely without the precedent of "Cézanne in the Southwest." And ultimately, it was Marin who provided the catalyst for a large group of younger New Mexican artists, like Gina Knee, whose *Near Cordova, N. M.* reflects her

208. *Gina Knee*, Near
Cordova, N.M., *1943,*
watercolor on paper, 19 x 23
in. The Anschutz Collection

209. *Victor Higgins, Arroyo*
Hondo, *ca. 1930, watercolor*
on paper, 16¼ x 19¾ in.
Phoenix Art Museum,
Arizona, Gift of Mr. and Mrs.
Orme Lewis

*210. Victor Higgins, Winter
Funeral, ca. 1930, oil on
canvas, 46 x 60 in. The
Harwood Foundation Museum
of Taos Art, Taos*

debt to Marin (fig. 208). At its best, Marin's model helped Victor Higgins invent with new power (figs. 209, 210); at the other extreme, in less inventive hands, it led to critics' complaints of "tendencies to Marinitis."[35]

The contrast between near and far that charges the New Mexican work of Marin and others was not a mere optical illusion; it was an integral part of desert vision. Several years before Marin and O'Keeffe were drawn there, D. H. Lawrence was captivated by Taos, and the area provided the setting for some of his most memorable tales. In *St. Mawr* (1925) he portrayed another outlander,

a New England woman, facing the realities of life in northern New Mexico. One passage offers a literary parallel to the dual vision of the desert painters:

But even a woman cannot live only into the distance, the beyond. Willy-nilly she finds herself juxtaposed to the near things, . . . and willy-nilly, she is caught up into the fight with the immediate object. The New England woman had fought to make the nearness as perfect as the distance: for the distance was absolute beauty. She had been confident of success. She had felt quite assured, when the water came running out of her bright brass taps, the wild water of the

211. Georgia O'Keeffe, From the Faraway Nearby, 1937, oil on canvas, 36 x 40⅛ in. The Metropolitan Museum of Art, New York, The Alfred Stieglitz Collection

*hills caught, trickled into the narrow iron pipes,
and led tamely to her sink, to jump out over
her sink, into her sink, into her wash basin, at her
service. There! she said. I have tamed the waters
of the mountain to my service. So she had, for the
moment.*

*At the same time, . . . while she revelled
in the beauty of the luminous world that wheeled
around and below her, the gray-rat-like spirit
of the inner mountains was attacking her from
behind. . . . The underlying rat-dirt, the
everlasting bristling tussle of the wild life, with
the tangle and the bones strewing. Bones of horses
struck by lightning, bones of dead cattle, skulls of
goats with little horns: bleached, unburied
bones. The cruel electricity of the mountains. And
then, most mysterious but worst of all, the
animosity of the spirit of the place: like some
serpent-bird forever attacking man.[36]*

Georgia O'Keeffe and the New England
woman shared the struggle with the near
and the far. It was in these vast spaces and
inhuman environs that the painter who is
most prominently identified with New
Mexico found inspiration for her memorable
images. *From the Faraway Nearby* (fig. 211)
combines the "absolute beauty" of the
distance with the "tangle and the bones
strewing," as deerhorns reach down to
embrace and uplift the distant curve of hill,
forsaking any middle ground, locking the
close and the infinite together. The painting
enchants and haunts with a special spirit
of place, not one of Lawrencian animus, but
of art. On this and other occasions, O'Keeffe
moved beyond a pictorial essay on desert
vision to create an icon of a special American
precinct—the nation's exotic, the faraway
nearby.

Explaining his reason for painting in New
Mexico, Robert Henri once said: "I only

want to find whatever of the *great spirit*
there is in the Southwest. If I can hold it on
my canvas I am satisfied."[37] Georgia
O'Keeffe's accomplishment was to hold that
spirit, and to make visual what others had
sensed in the country Ansel Adams
described as "magical." "The skies and land
are so enormous and the detail so precise
and exquisite," he exclaimed, "that
wherever you are, you are isolated in a
glowing world between the macro and the
micro—where everything is sidewise under
you and over you, and the clocks stopped
long ago."[38] The painters' formal plays
with near and far, with macro and micro,
suggest other mergers: of the tangible with
the infinite, of mortality and immortality,
of the personal and the universal. In
depicting New Mexico's vast and magical
spaces, modern landscapists discovered a
metaphor whose romantic possibilities
charged their artistic imaginations, yielding
some of the most memorable images in the
annals of American art.

Notes

1. Marling, "Introduction," in *Woodstock: An
American Art Colony*, n.p.

2. The Whittredge and the Moran are illustrated in
Coke, *Taos and Santa Fe*, pp. 113, 12.

3. Fenn, *The Beat of the Drum and the Whoop of the Dance*,
p. 61.

4. D. H. Lawrence, "New Mexico," *Survey Graphic*
(May 1931), reprinted in *Phoenix: The Posthumous Papers
of D. H. Lawrence*, pp. 141–47.

5. Luhan, "Georgia O'Keeffe in Taos," pp. 407–10.

6. DeKooning, "New Mexico," p. 56.

7. Hartley to Harriet Monroe, 22 August 1918, Elizabeth
McCausland Papers; Hartley, "Aesthetic Sincerity,"
p. 332.

8. Hartley, "America as Landscape," p. 340.

9. Hartley to Stieglitz, 26 August 1918, Alfred Stieglitz Papers; Hartley, "Aesthetic Sincerity," p. 333.

10. Hartley to Harriet Monroe, 13 September 1918, McCausland Papers.

11. Ibid.

12. Rosenfeld, *Port of New York*, p. 92.

13. Quoted in "My World is Different," p. 101.

14. Quoted in Hughes, "Loner in the Desert," p. 67.

15. Jonson address to the Chili Club, Santa Fe, 29 August 1949, quoted in Garman, *The Art of Raymond Jonson*, p. 57.

16. Jonson to Reginald Fisher, 10 March 1956, quoted in Garman, p. 63.

17. Dixon quoted in Burnside, *Maynard Dixon*, pp. 74, 105.

18. Blumenschein quoted in Bickerstaff, *Pioneer Artists of Taos*, p. 37.

19. "Statement by the Artist," in An American Place, *Georgia O'Keeffe: Exhibition of Oils and Pastels*.

20. O'Keeffe, *Georgia O'Keeffe*, opp. pl. 64.

21. Lockwood Journal, 24 February 1933.

22. Luhan, *Winter in Taos*, pp. 85–86.

23. Stuart Davis Notebook, 23 March 1923, quoted in Kelder, *Stuart Davis*, pp. 41–42.

24. Quoted in Sweeney, *Stuart Davis*, p. 15.

25. Illustrated in Udall, *Modernist Painting in New Mexico*, p. 160; and Broder, *The American West*, p. 120.

26. Helm, *John Marin*, p. 64.

27. Marin, *Selected Writings*, p. 127.

28. Marin to Paul Strand, 20 September 1930, quoted in Marin, *Selected Writings*, p. 137; Marin quoted in Lockwood, "The Marin I Knew," p. 109.

29. Marin to Stieglitz, 21 July 1929, in Marin, *Selected Writings*, p. 130.

30. Aldous Huxley, "Preface," in Merrild, *With D. H. Lawrence in New Mexico*, p. xvii.

31. Bisttram quoted in Coke, *Taos and Santa Fe*, p. 90.

32. Marin, *Selected Writings*, p. 129.

33. Quoted in Coke, *Taos and Santa Fe*, p. 10.

34. Dasburg quoted in Coke, *Andrew Dasburg*, p. 46.

35. "Attractions in Other Galleries," *New York Sun*, 9 May 1931, with Lockwood Papers.

36. Lawrence, *St. Mawr: The Later D. H. Lawrence*, p. 159.

37. Henri, *The Art Spirit*, p. 149.

38. Quoted in Richard, "Ansel Adams: Appreciation."

Julie Schimmel

Chronology, 1879–1945

The following literary, historical, scientific, and artistic events served as benchmarks for the authors during the preparation of this manuscript. They represent a broad cultural history of New Mexico between 1879, when Frank Hamilton Cushing arrived at Zuni, and 1945, the year Hopi Indian Fred Kabotie received a Guggenheim Foundation Fellowship. Articles and books listed in the chronology are included to indicate trends in interest; they do not form a complete documentation of publications inspired by New Mexico.

1879

Julius Rolshoven enters Royal Academy in Munich, where he studies until 1893.

Frank Hamilton Cushing arrives at Zuni Pueblo, New Mexico.

Bureau of American Ethnology founded; headed by John Wesley Powell.

John K. Hillers photographs archaeological ruins in New Mexico and Arizona under auspices of Bureau of American Ethnology, Smithsonian Institution.

First passenger train (The Atchison, Topeka and Santa Fe Railway) arrives in Las Vegas, New Mexico.

1880

Original Jake Gold Curio store (renamed in 1903 The Original Old Curio store) sells curios and crafts in Santa Fe, eventually hiring Pueblo and Hispanic craftsmen to work on the premises.

Peter Moran visits San Juan Pueblo; he returns to New Mexico several times during the early 1880s.

Bureau of Immigration established by territorial legislature to attract settlers.

Adolph F. Bandelier begins survey of southwestern archaeological ruins under auspices of Archaeological Institute of America; survey continues for a decade.

U.S. Census reports population of New Mexico as 119,565.

1881

Joseph Henry Sharp enters Antwerp Academy of Fine Arts, where he studies until 1882.

Helen Hunt Jackson's *A Century of Dishonor* is published.

Trading post at Keams Canyon, Arizona, serves as outlet for work of Nampeyo and other Hopi artisans during 1890s.

Billy the Kid killed by Sheriff Pat Garrett near Fort Sumner, New Mexico.

Atchison, Topeka and Santa Fe Railway reaches Deming from Las Vegas, New Mexico, forging a transcontinental link with the Southern Pacific building eastward from California.

1882

Sylvester Baxter's "The Father [Zuni Pueblo] of the Pueblos" appears in *Harper's* (June), illustrated by Willard L. Metcalf and others.

Frank Hamilton Cushing's "My Adventures in Zuni" is published in *Century* (December 1882 and February 1883), illustrated by Henry F. Farny and Willard L. Metcalf.

1883

Sharp first visits New Mexico in course of travels through Southwest and Northwest.

1884

E. Irving Couse enters National Academy of Design in New York, where he studies until 1885.

Rolshoven enters Académie Julian in Paris, where he studies until ca. 1886.

Charles F. Lummis first visits New Mexico.

The United States Indian Industrial School founded in Albuquerque.

1885

Metcalf writes and illustrates "Along the Rio Grande," *Harper's* (April).

Birge Harrison writes and illustrates "Española and Its Environs," *Harper's* (May).

1886

Couse enters Académie Julian, where he studies until 1891; returns to Académie 1892–93.

Robert Henri enters Pennsylvania Academy of the Fine Arts, where he studies until 1888.

Bert Geer Phillips enters Art Students League in New York, where he studies until 1889.

Sharp studies at Royal Academy in Munich; returns in 1889.

Frederic Remington first visits New Mexico; returns repeatedly until last visit in 1907.

Apache leader Geronimo surrenders to General Nelson A. Miles in Mexico.

New territorial capitol building completed in Santa Fe.

Hemenway expedition begins investigating ancient ruins in central Arizona; first scientific excavation in the Southwest.

1887

Sharp studies at Académie Julian ca. 1887–88; returns to Académie 1894–96.

General Allotment (Dawes) Act grants full citizenship and land-owning rights to Plains tribes. The act was also meant to hasten acculturation in the Southwest by uprooting Pueblos from traditional life-styles.

1888

Couse matriculates Ecole des Beaux-Arts in Paris (July).

Lummis photographs Penitentes in New Mexico.

Archaeological Society of New Mexico founded for preservation of New Mexican landmarks.

1889

Phillips enters National Academy of Design, where he studies until 1894.

Governor Edmund Ross signs bill creating University of New Mexico at Albuquerque, agricultural college at Las Cruces, and School of Mines at Socorro (February 28).

1890

Gerald Cassidy establishes residence in Albuquerque; moves to Santa Fe in 1912.

U.S. Census reports population of New Mexico as 160,282 and Taos Indian population in the pueblo as 401.

Bandelier's *The Delight Makers* is published.

The United States Santa Fe Indian School (renamed Institute of American Indian Arts, 1962) established.

Hubbell Trading Post, opened in 1878, in operation at Ganado, Arizona; owner Lorenzo Hubbell begins his campaign to upgrade design and quality of Navajo weaving.

Battle of Wounded Knee, South Dakota, ends Indian resistance to settlement of Great Plains (December 29).

1891

Court of Private Land Claims established primarily to adjudicate property disputes that arose in New Mexico after the Mexican War (1848).

Lummis's "The Land of Poco Tiempo" appears in *Scribner's* (December).

1892

Ernest L. Blumenschein enters Art Students League, where he studies until 1894.

Couse returns to Académie Julian, where he studies until 1893.

John Sloan enters Pennsylvania Academy of the Fine Arts, where he studies until 1893.

New capitol building at Santa Fe burns, destroying many public documents (May 12).

Atchison, Topeka and Santa Fe Railway sends Thomas Moran and Fernand H. Lungren to Arizona and New Mexico.

1893

Sharp sent by *Harper's Weekly* to Taos; illustrates "The Harvest Dance of the Pueblo Indians of New Mexico" (October 14).

World's Columbian Exposition in Chicago features major anthropological exhibits devoted to Plains and southwestern tribes.

Lummis's *The Land of Poco Tiempo* is published.

1894

Blumenschein enters Académie Julian, where he studies until 1896; continues at Académie 1899–1901 and, intermittently, 1902–9.

Sharp returns to Académie Julian, where he studies until 1896.

Photographer Frederick I. Monsen first visits Southwest; remains until 1895.

1895

Phillips enters Académie Julian in late 1895 or early 1896 and remains until 1897.

Sharp tells Blumenschein and Phillips about Taos while they are together in Paris.

Walter Ufer enters Royal Academy of Fine Arts in Dresden, where he studies until 1898.

Adam Clark Vroman first visits New Mexico and photographs Hopi Snake Dance.

Nampeyo examines pottery shards excavated by J. Walter Fewkes at Sikyatki, an ancient site on First Mesa. Revival of Sikyatki ware begun by Hopi potters.

Owen Wister's "La Tinaja Bonita" appears in *Harper's* (May).

1896

Lungren illustrates Owen Wister's "Thirst," *Harper's Weekly* (February 8).

1897

Blumenschein sent by *McClure's* to New Mexico; illustrates "A Strange Mixture of Barbarism and Christianity: The Celebration of San Geronimo's Day among the Pueblo Indians" (December 10).

1898

Blumenschein and Phillips first visit Taos; Phillips remains.

1899

Oscar E. Berninghaus first visits Taos; returns each summer until 1925, when he establishes residence.

Blumenschein illustrates "The Advance of Civilization in New Mexico: The Merry-Go-Round Comes to Taos," *Harper's Weekly* (October 28).

Marsden Hartley studies at New York School of Art (Chase School).

John Marin enters Pennsylvania Academy of the Fine Arts, where he studies until 1901.

Ufer enters Art Institute of Chicago, where he studies until 1900.

Vroman accompanies Frederick W. Hodge to photograph New Mexican pueblos.

Herman Schweizer of Fred Harvey organization (owner and operator of tourist facilities in the Southwest) commissions new Navajo silverwork for tourists.

1900

Berninghaus attends St. Louis School of Fine Arts (Washington University School of Fine Arts) ca. 1900; begins spending summers in Taos.

Hartley enters National Academy of Design, where he studies until 1904.

New capitol building in Santa Fe designed by firm of I. H. Rapp and W. M. Rapp is dedicated; remodeled 1951.

U.S. Census reports population of New Mexico as 195,310.

1901

E. Martin Hennings enters Art Institute of Chicago, where he studies until 1904; periodically returns to Institute 1904–12.

1902

Couse first visits New Mexico; summers in Taos until 1927, when he establishes residence there.

Andrew Dasburg enters Art Students League, where he studies periodically until 1906; also studies briefly with Henri at New York School of Art (Chase School).

Victor Higgins enters Art Institute of Chicago, where he studies until 1905 and again 1908–9.

Kenneth Chapman discovers Navajo painter Apie Begay.

Hopi restrict photography at village of Oraibi.

Charles F. Whittlesey designs Alvarado Harvey House (hotel), Albuquerque, in California Mission style. Mary Elizabeth Jane Colter designs interior exhibit room and workroom for artisans. Building houses Fred Harvey Fine Arts Department, which eventually amasses some six thousand Indian and Spanish colonial articles.

Sunmount Sanitorium, Santa Fe, established by Dr. Frank E. Mera; many influential Santa Feans begin New Mexican residence here, including Witter Bynner, Alice Corbin Henderson, John Gaw Meem, and Carlos Vierra.

1903

George A. Dorsey's *Indians of the Southwest* is published by Atchison, Topeka and Santa Fe Railway.

Edward S. Curtis photographs Indians in New Mexico.

1904

Louisiana Purchase Exposition held in St. Louis, featuring 1,100 representatives of aboriginal tribes.

Carlos Vierra becomes Santa Fe's first resident artist.

Max Frost and Paul A. F. Walter publish *Resources, Products, Industries and Climate of New Mexico* (Bureau of Immigration).

George Wharton James publishes series of articles on Spanish missions in the Southwest in *The Craftsman* (March, April, July, and August 1904).

1905

Marin goes to Paris, where he remains until 1910.

Georgia O'Keeffe enters Art Institute of Chicago, where she studies until 1906.

Natalie Curtis's *Songs of Ancient America* is published.

1907

O'Keeffe enters Art Students League, where she studies until 1908.

School of American Archaeology founded by Edgar L. Hewett.

1908

The Eight stage legendary exhibition at Macbeth Gallery; participants Henri and Sloan later visit New Mexico.

1909

Dasburg goes to Paris and meets Matisse, Leo and Gertrude Stein, and Picasso.

N. C. Wyeth's "A Sheep-Herder of the Southwest" appears in *Scribner's* (January).

Territorial legislature establishes Museum of New Mexico, which transforms old Palace of the Governors into combined historical museum and headquarters for the School of American Archaeology. Hewett serves as director of the museum and school until his death in 1946.

Restoration of the Palace of the Governors begins under supervision of Jesse Nusbaum; completed 1913.

About this time, San Ildefonso Indians, including Julian Martinez, are employed by School of American Archaeology in excavation at Frijoles Canyon.

1910

Stuart Davis begins studies with Henri in New York, which continue until 1913.

Higgins attends Académie de la Grande Chaumière, Paris, 1910–13.

El Ortiz hotel built, Lamy, New Mexico; Colter interior designer.

U.S. Census reports population of New Mexico as 327,301 and Taos Indians living in the pueblo as 515.

1911

W. Herbert Dunton attends Art Students League.

Ufer enters Royal Academy in Munich, where he studies until 1913.

Franz Boas's *The Mind of Primitive Man* is published.

1912

Dunton moves to Taos.

Hartley travels to Paris, London, and Berlin 1912–15; meets Wassily Kandinsky, Franz Marc, and other members of the Blaue Reiter group.

Hennings enters Royal Academy in Munich, where he studies until 1915.

O'Keeffe supervisor of art in the public schools, Amarillo, Texas, until 1914.

Sharp establishes permanent residence in Taos.

President Taft proclaims New Mexico the forty-seventh state of the Union (January 6).

1913

Paul Burlin settles in Santa Fe.

Armory Show held in New York (February) and a reduced version in Chicago (March) and Boston (April).

El Palacio published by the New Mexico Archaeological Society; Paul A. F. Walter editor.

Society for the Preservation of Spanish Antiquities in New Mexico founded.

1914

Higgins first visits Taos; establishes permanent residence 1915.

O'Keeffe studies with art educator and theoretician Arthur W. Dow at Teachers College, Columbia University, until 1915.

Ufer first visits Taos.

James Earle Fraser designs Buffalo Nickel.

1915

O'Keeffe returns to Texas and teaches in Canyon until 1917; paints her first modern southwestern landscapes.

First official meeting of the Taos Society of Artists (July), founded by Berninghaus, Blumenschein, Couse, Dunton, Phillips, and Sharp; annual meetings continue until 1927. First major TSA exhibition in the Palace of the Governors, Santa Fe.

Willa Cather first visits New Mexico.

Panama–California Exposition held in San Diego, featuring a building devoted to Indian arts and an exhibition of Taos/Santa Fe paintings.

Panama–Pacific Exposition held in San Francisco, for which Fraser enlarged to heroic size *End of the Trail*.

1916

Henri first visits Santa Fe.

Rolshoven first visits New Mexico; remains two years.

Theodore Van Soelen moves to Albuquerque.

Alfred Stieglitz exhibits watercolors and drawings by O'Keeffe in group show at Gallery 291.

Mr. and Mrs. Burrit (Burt) Harwood move to Taos.

First Taos Society of Artists traveling exhibition.

Alice Corbin and William Penhallow Henderson move to Santa Fe.

Mabel Dodge Sterne (later Luhan) moves to Taos.

Jan Matulka visits Arizona and New Mexico.

1917

United States enters World War I (April 6).

Leon Kroll first visits Santa Fe.

Hennings first visits Taos; establishes residence in 1921.

O'Keeffe first visits New Mexico (establishes residence in 1949); given first solo exhibition by Stieglitz.

Museum of Fine Arts, Santa Fe, dedicated.

TSA elects members Ufer and Higgins and associate member Rolshoven.

School of American Archaeology becomes School of American Research, with a revised charter enabling it to collect Indian material.

Hewett commissions Indian artists Crescencio Martinez and Awa Tsireh to illustrate customs and ceremonies of Pueblo life. Studio space for both provided in the Palace of the Governors, where other Indian and Anglo artists are in residence.

1918

Gustave Baumann moves to Santa Fe.

Blumenschein, acting as special representative of the War Service committee for the Salmagundi Club (New York), spearheads contributions from Taos artists of "range finder" (scenes of European landscape used for target practice) paintings to the war effort.

Dasburg first visits Taos as guest of Mabel Dodge Sterne; establishes residence in 1933.

Hartley first visits Taos and Santa Fe; returns 1919.

TSA elects associate member Henri; honorary members Hewett and Frank Springer; Rolshoven made active member.

Mary Austin first visits Santa Fe; settles there in 1924.

Maria and Julian Martinez make first black-on-black pottery (San Ildefonso Pueblo).

1919

Blumenschein establishes residence in Taos.

B. J. O. Nordfeldt moves to Santa Fe.

Sloan summers in Santa Fe; returns annually for thirty years.

TSA elects associate member Albert Groll.

Santa Fe Fiesta, established in 1712 and sporadically held thereafter, is revived by Hewett and others; includes Spanish Market.

1920

Willard Nash moves to Santa Fe.

Will Shuster moves to Santa Fe.

Jozef Bakos first visits Santa Fe; moves there 1921.

Sloan sends group of Indian watercolors to Society of Independent Artists exhibition, New York. Mary Austin arranges show at American Museum of Natural History, New York; includes Crescencio Martinez, Awa Tsireh, and others.

Alice Corbin Henderson's *Red Earth: Poems of New Mexico* is published.

Hartley's "Red Man Ceremonials: An American Plea for American Esthetics" appears in *Art and Archaeology* (January).

Poets Carl Sandburg, Vachel Lindsay, and Harriet Monroe visit Santa Fe.

U.S. Census reports population of New Mexico as 360,350.

1921

Los Cinco Pintores founded by Bakos, Fremont F. Ellis, Walter Mruk, Nash, and Shuster. Group holds first exhibition at the Museum of Fine Arts; dissolves 1926.

TSA elects associate members Sloan, Randall Davey, and Nordfeldt.

Frank Applegate moves to Santa Fe; Lorin W. Brown introduces him to Cordova woodcarver José Dolores Lopez. Santa Feans subsequently frequent Cordova both to encourage woodcarving tradition and to witness Penitente rituals during Holy Week.

Senator Holm O. Bursum introduces congressional bill to confirm all non-Indian land claims held for more than ten years prior to statehood in 1912. Bill recalled after protest by Indian Rights Association, the Eastern Association on Indian Affairs, and the General Federation of Women's Clubs.

New Mexico experiences drought and depression through 1923.

1922

Hartley's "The Scientific Esthetic of the Redman" appears in *Art and Archaeology* (March and September).

Raymond Jonson first visits Santa Fe; establishes residence 1924.

TSA elects associate members Birger Sandzen and Baumann.

Committee for the Preservation and Restoration of New Mexico Missions is spearheaded by Anne Evans and John Gaw Meems with support of Mary Austin, Dan Kelly, Paul A. F. Walter, Frank Mera, and Carlos Vierra.

First Annual Southwest Indian Fair held in connection with Fiesta.

Amelia White opens Ishauu Shop (978 Madison Avenue, New York) offering Indian arts and crafts; closes 1931.

Formation of Indian Arts Association in Santa Fe to encourage native crafts.

Witter Bynner arrives at Sunmount Sanitorium in Santa Fe.

Spud Johnson, James Van Rensselaer, and Roy Chanslor publish New Mexican literary magazine, *Laughing Horse*.

D. H. and Frieda Lawrence visit New Mexico (1922–23 and 1924–25).

1923

New Mexico Painters group formed by Applegate, Bakos, Baumann, Blumenschein, William P. Henderson, Higgins, Nordfeldt, and Ufer.

Stuart Davis summers in New Mexico.

Laura Gilpin begins photographing in New Mexico.

Mabel Dodge marries Tony Luhan.

El Navajo hotel, Gallup, New Mexico, built by Fred Harvey organization; Colter architect and designer.

Burt Harwood dies. Taos home willed to the University of New Mexico; becomes Harwood Foundation.

1924

Kenneth Adams joins Andrew Dasburg; shortly thereafter moves to Santa Fe.

Sloan's "The Indian Dance from an Artist's Point of View" appears in *Arts and Decoration* (January).

New Mexico Painters show at Montross Gallery, New York; original members joined by Dasburg, Davey, Sloan, and Van Soelen.

Taos Society of Artists elects active members Catherine C. Critcher and Hennings.

Mary Austin settles in Santa Fe.

Blanche C. Grant's *Taos Today* is published.

Act of Congress creates Pueblo Lands Board to settle non-Indian claims to land in conflict with Pueblo land grants.

The Spanish Colonial Arts Society created by Austin and Applegate.

1925

William P. Henderson forms Pueblo-Spanish Building Company with partners; renovates and extends Sena Plaza as well as the home of the Misses Amelia and Martha White (later to become the School of American Research). In 1926 he begins to design and produce handmade furniture.

Edward Hopper summers in Santa Fe.

Indian Art Fund established to preserve heritage of Pueblo tribes.

Barbara Latham moves to Taos.

Carl Jung visits Taos.

1926

Howard Cook first visits Taos to prepare woodcuts for serialized version of Willa Cather's *Death Comes for the Archbishop*; establishes residence in 1935.

Alexandre Hogue first visits Taos.

Ward Lockwood moves to Taos.

Paul Strand first visits New Mexico.

TSA elects active member Kenneth M. Adams; tours final exhibition.

Spanish and Indian Trading Post established by Bynner, Dasburg, Mruk, Nordfeldt, and John Evans (son of Mabel Dodge Luhan).

First Fred Harvey "Indian Detour" automobile excursion to New Mexico sites.

Anglo artists first stage El Pasatiempo, a humorous parade intended to establish their "presence" in Santa Fe society.

1927

TSA dissolved by members.

Willa Cather's *Death Comes for the Archbishop* is published.

Ansel Adams first visits New Mexico.

1928

Lewis Meriam and associates produce *The Problem of Indian Administration*; lays groundwork for introduction of art education into Indian schools; opposes policy of assimilation that had discouraged the continuity of Indian culture.

The Turquoise Trail: An Anthology of New Mexico Poetry, edited by Alice Corbin Henderson, is published.

1929

Panic of 1929; stock market crashes October 29.

Marin summers in Taos at invitation of Mabel Dodge Luhan; returns summer 1930.

O'Keeffe with Rebecca Strand first visits Taos as guest of Mabel Dodge Luhan.

Applegate's *Indian Stories from the Pueblos* is published.

Bynner's *Indian Earth* is published.

Oliver La Farge's *Laughing Boy* is published.

Laboratory of Anthropology established in Santa Fe with grant from John D. Rockefeller; building designed by Meem is completed in 1931.

E. Boyd arrives in New Mexico.

Spanish Colonial Arts Society purchases the Santuario at Chimayo to prevent dismantling of the chapel.

Spanish Arts shop, sponsored by Spanish Colonial Arts Society, opens; closes 1934.

La Fonda hotel, Santa Fe, originally designed in 1920 by the firm of I. H. Rapp, W. M. Rapp, and A. C. Hendrickson, is remodeled and enlarged by Meem; Colter interior designer.

1930

Emil Bisttram first visits New Mexico; establishes residence 1932.

Hewett's *Ancient Life in the American Southwest* is published.

U.S. Census reports population of New Mexico as 423,317.

1931

Austin's *Starry Adventure* is published.

Erna Fergusson's *Dancing Gods: Indian Ceremonials of New Mexico and Arizona* is published.

Exposition of Indian Tribal Arts, Grand Central Art Galleries, New York, is held, featuring southwestern Indian objects and including a publication with essays by Sloan, Oliver La Farge, Mary Austin, Kenneth M. Chapman, Alice Corbin Henderson, and prominent anthropologists.

1932

Bisttram founds Heptagon Gallery, probably first commercial gallery in Taos.

Cady Wells moves to New Mexico; studies with Dasburg until 1933.

Ernest Knee moves to Santa Fe.

Martha Graham visits Santa Fe.

Austin's *Earth Horizon: An Autobiography* is published.

Dorothy Dunn teaches first studio classes at the Santa Fe Indian School, Santa Fe.

Brice Sewell appointed state director for Vocational Education and Training in New Mexico; utilizing city, state, and federal funds, he establishes statewide vocational centers to revive Hispanic craft traditions.

1933

Amelia White sponsors Gallery of American Indian Art (850 Lexington Avenue, New York), offering selected items from Exposition of Indian Tribal Arts (1931). Dolly Sloan manages gallery until 1937, when it closes and contents are distributed to museums on exposition tour.

Santa Fe/Rio Grande Painters formed, including E. Boyd; dissolves 1936.

Federal art patronage operates in New Mexico until 1943; includes four major New Deal art projects: Public Works of Art Project (PWAP, December 1933–June 1934, Jesse Nusbaum director, Gustave Baumann area co-ordinator); Treasury Section of Painting and Sculpture (October 1934–July 1939, Nusbaum director); Treasury Relief Art Project (TRAP, July 1935–June 1939, Nusbaum regional advisor and, with Emil Bisttram, local

supervisor in New Mexico); and Works Progress Administration (WPA, August 1935–July 1943, R. Vernon Hunter director in New Mexico).

Kenneth M. Chapman's *Pueblo Indian Pottery* is published.

1934

Bisttram, Higgins, Lockwood, and Phillips paint ten fresco murals for Taos County Courtyard.

O'Keeffe spends first summer at Ghost Ranch, north of Abiquiu.

Indian Reorganization Act; sanctions teaching of Indian art in government Indian schools.

Native Market (nonprofit) operates as outlet for Hispanic crafts until 1940.

Baumann submits PWAP report on New Mexican federal art projects to Treasury Department, Washington, D.C.

1935

First scholarly study of the Penitente Brotherhood completed: Dorothy Woodward, "The Penitentes of New Mexico," Yale University doctoral dissertation.

Indian Arts and Crafts Board established, headed by René d'Harnoncourt; provides focus and encouragement on a national level for Indian art revival.

1936

Main library and exhibition room of the Harwood Foundation, designed by Meem, is built.

1937

Alice Corbin Henderson's *Brothers of Light: The Penitentes of the Southwest* is published; illustrated by her husband, William P. Henderson.

1938

Bisttram and Jonson found New Mexico Transcendental Artists group.

1939

Thomas Benrimo moves to Taos.

1941

Helen Pearce moves to New Mexico.

Frank Waters's *People of the Valley* is published.

1942

Los Alamos selected as national center for nuclear research.

Frank Waters's *The Man Who Killed the Deer* is published.

1945

Fred Kabotie (Hopi) awarded Guggenheim Foundation Fellowship.

Artists' Biographies

The following biographies provide additional information on seventy-two of the artists, artisans, and photographers mentioned in the preceding chapters. The subjects are Hispanic and Indian, as well as Anglo. "A.N.A." denotes the date of an artist's election as an associate member of the National Academy of Design; "N.A.," election as a full member. Selected references in chronological order follow each biography; in the case of short-form entries, see the alphabetical Bibliography (p. 210) for the full citation.

All Hispanic artists listed are *santeros*, a twentieth-century term that refers to makers of sacred images used for public and private devotion in colonial and nineteenth-century New Mexico. Other terms with which the reader may not be familiar are:

santo

a religious folk image, painted or carved, used in daily Christian practice; *santos* decorated homes, private chapels, and churches and were often carried in religious processions

retablo

sometimes used to refer to a complete altar screen, the term more commonly describes an individual, two-dimensional panel painting, which may or may not be a component of a larger decorative scheme

bulto

a sculptured image, generally of carved and painted wood, representing an individual saint; a *bulto* may also be a component of an altar screen

morada

a small meetinghouse, usually of adobe construction, that functioned as the center of neighborhood Penitente activities; during Holy Week, these entailed a dramatic re-enactment of Christ's passion; at other times of the year, the observance of various saint's days

A. J. Santero

(active 1820s)
Painter, sculptor

Spontaneous draftsmanship, high-keyed colors, and distortion of figures and details characterize the work of this artist, named for the initials that appear on one of his *retablos*. His diverse subject matter suggests a knowledge of popular prints imported from Mexico. Although not prolific, the A. J. Santero was a technical innovator, with a broader, freer style than many of his contemporaries.

References

Boyd. *Popular Arts of Spanish New Mexico*, p. 366.

Wroth. *Christian Images in Hispanic New Mexico*, p. 192.

Kenneth Miller Adams

(1897–1981)
Painter, printmaker
A.N.A. 1938, N.A. 1961

Born in Topeka, Kansas, Adams first studied at the Art Institute of Chicago, then at the Art Students League in New York with Kenneth Hayes Miller and George Bridgman. He attended summer classes in Woodstock, New York, taught by Andrew Dasburg, who encouraged him to move to New Mexico in 1924, where Adams lived until his death. His compassionate regard for Hispanics and a renewed interest in landscape largely determined the subjects of his paintings. Adams was the last artist to join the Taos Society of Artists before it disbanded in 1927. His blend of conservative and modernist styles made him a pivotal figure between the founders of the society and the second generation of artists, many of whom were sympathetic to new trends developing in New York and Europe.

References

Goff, Lloyd Lozes. "Kenneth M. Adams." In *New Mexico Artists, New Mexico Artists Series No. 3*, pp. 51–60. Albuquerque: University of New Mexico Press, 1952.

Coke, Van Deren. *Kenneth M. Adams: A Retrospective Exhibition*. Albuquerque: University of New Mexico Press, 1964.

Broder. *Taos: A Painter's Dream*, pp. 269–85.

José Rafael Aragon

(ca. 1796–1862)
Sculptor, painter

Frequently called Rafael Aragon to distinguish him from his contemporary and fellow *santero* José Aragon, José Rafael Aragon was the most accomplished and popular religious artist in New Mexico during the first half of the nineteenth century. His figures, based on Late Baroque sources, deliver a simple and universal message of faith with what one authority has called "angelic freshness." Unlike most nineteenth-century inhabitants of New Mexico, Rafael Aragon could read and write, perhaps because he was raised in Santa Fe, in the *barrio* near the cathedral. Eventually he moved his family to Pueblo Quemado (now Cordova), where he divided his time between farming and painting and carving altar screens. During the 1830s, because of increasing demand for the latter, he established a workshop in which apprentices were trained in the master's technique and style. Rafael's remarkable career lasted another thirty years, during which his work went through considerable change and development.

References

Boyd. *Popular Arts of Spanish New Mexico*, pp. 392–407.

Mather, Christine. "José Rafael Aragon." In *American Folk Painters of Three Centuries*, edited by Jean Lipman and Tom Armstrong, pp. 47–51. New York: Hudson Hills Press, 1980.

Wroth. *The Chapel of Our Lady of Talpa*, pp. 129–59.

Arroyo Hondo Carver

(active 1830–50)
Sculptor

An anonymous *santero*, named for the village north of Taos where many of his works were found, the Arroyo Hondo Carver may have studied with the painter named for the same village. His figures, frontal and static, have the appearance of medieval sculpture, but with more graceful contours and softer drapery lines. Facial features are schematic, impassive, yet strangely moving. Scholars generally agree that the figures of the Arroyo Hondo Carver represent the most purely spiritual work by any sculptor active in New Mexico during the nineteenth century.

References

Espinosa, José E. *Saints in the Valleys: Christian Sacred Images in the History, Life and Folk Art of Spanish New Mexico*, pp. 75–76. Albuquerque: University of New Mexico Press, 1960.

Denver Art Museum. *Santos of the Southwest*, pp. 34–35. Denver: Denver Art Museum, 1970.

Wroth. *Christian Images in Hispanic New Mexico*, pp. 185–91.

Arroyo Hondo Painter

(active ca. 1825–40)
Painter

With a limited palette and exacting brushwork, the Arroyo Hondo Painter created an oeuvre of great delicacy, sweetness, and refinement. His use of decorative patterns rather than solid areas of color for clothing, draperies, and background led an earlier scholar to name him the "Dot-Dash Santero." More recently he has been referred to as the "Arroyo Hondo Painter," after his major work, the altar screen for the church of Nuestra Señora de los Dolores de Arroyo Hondo, in a small village north of Taos. Although there are few known works by this anonymous *santero*, they are considered among the best of New Mexican folk painting.

References

Boyd. *Popular Arts of Spanish New Mexico*, pp. 374–75.

Wroth. *Christian Images in Hispanic New Mexico*, pp. 115–22.

Awa Tsireh (Alfonso Roybal)

(ca. 1895–ca. 1955)
Painter

Nephew of Crescencio Martinez, Awa Tsireh received a brief formal education in his home village, San Ildefonso Pueblo, New Mexico. He was inspired to paint by his uncle, whom he soon surpassed in graphic skills. About 1917 Awa Tsireh was commissioned by Edgar L. Hewett to make paintings of Indian ceremonies. This brought him into daily contact at the School of American Research with Indian painters Fred Kabotie (Hopi) and Ma-Pe-Wi (Zia) and artist William P. Henderson, who also occupied studios there. By the thirties, after his work had appeared in major exhibitions of Indian art in Chicago and New York, Awa Tsireh enjoyed a national reputation. With India ink and a brilliant, distinctive palette, he produced decorative paintings of great precision. His style developed from a naive realism, used to depict genre and dance scenes, through more abstract phases featuring landscape "props" and stylized animal forms. Awa Tsireh had a profound influence on the work of many other artists, who were inspired by his wide range of subject matter, delicacy of draftsmanship, color variations, and preservation of indigenous design elements.

References

"An Indian Goya Who Amazes Artists." *The Literary Digest* 87 (17 October 1925): 44–46.

Dunn, Dorothy. "Awa Tsireh: Painter of San Ildefonso." *El Palacio* 63 (April 1956): 108–15.

————. *American Indian Painting*, pp. 204–7.

Tanner. *Southwest Indian Painting*, pp. 88–98.

Jozef G. Bakos

(1891–1977)
Painter

Bakos first studied at the Albright Art Institute in his native Buffalo, New York, and later with John Thompson in Denver. In 1920, during a break from teaching at the University of Colorado in Boulder, he visited Walter Mruk, a childhood friend who was working in Santa Fe. During Bakos's stay, the two exhibited together at the Museum of Fine Arts, which had opened in Santa Fe three years earlier. The next year Bakos returned permanently, and with Mruk, Fremont Ellis, Willard Nash, and Will Shuster, formed the avant-garde group Los Cinco Pintores, which held its first exhibition in December 1921 at the Museum of Fine Arts. Bakos responded to the New Mexican landscape and the indigenous population with a broad, flowing style, highly charged with personal meaning.

References

"Los Cinco Pintores." *El Palacio* 11 (1 November 1921):110–13.

Cassidy, Ina Sizer. "Art and Artists of New Mexico." *New Mexico Magazine* 10 (February 1932):18.

Robertson, Edna. *Los Cinco Pintores.* Santa Fe: The Museum of New Mexico, 1975.

Gustave Baumann

(1881–1971)
Printmaker, painter

While still a young boy, Baumann emigrated with his family from Magdeburg, Germany, to Chicago. He returned to Germany to study at Kunstgewerbeschule in Munich and later attented the Art Insititue of Chicago. After moving to Santa Fe in 1918, he became a leading member of the art community, respected for services he performed on behalf of his colleagues and for his experiments in a wide variety of media. Baumann was appointed area coordinator of the Public Works of Art Project of the Works Progress Administration beginning in the early 1930s. During this time, he also carved and decorated a large number of marionettes, with which he and his wife and other artists toured the state, acting out Hispanic and Indian folk stories. In 1939, he published *Frijoles Canyon Pictographs*, illustrated with woodblock prints of prehistoric Indian designs and figures carved in the canyon walls. Later he incorporated such anthropological imagery into his art.

References

Baumann, Gustave. "At Work on Taos and Rio Pictures." *El Palacio* 6 (January 1919):47.

Cassidy, Ina Sizer. "Art and Artists of New Mexico." *New Mexico Magazine* 10 (October 1932):24.

Garoffolo, Vincent. "The Woodblock Art of Gustave Baumann." In *New Mexico Artists, New Mexico Artist Series No.3*, pp. 35–44. Albuquerque: University of New Mexico Press, 1952.

Thomas Duncan Benrimo

(1887–1958)
Painter

Benrimo, a native of San Francisco, briefly attended the Art Students League in New York, after which he began a career as a commercial artist and theatrical scene designer. From 1935 to 1939, he taught at the Pratt Institute but then moved to Taos with the intent of devoting more time to easel painting. The vast, lonely landscape of New Mexico suggested to Benrimo a surreal stage set, the mood of which he captured in a number of paintings during the early 1940s. He was the first artist in the region to employ a surrealist style, although he gave it up several years later in favor of a more nonrepresentational approach.

References

MacAgy, Douglas. *American Genius in Review, No. 1: Murphy, Schamberg, Benrimo, Russell, Covert.* Dallas: Dallas Museum for Contemporary Arts, 1960.

Coke. *Taos and Santa Fe*, p. 100.

Witt, David L. *The Taos Artists: A Historical Narrative and Biographical Dictionary.* Colorado Springs: Ewell Fine Art Publications, 1984.

Oscar Edmund Berninghaus

(1874–1952)
Painter
A.N.A. 1926

A few months of night classes at the St. Louis School of Fine Arts, his only formal training, led Berninghaus to a successful career as a painter and illustrator. While touring the Southwest in 1899, he was persuaded by a brakeman on the Denver and Rio Grande Railroad to visit Taos. He stayed only a week on his first trip but returned from his native St. Louis each summer until 1925, when he settled in Taos permanently, drawn by the diverse population and scenic landscape. Berninghaus was one of six founders of the Taos Society of Artists in 1915. By the early 1920s, he was well known in the East as a painter of Indians and the southwestern landscape, which remained his favorite subjects for the next thirty years.

References

Cassidy, Ina Sizer. "Art and Artists of New Mexico." *New Mexico Magazine* 11 (January 1933):28, 41–42.

Broder. *Taos: A Painter's Dream*, pp. 115–35.

Bickerstaff. *Pioneer Artists of Taos*, pp. 85–98.

Emil James Bisttram

(1895–1976)
Painter

Bisttram, who left his native Hungary as a young boy, began a career as a commercial artist in New York. He then changed direction, studying successively at the National Academy of Design, Cooper Union, the Art Students League, and with Howard Giles at the New York School of Fine and Applied Art. Bisttram developed into an accomplished teacher in his own right during this period. In 1930 he traveled to New Mexico for a three-month stay, finding it difficult to adjust at first to the strong light and color. He then went to Mexico, supported by a Guggenheim grant, to study fresco techniques with Diego Rivera. After returning to Taos (1932), he started the Heptagon Gallery, probably the first commercial gallery in town, and the Taos School of Art, with a decidedly avant-garde curriculum. Bisttram's own style, which reflected the extent of his taste and interests, ranged from a broad, calm, 1930s classicism to cosmic abstractions based on Jay Hambidge's Dynamic Symmetry theory. In 1938 Bisttram founded the New Mexico Transcendental Artists group and in 1952 cofounded the Taos Art Association.

References

Bisttram, Emil. "On Understanding Contemporary Art." *El Palacio* 64 (July/August 1957):201–8.

Witt, David. *Emil James Bisttram.* Taos: Harwood Foundation, 1983.

Udall. *Modernist Painting in New Mexico*, pp. 196–98.

Ernest Leonard Blumenschein

(1874–1960)
Painter
A.N.A. 1910, N.A. 1927

Born in Pittsburgh and raised in Dayton, Ohio, Blumenschein was offered a scholarship to study violin at the Cincinnati Conservatory when he was seventeen. After a year of music training, however, he chose to follow his interest in art. He studied first at the Cincinnati Art Academy, then at the Art Students League in New York and the Académie Julian in Paris, where in 1895 he met Joseph Henry Sharp, who had already been to Taos, and Bert G. Phillips. On the advice of Sharp, Blumenschein and Phillips set out on a sketching trip to Taos in 1898. Blumenschein returned to Paris in 1899 and remained, with the exception of one trip home, until 1909. From 1910 until 1918, he spent summers in New Mexico and the rest of the year in New York,

where he continued to work as an illustrator and to teach at the Art Students League. In 1915 he was a founding member of the Taos Society of Artists with Phillips, Sharp, Oscar E. Berninghaus, E. Irving Couse, and W. Herbert Dunton. His colleagues regarded him as the most accomplished painter of the group. After moving permanently to Taos in 1919, Blumenschein and his artist wife Mary contributed significantly to the development of the art community.

References

"Blumenschein Is Interviewed," pp. 84–86.

Henning. *Ernest L. Blumenschein Retrospective.*

Brown, Sherry. "Ernest L. Blumenschein, 1874–1960." *Artists of the Rockies and the Golden West* 9 (Spring 1982):68–75.

Bickerstaff. *Pioneer Artists of Taos*, pp. 29–50.

John Gutzon de la Mothe Borglum
(1867–1941)
Sculptor

Born in Idaho Territory, Borglum spent most of his youth in the Midwest, where he gained a deep respect for frontier life, an enduring love of horses, and a fascination with "the wild red men of the plains," as he referred to them. He began his studies at the Mark Hopkins Art Institute in San Francisco, experimenting with small sculpture. From 1891 to 1892, while at the Ecole des Beaux-Arts and the Académie Julian in Paris, he exhibited scenes of the American West at the New Salon. Borglum settled in New York and Connecticut in 1902, hoping to concentrate on subjects that would

evoke the spirit of America's past. His largest completed work, the four presidential portraits on Mount Rushmore, is typical of the grandiose, patriotic visions of his later career.

References

Borglum, Gutzon. "Art that Is Real and American." *The World's Work* 28 (June 1914):200–17.

Casey, Robert Joseph, and Mary Williams Borglum. *Give the Man Room: The Story of Gutzon Borglum.* Indianapolis and New York: Bobbs-Merrill Co., 1952.

Broder. *Bronzes of the American West*, pp. 62–69.

Craven, Wayne. *Sculpture in America*, pp. 488–92. Newark, Del.: University of Delaware Press, 1984.

George de Forest Brush
(1855–1941)
Painter
A.N.A. 1888, N.A. 1908

Shortly after the artist was born, his family left Tennessee and settled in Connecticut. At age sixteen, Brush was commuting to New York City to study at the National Academy of Design, and three years later he won a scholarship to the Ecole des Beaux-Arts in Paris, where he worked under Jean-Léon Gérôme. Brush's trips West began in 1881, with visits to the Shoshone, Arapaho, and Crow Indian tribes in Wyoming. He became a respected and influential friend of the Crow in the years that followed and produced reasonably accurate views of Indian life for *Harper's* and *Century* magazines. After he returned to the East in late 1885, however, his Indian subjects became more ideal and poetic, as if he were trying to recapture the ancient spirit of the race. By the turn of the century, Brush was better known for his portraits of women and children conceived in the image of Renaissance Madonnas.

References

Brush, George de Forest. "An Artist among the Indians," pp. 54–57.

Bowditch, Nancy Douglas. *George de Forest Brush: Recollections of a Joyous Painter.* Peterborough, N.H.: Noone House, 1970.

Morgan, Joan B. "The Indian Paintings of George de Forest Brush." *American Art Journal* 15 (Spring 1983):60–73.

Paul Burlin
(1886–1969)
Painter

Although based in his native New York for much of his life, Burlin traveled extensively in the United States and Europe. He was trained as an illustrator but advanced under the influence of the Ash Can School and Stieglitz's Gallery 291. As a result, he was one of the youngest artists invited to exhibit in the Armory Show of 1913. That same year, Burlin moved to Santa Fe to begin a study of Indian and Hispanic artists of the region, perhaps inspired by the new enthusiasm for primitive art then developing in New York. With his ethnologist wife, Natalie Curtis, he wrote a now-classic study of the music and poetry of the southwestern Indians. Burlin returned to New York in 1920 and painted in more abstract and expressionist modes for the remainder of his career.

References

"A New Art in the West," pp. xiv–xvii.

Paul Burlin, Exhibition of Paintings and Drawings. Minneapolis: University of Minnesota, 1949.

Sandler, Irving. *Paul Burlin.* New York: American Federation of Arts, 1962.

Gerald Cassidy

(1869–1934)
Painter

Born in Kentucky and raised in Cincinnati, Cassidy studied with Frank Duveneck before embarking on a career in New York. There he briefly attended the Art Students League and the National Academy of Design. Within a few years he had earned a considerable reputation in the field of commercial art and lithography, both in New York and Denver, where he later settled. In order to improve his health, he moved to Albuquerque (1890), where he became an illustrator of Indian subjects. In 1912 Cassidy moved to Santa Fe, which provided a convenient base for his frequent sketching trips to the pueblos. He also specialized in landscapes and large historical murals for expositions and commercial buildings. Cassidy's wife, Ina Sizer Davis, became noted as the author of numerous articles about the art colonies of New Mexico.

References

Trenton. *Picturesque Images from Taos and Santa Fe*, pp. 45–47.

Robertson and Nestor. *Artists of the Canyons and Caminos*, pp. 33–37.

Robertson, Edna. *Gerald Cassidy, 1869–1934*. Santa Fe: Museum of New Mexico, 1977.

Norman Stiles Chamberlain

(1887–1961)
Painter

Chamberlain was born in Grand Rapids, Michigan, and received artistic training in Holland and France. His career was interrupted by World War I, after which he moved to California and resumed his painting (1921). During the Depression, he worked for both the Public Works of Art Project and the Treasury Department Relief Art Project. He was commissioned by the latter to decorate the Huntington Park, California, post office. For the PWAP, Chamberlain painted several Indian subjects, the material for which he had gathered during summers in Taos in the twenties and early thirties. Indian themes and mural designs sketched in New Mexico continued to influence his work long after his return to California.

References

Mecklenburg, Virginia. *The Public as Patron: A History of the Treasury Department Mural Program Illustrated with Paintings from the Collection of the University of Maryland Art Gallery*, p. 45. College Park: University of Maryland, 1979.

Contreras, Belisario R. *Tradition and Innovation in New Deal Art*, pp. 68–72. Cranbury, N.J.: Associated University Presses, 1983.

Howard Norton Cook

(1901–1980)
Painter, printmaker
A.N.A. 1948, N.A. 1949

Cook left his native Springfield, Massachusetts, in 1919 on a scholarship to the Art Students League in New York, where he studied with Andrew Dasburg and Maurice Sterne. After several years of foreign travel, he established himself as a commercial artist, working for such magazines as *Century*, *Atlantic Monthly*, *Scribner's*, and *Harper's*. In 1926, on assignment for *Forum* magazine, he visited Taos to prepare woodcut illustrations for a serialized version of Willa Cather's *Death Comes for the Archbishop*. There he met and married the artist Barbara Latham. He spent the next several years concentrating on printmaking, then departed in 1932 for Mexico on a Guggenheim Fellowship to study fresco technique. Cook settled in Taos in 1935, but not until 1944 did he begin painting in oil. For the remainder of his career, he portrayed the southwestern landscape and Pueblo Indians in a monumental style based on the broad forms and patterns of his prints.

References

Zigrosser, Carl. "Howard Cook." In *New Mexico Artists, New Mexico Artist Series No.3*, pp. 119–28. Albuquerque: University of New Mexico Press, 1952.

Trenton. *Picturesque Images from Taos and Santa Fe*, pp. 48–53.

Duffy, Betty and Douglas. *The Graphic Work of Howard Cook: A Catalogue Raisonné*. Bethesda, Md.: Bethesda Art Gallery, 1984.

Eanger Irving Couse

(1866–1936)
Painter
A.N.A. 1902, N.A. 1911

Couse gained firsthand knowledge of Chippewa Indians while growing up in Saginaw, Michigan. At the age of seventeen, he attended classes at the newly founded Art Institute of Chicago, then moved to New York to study at the Art Students League and the National Academy of Design. He departed for Paris in 1886 and remained there for most of the next ten years, working first at the Académie Julian under Adolphe Bouguereau, who remained a life-long influence. He may also have studied at the Ecole des Beaux-Arts during the summer of 1886. After 1903 Couse spent his summers in Taos, where he helped form the Taos Society of Artists (1915). He also painted Indian tribes of the Northwest, but in 1927 he settled permanently in Taos. His Indian

paintings gained national recognition through publication in the calendars distributed by the Atchison, Topeka and Santa Fe Railway Company.

References

Woloshuk, Nicholas. *E. Irving Couse*. Santa Fe: Santa Fe Village Art Museum, 1976.

Broder. *Taos: A Painter's Dream*, pp. 136–61.

Bickerstaff. *Pioneer Artists of Taos*, pp. 75–84.

Edward Sheriff Curtis

(1868–1955)
Photographer

Curtis became an accomplished photographer during his youth in Whitewater, Wisconsin. After moving with his family to Seattle, he began photographing Indians in the Puget Sound area; but not until 1898, after a chance meeting with George Bird Grinnell, editor of *Field and Stream*, did he launch his career of compiling, in his words, "a comprehensive and permanent record of all the important tribes of the United States and Alaska that still retain to a considerable degree their primitive customs and traditions." Encouraged by Theodore Roosevelt and underwritten by J. Pierpont Morgan, Curtis's thirty-year project resulted in his monumental publication *The North American Indian*. Its twenty volumes contain extensive ethnographic information and Curtis's commentary on each photograph. From 1903 to 1904, and again in the early 1920s, he proceeded carefully through the Southwest, compiling a romantic portrait of life among the region's aboriginal people.

References

Andrews, Ralph W. *Curtis' Western Indians*. Seattle: Superior Publishing Co., 1962.

Boesen, Victor, and Florence Graybill. *Edward Sheriff Curtis: Visions of a Vanishing Race*. New York: Thomas Y. Crowell Co., 1976.

Lyman, Christopher M. *The Vanishing Race and Other Illusions: Photographs of Indians by Edward S. Curtis*. Washington, D.C.: Smithsonian Institution Press, 1982.

Andrew Michael Dasburg

(1887–1979)
Painter

Dasburg was born in Paris but moved to the United States when he was five. His training began at the Art Students League with Kenyon Cox and Birge Harrison; it continued with Robert Henri and numerous visits to the circle of Gertrude Stein in Paris. His early work, which was included in the Armory Show of 1913, was inspired by contemporary European artists, particularly Cézanne, Matisse, and the Futurists. In 1918, encouraged by Mabel Dodge (Luhan) and Maurice Sterne, he spent a summer in Taos. From then on he returned either to Taos or Santa Fe for part of each year, becoming one of the first modernists to form a lasting attachment to the region. He also became an avid collector of and dealer in Hispanic and Indian crafts. In 1933 he settled permanently in New Mexico, continuing to employ a modified form of Cubism to find structure and meaning in the landscape.

References

Bywaters, Jerry. *Andrew Dasburg*. New York: American Federation of Arts, 1959.

Coke. *Andrew Dasburg*.

Udall. *Modernist Painting in New Mexico*, pp. 55–70.

Stuart Davis

(1894–1964)
Painter

As a child in Philadelphia, Davis met John Sloan, William Glackens, George Luks, and Everett Shinn, from whom his father, the art director of the *Philadelphia Press*, commissioned illustrations. In 1910, while the family lived in East Orange, New Jersey, Davis attended Robert Henri's newly opened art school in New York City and sent works to the Independent Artists exhibition. In 1913 he began illustrating for *Harper's* and the socialist periodical *The Masses* and exhibited five watercolors at the Armory Show. At the invitation of Sloan, Davis spent the summer of 1923 in New Mexico, where he painted topical landscapes, sometimes with a humorous twist, but more abstract figures and still lifes. The assertive character of the local scenery, he maintained, hindered his search for a modernist idiom. During the next four decades, Davis's colorful geometric compositions provided inspiration for new developments in American modernism.

References

National Collection of Fine Arts. *Stuart Davis Memorial Exhibition*. Washington, D.C.: Smithsonian Institution Press, 1965.

Lane, John R. *Stuart Davis: Art and Art Theory*. Brooklyn: Brooklyn Museum, 1978.

Udall. *Modernist Painting in New Mexico*, pp. 154–62.

Edwin Willard Deming

(1860–1942)
Painter, sculptor

When he was still an infant, Deming's family moved from his birthplace in Ashland, Ohio, to western Illinois, an area that during those pre– and

post–Civil War years retained a frontier character, and where roaming Winnebago Indians were sometimes neighbors. While still in his teens, Deming traveled to Indian territory in Oklahoma and sketched extensively. Determined to become a painter of Indians, he enrolled at the Art Students League, then spent a year at the Académie Julian in Paris (1884–85), studying under Gustave Boulanger and Jules Lefebvre. Back in the United States, he worked the next two years painting cycloramas. In 1887 Deming first visited and painted the Apaches and Pueblos of the Southwest. His active career of painting and illustrating took him repeatedly to the lands of the Blackfoot, Crow, and Sioux, as well as to Arizona and New Mexico. After the turn of the century, Deming devoted more time to sculpture but also began work on a series of romantic murals of Indian life, which were subsequently installed in the American Museum of Natural History and the Museum of the American Indian in New York.

References

Walsh. *Edwin Willard Deming: His Work.*

Frink, Maurice. "Edwin W. Deming: That Man, He Paint." *American Scene* 12, no. 3 (1971): entire issue.

Broder. *Bronzes of the American West*, pp. 57–61.

William Herbert Dunton

(1878–1936)
Painter, printmaker

Known to his friends as "Buck," Maine-born Dunton traveled extensively in the West as a young man, working as a ranch hand and cowboy. When he became a commercial illustrator, Dunton used this experience to authenticate details in sketches commissioned by such

periodicals as *Harper's*, *Collier's*, and *Scribner's*. A desire to study painting more seriously brought him in 1912 to the Art Students League, where his teacher Ernest Blumenschein suggested a visit to Taos. Dunton responded immediately to the pictorial richness of New Mexico, finding his favorite subjects in the wildlife and rugged mountain men of the region. During the Depression, suffering financially and, increasingly, from poor health, Dunton worked on Public Works of Art Project murals and practiced lithography. His concern for preserving the vanishing spirit of the Old West exceeded that of all his artist colleagues in Taos.

References

Dunton, W. Herbert. Papers. Archives of American Art, Smithsonian Institution, Washington, D.C.

Broder. *Taos: A Painter's Dream*, pp. 162–79.

Schimmel, Julie. *The Art and Life of W. Herbert Dunton, 1878–1936*. Austin: University of Texas Press and Stark Museum of Art, 1984.

Henry F. Farny

(1847–1916)
Painter

Farny was attracted to Indians as a boy in Warren, Pennsylvania, his family's first residence in America after leaving France in 1853. Another move took him to Cincinnati, where Farny remained until 1866, when he found a job in New York as an engraver and cartoonist for *Harper's Monthly*. Over the next ten years, he went abroad three times, studying in Rome, Düsseldorf, and Munich. On the last trip, he was accompanied by fellow Cincinnatians Frank Duveneck and John Twachtman. In 1881, inspired by the developing market for Indian paintings, Farny traveled up the Missouri River, making sketches, taking notes and photographs,

and collecting artifacts. On several more trips west he did the same, until his Cincinnati studio contained enough material for almost any Indian subject he wished to illustrate. Many of his oil paintings were done after 1893, in a style that combined his documentary skills with a nostalgia for vanishing western tribes.

References

Baltzer, Charles. *Henry F. Farny*. Cincinnati: Indian Hill Historical Museum Association, 1978.

Carter, Denny. *Henry Farny*. New York: Watson-Guptill Publications, 1978.

Snite Museum of Art. *The Realistic Expressions of Henry Farny: A Retrospective*. Notre Dame, Ind.: Snite Museum of Art, University of Notre Dame, 1981.

DeLancey W. Gill

(1859–1940)
Painter, photographer

For almost six decades, Gill worked for the Smithsonian's Bureau of American Ethnology, first as an illustrator and then as director of the Division of Illustration. During those years, he did field work with W. H. Holmes, from whom he learned his watercolor technique, and practiced photography, both as an illustrative aid and as an independent creative medium. His professional interests no doubt contributed significantly to the clarity and precision of his painting style. Gill was born in Camden, South Carolina, and trained as a draftsman with the Supervising Architect of the U.S. Capitol. In later, years, he taught at the Corcoran School of Art in Washington, D.C., and the Art Students League in New York.

References

Cosentino, Andrew J., and Henry H. Glassie. *The Capital Image: Painters in Washington, 1800–1915*, pp. 218–19, 260. Washington, D.C.: Smithsonian Institution Press, 1983.

Glenn, James R. "DeLancey W. Gill: Photographer for the Bureau of American Ethnology." *History of Photography* 7 (January 1983):7–22.

Marsden Hartley

(1877–1943)
Painter, printmaker

Born in Lewiston, Maine, Hartley followed his family to Cleveland, Ohio, where he won a scholarship to the Cleveland School of Art. In 1899 he moved to New York, studying first under William Merritt Chase and F. Luis Mora and the next year at the National Academy of Design. With financial assistance from Alfred Stieglitz, Hartley went to Europe in 1912, spending much of his time in Germany, where he met Wassily Kandinsky, Franz Marc, and other members of the Blaue Reiter group. On the advice of Charles L. Daniel, a gallery owner who had earlier sponsored Paul Burlin's stay in New Mexico, Hartley visited Taos and Santa Fe in 1918 and 1919. He was attracted by the landscape, which he thought "magnificent" and "austere," by the primitive simplicity of local *santos*, and by Indian dances, which he proclaimed the one truly indigenous art form in America. In the early 1920s, while living in Berlin, Hartley recalled the New Mexican landscape in a series of paintings far more turbulent and brooding than any he had done on location. The next decade he divided between Europe and America, but his last years were spent mostly in his native Maine, painting the rugged coastline and "archaic portraits" of local fishermen.

References

American Federation of Arts. *Marsden Hartley*. New York: American Federation of Arts, 1960.

Haskell. *Marsden Hartley*.

Udall. *Modernist Painting in New Mexico*, pp. 29–52.

William Penhallow Henderson

(1877–1943)
Painter, architect

Henderson grew up in Medford, Massachusetts, on a cattle ranch in Texas, and in a small Kansas town. Studies at the Massachusetts Normal Art School and Boston Museum of Fine Arts prefaced European travel and further art training abroad. In 1916, after more than a decade teaching and painting in Chicago, Henderson moved to Santa Fe with his wife, the poet and editor Alice Corbin. There his interest in the Indian and Hispanic residents of the Southwest inspired work in several media. Best known are his pastels and oils, less so his murals, handcrafted furniture, stage designs, and innovative architectural projects. As an illustrator, he was noted for his work on novels and scholarly studies focusing on the Southwest, including his wife's classic, *Brothers of Light: The Penitentes of the Southwest*. Henderson's emotive, high-keyed color and decorative spatial treatment suggest Post-Impressionism applied to distinctly southwestern imagery. His work was an inspiration to avant-garde as well as conservative painters in the Southwest.

References

Breeskin, Adelyn D. *William Penhallow Henderson, 1877–1943: An Artist of Santa Fe*. Washington, D.C.: Smithsonian Institution Press, 1978.

Feldman, Sandra K. *William Penhallow Henderson, The Early Years: 1901–1916*. New York: Hirschl & Adler Galleries, 1982.

Phoenix Art Museum. *William Penhallow Henderson: Master Colorist of Santa Fe*. Phoenix: Phoenix Art Museum, 1984.

Ernest Martin Hennings

(1886–1956)
Painter, printmaker

After graduating from high school, Hennings left his native Pennsgrove, New Jersey, for five years of study at the Art Institute of Chicago. His training continued with two years at the Royal Academy in Munich. Fellow art students in Munich included Walter Ufer and Victor Higgins. In 1914, at the outbreak of World War I, Hennings returned to Chicago, where he made his living as a muralist and commercial artist. At the urging of former Chicago mayor Carter Harrison, Hennings spent a few months in Taos in 1917. Four years later, he made Taos his permanent home, joining the Taos Society of Artists in 1924. Hennings's favorite subject was the Indian, whom he often posed singly or in groups against a bright foliage curtain. His compositions, featuring stylized line, decorative patterns, and warm colors, won him twelve national prizes between 1916 and 1938.

References

White, Robert Rankin. "Taos Founder, E. Martin Hennings." *Southwest Art* 4 (April 1974):50–52.

———. "The Lithographs and Etchings of E. Martin Hennings." *El Palacio* 84 (Fall 1978):21–36.

Broder. *Taos: A Painter's Dream*, pp. 252–67.

Robert Henri

(1865–1929)
Painter
A.N.A. 1905, N.A. 1906

Despite conventional art training, Cincinnati-born Henri became a famous crusader against academic conservatism. After study at the Pennsylvania Academy of the Fine Arts, he enrolled at the Académie Julian and the Ecole des Beaux-Arts in Paris. In 1891 he settled in Philadelphia, where he met four young newspaper illustrators—John Sloan, William Glackens, Everett Shinn, and George Luks—to whom he introduced the work of Hals, Manet, and Velázquez, the European masters who most influenced his work. Following a trip to Europe in 1901, Henri moved to New York, where he was soon joined by his four Philadelphia colleagues. He began teaching at the Chase School but became impatient with its traditional artistic approach and opened his own, more progressive school. Over the years his students included Edward Hopper, George Bellows, Morgan Russell, and Stuart Davis. In 1908 Henri and his group staged the legendary exhibition of The Eight (sometimes called the Ash Can School) at the Macbeth Gallery, and in 1910 he helped organize the Independent Artists show. At the invitation of Edgar L. Hewett, director of the Museum of Fine Arts, he spent the summer of 1916 in Santa Fe. So captivated was he by Pueblo Indians and their artistic products that he per-suaded Sloan, Bellows, and a number of other painters to visit Santa Fe in the years that followed, thus inaugurating the colony's most productive era.

References

Henri. *The Art Spirit*.

Homer and Organ. *Robert Henri and His Circle*.

Perlman, Bernard B. *Robert Henri, Painter*. Wilmington: Delaware Art Museum, 1984.

William Victor Higgins

(1884–1949)
Painter
A.N.A. 1921, N.A. 1935

At fifteen, Victor Higgins defied his parents' wishes and left his native Indiana for Chicago, where he studied at the Art Institute and the Academy of Fine Arts. Sponsored by ex-mayor and collector Carter Harrison, Higgins spent two and a half years studying and traveling in Europe. While in Munich, he associated with fellow art students Walter Ufer and Martin Hennings. The year after his return (1914), Harrison sent him on a painting trip to New Mexico. There Higgins found the strong light, brilliant color, and lure of the land a powerful antidote to the confines of academic training. He joined the Taos Society of Artists in 1917, but he continued to divide his time between Chicago and Taos for some years and to exhibit in Indianapolis and New York, with an occasional painting sent to Europe. As a link between his more conservative colleagues and the emerging artistic developments of the twentieth century, Higgins wedded theory to his own intuitively derived visual harmonies. The result was a rich and varied body of work in still life, figure painting, and, most significantly, landscape.

References

Art Gallery of The University of Notre Dame and the Indianapolis Museum of Art. *Victor Higgins*. Notre Dame, Ind.: Art Gallery of the University of Notre Dame and Indianapolis Museum of Art, 1975.

Bickerstaff. *Pioneer Artists of Taos*, pp. 175–93.

Art Museum of South Texas. *Victor Higgins in New Mexico*. Corpus Christi: Art Museum of South Texas, 1984.

John K. Hillers

(1843–1925)
Photographer

A German immigrant, Hillers found employment as a boatman on John Wesley Powell's 1871 survey of the Colorado River. By first assisting and then substituting for the expedition's official photographer, Hillers progressed quickly, showing a natural aptitude for the medium. The next year he was made chief photographer for the survey. From 1879 to 1880, Hillers accompanied a Bureau of American Ethnology (BAE) survey into New Mexico and Arizona, where he photographed Canyon de Chelly, the Rio Grande pueblos, and Zuni. His portraits of the Indians and their homes and villages tell much about their social structure and life-style. During his long career, Hillers made some twenty thousand negatives for the U.S. Geological Survey and the BAE; many are works of high artistic and technical merit, satisfying both as pictorial views and historical documents.

References

Darrah, William Culp. "Bedman, Fennemore, Hillers, Dellenbaugh, Johnson and Hattan: Photographers and Other Members of the Expedition." *Utah Historical Quarterly* 16–17 (1948–49): 491–503.

Debooy, H. T. "Pioneer Photographers." *New Mexico Magazine* 37 (February 1959):22–23.

Coke. *Photography in New Mexico*.

Ballinger and Rubinstein. *Visitors to Arizona, 1846–1980*, pp. 94–95.

Alexandre Hogue

(born 1898)
Painter, printmaker

Leaving his boyhood home in Texas, Hogue began his formal art-education at the College of Art and Design in Minneapolis. In 1921 he moved to New

York, where he lived and worked for four years, returning to Texas during the summers to paint. He eventually settled in Dallas. Starting in 1926, Hogue began making long visits to Taos, which he continued until 1942, forming close friendships with Ernest Blumenschein, W. Herbert Dunton, Joseph Imhof, Victor Higgins, Emil Bisttram, and others who became valuable mentors and advisers. Hogue remains best known for his Dust Bowl scenes of the 1930s, but during his Taos visits, he became deeply interested in the Pueblos, their spiritual concerns, and their land ethic. The latter reinforced his own investigation of the southwestern environment, which continued in more abstract and metaphysical terms through the next four decades.

References

Wilbanks, Elsie Montgomery. *Art on the Texas Plains: The Story of Regional Art and the South Plains Art Guild*. Lubbock, Tex.: South Plains Art Guild, 1959.

DeLong, Lea Rosson. *Nature's Forms/ Nature's Forces: The Art of Alexandre Hogue*. Norman: University of Oklahoma Press and Philbrook Art Center, 1984.

Stewart, Rick. *Lone Star Regionalism: The Dallas Nine and Their Circle*, pp. 168–72. Dallas: Dallas Museum of Art, 1985.

William Henry Holmes

(1846–1933)
Painter

Born in rural Ohio, Holmes supplemented his training as a scientist with art lessons in Washington, D.C. His career began in 1872 with the government-sponsored Hayden Survey, on which he served as official geologist and artist, traveling through Wyoming and Colorado. During an association that lasted seven years, Hayden credited Holmes's "usual zeal and skill" with inspiring "much of the accuracy and value of the work." A subsequent expedition in 1880 through the Grand Canyon resulted in the remarkable

drawings and watercolors Holmes made to illustrate Clarence Dutton's official report of the journey. In later years, Holmes's interests turned to archaeology and then back to art, when he was named director of the National Gallery of Art (now the National Museum of American Art) in 1920. His watercolors combined poetic mood with a scientist's eye for the panoramic grandeur of the West.

References

Goetzmann. *Exploration and Empire*.

Nelson, Clifford M. "William Henry Holmes: Beginning a Career in Art and Science." *Records of the Columbia Historical Society* 50 (1980):252–78.

Trenton, Patricia, and Peter H. Hassrick. *The Rocky Mountains: A Vision for Artists in the Nineteenth Century*, pp. 166–77. Norman: University of Oklahoma Press, 1983.

Edward Hopper

(1882–1967)
Painter, printmaker

The distinctive, light-bathed realist style that placed Hopper in the forefront of American painters was developed around the turn of the century under teachers Robert Henri, William Merritt Chase, and Kenneth Hayes Miller. To this beginning Hopper added elements of Degas, French Impressionism, and Post-Impressionism gleaned from study in Paris between 1906 and 1910. Hopper visited New Mexico only once, when John Sloan persuaded him to spend the summer of 1925 in Santa Fe. Finding few suitable subjects to paint, he produced watercolors of railroad yards and buildings chosen for their angular conformation and potential for light-and-dark patterning. These works presage watercolors painted in other art colonies, where Hopper continued to reconcile the world of his imagination with a strong predilection for observable facts.

References

Goodrich, Lloyd. *Edward Hopper*. New York: Harry N. Abrams, 1971.

Levin, Gail. *Edward Hopper: The Art and the Artist*. New York: W. W. Norton & Co., 1980.

Raymond Jonson

(1891–1982)
Painter

No stranger to the West, Iowa-born Jonson moved often during his childhood. His art training began at the Portland (Oregon) Art Museum School and continued after his 1910 move to Chicago at the Academy of Fine Arts and the Art Institute. Encouraged by his teacher B. J. O. Nordfeldt, Jonson became art director at the Chicago Little Theatre. His experimental stage-design work and Bauhaus concepts influenced his painting, which took on distinctly abstract qualities in the twenties. A 1922 summer visit to Santa Fe prompted Jonson's permanent move to New Mexico two years later. For twenty-five years, he taught and painted in Santa Fe, producing rhythmic, sculpturally modeled landscapes, suggestive of a life force underlying the land. In the late thirties, he experimented with airbrush, collage, and spatter techniques. Jonson continued to work in an abstract mode after joining the University of New Mexico faculty in 1949.

References

Jonson, Raymond. Papers. Archives of American Art, Smithsonian Institution, Washington, D.C.

Garman. *The Art of Raymond Jonson*.

McCauley, Elizabeth Anne. *Raymond Jonson: The Early Years*. Albuquerque: University Art Museum, University of New Mexico, 1980.

Fred Kabotie
(born ca. 1900)
Painter

Born at Shungopavi, Second Mesa, Arizona, into a traditional Hopi family, Kabotie received his education there and at the Santa Fe Indian School, where his artistic talents were encouraged. His subsequent career was divided among independent creative work, high-school teaching, art administration, and commissions to record Indian customs, ceremonies, and prehistoric murals for such institutions as the School of American Research, the Heye Foundation in New York, and the Peabody Museum at Harvard. In 1945 Kabotie received a Guggenheim Fellowship in recognition of his work as painter, teacher, author, lecturer, and craftsman. He became the most accomplished and versatile of the early Pueblo-Hopi painters, noted for a personal style that combines naturalistic detail with a measure of the spirituality of Hopi life.

References

Tanner, Clara Lee. "Fred Kabotie: Hopi Indian Artist." *Arizona Highways* 27 (July 1951):16–29.

————.*Southwest Indian Painting*, pp. 218–31.

Kabotie, Fred, with Bill Belknap. *Fred Kabotie: Hopi Indian Artist*. Flagstaff: Museum of Northern Arizona, 1977.

Gina Knee
(1898–1983)
Painter

Born in Marietta, Ohio, Knee was drawn to New Mexico by an exhibition of John Marin's watercolors, which she saw in New York in 1930. The next summer in Taos, while studying with Ward Lockwood, she experienced firsthand the powerful landscape forms that had influenced Marin. Several years later, she married the photographer Ernest Knee and settled in Santa Fe. Like Marin, whom she greatly admired, Knee distilled geometric forms from observed nature, refining her watercolors into confident, modernist statements. Ten years in New Mexico left an indelible imprint on her work. Married in 1945 to painter Alexander Brook, Knee continued to paint, exhibit, and teach, first in Georgia and then at Sag Harbor, New York.

References

Cassidy, Ina Sizer. "Art and Artists of New Mexico: Gina Knee." *New Mexico Magazine* 17 (February 1939):23–28.

Johnson, Spud. "Impressions of Some Watercolors by Gina Knee." *New Mexico Quarterly* 12 (August 1942):301–3.

Eldredge. *Ward Lockwood, 1894–1963*, p. 43.

Leon Kroll
(1884–1974)
Painter
A.N.A. 1920, N.A. 1927

Winslow Homer encouraged young Kroll to make a career of art. Born in New York, he first enrolled at the Art Students League, then continued his training at the National Academy of Design and with Jean-Paul Laurens in Paris. Although he exhibited in the 1913 Armory Show, Kroll's style was more strongly informed by his association with the Henri circle. Indeed, it was the presence of Robert Henri and George Bellows in Santa Fe that brought Kroll to New Mexico in the summer of 1917. During his brief stay, Kroll rendered the colorful southwestern scene with the same delight in plastic form that he brought to his better-known New York figure paintings and portraits.

References

Hale, Nancy, and Fredson Bowers. *Leon Kroll: A Spoken Memoir*. Charlottesville: University Press of Virginia, for the University of Virginia Art Museum, 1983.

Bernard Danenberg Galleries. *Leon Kroll: The Rediscovered Years*. New York: Bernard Danenberg Galleries, 1970.

Laguna Santero
(active 1796–1808)
Painter

From the hand of this anonymous master came the most influential group of late-colonial religious paintings in New Mexico. Assisted by a large and productive workshop, he created altar screens for a number of churches, including the pueblo missions at Pojaque, Zia, Santa Ana, Acoma, and Laguna, for which he is named. The work of the Laguna Santero is based on provincial Mexican sources, thus probably indicating his place of origin. Wealthy patrons must have lured him to New Mexico, where his simplified Baroque style had a major impact on his assistants and on the next generation of local *santeros*.

References

Boyd. *Popular Arts of Spanish New Mexico*, pp. 155–66.

Wroth. *Christian Images in Hispanic New Mexico*, pp. 69–93.

Barbara Latham
(born 1896)
Painter, printmaker

Studies in New York at the Pratt Institute and the Art Students League prepared Massachusetts-born Latham for a career

in commercial art, which she followed for a time; but subsequent instruction from Andrew Dasburg led to the style of her mature paintings. Shortly after Latham moved permanently to Taos, she met and married painter Howard Cook and found work in printmaking and book illustration. Her careful observations of Pueblo ceremonies and Hispanic life were often incorporated into her work. In her lively, stylized mode of realism, Latham offers a sympathetic and appealing view of her southwestern environment.

References

Latham, Barbara. Papers. Archives of American Art, Smithsonian Institution, Washington, D.C.

Roswell Museum and Art Center. *Paintings by Barbara Latham*. Roswell, N.M.: Roswell Museum and Art Center, n.d.

Governors Gallery. *Barbara Latham/ Howard Cook*. Santa Fe: Governors Gallery, 1977.

John Ward Lockwood
(1894–1963)
Painter, printmaker

Ward Lockwood received his artistic training at the University of Kansas, Pennsylvania Academy of the Fine Arts, and in Paris. Further studies with Andrew Dasburg at Woodstock, New York, preceded his move to New Mexico in 1926. There he painted with fellow Kansan Kenneth M. Adams and with Dasburg and John Marin. During the 1930s, Lockwood participated in Works Progress Administration mural projects, responding to the taste for American Scene realism. A versatile artist in many media, Lockwood was a sought-after

teacher; he held faculty positions at the University of Texas and the University of California at Berkeley. His southwestern landscapes are based on observed reality but demonstrate his enduring concern with formal problem solving, unified chromatic impact, and contrasting paint surfaces.

References

Ward Lockwood Papers.

Lockwood, J. Ward. "An Artist's Roots." *Magazine of Art* 33 (May 1940): 268–73.

Eldredge. *Ward Lockwood 1894–1963*.

Hermon Atkins MacNeil
(1866–1947)
Sculptor
A.N.A. 1905, N.A. 1906

Born and raised on his father's farm in Everett, Massachusetts, MacNeil supplemented art school in Boston with study in Paris at the Ecole des Beaux-Arts and the Académie Julian. Returning to the United States in 1891, he worked with Philip Martiny on the sculpture for the World's Columbian Exposition. Appearing in Chicago at the same time was Buffalo Bill's Wild West show, which aroused MacNeil's interest in Indians and led to a long trip through the Southwest, during which he studied the history, customs, and ceremonies of the local tribes. For the next decade, MacNeil concentrated on Indian subjects in an effort to rehabilitate their image and give his own work more of a national character. At the turn of the century, the Santa Fe Railway commissioned a series of portraits of the Navajo and the Hopi; but by 1910, MacNeil had modeled the last of his Indian sculptures, and the remainder of his career was devoted to public monuments celebrating American heroes.

References

Broder. *Bronzes of the American West*.

Whitney Museum of American Art. *Two Hundred Years of American Sculpture*, p. 291. New York: Whitney Museum of American Art, 1976.

Craven, Wayne. *Sculpture in America*, pp. 516–21. Newark, Del.: University of Delaware Press, 1984.

Ma-Pe-Wi (Velino Shije Herrera)
(1902–1973)
Painter

Born at Zia Pueblo, New Mexico, Herrera was a self-taught artist whose painting career began in 1917 at the School of American Research in Santa Fe. His subjects included native dances, genre scenes from the pueblos, portraits, and hunting scenes. As his work grew in breadth and confidence, his style changed from flat, patternlike compositions to more naturalistic representations, often with a delicate rendering of texture and detail. In 1938 he reproduced ancient *kiva* murals found at Kuau (near Bernalillo, New Mexico). He also painted murals for the Department of the Interior building in Washington, D.C., and illustrated several books on Pueblo life and art. With his skillful blend of tradition and innovation, Ma-Pe-Wi became one of the most highly regarded figures in the Indian watercolor movement.

References

Pach, Walter. "Notes on the Indian Water-Colours." *The Dial* 68 (March 1920):343–45.

Dunn. *American Indian Painting*, pp. 204–8.

Tanner. *Southwest Indian Painting*, pp. 151–55.

John Marin
(1870–1953)
Painter

By the time Marin came to New Mexico in the summers of 1929 and 1930, his reputation as a major American modernist was well established. Born in Rutherford, New Jersey, he trained first as an architect, then spent two years at the Pennsylvania Academy of the Fine Arts. But it was his five years in Europe, where he absorbed the artistic lessons of Cézanne, the Fauves, Cubists, and Futurists, that enabled him to probe beneath appearances, to portray landscape as a resolution of structure and motion. Early critical and financial success through photographer-dealer Alfred Stieglitz enabled Marin to pursue his personal vision in various places, including Maine, upstate New York, Manhattan, and the Southwest. As a guest of the controversial Taos hostess Mabel Dodge Luhan, Marin produced some one hundred watercolors of New Mexico, a number of which he shared with his colleagues. Before long, several artists, including Andrew Dasburg, Ward Lockwood, Victor Higgins, and Cady Wells, were influenced by his dynamic interpretation of local scenery.

References

Coke. *Marin in New Mexico, 1929 and 1930.*

Reich, Sheldon. *John Marin: A Stylistic Analysis and Catalogue Raisonne.* 2 vols. Tucson: University of Arizona Press, 1970.

Udall. *Modernist Painting in New Mexico,* pp. 123–36.

Crescencio Martinez
(?–1918)
Painter

Martinez, of San Ildefonso Pueblo, New Mexico, was the first Pueblo artist encouraged to become a watercolorist.

He began by decorating pottery, then learned to draw and paint. About 1910, archaeologist Edgar L. Hewett found Martinez painting single dance figures on the ends of cardboard boxes. Hewett's gift of watercolors and paper led the young man to his subsequent career. Martinez's close contact with non-Indian patrons and with developing artists made him an influential figure in the modern watercolor movement among the Pueblos. In 1920, when his work appeared at the Independent Artists exhibition in New York, he was among the first Indian artists to gain national recognition. Unfortunately, the recognition was posthumous: Martinez had died two years earlier, a victim of influenza. During his short career, he nearly completed a commissioned series of paintings for the Museum of New Mexico depicting all the costumed dances held at San Ildefonso.

References

Hewett, Edgar. "Crescencio Martinez, Artist." *El Palacio* 5 (3 August 1918): 67–69.

Dunn. *American Indian Painting,* pp. 198–205.

Tanner. *Southwest Indian Painting,* pp. 86–88.

Highwater. *Song from the Earth,* pp. 46–47.

Maria Montoya Martinez
(1880s–1980)
Potter

Julian Martinez
(1879–1943)
Painter

Maria Montoya Martinez, a Tewa Indian of San Ildefonso Pueblo, learned to make pottery as a young girl. When Kenneth M. Chapman, an associate of

Edgar L. Hewett, encouraged local potters to recreate the shapes of ancient pots excavated near the pueblo from 1907 to 1909, Maria and her husband, Julian, began a decade of experimentation that led to their first black-on-black pieces in 1918. Maria made the pots by the ancient method of hand coiling clay; Julian, a skillful self-taught painter, decorated them. Increasingly, they worked in the new burnished blackware, turning away from the traditional, polychrome pottery of San Ildefonso. In his watercolors as well as his pottery decoration, Julian excelled in painting geometrically stylized forms, especially birds and serpent figures. Credited with revitalizing a moribund pottery tradition, the Martinezes had won international honors by the time Julian died in 1943. Maria demonstrated pottery making at every world's fair until World War II and trained three younger generations of her family.

References

Marriott, Alice Lee. *Maria, The Potter of San Ildefonso.* Norman: University of Oklahoma Press, 1948.

Tanner. *Southwest Indian Painting,* pp. 98–100.

Peterson, Susan. *The Living Tradition of Maria Martinez.* New York: Harper & Row, 1977.

_____. *Maria Martinez: Five Generations of Potters.* Washington, D.C.: Smithsonian Institution Press, 1978.

Jan Matulka
(1890–1972)
Painter, printmaker

Brought to the United States from Bohemia at the age of sixteen, Matulka studied at the National Academy of Design from 1911 to 1916. The next year he was awarded a Joseph Pulitzer Traveling Scholarship, which enabled him to tour the American Southwest.

While in New Mexico and Arizona, he frequented Indian dances and studied the art, ceremonies, and customs of the Pueblo tribes. Like other modernist-inclined painters of the post-Armory Show era, Matulka was drawn by the romantic appeal of the Indian and Hispanic cultures of the Southwest, subjects he translated into stylized geometric drawings and paintings. As an influential teacher during the twenties and thirties, he transmitted modernist precepts to many American art students who gained prominence in succeeding decades.

References

Lowenbach, Jan V., and Isaac Kloomok. *Matulka*. New York: A.C.A. Gallery, 1944.

Kramer, Hilton. "The Pictorial Styles of Jan Matulka." *New York Times*, 30 October 1970, sec. 2, p. 1.

National Collection of Fine Arts and the Whitney Museum of American Art. *Jan Matulka 1890–1972*.

Willard Leroy Metcalf

(1858–1925)
Painter

Born in Lowell, Massachusetts, Metcalf was apprenticed to a local wood engraver and then sent to Boston to study with the landscape painter George Loring Brown. In 1881, concerned about his health, he went to New Mexico, where he met Frank Hamilton Cushing and made vivid sketches of life at the Zuni pueblo. These appeared in *Century* and *Harper's* magazines, accompanying landmark articles on the Southwest by Cushing and Sylvester Baxter, a Boston journalist. A year later, Metcalf left for France to pursue very different aims. He worked successively in Paris, Brittany, and Giverny, associating with French *plein-air* and Impressionist painters and their American followers,

absorbing the tenets of a brighter, freer style. He spent the last decades of his career painting seasonal views of New England, for which he is best known today.

References

Metcalf, Willard Leroy. Papers. Archives of American Art, Smithsonian Institution, Washington, D.C.

Museum of Fine Arts. *Willard Leroy Metcalf: A Retrospective*. Springfield, Mass.: Museum of Fine Arts, 1976.

Gerdts, William H. *American Impressionism*, pp. 51–58, 194–99. New York: Abbeville Press, 1984.

Peter Moran

(1841–1914)
Etcher, painter

The youngest of four Moran brothers, Peter was born in Lancashire, England, and came with his family to America in 1844. He was apprenticed to a lithographer at the age of sixteen but disliked the work and began to study with his brothers Thomas and Edward, who were both established artists in Philadelphia. Peter traveled to New Mexico in 1864—seven years before Thomas's first sketching trip to Yellowstone—and again in the early 1880s. Several more trips west were made in the company of his brothers. Peter was also known for paintings and etchings of animal subjects, drawn from the bucolic surroundings of Philadelphia, where he maintained a studio throughout his career.

References

McCracken, Harold. *Portrait of the Old West*, pp. 150–51. New York: McGraw-Hill Book Company, 1952.

Amon Carter Museum of Western Art. *Catalogue of the Collection*, pp. 58–66. Fort Worth, Tex.: Amon Carter Museum of Western Art, 1972.

Trenton, Patricia, and Peter H. Hassrick. *The Rocky Mountains: A Vision for Artists in the Nineteenth Century*, pp. 282, 292. Norman: The University of Oklahoma Press, 1983.

James S. Morris

(ca. 1902–1973)
Painter

Born in Marshall, Missouri, Morris variously listed his birthdate as 1898 or 1902. He studied at the Cincinnati Art Academy from 1925 to 1926 and at the Pennsylvania Academy of the Fine Arts. In the late 1920s, he visited Santa Fe, where he met John Sloan and became entranced by the southwestern landscape. Sloan subsequently arranged a scholarship for Morris at the Art Students League in New York. During the Depression, Morris returned to New Mexico, where his boldly executed oils and more delicate watercolors grew increasingly abstract, then shifted to a more representational, social-commentary style. After World War II, Morris's work took on elements of fantasy, perhaps reflecting his concern about the diminishing coherence of twentieth-century society.

References

"Pieces of Men." *Time*, 15 January 1951, p 60.

White, Jerry. "About the Arts." *Santa Fe New Mexican*, 31 January 1965, p.3.

Bermingham. *The New Deal in the Southwest*.

Walter Mruk

(1883–1942)
Painter

Wladyslaw (Walter) Mruk grew up in Buffalo, New York, where he attended the Albright Art Institute. Later he studied with John Thompson, the leading modernist in Denver. Working his way south, Mruk found a

job as a forest ranger near Santa Fe and remained in the area for five or six years. On a 1924 expedition to Carlsbad Caverns, he and Will Shuster became the first artists to paint the caves' spectral interiors, lighted in those days only by lanterns. Mruk left New Mexico in 1926 to return East. He is the least remembered of Los Cinco Pintores, in part because few of his works have survived; those that have, however, are among the most imaginary and expressive of the era.

References

Robertson, Edna. *Los Cinco Pintores*. Santa Fe: Museum of New Mexico, 1975.

Harmsen, Dorothy. *American Western Art*, p. 144. Denver: Harmsen Publishing Co., 1977.

Udall. *Modernist Painting in New Mexico*, pp. 181–83.

Nampeyo

(ca. 1860–1942)
Potter

A Hopi-Tewa from First Mesa, Arizona, Nampeyo learned pottery making from her grandmother; by her thirties she had achieved a reputation as a highly skilled artisan. Between 1895 and 1900, excavations conducted by J. Walter Fewkes, a Smithsonian archaeologist, at the nearby prehistoric site of Sikyatki unearthed decorated ceramic mortuary vessels, the shapes, surfaces, and designs of which inspired Nampeyo to emulate ancient materials and decoration. With the help of Fewkes and local traders, but primarily through her own sense of form and pattern, Nampeyo developed and perfected her style. When she began to paint the ancestral designs on

unslipped polished vessels, Nampeyo initiated the Sikyatki Revival, the modern renaissance of Hopi pottery. By 1920 she was a recognized artist and had traveled well beyond the Hopi reservation. Her descendants in the First Mesa area have carried on her innovations, combining high standards of quality with a proliferation of colors and styles.

References

Colton, M. R., and H. S. Colton. "An Appreciation of the Art of Nampeyo and Her Influence on Hopi Pottery." *Plateau* 15 (January 1943): 43–45.

Frisbie. "The Influence of J. Walter Fewkes on Nampeyo: Fact or Fancy?" pp. 231–40.

Harlow. *Modern Pueblo Pottery, 1880–1960*, pp. 91–93.

Nequatewa, Edmund. "Nampeyo, Famous Hopi Potter." *Plateau* 15 (January 1943):40–42.

Willard Nash

(1898–1943)
Painter, printmaker

Trained in Detroit under John P. Wicker, Philadelphia-born Nash moved to New Mexico in 1920 in search of a stimulating artistic environment. His early southwestern work was still academic in conception, but after studying with Andrew Dasburg, he experimented with the techniques of the Fauves and Post-Impressionists, especially Cézanne. With his four colleagues in the Cinco Pintores group, Nash exhibited in the Midwest and on the West Coast with the stipulated aim of taking "art to the people." His growing devotion to the architectonic structure of Cézanne in the thirties and to abstraction in the forties marks him as one of the more daring New Mexico modernists. In 1936 Nash left Santa Fe for California, where he taught in San Francisco and Los Angeles.

References

Robertson, Edna. *Los Cinco Pintores*. Santa Fe: Museum of New Mexico, 1975.

Roswell Museum and Art Center. *Willard Nash*. Roswell, N.M.: Roswell Museum and Art Center, 1979.

Love, Marian F. "Willard Nash, Painter." *The Santa Fean Magazine* 9 (October 1981):26–29.

Udall. *Modernist Painting in New Mexico*, pp. 177–80.

Bror Julius Olsson Nordfeldt

(1878–1955)
Painter, printmaker

Nordfeldt's direct and vigorous brushwork converted landscapes, portraits, and still lifes into powerful formal statements. Born in Sweden, he emigrated in 1891 to Chicago, where he began his art training in 1899 with a year at the Art Institute. Following a decade of painting, printmaking, and study in Chicago and Europe, Nordfeldt moved in 1919 to Santa Fe, where he remained for the next twenty years. While abroad he had absorbed the work of the Fauves and Expressionists. His first New Mexico paintings were Cézannesque renderings of Indian dances. Other etchings, lithographs, and paintings portrayed the simple dignity of Hispanic neighbors or analyzed the rugged topography of the Southwest. Nordfeldt's work in New Mexico represents a marriage of his formal predilections with an aggressive environment. Much of his later abstract painting would proceed from the interaction of these two elements.

References

Nordfeldt, B. J. O. Papers. Archives of American Art, Smithsonian Institution, Washington, D.C.

Coke, Van Deren. *Nordfeldt the Painter*. Albuquerque: University of New Mexico Press, 1972.

Hunter, Sam. *B. J. O. Nordfeldt: An American Expressionist*. Pipersville, Pa.: Richard Stuart Gallery, 1984.

Georgia O'Keeffe
(born 1887)
Painter

From her birthplace in Sun Prairie, Wisconsin, O'Keeffe's world expanded in stages: she studied at the Art Institute of Chicago, then with William Merritt Chase at the Art Students League in 1907, and finally with Arthur Dow at Columbia University from 1914 to 1915. From 1912 to 1918, she taught art in South Carolina and Texas; her summer vacations included travel and a first visit to New Mexico in 1917. In 1916 Alfred Stieglitz exhibited her work and began his life-long dedication to and sponsorship of her art. Until 1924, the year of her marriage to Stieglitz, O'Keeffe's drawings and paintings in watercolor and oil were frequently abstract. But her artistic language broadened to include representational subjects, usually taken from nature and often painted in series. Visiting Taos in 1929 as the guest of Mabel Dodge Luhan, O'Keeffe discovered new interpretations of light and shadow and began to extract and simplify the monumental natural forms and architecture of the Southwest. Long a summer visitor, O'Keeffe became a New Mexico resident in 1949. Within the disciplined forms of her southwestern subjects—bones, buildings, hills, flowers, and crosses—she evolved a highly personal style.

References

Goodrich, Lloyd, and Doris Bry. *Georgia O'Keeffe*. New York: Whitney Museum of American Art, 1970.

O'Keeffe. *Georgia O'Keeffe*.

Hoffman, Katherine. *An Enduring Spirit: The Art of Georgia O'Keeffe*. Metuchen, N.J.: Scarecrow Press, 1984.

José Benito Ortega
(1858–1941)
Sculptor

The last of the notable pre-revival *santeros*, Ortega was perhaps the most prolific. But his figures, often created from scrap mill board and cheap calico rags, upon which he applied poorly prepared gesso, have disintegrated more rapidly than those of older *santeros*. Most of his work was done in the remote villages near Mora, his home, at a time when the clergy was attempting to replace *santos* with mass-produced plaster statues. In spite of this, Ortega continued to produce traditional images for Penitente *moradas* and for church, chapel, and private use. His crude carving of hands and feet contrasts with the sensitive, individual touch he gave facial features. In 1907, after the death of his wife, he moved to Raton and ceased making *santos*.

References

Denver Art Museum. *Santos of the Southwest*, pp. 36–42. Denver: Denver Art Museum, 1970.

Boyd. *Popular Arts of Spanish New Mexico*, pp. 416–29.

Helen Spang Pearce
(born 1895)
Painter

The folk art and handicrafts of Reading, Pennsylvania, her hometown, inspired Pearce to take up design and drawing at an early age. She later attended the Philadelphia School of Design for Women. In 1941 Pearce moved to Albuquerque, where she registered as a student at the University of New Mexico, studying with Raymond Jonson, Kenneth Adams, and Randall Davey. She was a founding member of the New Mexican women's art group Las Artistas, which mounted several exhibitions at the Museum of Fine Arts in Santa Fe and around New Mexico. Often relying on the landscape for inspiration, Pearce employed sweeping curves and broad planes of color to suggest the form and structure of the New Mexican environment.

References

Fisher, Reginald Gilbert. *An Art Directory of New Mexico, s.v.* "Pearce, Helen." Santa Fe: Museum of New Mexico, 1947.

American Federation of Arts. *Who's Who in American Art*, p. 362. New York: R. R. Bowker Company, 1956.

Who's Who of American Women, p. 993. Chicago: A. N. Marquis Company, 1958.

Bert Geer Phillips
(1868–1956)
Painter

Born in Hudson, New York, near a Mohican battlefield, Phillips grew up with a taste for James Fenimore Cooper and a passion for art. The latter was enhanced by early studies at the Art Students League and the National Academy of Design. In 1895, after five years in a New York studio, he sailed for Paris, where he enrolled at the Académie Julian and met Joseph Henry Sharp, who convinced him and fellow student Ernest Blumenschein to visit Taos, where Sharp had been two years earlier. Three years later, Blumenschein stumbled into Taos with a broken wagon wheel; Phillips was not far behind. Immediately establishing his home there, Phillips became a founding member of the Taos Society of Artists and committed himself to New Mexico for the next sixty years. His vivid, high-keyed oils fostered a romantic view of Pueblo life. Many

of the Indian objects that appear in these paintings came from his studio collection, one of the finest assembled by any of the early residents of the colony.

References

Broder. *Taos: A Painter's Dream*, pp. 96–113.

Nelson, Mary Carroll. *The Legendary Artists of Taos*, pp. 22–27. New York: Watson-Guptill, 1980.

Bickerstaff. *Pioneer Artists of Taos*, pp. 51–63.

Frederic Sackrider Remington

(1861–1909)
Painter, sculptor
A.N.A. 1891

Born in Canton, New York, Remington found his spiritual home in the American West. In 1881 the young artist set out for the Montana Territory, determined to gain a firsthand knowledge of western life. During the next few years, he sampled sheepherding, gold prospecting, cowboy life, and cavalry maneuvers in the Southwest. At the same time, he produced black-and-white illustrations of cowboys, Indians, and Plains military campaigns that brought him considerable recognition. In the early 1890s he began to paint and sculpt these same subjects, eventually producing a body of some three thousand vivid pictorial narratives. These made his name synonymous with a powerful nostalgia for the vanishing Wild West.

References

Hassrick. *Frederic Remington*.

Vorpahl, Ben Merchant. *Frederic Remington and the West*. Austin: University of Texas Press, 1978.

Denver Art Museum. *Frederic Remington: The Late Years*. Denver: Denver Art Museum, 1981.

Shapiro, Michael Edward. *Cast and Recast: The Sculpture of Frederic Remington*. Washington, D.C.: National Museum of American Art and Smithsonian Institution Press, 1981.

Julius Rolshoven

(1858–1930)
Painter
A.N.A. 1926

Son of a wealthy Detroit jeweler, Rolshoven studied at the Cooper Union in New York, the Düsseldorf Academy, and in Munich, after which he joined the "Duveneck Boys" in Venice. Two years at the Académie Julian during the early 1880s concluded his training. He remained in Paris until 1896, moved to London, and finally settled in Florence. In 1910 he visited North Africa and in 1916 honeymooned in New Mexico, where he and his bride were captivated by Santa Fe and Taos. They stayed two years in New Mexico before returning to Florence. Rolshoven was elected to associate membership in the Taos Society of Artists in 1917 and became an active member in 1918, but his romantic oils and pastels of southwestern Indians were often conceived in his Italian studio. In an era of rapidly changing artistic styles, Rolshoven remained faithful to his academic origins and his picturesque view of Indian life.

References

Quick, Michael. *American Expatriate Painters of the Late Nineteenth Century*, pp. 126–27, 156. Dayton, Ohio: Dayton Art Institute, 1976.

Robertson and Nestor. *Artists of the Canyons and Caminos*, pp. 118–21.

Grand Central Art Galleries. *Memorial Exhibition, Julius Rolshoven*. New York: Grand Central Art Galleries, 1954.

Charles Marion Russell

(1864–1926)
Painter, sculptor

Born in St. Louis and self-taught, Russell moved at sixteen to Montana, where he spent most of his career depicting cowboy and Indian life on the Northern Plains. Jobs as sheepherder, trapper, and wrangler and a winter with the Blood Indians in Canada brought authenticity, rich insight, and sympathy to his work. During the years when the American frontier was vanishing, Russell's illustrations appeared in such widely read publications as *Harper's*, *McClures*, and *Leslie's*, as well as in scores of personal letters written during his long career. Executed in pencil, pen and ink, watercolor, oil, and bronze, Russell's 2,500 works established his fame as one of the best-known and most-admired western artists.

References

McCracken, Harold. *The Charles M. Russell Book: The Life and Work of the Cowboy Artist*. Garden City, N.Y.: Doubleday, 1957.

Renner, Frederick G. Introduction and commentary to *Paper Talk: Illustrated Letters of Charles M. Russell*. Fort Worth: Amon Carter Museum of Western Art, 1962.

———. *Charles M. Russell: Paintings, Drawings, and Sculpture in the Amon G. Carter Collection*. Austin: University of Texas Press, 1966.

Santo Niño Santero

(active 1830–60)
Painter, sculptor

This anonymous *santero*, named for his numerous images of the Santo Niño, the Christ Child, is noted for the simplicity of his compositions and figures, which float naively against plain backgrounds. On the basis of technical and stylistic comparisons, he

is also linked to the decoration of a group of *bultos*, probably from the same workshop. The bright colors and careful outlines of the Santo Niño Santero's paintings show the influence of Rafael Aragon; such stylistic affinities probably developed either under instruction from Aragon or through the proximity of the artists' communities. The sculpture that the former decorated, however, soars above that of Aragon. The gracefully proportioned and beautifully detailed figures set a new standard for New Mexican *bultos*, never equalled during the nineteenth century.

References

Boyd. *Popular Arts of Spanish New Mexico*, pp. 376–77, 384.

Wroth. *Christian Images in Hispanic New Mexico*, pp. 160–69.

Joseph Henry Sharp

(1859–1953)
Painter

A childhood hearing loss curtailed Sharp's conventional schooling in his native Bridgeport, Ohio, but his artistic skill enabled him to enroll at the McMicken School of Design in Cincinnati at the age of fourteen. In 1881 he went off to Europe, the first of three study trips abroad, each of which was followed by visits to New Mexico and the Columbia River basin. He spent part of the summer of 1893 in Taos and passed on word of its artistic resources to Ernest Blumenschein and Bert Phillips, whom he had met in Paris in 1895. For two decades, he divided his time between teaching at the Cincinnati Art Academy, sketching in the Northwest, and summering at Taos, where he finally established a permanent residence in 1912. Sharp was a charter member of the Taos

Society of Artists, with which he exhibited for many years. His favorite subject was the Indian and his fast-disappearing life-style. Sharp drew and painted with a facility and accuracy that gave his work ethnographic as well as artistic value.

References

C. M. Russell Museum. *Joseph Henry Sharp and the Lure of the West*. Great Falls, Mont.: C. M. Russell Museum, 1978.

Broder. *Taos: A Painter's Dream*, pp. 37–63.

Fenn. *The Beat of the Drum and the Whoop of the Dance*.

William Howard Shuster

(1893–1969)
Painter, printmaker

As a young man in his native Philadelphia, Shuster painted as an avocation but found it so absorbing that he began studying painting and etching with John Sloan. When Sloan moved to New Mexico for the summers, Shuster followed, settling there in 1920. Soon after, he joined four other young Santa Fe newcomers to form the exhibition group Los Cinco Pintores. With Walter Mruk, Shuster explored the recently opened Carlsbad Caverns in 1924. For the rest of his life, he remained an active member of the Santa Fe artistic community. He designed "Zozobra" or "Old Man Gloom," the giant effigy puppet still burned annually to initiate the town's Fiesta celebration. Primarily a realist, Shuster is best remembered for his vigorous representations of Indian and Spanish life.

References

Shuster, William Howard. Papers. Archives of American Art, Smithsonian Institution, Washington, D.C.

Cassidy, Ina Sizer. "Art and Artists of New Mexico: Will Shuster." *New Mexico Magazine* 10 (February 1932): 18.

Robertson, Edna. *Los Cinco Pintores*. Santa Fe: Museum of New Mexico, 1975.

John Sloan

(1871–1951)
Painter, printmaker

Born in Lock Haven, Pennsylvania, Sloan began his career as a newspaper artist in Philadelphia while studying nights with Thomas Anshutz at the Pennsylvania Academy of the Fine Arts. Under the influence of Robert Henri, he began painting in oils in the mid 1890s and followed the older artist to New York in 1904. There he became a member of The Eight (sometimes called the Ash Can School), participating in the 1908 Macbeth Gallery exhibition and subsequently in the 1913 Armory Show. He also enjoyed a long association with the Art Students League, as teacher and president, and worked two years as art editor of *The Masses*. Encouraged by his friend and mentor Henri, Sloan motored to Santa Fe in 1919 with his wife Dolly and the Randall Daveys. There he established a summer home in 1920, returning for the next thirty-one years to paint landscapes and scenes of southwestern life. Sloan actively promoted exhibitions of American Indian art in the East, encouraged younger Santa Fe artists, and advised the fledgling art museum. His own summer work in New Mexico admitted a certain spiritual and chromatic freshness to his work.

References

Brooks, Van Wyck. *John Sloan: A Painter's Life*. New York: Dutton, 1955.

Scott, David. *John Sloan*. New York: Watson-Guptill Publications, 1975.

Holcomb, Grant. "John Sloan in Santa Fe." *American Art Journal* 10 (May 1978):33–54.

Kraft, James, and Helen Farr Sloan. *John Sloan in Santa Fe*. Washington, D.C.: Smithsonian Institution, 1981.

Truchas Master

(active 1780–1840)
Painter

Previously called the "Calligraphic Santero" because of his distinctive drawing style, this highly original painter is now called the Truchas Master based on his two major works: altar screens in the church of Nuestra Señora del Rosario de las Truchas, forty miles north of Santa Fe. His free-flowing, linear technique, flat figures, and obscure iconography set him apart from any of the known artistic personalities in New Mexico or Mexico during this period. He seems instead to have developed on his own, basing his style and imagery on religious prints and the large numbers of paintings and sculptures imported into the colony from the south during the eighteenth century. Inscriptions, written in a hand as spontaneous as his painting style, are found on a number of his panels. Literacy doubtless gave him access to sources beyond the reach of the average *santero*.

References

Boyd. *Popular Arts of Spanish New Mexico*, pp. 327–35.

Wroth. *Christian Images in Hispanic New Mexico*, pp. 171–84.

Walter Ufer

(1876–1936)
Painter
A.N.A. 1920, N.A. 1926

Born in Louisville, Kentucky, and trained as a lithographer, Ufer decided on a painting career after visiting the World's Columbian Exposition in Chicago. He began his studies in Hamburg and then moved on to the Royal Academy in Dresden. In 1900 he took up commercial art and portrait painting in Chicago, but he went to Munich in 1911 for further study. When he returned, his talent attracted former Chicago mayor Carter Harrison, who offered to subsidize a trip to Taos in 1914. There Ufer soon abandoned studio methods in favor of working outdoors in direct sunlight. His favorite subjects were Indians absorbed in their daily activities or traveling across the brilliant landscape. In 1920 he became the first Taos artist to win a prize at the Carnegie International, and through the rest of the decade his dazzling brand of Impressionism retained considerable appeal. The Depression and a waning of interest in Indian subjects affected Ufer's work during the 1930s, however, and he never regained his previous reputation.

References

Walter Ufer Papers.

"The Santa Fe/Taos Art Colony: Walter Ufer." *El Palacio* 3 (August 1916):75–81.

Phoenix Art Museum. *Ufer in Retrospect*. Phoenix: Phoenix Art Museum, 1970.

Bickerstaff. *Pioneer Artists of Taos*, pp. 113–73.

Theodore Van Soelen

(1890–1964)
Painter, printmaker
A.N.A. 1933, N.A. 1940

By 1916, when Van Soelen moved to New Mexico for his health, he was a thoroughly trained painter. He had first studied in St. Paul, his hometown, at the Institute of Arts and Sciences, and then at the Pennsylvania Academy of the Fine Arts, where he earned a travel-study scholarship to Europe. His early years in New Mexico were spent in Albuquerque as a painter-illustrator, but in 1920, seeking a closer view of Indian subjects, he moved to a trading post. This was followed by a working visit to a Texas ranch to observe cowboy life, after which he settled permanently at Tesuque. A muralist for the Works Progress Administration and an accomplished lithographer, Van Soelen recorded the Southwest and its people with keen accuracy and economy of means.

References

Museum of New Mexico. *A Retrospective Exhibition of the Work of Van Soelen*. Santa Fe: Museum of New Mexico, 1960.

Robertson and Nestor. *Artists of the Canyons and Caminos*, pp. 73–75.

Museum of New Mexico. *Light and Color: Images from New Mexico*, p. 88. Santa Fe: Museum of Fine Arts, Museum of New Mexico, 1981.

Carlos Vierra

(1876–1937)
Painter

A Californian of Portuguese descent, young Vierra left home determined to become a marine painter. Following a voyage around Cape Horn to New York, he studied art there and found work as a cartoonist. Respiratory problems mandated a change of climate

in 1904, so Vierra set out for New Mexico, becoming Santa Fe's first resident artist. His love of the historical scenes he painted and photographed led to designs that anticipated the so-called "Santa Fe style," a blending of Pueblo and mission architecture. He was also an avid amateur archaeologist, using field research as the basis for murals he painted in Santa Fe and San Diego. His landscape paintings are carefully orchestrated compositions of rich color, sweeping skies, and the natural forms of the Southwest.

References

"Vierra Memorial Show." *El Palacio* 44, no. 1–2 (5–12 January 1938): 10–12.

Trenton. *Picturesque Images from Taos and Santa Fe*, pp. 207–8.

Robertson and Nestor. *Artists of the Canyons and Caminos*, pp. 24–27.

Adam Clark Vroman
(1856–1916)
Photographer

Born in La Salle, Illinois, Vroman abandoned a career as a railroad agent and moved to Pasadena, California, in 1893. There he opened a book and photo-supply store and began to pursue his own interest in photography. At first Vroman concentrated on California landscapes and architectural subjects, but between 1895 and 1904 he made eight trips to Arizona and New Mexico, observing and documenting on film the local Indian tribes. He concentrated on the daily lives and ceremonial activities of the Hopi and Zuni. His photographic travels also took him to Japan, Yosemite, various European countries, and the Canadian Rockies, but his views of the Southwest are generally recognized as his most significant work.

References

Mahood. *Photographer of the Southwest.*

Vroman, Adam Clark. "The Pueblo of Zuni." *Photo Era* 7 (August 1901): 59–65. (Reprinted with an introduction by Ruth Mahood in *American West* 3 [Summer 1966]: 42–55.)

Webb, William, and Robert A. Weinstein. *Dwellers at the Source: Southwestern Indian Photographs of A. C. Vroman 1895–1904.* New York: Grossman Publishers, 1973.

Cady Wells
(1904–1954)
Painter

Not until his late twenties did Wells decide to become an artist. After a comfortable youth in Southbridge, Massachusetts, he studied and traveled widely, pursuing interests in music and the visual arts. In 1932 he arrived in New Mexico and almost immediately fell under the influence of Andrew Dasburg, who became his mentor for the next several years. Portraying the southwestern landscape in watercolor, Wells moved through various modernist idioms. His early work incorporated gestural, calligraphic lines suggestive of Chinese ideograms. Later he investigated the structure of natural forms and the patternlike appearance of the landscape. Influenced by Dasburg, Raymond Jonson, and Georgia O'Keeffe, Wells developed a personal, semi-abstract style that brought considerable praise from his peers. He also deserves recognition for donating his extensive collection of *santos* to the Museum of New Mexico. At Wells's recommendation, E. Boyd—who had originally invited Wells to New Mexico—became the museum's first curator of Spanish colonial art.

References

Museum of New Mexico. *Cady Wells 1904–1954.* Santa Fe: Museum of New Mexico, School of American Research, 1956.

Duncan, Kate C. "Cady Wells: The Personal Vision." In *Cady Wells: A Retrospective Exhibition.* Albuquerque: University Art Museum, University of New Mexico, 1967.

Udall. *Modernist Painting in New Mexico*, pp. 199–201.

Bibliography

Ahlborn, Richard E. "The Penitente Moradas of Abiquiu." Paper 63 in *Contributions from the Museum of History and Technology*. Washington, D.C.: Smithsonian Institution Press, 1968.

Albuquerque Museum. *The Transcendental Painting Group, New Mexico, 1938–1941*. Albuquerque: Albuquerque Museum, 1982.

American Art News 5 (23 February 1907):4.

An American Place. *Georgia O'Keeffe: Exhibition of Oils and Pastels*. New York: An American Place, 1939.

Amon Carter Museum of Western Art. *Quiet Triumph: Forty Years with the Indian Arts Fund, Santa Fe*. Fort Worth, Tex.: Amon Carter Museum of Western Art, 1966.

Armitage, Shelly. "New Mexico's Literary Heritage." *El Palacio* 90 (Anniversary Issue 1984):20–29.

Arnold, Carrie Forman. "The Museum's Adobe Palace." *El Palacio* 90 (Anniversary Issue 1984):36–45.

Austin, Mary. *Red Earth*. Chicago: Ralph Fletcher Seymour, 1920.

———. "Indian Arts for Indians." *Survey* 60 (1 July 1928):381–88.

———. *Starry Adventure*. Boston and New York: Houghton Mifflin Company, 1931.

———. *Earth Horizon: The Land of Journeys' Ending*. Boston: Houghton Mifflin Company, 1932.

Ballinger, James K. *Painters in Taos, The Formative Years: The Harrison Eiteljorg Collection*. Phoenix: Phoenix Art Museum, 1980.

Ballinger, James K., and Andrea D. Rubinstein. *Visitors to Arizona, 1846 to 1980*. Phoenix: Phoenix Art Museum, 1980.

Bancroft, Hubert Howe. *History of Arizona and New Mexico, 1530–1888*. San Francisco: The History Company, 1889. Albuquerque: Horn & Wallace, 1962.

Bandelier, Adolph F. *The Delight Makers*. New York: Dodd, Mead and Company, 1916.

Bandelier, Adolph F., and Edgar L. Hewett. *Indians of the Rio Grande Valley*. Albuquerque: University of New Mexico Press, 1937.

Bannan, Helen M. "The Idea of Civilization and American Indian Policy Reformers in the 1880s." *Journal of American Culture* 1 (Winter 1978): 787–99.

Barker, Ruth Laughlin. "John Sloan on Indian Tribal Arts." *Creative Art* 9 (December 1931):445–49.

Baxter, Sylvester. "The Father of the Pueblos." *Harper's Monthly* 65 (June 1882):72–91.

Beck, Warren A. *New Mexico: A History of Four Centuries*. Norman: University of Oklahoma Press, 1962.

Bedinger, Margery. *Indian Silver: Navajo and Pueblo Jewelers*. Albuquerque: University of New Mexico Press, 1973.

Berkhofer, Robert F., Jr. *The White Man's Indian: Images of the American Indian from Columbus to the Present.* New York: Alfred A. Knopf, 1978.

Bermingham, Peter. *The New Deal in the Southwest: Arizona and New Mexico.* Tucson: University of Arizona Museum of Art, 1980.

Bickerstaff, Laura M. *Pioneer Artists of Taos.* 1955; rev. and exp. Denver: Old West Publishing Co., 1983.

Bingham, Edfrid. "Sangre de Cristo." *Everybody's* 17 (September 1907): 302–11.

Blumenschein, Ernest L. "The Painting of Tomorrow." *Century* 87 (April 1914): 845–50.

———. "The Taos Society of Artists." *American Magazine of Art* 8 (September 1917):445–51.

———. "Origin of the Taos Art Colony." *El Palacio* 20 (15 May 1926): 190–93.

Blumenschein, Ernest L., and Bert Geer Phillips. "Appreciation of Indian Art." *El Palacio* 6 (24 May 1919):178–79.

"Blumenschein Is Interviewed." *El Palacio* 6 (1 March 1919):84–86. (Reprinted from *Albuquerque Evening Herald*, n.d).

Bodine, John J. "A Tri-Ethnic Trap: The Spanish Americans in Taos." In *Spanish-Speaking People in the United States,* Proceedings of the 1968 Annual Spring Meeting of the American Ethnological Society, distributed by the University of Washington Press, Seattle, 1969.

Boyd, E. *Popular Arts of Spanish New Mexico.* Santa Fe: Museum of New Mexico Press, 1974.

Brettell, Richard R., and Caroline B. Brettell. *Painters and Peasants in the Nineteenth Century.* New York: Rizzoli International Publications, 1983.

Briggs, Charles L. *The Wood Carvers of Cordova, New Mexico: Social Dimensions of an Artistic "Revival."* Knoxville: University of Tennessee Press, 1980.

Bright, Robert. *The Life and Death of Little Jo.* Garden City, N.Y.: Doubleday, Doran & Company, 1944.

Broder, Patricia Janis. *Bronzes of the American West.* New York: Harry N. Abrams, 1973.

———. *Taos: A Painter's Dream.* Boston: New York Graphic Society, 1980.

———. *The American West: The Modern Vision.* Boston: New York Graphic Society, 1984.

Brody, J. J. *Indian Painters and White Patrons.* Albuquerque: University of New Mexico Press, 1971.

———. *Between Traditions: Navajo Weaving Toward the End of the Nineteenth Century.* Iowa City: Stamats Publishing Company, for the University of Iowa Museum of Art, 1976.

Brooklyn Museum. *The American Renaissance, 1876–1917.* New York: Pantheon Books, 1979.

Brown, Lorin W. [Lorenzo de Cordova]. *Echoes of the Flute.* Santa Fe: Ancient City Press, 1972.

Brown, Lorin W., with Charles L. Briggs and Marta Weigle. *Hispano Folklife of New Mexico: The Lorin W. Brown Federal Writers' Project Manuscripts.* Albuquerque: University of New Mexico Press, 1978.

Brush, George de Forest. "An Artist among the Indians." *Century Magazine* 30 (May 1885):54–57.

Bryant, Keith L., Jr. "The Atchison, Topeka and Santa Fe Railway and the Development of the Taos and Santa Fe Art Colonies." *Western Historical Quarterly* 9 (October 1978):437–54.

Bunting, Bainbridge. *Early Architecture in New Mexico.* Albuquerque: University of New Mexico Press, 1976.

———. *John Gaw Meem: Southwest Architect.* Albuquerque: University of New Mexico Press, for the School of American Research, 1983.

Burnside, Wesley M. *Maynard Dixon: Artist of the West.* Provo, Utah: Brigham Young University Press, 1974.

Bynner, Witter. *Indian Earth.* New York: Alfred A. Knopf, 1929.

———. *Journey with Genius: Recollections and Reflections Concerning the D. H. Lawrences.* New York: John Day Company, 1951.

———. *The Works of Witter Bynner: Selected Poems.* Edited by Richard Wilbur. New York: Farrar, Straus, Giroux, 1978.

———. *The Works of Witter Bynner: Prose Pieces.* Edited by James Kraft. New York: Farrar, Straus, Giroux, 1979.

Cahill, E. H. "America Has Its 'Primitives': Aboriginal Water Colorists of New Mexico Make Faithful Record of Their Race." *International Studio* 75 (March 1922):80–83. Reprinted in *El Palacio* 12 (15 May 1922):126–31.

Campa, Arthur L. *Hispanic Culture in the Southwest.* Norman: University of Oklahoma Press, 1979.

Cather, Willa. *Death Comes for the Archbishop.* New York: Alfred A. Knopf, 1927; reprint ed., New York: Vintage Books, 1971.

Chamber of Commerce. *Official Program, Santa Fe Fiesta.* Santa Fe: Chamber of Commerce, 1921.

Champa, Kermit S., with Kate H. Champa. *German Painting of the Nineteenth Century*. New Haven: Yale University Art Gallery, 1970.

Chapman, Kenneth M. "America's Most Ancient Art." *School Arts Magazine* 30 (March 1931):386–402.

Chauvenet, Beatrice. *Hewett and Friends: A Biography of Santa Fe's Vibrant Era*. Santa Fe: Museum of New Mexico Press, 1983.

Cincinnati Art Museum. *The Golden Age: Cincinnati Painters of the Nineteenth Century Represented in the Cincinnati Art Museum*. Cincinnati: Cincinnati Art Museum, 1979.

Coke, Van Deren. *Taos and Santa Fe: The Artist's Environment, 1882–1942*. Albuquerque: University of New Mexico Press, for Amon Carter Museum of Western Art and Art Gallery, University of New Mexico, Albuquerque, 1963.

———. *Marin in New Mexico, 1929 and 1930*. Albuquerque: University Art Museum, University of New Mexico, 1968.

———. "Why Artists Came to New Mexico: 'Nature Presents a New Face Each Moment.'" *Art News* 73 (June 1974):22–23.

———. *Andrew Dasburg*. Albuquerque: University of New Mexico Press, 1979.

———. *Photography in New Mexico, From the Daguerreotype to the Present*. Albuquerque: University of New Mexico Press, 1979.

Colton, Harold S. "Exhibitions of Indian Arts and Crafts." *Plateau* 12 (April 1940):60–65.

Corbin, Alice. *The Sun Turns West*. Santa Fe: Writer's Editions, 1933.

Crews, Mildred, Wendell Anderson, and Judson Crews. *Patrocinio Barela: Taos Wood Carver*. 3d ed. Taos: Taos Recordings and Publications, 1976.

E. B. Crocker Art Gallery. *Munich and American Realism in the Nineteenth Century*. Sacramento, Calif.: E. B. Crocker Art Gallery, 1978.

Cunningham, Elizabeth. *Painters of the American West: Selections from the Anschutz Collection*. Denver: Anschutz Collection, 1981.

Cunningham, Elizabeth, with George Schriever. *Masterpieces of the American West: Selections from the Anschutz Collection*. Denver: Anschutz Collection, 1983.

Curtis, Natalie. "The Pueblo Singer: A Bit of Native American History." *Craftsman* 24 (July 1913):400–401.

Cushing, Frank Hamilton. "My Adventures in Zuñi." Parts 1, 2. *Century Magazine* 25 (December 1882, February 1883):191–207, 500–511.

———. *Zuñi: Selected Writings of Frank Hamilton Cushing*. Edited by Jesse Green. Lincoln: University of Nebraska Press, 1978.

Darley, Alexander M. *The Passionists of the Southwest, or The Holy Brotherhood: A Revelation of the 'Penitentes.'* Pueblo, Colo.: n.n., 1893; reprint ed., Glorieta, N.M.: Rio Grande Press, 1968.

Davis, William W. H. *El Gringo, or New Mexico and Her People*. New York: Harper and Brothers, 1857.

DeKooning, Elaine. "New Mexico." *Art in America* 49, no. 4 (1961):56–59.

Dickey, Roland F. *New Mexico Village Arts*. 1949; reprint ed., Albuquerque: University of New Mexico Press, 1970.

Dixon, Joseph K. *The Vanishing Race: The Last Great Indian Council*. Garden City, N.Y.: Doubleday, Page & Company, 1913.

Dorsey, George A. *Indians of the Southwest*. Chicago: Atchison, Topeka and Santa Fe Railway System, 1903.

Dozier, Edward P. "Rio Grande Pueblos." In *Perspectives in American Indian Culture Change*, edited by Edward H. Spicer, pp. 94–186. Chicago and London: University of Chicago Press, 1961.

Dunn, Dorothy. *American Indian Painting of the Southwest and Plains Areas*. Albuquerque: University of New Mexico Press, 1968.

Dunton, W. Herbert. "The Painters of Taos." *American Magazine of Art* 8 (August 1922):247–52.

Dutton, Bertha P. "Commerce on a New Frontier: The Fred Harvey Company and the Fred Harvey Fine Arts Collection." In *Colonial Arts*, edited by Christine Mather, pp. 91–104. Santa Fe: Ancient City Press, 1983.

Eastman, Charles A. "'My People': The Indians' Contribution to the Art of America." *Craftsman* 27 (November 1914):179–86.

Eldredge, Charles C. *Ward Lockwood 1894–1963*. Lawrence: University of Kansas Museum of Art, 1974.

Ellis, Richard N. "Hispanic Americans and Indians in New Mexico State Politics." *New Mexico Historical Review* 53 (1978):361–64.

Emery, Ina C. "The Carlisle Indian School." *Nickell Magazine* 11 (April 1899):133–43.

Ewers, John C. *Indian Life on the Upper Missouri*. Norman: University of Oklahoma Press, 1968.

Fehrer, Catherine. "A Search for the Académie Julian." *Drawing* 4 (July-August 1982):25–28.

———. "New Light on the Académie Julian and Its Founder (Rodolphe Julian)." *Gazette des Beaux-Arts* 7 (March–June 1984):207–16.

Fenn, Forrest. *The Beat of the Drum and the Whoop of the Dance: A Study of the Life and Work of Joseph Henry Sharp*. Santa Fe: Fenn Publishing Co., 1983.

Fergusson, Erna. *Dancing Gods: Indian Ceremonials in New Mexico and Arizona*. New York: Alfred A. Knopf, 1931.

————. *New Mexico: A Pageant of Three Peoples*. 1951. 2d ed. New York: Alfred A. Knopf, 1966.

Fergusson, Harvey. *The Blood of the Conquerors*. New York: Alfred A. Knopf, 1921.

Fink, Lois Marie, and Joshua C. Taylor. *Academy: The Academic Tradition in American Art*. Washington, D.C.: Smithsonian Institution Press, for the National Collection of Fine Arts, 1975.

Fletcher, A. C. "On Indian Education and Self Support." *Century Magazine* 26 (June 1883):312–15.

Francis, Rell G. *Cyrus E. Dallin*. Springville, Utah: Springville Museum of Art, 1976.

Frank, Larry, with the assistance of Millard J. Holbrook II. *Indian Silver Jewelry of the Southwest, 1868–1930*. Boston: New York Graphic Society, 1978.

Freeman, Martha Doty. "New Mexico in the Nineteenth Century: The Creation of an Artistic Tradition." *New Mexico Historical Review* 49 (January 1974):5–26.

Frisbie, Theodore R. "The Influence of J. Walter Fewkes on Nampeyo: Fact or Fancy?" In *The Changing Ways of Southwestern Indians*, edited by Albert H. Schroder, pp. 231–40. Glorieta, N.M.: Rio Grande Press, 1973.

Frost, Richard H., "The Romantic Inflation of Pueblo Culture." *American West* 17 (January–February 1980):5–9, 56–60.

Garland, Hamlin. *Hamlin Garland's Observations on the American Indian, 1895–1905*. Edited by Lonnie E. Underhill and Daniel F. Littlefield, Jr. Tucson: University of Arizona Press, 1976.

Garman, Ed. *The Art of Raymond Jonson, Painter*. Albuquerque: University of New Mexico Press, 1976.

Gebhard, David. "Architecture and the Fred Harvey Houses." *New Mexico Architecture* 4 (July–August 1962):11–17.

————. "Architecture and the Fred Harvey Houses: The Alvarado and La Fonda." *New Mexico Architecture* 6 (January–February 1964):18–25.

Gibson, Arrell Morgan. *The Santa Fe and Taos Colonies: Age of the Muses, 1900–1942*. Norman: University of Oklahoma Press, 1983.

————. *Santa Fe Collections of Southwestern Art*. Tulsa: Thomas Gilcrease Institute of American History and Art, 1983.

Gibson, Charles, ed. *The Black Legend: Anti-Spanish Attitudes in the Old World and the New*. New York: Alfred A. Knopf, 1971.

Goetzmann, William H. *Exploration and Empire*. New York: Alfred A. Knopf, 1966.

Golder, Nina. *The Hunt and the Harvest: Pueblo Paintings from the Museum of the American Indian*. Hamilton, N.Y.: Gallery Association of New York State, 1985.

Goldwater, Robert. *Primitivism in Modern Art*. 1938; reprint ed., New York: Vintage Books, 1967.

Grattan, Virginia L. *Mary Colter, Builder upon the Red Earth*. Flagstaff, Ariz.: Northland Press, 1980.

Hall, Trowbridge. *Californian Trails, Intimate Guide to the Old Missions: The Story of the California Missions*. New York: Macmillan Company, 1920.

Harlow, Francis H. *Modern Pueblo Pottery, 1880–1960*. Flagstaff, Ariz.: Northland Press, 1977.

Harmsen, W. D., ed. *Patterns and Sources of Navajo Weaving*. Denver: Harmsen's Western Americana Collection, 1977.

Harrison, Birge. "Española and Its Environs." *Harper's Monthly* 70 (May 1885):825–35.

Hartley, Marsden. "Aesthetic Sincerity." *El Palacio* 5 (9 December 1918):332–33.

————. "America as Landscape." *El Palacio* 5 (21 December 1918):340–42.

————. "Red Man Ceremonials: An American Plea for American Esthetics." *Art and Archaeology* 9 (January 1920):7–14.

————. "The Scientific Esthetic of the Redman." Parts 1, 2. *Art and Archaeology* 13 (March 1922):113–19; 14 (September 1922):137–39.

Haskell, Barbara. *Marsden Hartley*. New York: Whitney Museum of American Art, 1980.

Hassrick, Peter H. *Frederic Remington: Paintings, Drawings, and Sculpture in the Amon Carter Museum and the Sid W. Richardson Foundation Collections*. New York: Harry N. Abrams, 1973.

Hay, Robert C. "Dane Rudhyar and the Transcendental Painting Group of New Mexico from 1938–1941." Master's thesis, Michigan State University, 1981.

Hayden, F. V. *Tenth Annual Report of the United States Geological and Geographic Survey of the Territories*. Washington, D.C.: Government Printing Office, 1878.

Heard Museum. *Fred Harvey Fine Arts Collection*. Phoenix: Heard Museum, 1976.

Helm, MacKinley. *John Marin*. New York: Pellegrini and Cudahy, in association with the Institute of Contemporary Art, Boston, 1948.

Henderson, Alice Corbin. "The Dance Rituals of the Pueblo Indians." *Theatre Arts Magazine* 7 (April 1923):109–15.

Henderson, Alice Corbin, illus. William Penhallow Henderson. *Brothers of Light: The Penitentes of the Southwest*. New York: Harcourt, Brace and Company, 1937; reprint ed., Santa Fe: William Gannon, 1977.

Henderson, James David. *Meals by Fred Harvey*. Fort Worth, Tex.: Texas Christian University Press, 1969.

Henning, William T., Jr. *Ernest L. Blumenschein Retrospective*. Colorado Springs: Colorado Springs Fine Arts Center, 1978.

Henri, Robert. *The Art Spirit*. Compiled by Margery Ryerson. Philadelphia: J. B. Lippincott Co., 1960.

Hewett, Edgar L. "The School of American Archaeology." *Art and Archaeology* 4 (December 1916):317–29.

———. "America in the Evolution of Human Society." *Art and Archaeology* 9 (January 1920):2–6.

———. "Recent Southwestern Art." *Art and Archaeology* 9 (January 1920): 30–48.

———. *Ancient Life in the American Southwest*. Indianapolis: Bobbs-Merrill Co., 1930.

Hewett, Edgar L., and Bertha P. Dutton, eds. *The Pueblo Indian World: Studies on the Natural History of the Rio Grande Valley in Relation to Pueblo Indian Culture*. Handbooks of Archaeological History. Santa Fe: School of American Research, 1945.

The High Museum of Art. *The Düsseldorf Academy and the Americans: An Exhibition of Drawings and Watercolors*. Atlanta: High Museum of Art, 1972.

Highwater, Jamake. *Song from the Earth: American Indian Painting*. Boston: New York Graphic Society, 1976.

Hills, Patricia. *Turn of the Century America: Paintings, Graphics, Photographs, 1890–1910*. New York: Whitney Museum of American Art, 1977.

Hinsley, Curtis M., Jr. *Savages and Scientists*. Washington, D.C.: Smithsonian Institution Press, 1981.

Homer, William Innes, with Violet Organ. *Robert Henri and His Circle*. Ithaca, N.Y., and London: Cornell University Press, 1969.

Hornung, Clarence P. *Treasury of American Design and Antiques*. New York: Harry N. Abrams, 1979.

Hughes, Robert. "Loner in the Desert." *Time*, 12 October 1970, pp. 64–65, 67.

International Exhibitions Foundation. *The Grand Prix de Rome: Paintings from the Ecole des Beaux-Arts 1797–1863*. Washington, D.C.: International Exhibitions Foundation, 1984.

Jackson, Helen Hunt. *A Century of Dishonor*. New York: Harper & Brothers, 1881; reprint ed., New York: Harper & Row, 1965.

——— [H.H.]. "Father Juniper and His Works." Parts 1, 2. *Century Magazine* 26 (May–June 1883):3–18, 199–214.

———. *Ramona*. Boston: Roberts Brothers, 1884; reprint ed., New York: Avon Books, 1970.

James, George Wharton. "The Snake Dance of the Hopis." *Camera Craft* 6 (November 1902):3–10.

———. *New Mexico, The Land of the Delight Makers*. Boston: Page Company, 1920.

"Julian and His School of Art." *American Art News* 5 (23 February 1907):n.p. (Reprinted from *New York Evening Sun*.)

Kahlenberg, Mary Hunt, and Anthony Berlant. *The Navajo Blanket*. Los Angeles: Los Angeles County Museum of Art, 1972.

Kelder, Diane, ed. *Stuart Davis*. New York: Praeger, 1971.

Kent, Kate Peck. *Pueblo Indian Textiles: A Living Tradition*. Santa Fe: School of American Research Press, 1983.

Kessell, John L. *The Missions of New Mexico since 1776*. Albuquerque: University of New Mexico Press, for the Cultural Properties Review Committee, 1980.

Keune, Manfred E. "An Immodest Proposal: A Memorial to the North American Indian." *Journal of American Culture* 1 (Winter 1978):766–86.

King, Jeanne Snodgrass. "Dorothy Dunn and the Studio: Bà Olta i." *Southwest Art* 12 (June 1983): 72–80.

Klitgaard, Kaj. "New Mexico." In *Through the American Landscape*, pp. 154–75. Chapel Hill: University of North Carolina Press, 1941.

Krakel, Dean. *End of the Trail*. Norman: University of Oklahoma Press, 1973.

Kubler, George. *The Religious Architecture of New Mexico in the Colonial Period and since the American Occupation*. Colorado Springs: The Taylor Museum of the Colorado Springs Fine Arts Center, 1940.

Kuchta, Ronald A. *Provincetown Painters, 1890s–1970s*. Syracuse, N.Y.: Everson Museum of Art, 1977.

La Farge, Oliver. *Laughing Boy*. Cambridge, Mass.: Houghton Mifflin Company, 1929.

———. *Raw Material*. Boston: Houghton Mifflin Company, 1945.

Lamar, Howard Roberts. *The Far Southwest, 1846–1912: A Territorial History*. New Haven and London: Yale University Press, 1966.

Lange, Yvonne. "Lithography, An Agent of Technological Change in Religious Folk Art: A Thesis." In *Western Folklore*, edited by Don Yoder, pp. 51–64. Los Angeles: California Folklore Society, 1974.

Lawrence, D. H. Collection. University of Texas Library, Austin.

_____. "The Spirit of Place." In *Studies in Classic American Literature*. 1923; reprint ed., New York: Viking Press, 1964.

_____. *Mornings in Mexico*. New York: Alfred A. Knopf, 1927.

_____. *Phoenix: The Posthumous Papers of D. H. Lawrence*. Edited by Edward D. McDonald. Vol. 1. New York: Viking Press, 1936.

_____. *St. Mawr: The Later D. H. Lawrence*. New York: Alfred A. Knopf, 1952.

Lears, T. J. Jackson. *No Place of Grace: Antimodernism and the Transformation of American Culture, 1880–1920*. New York: Pantheon Books, 1981.

Levin, Gail. "Marsden Hartley and the European Avant-Garde." *Arts Magazine* 54 (September 1979):158–63.

_____. "'Primitivism' in American Art: Some Literary Parallels of the 1910s and 1920s." *Arts Magazine* 59 (November 1984):101–5.

Lockwood, John Ward. Papers. Archives of American Art, Smithsonian Institution, Washington, D.C.

_____. "The Marin I Knew: A Personal Reminiscence." *Texas Quarterly* 10 (Spring 1967):107–16.

"Los Cinco Pintores." *Artists of the Rockies and the Golden West* 6 (Summer 1979):66–73.

Luhan, Mabel Dodge. "Native Air." *New Republic* 42 (4 March 1925):40–42.

_____. "Georgia O'Keeffe in Taos." *Creative Art* 8 (June 1931):406–10.

_____. "Taos: A Eulogy." *Creative Art* 9 (October 1931):288–95.

_____. *Lorenzo in Taos*. New York: Alfred A. Knopf, 1932.

_____. *Winter in Taos*. New York: Harcourt, Brace & Co., 1935.

_____. *Taos and Its Artists*. New York: Duell, Sloan, and Pearce, 1947.

Lummis, Charles F. "The Land of Poco Tiempo." *Scribner's* 10 (December 1891): 763–64.

_____. *The Land of Poco Tiempo*. New York: Charles Scribner's Sons, 1893; reprint ed., Albuquerque: University of New Mexico Press, 1952.

_____. "The Artist's Paradise." Parts 1, 2. *Out West* 28, 29 (June, September 1908):437–51, 172–91.

Lyman, Christopher M. *The Vanishing Race and Other Illusions: Photographs of Indians by Edward S. Curtis*. Washington, D.C.: Smithsonian Institution Press, 1982.

Lyme Historical Society. *Old Lyme: The American Barbizon*. Old Lyme, Conn.: Florence Griswold Museum, 1982.

McCausland, Elizabeth. Papers. Archives of American Art, Smithsonian Institution, Washington, D.C.

McWilliams, Carey. *North from Mexico: The Spanish-Speaking People of the United States*. 1948; reprint ed., New York: Greenwood Press, 1968.

Mahood, Ruth I., ed. *Photographer of the Southwest: Adam Clark Vroman 1856–1916*. Los Angeles: Ward Ritchie Press, 1961.

Marin, John. *The Selected Writings of John Marin*. Edited by Dorothy Norman. New York: Pellegrini and Cudahy, 1949.

Marling, Karal Ann. *Woodstock, An American Art Colony, 1902–1977*. Poughkeepsie, N.Y.: Vassar College Art Gallery, 1977.

Marlor, Clark S. *The Society of Independent Artists: The Exhibition Record 1917–1944*. Park Ridge, N.J.: Noyes Press, 1984.

Mather, Christine, ed. *Colonial Frontiers: Art and Life in Spanish New Mexico: The Fred Harvey Collection*. Santa Fe: Ancient City Press, 1983.

Mauzy, Wayne. "Santa Fe's Native Market." *El Palacio* 40 (25 March, 1–8 April 1936):65–72.

Merriam, Lewis, et al. *The Problem of Indian Administration*. Institute for Government Research, Studies in Administration. Baltimore: Johns Hopkins Press, 1928.

Merrild, Knud. *With D. H. Lawrence in New Mexico*. London: Routledge and Kegan Paul, 1964.

Meyer, Doris L. "Early Mexican-American Responses to Negative Stereotyping." *New Mexico Historical Review* 53 (January 1978):75–91.

Miller, Margaret. "Religious Folk Art of the Southwest." *Bulletin of the Museum of Modern Art* 10 (May–June 1943):1–11.

Mitchell, Lee Clark. *Witnesses to a Vanishing America*. Princeton: Princeton University Press, 1981.

Monsen, Frederick. "The Destruction of Our Indians: What Civilization Is Doing to Extinguish an Ancient and Highly Intelligent Race by Taking Away Its Arts, Industries, and Religion." *Craftsman* 11 (March 1907):683–91.

_____. "Picturing Indians with the Camera." *Photo-Era* 25 (October 1910): 165–78.

Morrill, Claire. *A Taos Mosaic: Portrait of a New Mexican Village*. Albuquerque: University of New Mexico Press, 1973.

Museum of Art of the American West and the Gerald Peters Collection. *Masterworks of the Taos Founders*. Santa Fe: Peters Corporation, 1984.

Museum of Modern Art. *American Folk Art: The Art of the Common Man in America, 1750–1900*. New York: Museum of Modern Art, 1932.

Museum of New Mexico. *Light and Color: Images from New Mexico*. Kansas City, Mo.: Mid-America Arts Alliance, 1981.

"My World Is Different." *Newsweek*, 10 October 1960, p. 101.

National Collection of Fine Arts and the Whitney Museum of American Art. *Jan Matulka, 1890–1972*. Washington, D.C.: Smithsonian Institution Press, 1980.

Nestor, Sarah. *The Native Market of the Spanish New Mexican Craftsmen, Santa Fe, 1933–1940*. Santa Fe: Colonial New Mexico Historical Foundation, 1978.

"A New Art in the West." *International Studio* 63 (November 1917):xiv–xvii. By "N. C."

"New Mexico Mission Churches." *El Palacio* 5 (25 August 1918):115–16.

O'Keeffe, Georgia. *Georgia O'Keeffe*. New York: Viking Press, 1976.

Ortiz, Alfonso, ed. *Handbook of North American Indians*. Vol. 9. Washington, D.C.: Smithsonian Institution Press, 1979.

Outcalt, R. F. "Among the Artists." *Criterion* 1 (October 1887):135–36.

Parsons, Elsie Clews. *Pueblo Indian Religion*. 2 vols. Chicago: University of Chicago Press, 1939.

Pearce, Thomas Matthews. *Mary Hunter Austin*. New York: Twayne Publishers, 1965.

Peixotto, Ernest. "The Field of Art: The Taos Society of Artists." *Scribner's Magazine* 60 (August 1916):257–60.

Pennsylvania Academy of the Fine Arts. *In This Academy: The Pennsylvania Academy of the Fine Arts, 1805–1976*. Philadelphia: Pennsylvania Academy of the Fine Arts, 1976.

Phillips, Bert. "The Picturesque Shakers." *Leslie's Weekly* 82 (25 June 1896):435.

Philp, Kenneth. "Albert B. Fall and the Protest from the Pueblos." *Arizona and the West* 12 (Autumn 1970):237–54.

"Pictures of the New Mexico Mission Churches." *El Palacio* 5 (25 August 1918):116–23.

Pollock, Duncan. "Artists of Taos and Santa Fe: From Zane Grey to the Tide of Modernism." *Art News* 73 (January 1974):13–21.

Powell, Lawrence Clark. *Southwest Classics: The Creative Literature of the Arid Lands, Essays on the Books and Their Writers*. Los Angeles: Ward Ritchie Press, 1974.

Powell, Philip Wayne. *Tree of Hate: Propaganda and Prejudices Affecting United States Relations with the Hispanic World*. New York and London: Basic Books, 1971.

Pratt, Richard Henry. *Battlefield and Classroom: Four Decades with the American Indian, 1867–1907*. New Haven and London: Yale University Press, 1964.

Reeve, Kay Aiken. "Pueblos, Poets, and Painters: The Role of the Pueblo Indians in the Development of the Santa Fe–Taos Region as an American Cultural Center." *American Indian Culture and Research Journal* 5, no. 4 (1981):1–19.

———. *Santa Fe and Taos, 1898–1942: An American Cultural Center*. Southwestern Studies Monograph, no. 67. El Paso: Texas Western Press, 1982.

Rehnstrand, Jane. "Young Indians Revive Their Native Arts." *School Arts Magazine* 36 (November 1936):137–47.

Reich, Sheldon. "John Marin and the Piercing Light of Taos." *Art News* 73 (January 1974):17.

Richard, Paul. "Ansel Adams: Appreciation." *The Washington Post*, 24 April 1984, C–2.

Ritch, Wm. G. *Illustrated New Mexico: Historical and Industrial*. 5th ed., rev. and enl. Santa Fe: Bureau of Immigration, 1885.

Robertson, Edna, and Sarah Nestor. *Artists of the Canyons and Caminos: Santa Fe, The Early Years*. Layton, Utah: Peregrine Smith, 1976.

Rodee, Marian E. *Southwestern Weaving*. Albuquerque: University of New Mexico Press, 1977.

———. *Old Navajo Rugs: Their Development from 1900–1940*. Albuquerque: University of New Mexico Press, 1981.

Rodriguez, Arnold L. "New Mexico in Transition." Parts 1, 2. *New Mexico Historical Review* 24 (July, October 1949): 184–221, 267–99.

Rosenfeld, Paul. *Port of New York*. New York: Harcourt, Brace & Co., 1924.

Rubin, William, ed. *Primitivism in Twentieth Century Art: Affinity of the Tribal and the Modern*. 2 vols. New York: Metropolitan Museum of Art, 1984.

Rudisill, Richard, ed. *Frederick Monsen at Hopi*. Santa Fe: Museum of New Mexico Press, 1979.

Rumford, Beatrix T. *The Abby Aldrich Rockefeller Folk Art Collection*. Williamsburg, Va.: Abby Aldrich Rockefeller Folk Art Collection, 1975.

_____. "Uncommon Art of the Common People: A Review of Trends in the Collecting and Exhibiting of American Folk Art." In *Perspectives on American Folk Art*, edited by Ian M. G. Quimby and Scott T. Swank. New York and London: W. W. Norton & Company, for Henry Francis du Pont Winterthur Museum, 1980.

Rydell, Robert W. "The World's Columbian Exposition of 1893: Racist Underpinnings of a Utopian Artifact." *Journal of American Culture* 1 (Summer 1978):253–75.

_____. "All the World's A Fair: America's International Expositions, 1876–1916." Ph.D. diss., University of California at Los Angeles, 1980.

Sanchez, George I. *Forgotten People: A Study of New Mexicans*. Albuquerque: Calvin Horn Publisher, Inc., 1967.

Sands, Mrs. John Porter. *Today's Artist and the West by Members of the National Academy of Design*. Phoenix: Phoenix Art Museum, 1972.

The School of American Research. *Representative Art and Artists in New Mexico*. Santa Fe: Museum of Santa Fe, 1940. Rev. ed. with preface and biographical notes by George Schriever. Bronx, N.Y.: Olana Gallery, 1976.

Schwartz, Sanford. "When New York Went to New Mexico." In *The Art Presence*, pp. 85–94. New York: Horizon Press, 1976.

Scurlock, Dan. "Pastores of the Valles Caldera." *El Palacio* 88 (Spring 1982): 3–11.

Silberman, Arthur. *One Hundred Years of Native American Painting*. Oklahoma City: Oklahoma Museum of Art, 1978.

Simmons, Marc. *Two Southwesterners: Charles Lummis and Amado Chaves*. Cerrillos, N.M.: San Marcos Press, 1968.

Sims, Alida F. "Pueblo—A Native American Architecture." *House & Garden*, April 1922, pp. 52–53, 84, 86. (Reprinted in *El Palacio* 7 [15 April 1922]:103–6).

Sloan, John, and Oliver La Farge. *Introduction to American Indian Art*. New York: Exposition of Indian Tribal Arts, 1931. Reprint ed., Glorieta, N.M.: Rio Grande Press, 1970.

Spencer, Charles, ed. *The Aesthetic Movement, 1869–1890*. London: Academy Editions, 1973.

Sperry, Willard L. *Religion in America*. New York: Macmillan Company, 1946; reprint ed., Boston: Beacon Press, 1963.

Spurlock, William Henry, II. "Federal Support for the Visual Arts in the State of New Mexico: 1933–1943." Master's thesis, University of New Mexico, 1974.

Steele, Thomas J. *Santos and Saints: The Religious Folk Art of Hispanic New Mexico*. Albuquerque: Calvin Horn Publisher, 1974; reprint ed., Santa Fe: Ancient City Press, 1982.

Stieglitz, Alfred. Papers. Beinecke Rare Book and Manuscript Library, Yale University, New Haven.

Stocking, George W., Jr. *Race, Culture, and Evolution*. New York: Free Press, 1968.

Sweeney, James Johnson. *Stuart Davis*. New York: Museum of Modern Art, 1945.

Szasz, Margaret. *Education and the American Indian*. Albuquerque: University of New Mexico Press, 1974.

Tanner, Clara Lee. *Southwest Indian Painting: A Changing Art*. Tucson: University of Arizona Press, 1973.

Taft, Lorado. "Sculpture for the St. Louis World's Fair." *Brush and Pencil* 13 (December 1903):165–236.

Taylor, Lonn, and Dessa Bokides. *Carpinteros and Cabinetmakers: Furniture Making in New Mexico, 1600–1900*. Santa Fe: Museum of New Mexico Press, 1983.

Thomas, Diane H. *The Southwestern Indian Detours: The Story of the Fred Harvey/Santa Fe Railway Experiment in 'Detourism.'* Phoenix: Hunter Publishing Co., 1978.

Trenton, Patricia. *Picturesque Images from Taos and Santa Fe*. Denver: Denver Art Museum, 1974.

Trenton, Patricia, and Peter H. Hassrick. *The Rocky Mountains: A Vision for Artists in the Nineteenth Century*. Norman: University of Oklahoma Press, 1983.

Udall, Sharyn Rohlfsen. *Modernist Painting in New Mexico, 1913–1935*. Albuquerque: University of New Mexico Press, 1984.

Ufer, Walter. Papers. Rosenstock Arts, Denver.

University of New Hampshire Art Gallery. *A Stern and Lively Scene: A Visual History of the Isles of Shoals*. Durham, N.H.: University of New Hampshire, 1978.

Utley, Robert M. *The Indian Frontier of the American West, 1846–1890*. Albuquerque: University of New Mexico Press, 1984.

Utley, Robert M., and Wilcomb E. Washburn. *The American Heritage History of the Indian Wars*. New York: American Heritage Publishing Co., 1977.

Vierra, Carlos. "New Mexico Architecture." *Art and Archaeology* 7 (January–February 1918):37–52.

Walsh, Henry Collins, ed. *Edwin Willard Deming: His Work*. New York: privately printed by the Riverside Press, 1925.

Walter, Paul A. F. "The Santa Fe/Taos Art Movement." *Art and Archaeology* 4 (December 1916):330–38.

———. "The Fiesta of Santa Fe." *Art and Archaeology* 9 (January 1920):15–23.

Washburn, Wilcomb E. *The Indian in America*. New York: Harper & Row, 1975.

Waters, Frank. *People of the Valley*. 1941; reprint ed., Athens, Ohio, and London: Swallow Press, 1969.

———. *The Man Who Killed the Deer*. Denver: University of Denver Press, 1942.

———. "Indian Influence on Taos Art." *New Mexico Quarterly Review* 21 (Summer 1951):173–80.

Weber, David J. *Richard H. Kern: Expeditionary Artists in the Far Southwest, 1848–1853*. Albuquerque: University of New Mexico Press, for the Amon Carter Museum, 1985.

Weigle, Marta. *The Penitentes of the Southwest*. Santa Fe: Ancient City Press, 1970.

———. *Brothers of Light, Brothers of Blood: The Penitentes of the Southwest*. Albuquerque: University of New Mexico Press, 1976.

———. "Publishing in Santa Fe, 1915–40." *El Palacio* 90 (Anniversary Issue, 1984):10–19.

Weigle, Marta, and Kyle Fiore. *Santa Fe and Taos: The Writer's Era, 1916–1941*. Santa Fe: Ancient City Press, 1982.

Weigle, Marta, with Claudia Larcombe, and Samuel Larcombe, eds. *Hispanic Arts and Ethnohistory in the Southwest: New Papers Inspired by the Work of E. Boyd*. Santa Fe: Ancient City Press, 1983.

Weinberg, H. Barbara. "Nineteenth-Century American Painters at the Ecole des Beaux-Arts." *American Art Journal* 13 (Autumn 1981):66–84.

White, Robert R., ed. *The Taos Society of Artists*. Albuquerque: University of New Mexico Press, 1983.

Whitman, William, III. *The Pueblo Indians of San Ildefonso, A Changing Culture*. New York: Columbia University Press, 1947.

Wilder, Mitchell A., with Edgar Breitenbach. *Santos: The Religious Folk Art of New Mexico*. Colorado Springs: Taylor Museum of the Colorado Springs Fine Arts Center, 1943.

Wilson, Olive. "The Survival of an Ancient Art." *Art and Archaeology* 9 (January 1920):24–29.

Wroth, William. *The Chapel of Our Lady of Talpa*. Colorado Springs: Taylor Museum of the Colorado Springs Fine Arts Center, 1979.

———. *Christian Images in Hispanic New Mexico: The Taylor Museum Collection of Santos*. Colorado Springs: Taylor Museum of the Colorado Springs Fine Arts Center, 1982.

———. "New Hope in Hard Times: Hispanic Crafts are Revived During Troubled Years." *El Palacio* 89 (Summer 1983):22–31.

———, ed. *Hispanic Crafts of the Southwest*. Colorado Springs: Taylor Museum of the Colorado Springs Fine Arts Center, 1977.

Index

Photo Credits

Exhibition Checklist

A. J. Santero
(active 1820s)

Saint Joseph, 1820s
fig. 144
water-soluble paint and straw on pine
13⅜ x 10¾ in. (34 x 27.3 cm)
The Taylor Museum of the Colorado
Springs Fine Arts Center, Colorado

Kenneth M. Adams
(1897–1981)

Evening, ca. 1940
fig. 125
oil on canvas
24 x 30 in. (61 x 76.2 cm)
The Arvin Gottlieb Collection

Juan Duran, ca. 1933–34
fig. 5
oil on canvas
40⅛ x 30⅛ in. (102 x 76.5 cm)
National Museum of American Art,
Smithsonian Institution, Washington,
D.C., Transfer from the U.S.
Department of Labor

Anonymous

Chair from the Blumenschein House,
ca. 1910
wood
34⅝ x 17⅞ x 19¼ in. (88 x 45.5 x 49 cm)
Kit Carson Memorial Foundation, Taos

Saint Anthony, 19th century
fig. 146
tempera and gesso on wood
12⅝ x 5¾ x 3¾ in. (32 x 14.5 x 9.4 cm)
Fred Harvey Collection of the
International Folk Art Foundation
Collections at the Museum of
International Folk Art, Museum of New
Mexico, Santa Fe

Acoma
Dough Bowl, ca. 1920
fig. 69
earthenware
8½ x 14 in. (21.6 x 35.6 cm)
School of American Research,
Santa Fe

Hopi
Embroidered Manta, late 19th century
fig. 55
cotton with wool embroidery
40⅛ x 49⁹⁄₁₆ in. (101.7 x 125.9 cm)
Thomas Gilcrease Institute of American
History and Art, Tulsa, Oklahoma

Hopi
Coiled Basketry Tray, early 20th
century
fig. 78
yucca and aniline dyes
20¼ in. diameter (51.5 cm)
National Museum of Natural History,
Smithsonian Institution, Washington,
D.C., The Victor Justice Evans
Collection

Jicarilla Apache
Basketry Bowl, ca. 1920
fig. 79
split sumac and aniline dye
8 x 20 in. (20.3 x 50.8 cm)
Millicent Rogers Museum, Taos

Painting: Mexican
Saint John of Nepomuk, ca. 1820–35
oil on canvas
Frame: New Mexican, ca. 1830–50
tinned sheet iron
28 x 21¾ in. (71.1 x 55.3 cm)
fig. 123
Dr. and Mrs. Ward Alan Minge

Navajo
Bracelet, before 1890
fig. 81
silver
2¾ x ⅜ in. (7 x 1 cm)
National Museum of Natural History,
Smithsonian Institution, Washington,
D.C.

Navajo
Bracelet, ca. 1900
fig. 81
silver
2⅜ x 1 in. (6 x 2.4 cm)
National Museum of Natural History,
Smithsonian Institution, Washington,
D.C., The Victor Justice Evans
Collection

Navajo
Bracelet, ca. 1920
fig. 82
silver and turquoise
2½ x ½ in. (6.2 x 1.3 cm)
National Museum of Natural History,
Smithsonian Institution, Washington,
D.C., Gift of Dr. Lucinda de Leftwich
Templin

Navajo
Bracelet, ca. 1930
fig. 82
silver and turquoise
2¾ x ½ in. (7 x 1.4 cm)
National Museum of Natural History,
Smithsonian Institution, Washington,
D.C., Gift of Dr. Lucinda de Leftwich
Templin

Navajo
Chief Blanket, Third Phase, ca. 1860–80
fig. 72
wool
76 x 59 in. (193 x 150 cm)
National Museum of Natural History,
Smithsonian Institution, Washington,
D.C., The Victor Justice Evans
Collection

Navajo
Squash-blossom Necklace, ca. 1910
fig. 84
silver on cotton cord
26 in. long (66 cm)
National Museum of Natural History,
Smithsonian Institution, Washington,
D.C., The Victor Justice Evans
Collection

Navajo
Wedge-weave Blanket, ca. 1880–1900
fig. 75
wool
52 x 67½ in. (132 x 171.5 cm)
Maxwell Museum of Anthropology,
University of New Mexico,
Albuquerque

New Mexican
Chair, 1800s
fig. 121
pine
33⅛ x 18⅞ x 15¾ in. (84 x 48 x 40 cm)
Museum of International Folk Art,
Museum of New Mexico, Santa Fe, Gift
of the Historical Society of New Mexico

Northern New Mexican
Chest, early 1800s
fig. 120
pine with iron hinges
28⅜ x 26¾ x 15¾ in. (72 x 68 x 40 cm)
Museum of International Folk Art,
Museum of New Mexico, Santa Fe, Gift
of the Historical Society of New Mexico

Papago
Basketry Bowl, before 1884
fig. 80
yucca and *martynia* ("devil's claw")
seed-pod skin
7¾ x 18½ in. (19.6 x 47 cm)
National Museum of Natural History,
Smithsonian Institution, Washington,
D.C.

Pueblo
Striped Blanket, ca. 1870s
fig. 74
wool
47 x 68 in. (119.3 x 172.7 cm)
School of American Research, Santa Fe

Pueblo
Woven Sash, ca. 1900
fig. 55
wool and cotton
110¼ x 4 in. (279.9 x 10.1 cm)
Thomas Gilcrease Institute of American
History and Art, Tulsa, Oklahoma

Rio Grande
Blanket, ca. 1840
fig. 122
wool
80¾ x 46⅞ in. (205.1 x 119 cm)
Museum of International Folk Art,
Museum of New Mexico, Santa Fe, Gift
of Miss Florence Dibell Bartlett

Santa Clara
Water Jar, ca. 1890
fig. 67
oxidized earthenware
12½ x 14¾ in. (31.8 x 37.5 cm)
Kent Denver Country Day School,
Englewood, Colorado, Gift of
Mrs. Lucius Hallet to the Kent School

Zia
Water Jar, before 1890
fig. 68
polychromed earthenware
9½ x 10⅝ in. (24 x 27 cm)
National Museum of Natural History,
Smithsonian Institution, Washington,
D.C.

José Rafael Aragon
(active 1796–1862)

Saint Joseph, ca. 1820–62
water-soluble paints on cottonwood
figure: 33⅞ x 11 x 6¼ in. (86.1 x 28 x
15.9 cm)
The Taylor Museum of the Colorado
Springs Fine Arts Center, Colorado

Virgin and Child, ca. 1816–62
fig. 136
tempera and gesso on pine
24 x 14¼ in. (61 x 35.8 cm)
Museum of International Folk Art,
Museum of New Mexico, Santa Fe,
Charles D. Carroll Bequest

Style of José Rafael Aragon
(active 1796–1862)

Christ Carrying Cross, ca. 1816–62
fig. 159
tempera and gesso on pine
21¼ x 14⅜ in. (54 x 36.5 cm)
Museum of International Folk Art,
Museum of New Mexico, Santa Fe

Arroyo Hondo Carver
(active 1830–50)

Saint Isidore, ca. 1830–50
fig. 118
water-soluble paint on cottonwood
figures and pine framing
21 x 16½ x 9 in. (53.4 x 41.9 x 22.9
cm)
The Taylor Museum of the Colorado
Springs Fine Arts Center, Colorado

Arroyo Hondo Painter
(active 1825–40)

Our Lady of Sorrows, ca. 1825–40
water-soluble paint on pine
25¼ x 15 x ⅝ in. (64.2 x 38.1 x 1.6 cm)
The Taylor Museum of the Colorado
Springs Fine Arts Center, Colorado

Awa Tsireh
(Alfonso Roybal; ca. 1895–ca. 1955)

Koshare Sun Design, ca. 1925
fig. 63
watercolor on paper
10⅞ x 14 in. (27.6 x 35.6 cm)
Museum of Northern Arizona,
Flagstaff, Bequest of Katherine Harvey

Jozef G. Bakos
(1891–1977)

Sanctuario, Chimayo, before 1940
fig. 149
oil on canvas
30 x 34 in. (76.2 x 86.3 cm)
The Anschutz Collection

Gustave Baumann
(1881–1971)

Winter Ceremony, Deer Dance, 1922
fig. 105
oil on panel
30½ x 52⅝ in. (77.5 x 133.7 cm)
Museum of Fine Arts, Museum of New
Mexico, Santa Fe

Thomas Benrimo
(1887–1958)

Death of a Penitente, 1940
fig. 158
watercolor over pencil on paper
9½ x 14³⁄₁₆ in. (24.1 x 36 cm)
Cincinnati Art Museum, Ohio, Gift
of Mrs. Howard Wurlitzer

Oscar E. Berninghaus
(1874–1952)

Peace and Plenty, 1925
fig. 90
oil on canvas
35 x 39½ in. (88.9 x 100.3 cm)
The Saint Louis Art Museum, Missouri

Emil J. Bisttram
(1895–1976)

Comadre Rafaelita, 1934
fig. 126
oil on canvas
72 x 44 in. (182.9 x 111.8 cm)
The Anschutz Collection

Hopi Snake Dance, 1933
fig. 100
oil on canvas
41 x 45 in. (104.1 x 114.3 cm)
Museum of Fine Arts, Museum of New
Mexico, Santa Fe

Koshares, 1933
fig. 106
watercolor on paper
22½ x 16¾ in. (57.1 x 42.5 cm)
Museum of Fine Arts, Museum of
New Mexico, Santa Fe

Mexican Wake, 1932
fig. 163
oil on canvas
36 x 48 in. (91.5 x 121.9 cm)
University Art Museum, University
of New Mexico, Albuquerque

Ernest L. Blumenschein
(1874–1960)

Canyon Red and Black, 1934
fig. 184
oil on canvas
40 x 45 in. (101.6 x 114.3 cm)
Dayton Art Institute, Ohio, Gift of Mr.
John G. Lowe

Dance at Taos, 1923
fig. 98
oil on canvas
24 x 27 in. (61 x 68.6 cm)
Museum of Fine Arts, Museum of New
Mexico, Santa Fe

Indians in the Mountains, 1934
fig. 77
oil on panel
20 x 44½ in. (50.8 x 113 cm)
Mr. and Mrs. L. D. Johnson

The Plasterer, 1921
fig. 131
oil on canvas
42 x 30 in. (106.7 x 76.2 cm)
Harrison Eiteljorg Collection

Sangre de Cristo Mountains, 1925
fig. 176
oil on canvas
50¼ x 60 in. (127.6 x 152.4 cm)
The Anschutz Collection

Gutzon Borglum
(1867–1941)

The Fallen Warrior, ca. 1891
fig. 21
bronze
10⅞ x 15⅝ x 7⁵⁄₁₆ in. (27.6 x 39.7 x 18.6 cm)
Thomas Gilcrease Institute of American History and Art, Tulsa, Oklahoma

George de Forest Brush
(1855–1941)

Mourning Her Brave, 1885
fig. 20
oil on board
35½ x 25½ in. (90.1 x 64.8 cm)
Anonymous lender
(only exhibited in Washington)

The Shield Maker, 1890
fig. 24
oil on canvas
11 x 16 in. (28 x 40.6 cm)
Mr. and Mrs. Gerald Peters

Paul Burlin
(1886–1969)

The Sacristan of Trampas, ca. 1913–20
fig. 160
oil on canvas
24 x 20 in. (61 x 50.8 cm)
Museum of Fine Arts, Museum of New Mexico, Santa Fe

Gerald Cassidy
(1869–1934)

The Buffalo Dancer, before 1922
fig. 94
oil on canvas
57 x 47 in. (144.8 x 119.3 cm)
The Anschutz Collection

Norman Chamberlain
(1887–1961)

Corn Dance, Taos Pueblo, 1934
fig. 101
oil on canvas
50¼ x 40¼ in. (127.5 x 102.1 cm)
National Museum of American Art, Smithsonian Institution, Washington, D.C., Transfer from the U.S. Department of Labor

Howard Cook
(1901–1980)

Koshari—San Domingo Corn Dance, 1948
fig. 108
oil on canvas
30 x 40 in. (76.2 x 101.6 cm)
The Anschutz Collection

E. Irving Couse
(1866–1936)

Elk-Foot of the Taos Tribe, ca. 1909
fig. 73
oil on canvas
78¼ x 36⅜ in. (198.6 x 92.4 cm)
National Museum of American Art, Smithsonian Institution, Washington, D.C., Gift of William T. Evans

In the Studio, 1889
fig. 48
oil on canvas
25 x 31½ in. (63.5 x 80 cm)
Mrs. Scott Leighton Libby, Jr.

The Pottery Decorator, before 1924
fig. 71
oil on canvas
35 x 46 in. (88.9 x 116.8 cm)
Loan arranged for by Rosenstock Arts, Denver, Colorado

Sheep in France, 1890
fig. 45
oil on canvas
36 x 30 in. (91.4 x 76.2 cm)
Museum of Fine Arts, Museum of New Mexico, Santa Fe

Edward S. Curtis
(1868–1955)

On the Housetop, probably 1906
sepia photogravure on paper
image: 15⅛ x 11⅜ in. (38.4 x 28.9 cm)
Smithsonian Institution Libraries, Washington, D.C.

Taos Water Girls, before 1905
sepia photogravure on paper
image: 13¹⁵⁄₁₆ x 11¾ in. (35.4 x 29.8 cm)
Smithsonian Institution Libraries, Washington, D.C.

Andrew Dasburg
(1887–1979)

Bonnie Concha, 1927
fig. 93
oil on canvas
26 x 22 in. (66 x 55.9 cm)
The Denver Art Museum, Colorado

Ramoncita, 1927
oil on canvas
30 x 22 in. (76.2 x 55.9 cm)
Cincinnati Art Museum, Ohio, Gift of Mrs. Howard Wurlitzer

Taos Valley, 1928
fig. 205
oil on artist's board
13 x 16¼ in. (33 x 41.3 cm)
Spencer Museum of Art, The University of Kansas, Lawrence, The Ward and Clyde Lockwood Collection

Stuart Davis
(1894–1964)

New Mexican Landscape, 1923
fig. 198
oil on canvas
32 x 40¼ in. (81.2 x 102.2 cm)
Amon Carter Museum, Fort Worth, Texas

Edwin W. Deming
(1860–1942)

The Mourning Brave, ca. 1910
oil on canvas
40 x 30 in. (101.5 x 76.1 cm)
National Museum of American Art,
Smithsonian Institution, Washington,
D.C., Gift of William T. Evans

W. Herbert Dunton
(1878–1936)

Pastor de Cabras, ca. 1926
fig. 129
oil on canvas
50 x 52 in. (127 x 132.1 cm)
Loan arranged for by Rosenstock Arts,
Denver, Colorado

Henry F. Farny
(1847–1916)

The Song of the Talking Wire, 1904
fig. 22
oil on canvas
22¹⁄₁₆ x 40 in. (56 x 101.6 cm)
The Taft Museum, Cincinnati, Ohio

DeLancey W. Gill
(1859–1940)

*Street in the Pueblo of Oraibi, Tusayan,
Arizona*, 1888
fig. 29
watercolor and pencil on paper
22³⁄₁₆ x 30¹⁄₁₆ in. (56.3 x 76.3 cm)
National Museum of American Art,
Smithsonian Institution, Washington,
D.C., Gift of Mrs. Fran Roberts

Marsden Hartley
(1877–1943)

Arroyo Hondo, Valdez, 1918
fig. 172
pastel on paper
image: 17 x 27½ in. (43.2 x 69.9 cm)
Phoenix Art Museum, Arizona, Gift of
Mrs. Oliver B. James

Landscape, New Mexico, 1920
fig. 173
oil on composition board
25⅝ x 29½ in. (65.1 x 74.9 cm)
Roswell Museum and Art Center,
Roswell, New Mexico, Gift of Ione and
Hudson D. Walker

The Little Arroyo, Taos, 1918
fig. 171
pastel on paper
16½ x 27 in. (41.9 x 68.6 cm)
University Art Museum, University
of Minnesota, Minneapolis, Bequest of
Hudson Walker from the Ione and
Hudson Walker Collection

El Santo, 1919
fig. 140
oil on canvas
36 x 32 in. (91.4 x 81.2 cm)
Museum of Fine Arts, Museum of New
Mexico, Santa Fe

Santos: New Mexico, ca. 1918–19
fig. 141
oil on composition board
31¾ x 23¾ in. (80.6 x 60.3 cm)
University Art Museum, University
of Minnesota, Minneapolis, Bequest of
Hudson Walker from the Ione and
Hudson Walker Collection

William P. Henderson
(1877–1943)

Espirito Santo Grant, ca. 1938
fig. 196
oil on canvas
18 x 30 in. (45.7 x 76.2 cm)
Mrs. Edgar L. Rossin

Lucero's Prayer, ca. 1921
fig. 162
oil on canvas
36 x 40 in. (91.4 x 101.6 cm)
Mrs. Edgar L. Rossin

Penitente Procession (formerly *Holy Week
in New Mexico*), ca. 1918
fig. 155
oil on canvas
32 x 40 in. (81.3 x 101.6 cm)
Museum of Fine Arts, Museum of New
Mexico, Santa Fe

Portrait of Mrs. William P. Henderson,
ca. 1910
oil on canvas
65½ x 27½ in. (166.4 x 69.8 cm)
Mrs. Edgar L. Rossin

E. Martin Hennings
(1886–1956)

At Dusk, ca. 1912–15
fig. 41
oil on canvas
28¼ x 24 in. (71.8 x 60.9 cm)
Museum of Fine Arts, Museum of New
Mexico, Santa Fe

Bone Studies, ca. 1912–15
fig. 34
pencil on paper
16¼ x 16¼ in. (41.3 x 41.3 cm)
Museum of Fine Arts, Museum of New
Mexico, Santa Fe

Female Figure, ca. 1912–15
fig. 33
pencil on paper
14¾ x 11¾ in. (37.5 x 29.9 cm)
Museum of Fine Arts, Museum of New
Mexico, Santa Fe

The Goatherder, 1925
fig. 130
oil on canvas
45 x 50 in. (114.3 x 127 cm)
Loan arranged for by Rosenstock Arts,
Denver, Colorado

Man with Turban, ca. 1912–15
fig. 50
oil on canvas
43¼ x 33¾ in. (109.8 x 85.7 cm)
Museum of Fine Arts, Museum of New
Mexico, Santa Fe

Passing By, 1924
fig. 92
oil on canvas
44 x 49 in. (111.7 x 124.4 cm)
The Museum of Fine Arts, Houston,
Gift of the Ranger Fund, National
Academy of Design

Robert Henri
(1865–1929)

Ricardo, 1916
fig. 76
oil on canvas
24 x 20 in. (60.9 x 50.8 cm)
University Art Museum, University of
New Mexico, Albuquerque

Victor Higgins
(1884–1949)

Arroyo Hondo, ca. 1930
fig. 209
watercolor on paper
16¼ x 19¾ in. (41.3 x 50.2 cm)
Phoenix Art Museum, Arizona, Gift of
Mr. and Mrs. Orme Lewis

Nude Study, ca. 1937
fig. 57
watercolor on paper
24 x 19 in. (60.9 x 48.2 cm)
Museum of Fine Arts, Museum of New
Mexico, Santa Fe

Pueblo of Taos, before 1927
fig. 89
oil on canvas
43¾ x 53½ in. (111.1 x 135.9 cm)
The Anschutz Collection

Reflected Light, 1921
fig. 186
oil on canvas
52¼ x 56¼ in. (132.7 x 142.9 cm)
Anonymous loan

Shrine to Saint Anthony, ca. 1917
fig. 139
oil on canvas
40 x 43 in. (101.6 x 109.2 cm)
Loan arranged for by Rosenstock Arts,
Denver, Colorado

Storm Approaching Adobe, ca. 1920s
fig. 185
watercolor on paper
19 x 23½ in. (48.2 x 60.9 cm)
Mr. and Mrs. Gerald Peters

The Widower, ca. 1923
fig. 127
oil on canvas
57 x 60½ in. (144.7 x 153.7 cm)
Pennsylvania Academy of the Fine
Arts, Philadelphia, Templer Fund
Purchase

Winged Victory, ca. 1910–14
fig. 36
oil on canvas
40 x 43 in. (101.6 x 109.2 cm)
Museum of Fine Arts, Museum of New
Mexico, Santa Fe

Winter Funeral, ca. 1930
fig. 210
oil on canvas
46 x 60 in. (116.8 x 152.4 cm)
The Harwood Foundation Museum of
Taos Art, Taos

John K. Hillers
(1843–1925)

View of Taos, 1879
fig. 60
albumen silver print
image: 9⅞ x 12¹³⁄₁₆ in. (25 x 32.5 cm)
National Anthropological Archives,
Smithsonian Institution, Washington,
D.C.

Zuni Maiden, 1879
fig. 32
albumen silver print
9⁷⁄₁₆ x 7⅛ in. (24 x 18.2 cm)
Amon Carter Museum, Fort Worth,
Texas

Alexandre Hogue
(born 1898)

Procession of the Saint—Santo Domingo,
1928
fig. 3
oil on canvas
31 x 40 in. (78.7 x 101.5 cm)
Nebraska Art Association, Nelle
Cochrane Woods Collection, Courtesy
of Sheldon Memorial Art Gallery,
University of Nebraska, Lincoln

William Henry Holmes
(1846–1933)

Cliff House in 1875, 1875
fig. 9
watercolor on paper
9⅞ x 13½ in. (25.5 x 34.3 cm)
Peabody Museum of Archaeology and
Ethnology, Harvard University,
Cambridge, Massachusetts

Edward Hopper
(1882–1967)

St. Francis's Towers, Santa Fe, 1925
fig. 202
watercolor on paper
13½ x 19½ in. (34.3 x 49.5 cm)
The Phillips Collection, Washington,
D.C.

Raymond Jonson
(1891–1982)

Cliff Dwellings No.3, 1928
fig. 182
oil on canvas
48 x 38 in. (121.9 x 96.5 cm)
The Jonson Gallery of the University
Art Museum, University of New
Mexico, Albuquerque

Santo, 1928
fig. 142
oil on linen
40 x 28 in. (101.6 x 71.1 cm)
Roswell Museum and Art Center,
Roswell, New Mexico, Gift of Arthur
Jonson in memory of his wife,
Mary Van Dyke

Fred Kabotie
(born ca. 1900)

Dance of the Corn Maidens, ca. 1920
fig. 64
watercolor on paper
14 x 22 in. (35.5 x 55.8 cm)
School of American Research Collection
at the Museum of Fine Arts, Museum
of New Mexico, Santa Fe

Gina Knee
(1898–1983)

Near Cordova, N.M., 1943
fig. 208
watercolor
19 x 23 in. (48.2 x 58.4 cm)
The Anschutz Collection

Leon Kroll
(1884–1974)

Santa Fe Hills, 1917
fig. 204
oil on canvas
34 x 40 in. (86.3 x 101.6 cm)
Museum of Fine Arts, Museum of New
Mexico, Santa Fe

Laguna Santero
(active 1796–1808)

Saint Joseph, ca. 1796–1808
fig. 119
water-soluble paint on pine
16¾ x 11¼ in. (42.6 x 28.6 cm)
The Taylor Museum of the Colorado
Springs Fine Arts Center, Colorado

Barbara Latham
(born 1896)

Decoration Day, ca. 1940
fig. 164
tempera on panel
24½ x 29 in. (61 x 76 cm)
The Harwood Foundation Museum of
Taos Art, Taos

J. Ward Lockwood
(1894–1963)

Midwinter, 1933
fig. 195
oil on canvas
24¼ x 32½ in. (61.6 x 82.5 cm)
Addison Gallery of American Art,
Phillips Academy, Andover,
Massachusetts
(only exhibited in Washington)

Taos Plaza in Snow, ca. 1933
fig. 4
oil on canvas
30 x 40 in. (76.2 x 101.6 cm)
Pennsylvania Academy of the Fine
Arts, Philadelphia, Lambert Fund
Purchase

Hermon Atkins MacNeil
(1866–1947)

A Chief of the Multnomah Tribe, 1907
fig. 19
bronze
32 x 10 x 9¼ in. (81.3 x 25.4 x 23.5 cm)
Thomas Gilcrease Institute of American
History and Art, Tulsa, Oklahoma

Ma-Pe-Wi
(Velino Shije Herrera; 1902–1973)

Buffalo Hunt, ca. 1930
fig. 65
watercolor on paper
20 x 29 in. (50.8 x 73.7 cm)
School of American Research, Santa Fe

John Marin
(1870–1953)

*Aspen Trees in Hondo Canyon, New
Mexico*, 1929
fig. 199
watercolor on paper
16½ x 14 in. (41.9 x 35.5 cm)
Anonymous loan

Canyon of the Hondo, New Mexico, 1930
fig. 201
watercolor on paper
15 x 20 in. (38.1 x 50.8 cm)
The Anschutz Collection

Dance of the Santo Domingo Indians, 1929
fig. 103
watercolor and charcoal on paper
22 x 30¾ in. (55.9 x 78.1 cm)
The Metropolitan Museum of Art, New
York, The Alfred Stieglitz Collection
(only exhibited in Washington)

Storm over Taos, New Mexico, 1930
fig. 200
watercolor on composition board
15 x 20¹⁵⁄₁₆ in. (38.1 x 53.2 cm)
National Gallery of Art, Washington,
D.C., Alfred Stieglitz Collection
(not exhibited in Houston)

Crescencio Martinez
(? –1918)

San Ildefonso Eagle Dancers, ca. 1917
fig. 62
watercolor on paper
18½ x 32 in. (47 x 81.3 cm)
Millicent Rogers Museum, Taos

Maria and Julian Martinez
ca. 1880s–1980 and 1879–1943

Blackware Plate, late 1930s
fig. 66
oxidized earthenware and slip
14⅞ in. diameter (37.8 cm)
The Denver Art Museum, Colorado

Jan Matulka
(1890–1972)

Indian Dancers, ca. 1918
fig. 102
oil on canvas
26 x 16 in. (66 x 40.6 cm)
The Anschutz Collection

Willard L. Metcalf
(1858–1925)

Zuni Ceremony (formerly *Around the
Council Fire*), ca. 1882
fig. 26
gouache on paper
8½ x 13⅝ in. (21.6 x 34.6 cm)
Mr. and Mrs. Wallace E. Jeffs

Zuni Indians, ca. 1882
fig. 11
gouache on paper
9⁵⁄₁₆ x 13⅞ in. (23.6 x 35.2 cm)
The Hyde Collection, Glens Falls, New
York

Peter Moran

(1841–1914)

Indians Winnowing Wheat, ca. 1879–90
fig. 27
watercolor on paper
5½ x 13⅜ in. (13.9 x 33.9 cm)
Amon Carter Museum, Fort Worth,
Texas
(exhibited only in Washington and
Cincinnati)

Threshing Wheat, San Juan, ca. 1879–90
watercolor on paper
7⅜ x 13⅜ in. (18.7 x 33.9 cm)
Amon Carter Museum, Fort Worth,
Texas
(exhibited only in Denver)

Zia, ca. 1879–90
fig. 28
watercolor on paper
5⅞ x 9¾ in. (14.9 x 24.7 cm)
Amon Carter Museum, Fort Worth,
Texas
(exhibited only in Washington
and Houston)

James S. Morris

(ca. 1902–1973)

Lightning, late 1930s
fig. 179
oil on canvas
20 x 24 in. (50.8 x 60.9 cm)
Museum of Fine Arts, Museum of New
Mexico, Santa Fe

Walter Mruk

(1883–1942)

The Ghost of Carlsbad Caverns, ca.
1924–25
fig. 178
oil on canvas
20 x 24 in. (50.8 x 60.9 cm)
The Harmsen Collection

Nampeyo

(ca. 1860–1942)

Jar, 1915
slipped and polychromed earthenware
7 x 15 in. (17.8 x 38.1 cm)
School of American Research, Santa Fe,
Gift of Inez B. Westlake

Willard Nash

(1898–1943)

Penitentes, ca. 1930
fig. 156
oil on canvas
24 x 30 in. (60.9 x 76.2 cm)
The Museum of the Southwest,
Midland, Texas

Santa Fe Landscape, ca. 1930
oil on canvas
19½ x 23½ in. (49.5 x 59.7 cm)
Mr. and Mrs. Gerald Peters

B. J. O. Nordfeldt

(1878–1955)

Antelope Dance, 1919
fig. 97
oil on canvas
35⅝ x 43 in. (90.5 x 109.2 cm)
Museum of Fine Arts, Museum of New
Mexico, Santa Fe

Standing Nude, ca. 1900
fig. 38
charcoal on paper
23 x 15 in. (58.4 x 38.1 cm)
Van Deren Coke

Still Life with Santo, ca. 1930
fig. 138
oil on canvas
40 x 28 in. (101.6 x 71.1 cm)
The Anschutz Collection

Georgia O'Keeffe

(born 1887)

After a Walk Back of Mabel's, 1929
fig. 191
oil on canvas
40 x 30½ in. (101.6 x 77.5 cm)
Philadelphia Museum of Art,
Gift of Dr. and Mrs. Paul Todd Makler
(exhibited only in Washington)

Another Church, Hernandez, New Mexico,
1931
fig. 150
oil on canvas
10 x 24 in. (25.4 x 60.9 cm)
The Anschutz Collection

Black Cross with Stars and Blue, 1929
fig. 134
oil on canvas
40 x 30 in. (101.6 x 76.2 cm)
Mr. and Mrs. George Segal

Cliffs beyond Abiquiu—Dry Waterfall,
1943
fig. 1
oil on canvas
30 x 16 in. (76.2 x 40.6 cm)
Anonymous loan

Ranchos Church No. 1, 1929
fig. 151
oil on canvas
18¾ x 24 in. (47.6 x 61 cm)
Norton Gallery and School of Art, West
Palm Beach, Florida

Red and Orange Hills (formerly
My Red Hills), 1938
fig. 188
oil on canvas
20 x 36 in. (50.8 x 91.4 cm)
Judge and Mrs. Oliver Seth

José Benito Ortega

(1858–1941)

Christ with Mourning Figures, ca. 1880
fig. 117
paint and gesso on wood
36¾ x 22 in. (93.4 x 55.9 cm)
Millicent Rogers Museum, Taos

Helen Spang Pearce

(born 1895)

New Mexico Ribbon, 1946
fig. 177
oil on canvas board
21¾ x 27⅞ in. (55.2 x 70.8 cm)
Mr. and Mrs. William P. Albrecht

Bert Geer Phillips

(1868–1956)

New Mexico Bulto, ca. 1924
fig. 147
oil on canvas
36 x 36 in. (91.4 x 91.4 cm)
Folsom Investments, Inc., Dallas

Our Washerwoman's Family, ca. 1918
fig. 135
oil on canvas
41 x 41½ in. (104.1 x 105.3 cm)
Museum of Fine Arts, Museum of New
Mexico, Santa Fe

Relics of His Ancestors, before 1917
fig. 70
oil on canvas
34 x 40 in. (86.3 x 101.6 cm)
James F. Burshears

The Santero, ca. 1930
fig. 133
oil on canvas
30 x 25 in. (76.2 x 63.5 cm)
The Anschutz Collection

Sister Charlotte, ca. 1894
fig. 44
oil on canvas
23 x 14 in. (58.4 x 35.5 cm)
Hancock Shaker Village, Inc., Pittsfield,
Massachusetts

Song of the Aspen, ca. 1926–28
fig. 53
oil on canvas
40 x 27 in. (101.6 x 68.5 cm)
Harrison Eiteljorg Collection

Frederic Remington

(1861–1909)

An Indian Dream, ca. 1899
fig. 23
oil on canvas
40 x 27½ in. (101.6 x 69.8 cm)
Thomas Gilcrease Institute of American
History and Art, Tulsa, Oklahoma

Julius Rolshoven

(1858–1930)

Tunisian Bedouins, ca. 1910
fig. 51
oil on canvas
42½ x 35 in. (108 x 88.9 cm)
University Art Museum, University
of New Mexico, Albuquerque

Charles M. Russell

(1864–1926)

Sun River War Party, 1903
fig. 7
oil on canvas
18 x 30 in. (45.7 x 76.2 cm)
The Rockwell Museum, Corning, New
York

Santo Niño Santero

(active 1830–60)

Saint Michael, ca. 1830–60
fig. 145
water-soluble paint on cottonwood,
pine base
figure: 13⅜ x 7½ x 4 in. (34 x 19.1 x
10.2 cm)
The Taylor Museum of the Colorado
Springs Fine Arts Center, Colorado

La Virgen de Guadalupe, ca. 1830
fig. 2
tempera and gesso on wood
16¾ x 8⅝ x 5½ in. (42.5 x 22 x 14 cm)
Fred Harvey Collection of the
International Folk Art Foundation
Collections at the Museum of
International Folk Art, Museum of New
Mexico, Santa Fe

Joseph Henry Sharp

(1859–1953)

Crucita, A Taos Indian Girl
fig. 54
oil on canvas
40¼ x 48½ in. (102.2 x 123.2 cm)
Thomas Gilcrease Institute of American
History and Art, Tulsa, Oklahoma

Devant Saint Antoine, 1896
fig. 40
oil on canvas
72 x 22 in. (182.9 x 55.9 cm)
The Queen City Club of Cincinnati,
Ohio
(only exhibited in Washington
and Cincinnati)

Enchanted Mesa, 1915
fig. 166
oil on canvas
40 x 56 in. (101.6 x 142.2 cm)
Thomas Gilcrease Institute of American
History and Art, Tulsa, Oklahoma

In the Studio, 1897
fig. 47
oil on canvas
32¾ x 22¼ in. (83.2 x 56.5 cm)
Courtesy of Hirschl & Adler Galleries,
Inc., New York

*Sunset Dance—Ceremony to the Evening
Sun*, 1924
fig. 87
oil on canvas
25 x 30 in. (63.5 x 76.2 cm)
The Arvin Gottlieb Collection

Will Shuster

(1893–1969)

Penitente Crucifixion
fig. 157
oil on canvas
40 x 30 in. (101.6 x 76.2 cm)
The Harmsen Collection

John Sloan

(1871–1951)

Ancestral Spirits, 1919
fig. 96
oil on canvas
24 x 20 in. (60.9 x 50.8 cm)
Museum of Fine Arts, Museum of New
Mexico, Santa Fe

East at Sunset, 1921
fig. 193
oil on canvas
26 x 32 in. (66 x 81.3 cm)
Kraushaar Galleries, New York

Threshing Floor, Goats, Santa Fe, 1924
and 1945
fig. 161
oil on canvas
30 x 40 in. (76.2 x 101.6 cm)
Kraushaar Galleries, New York

Truchas Master
(active 1780–1840)

Saint Joseph, ca. 1800–1840
fig. 143
tempera and gesso on pine
12 x 9⅞ in. (30.5 x 25 cm)
Museum of International Folk Art,
Museum of New Mexico, Santa Fe,
Cady Wells Bequest

Walter Ufer
(1876–1936)

The Bakers, 1917
fig. 88
oil on canvas
50¼ x 50¼ in. (127.6 x 127.6 cm)
Mr. and Mrs. L. D. Johnson

Callers, ca. 1926
fig. 58
oil on canvas
50½ x 50½ in. (128.4 x 128.4 cm)
National Museum of American Art,
Smithsonian Institution, Washington,
D.C., Gift of Mr. and Mrs. R. Crosby
Kemper, Jr.

Life Class Drawing, 1903
fig. 39
charcoal on paper
24 x 14½ in. (60.9 x 36.8 cm)
Mr. and Mrs. Ramon Kelley

Oferta para San Esquipula, 1918
fig. 148
oil on canvas
25 x 30 in. (63.5 x 76.2 cm)
The Anschutz Collection

Where the Desert Meets the Mountain,
before 1922
fig. 203
oil on canvas
36½ x 40½ in. (92.7 x 102.8 cm)
The Anschutz Collection

Woman from Dachau, 1912
fig. 43
oil on canvas
21½ x 17¼ in. (54.6 x 43.8 cm)
Charles J. Murphy, Dubuque, Iowa

Theodore Van Soelen
(1890–1964)

The World of Don Francisco, 1934
fig. 137
oil on canvas
36 x 48 in. (91.4 x 121.9 cm)
The Museum, Texas Tech University,
Lubbock

Carlos Vierra
(1876–1937)

Northern New Mexico in Winter, ca. 1922
fig. 194
oil on canvas
28 x 38 in. (71.1 x 96.5 cm)
Collection of E. W. Sargent

Adam Clark Vroman
(1856–1916)

Acoma, Mary Painting Pottery, 1902
fig. 30
modern print from original negative
image: 9½ x 7⅛ in. (24.1 x 18.1 cm)
Adam Clark Vroman Collection,
Seaver Center, Natural History
Museum of Los Angeles County,
California

Hopi Towns, Grinding Corn, Tewa, 1895
fig. 18
modern print from original negative
image: 7 x 9½ in. (17.8 x 24.1 cm)
Adam Clark Vroman Collection, Seaver
Center, Natural History Museum of
Los Angeles County, California

Hopi Towns, Men of Sichimovi, 1901
fig. 6
modern print from original negative
image: 7⁹⁄₁₆ x 9½ in. (19.1 x 24.1 cm)
Adam Clark Vroman Collection, Seaver
Center, Natural History Museum of
Los Angeles County, California

*Hopi Towns, The Niman Dance,
Shungopavi*, 1901
fig. 99
modern print from original negative
image: 7⅛ x 9½ in. (18.1 x 24.1 cm)
Adam Clark Vroman Collection, Seaver
Center, Natural History Museum of
Los Angeles County, California

Cady Wells
(1904–1954)

New Mexico Landscape, 1933
watercolor on paper
14¾ x 21¾ in. (37.4 x 55.2 cm)
Museum of Fine Arts, Museum of New
Mexico, Santa Fe

Lenders to the Exhibition

Addison Gallery of American Art, Andover, Massachusetts
Mr. and Mrs. William P. Albrecht
Amon Carter Museum, Fort Worth, Texas
Anonymous
The Anschutz Collection
James F. Burshears
Kit Carson Memorial Foundation, Inc., Taos
Cincinnati Art Museum, Ohio
Van Deren Coke
Dayton Art Institute, Dayton, Ohio
The Denver Art Museum, Denver
Harrison Eiteljorg Collection
Folsom Investments, Inc., Dallas
Thomas Gilcrease Institute of American History and Art, Tulsa, Oklahoma
The Arvin Gottlieb Collection
Hancock Shaker Village, Inc., Pittsfield, Massachusetts
The Harmsen Collection
The Harwood Foundation Museum of Taos Art, Taos
Hirschl & Adler Galleries, New York
The Hyde Collection, Glens Falls, New York
Mr. and Mrs. Wallace E. Jeffs
Mr. and Mrs. L. D. Johnson
The Jonson Gallery of the University Art Museum, University of New Mexico, Albuquerque
Mr. and Mrs. Ramon Kelley
Kent Denver Country Day School, Englewood, Colorado
Kraushaar Galleries, New York
Mrs. Scott Leighton Libby, Jr.
Natural History Museum of Los Angeles County, Los Angeles
Museum of International Folk Art, Museum of New Mexico, Santa Fe

Maxwell Museum of Anthropology, University of New Mexico, Albuquerque
The Metropolitan Museum of Art, New York
Millicent Rogers Museum, Taos
Dr. and Mrs. Ward Alan Minge
Charles J. Murphy, Dubuque, Iowa
The Museum of Fine Arts, Houston
Museum of Fine Arts, Museum of New Mexico, Santa Fe
Museum of Northern Arizona, Flagstaff
Museum of the Southwest, Midland, Texas
National Anthropological Archives, Smithsonian Institution, Washington, D.C.
National Gallery of Art, Washington, D.C.
National Museum of American Art, Smithsonian Institution, Washington, D.C.
National Museum of Natural History, Smithsonian Institution, Washington, D.C.
Norton Gallery and School of Art, West Palm Beach, Florida
Peabody Museum of Archaeology and Ethnology, Harvard University, Cambridge, Massachusetts
Pennsylvania Academy of the Fine Arts, Philadelphia
Mr. and Mrs. Gerald Peters
Philadelphia Museum of Art, Philadelphia
The Phillips Collection, Washington, D.C.
Phoenix Art Museum, Phoenix
The Queen City Club of Cincinnati, Ohio
The Rockwell Museum, Corning, New York
Mrs. Edgar L. Rossin
Roswell Museum and Art Center, Roswell, New Mexico
Smithsonian Institution Libraries, Washington, D.C.
The Saint Louis Art Museum, Missouri
E. W. Sargent
School of American Research, Santa Fe
Mr. and Mrs. George Segal
Judge and Mrs. Oliver Seth
Sheldon Memorial Art Gallery, University of Nebraska, Lincoln
Spencer Museum of Art, The University of Kansas, Lawrence
The Taft Museum, Cincinnati, Ohio
The Taylor Museum of the Colorado Springs Fine Arts Center, Colorado
The Museum, Texas Tech University, Lubbock, Texas
University Art Museum, University of Minnesota, Minneapolis
University Art Museum, University of New Mexico, Albuquerque